From this "lingua universalis" evolved an art language. Contingent on and limited by its historical context, this language evolved within the framework of the creative arts of the late 19th century. Photographers conformed to the aesthetics of their time and regarded photography merely as an additional means for visually perceiving and recreating reality. They experimented with this third eye with the intention of thereby enhancing the art of painting.

At the beginning of this century, the awareness grew that the photographic image had achieved autonomy and that it had developed an aesthetic of its own. This autonomy led to a new fertile relationship with painting. Photographers and painters discovered the nearly unlimited possibilities of producing art with this medium, and continued technological advances in this field provided unexpected new ways of doing so. Even so, the history of photography as art evolved independently and parallel to the history of painting. Fear of contact between the two was great, disputes sometimes harsh, a reconciliation seemed hopeless.

Fortunately, a dialog did eventually evolve, and this is undoubtedly one of the most exciting chapters in the visual culture of our century. It was not just a matter of recognizing photography as an art, but definitively eliminating the borders between photography and the creative arts.

In time, photography succeeded in gaining public acceptance. Major artists made a name for themselves with their small black-and-white pictures. Diverse styles expanded the scope. In the end, photography became a significant component of our culture. Modern art meanwhile had questioned its own means, and artists sought new ideas and new means of expression, eager to experiment. Naturally, this also involved photography. Artists like the Russian avant-gardists Alexander Rodchenko and El Lissitzky, the American dadaist and surrealist Man Ray or the Hungarian constructivist László Moholy-Nagy have all created an important body of work, thus becoming pioneers of a development that to this day remains uncompleted. But these artists were to remain exceptions, and the general ranking of photography before the First World War was relatively low. It was not accorded the decisive recognition as "high art". Even the establishment of a Department of Photography at the Museum of Modern Art in New York (which opened in 1929) was to remain an exception, and there were hardly any significant collectors of photographs.

The breakthrough finally occurred in the late fifties and early sixties. The urban world, the media and advertising intrigued artists such as Andy Warhol and Robert Rauschenberg, and photography became an integral part of their creative activities, an expansion of their art. Other artists explored the specificity of the photographic image, like Gerhard Richter, for instance, who regarded photography both as a filter of reality and as an independent pictorial reality.

Photographers now felt more and more attracted by the world of advertising, fashion and the mundane, Horst P. Horst and Richard Avedon being two examples. This resulted in a progressive elimination of media-driven compartmentalization. At last photography achieved museum-worthy status. In addition to the traditional art categories of painting, sculpture, drawing and graphic design, now there was the additional category of photography.

The photography collection at the Museum Ludwig evolved from an art collection. When the photography collection became a separate entity, this dialog was continued judiciously, with an open-minded attitude towards any new trends. Even though it was only created mostly after the museum was founded in 1976, today the collection nevertheless contains about 9300 photographs. The present book of excerpts presents 860 works and profiles 278 photographers. This is the first time that a selection drawn from the entire photography collection of the Museum Ludwig is being published for a broad public. Earlier publications were scientific evaluations of sections of the museum's photography holdings. On the occasion of the 20th anniversary of the museum, it was decided to publish two volumes with the same format, one covering painting and sculpture, and the present one covering 20th century photography. The decisive moment for the establishment of the Department of Photography at the Museum Ludwig was the acquisition in 1977 of the famous L. Fritz Gruber collection. L. Fritz Gruber, a longtime mentor, patron and friend of the museum, has been fostering photography throughout his life. To this day, he is known and respected internationally for his knowledge and love of photography. His worldwide contacts opened many doors, and his collection grew steadily. Parts of his collection were gradually donated to the museum, most recently in 1993 and 1994. The Gruber Collection constitutes the core of the present volume, both in terms of quantity as well as quality. With the help of L. Fritz Gruber, the museum has also been able to acquire many other

20th Century

phy

ove your Ludwig

library

The Art of Photography

Marc Scheps

Photography, a 19th-century scientific invention, has – like many other technical innovations of that era – dramatically altered mankind's perception and experience of the world, an effect that continues to this day. The reproduction of a time-constrained reality by the immaterial medium of light, the "freezing" of a visually observable scene, seemed like a miracle, especially in its beginnings. It was, so to speak, the fulfillment of an ancient desire of mankind to create an imaginary world that would be as believable as the real world itself. This mirror image of the real world, chemically recorded on paper, was created in a miracle box, and the resulting pictures, memories of a past time-space situation, formed a visual archive. For the first time, one could record the past not just with written words or painted pictures. Now it could live on in the form of exact images. One could believe in this past as if one had experienced it personally. The photographic image evolved into a collective memory.

At first, the capability of creative interpretation inherent in painted pictures was challenged by the objective realism of the photographic image. Photography appeared to be unaffected by reality. Photographers celebrated the banality of daily life. They had the urge to create an overall record of our world, to assemble an endless collection of pictures into a kind of mega-memory.

The painted picture, the result of a long creative and additive process, could suddenly be replaced by a fast optical, mechanical and chemical process. The photographic image did not initially constitute a direct threat to painting. Its format was restricted by what the lens could cover, the images were black-and-white, and it was dependent on illumination. But even those who recognized the danger that photography posed to painting were fascinated by this new medium and the huge potential that it represented. The invention of photography was, after all, the birth of a new language and as such it should, above all, make possible a new kind of visual communication. This language is not localized, and the flood of photographic images knows no borders. Multiple reproduction and dissemination of these pictures created a virtual reality that has become part of our modern culture.

collectors, and it constantly strives to enhance the collection further with other means. Reinhold Mißelbeck, who has been running the Department of Photography and Video since 1980, performs this task with great dedication, expertise and empathy, in spite of the fact that the means at our disposal are modest. The overall picture is impressive. Nevertheless we are not resting on our laurels but are currently busy planning visions for the collection for the coming years.

With the 1993 exhibition "Photography in Contemporary German Art", we showcased a current development that has mostly taken place in the Rhineland. It pointed to a future emphasis of the collection. With the Richard Avedon Retrospective of 1994 we presented an important photographer who addresses subjects that have fascinated various other artists of his generation: fashion, media, art, politics, poverty, violence and death. At the same time, we experimented with a new kind of photographic exhibition which without doubt will influence exhibitions in the future. This and other exhibitions attest to the symbiosis of artistic media, to mutual stimulation and enhancement of all categories of the creative arts.

With the 1995 exhibition "Celebrities' Celebrities", drawn from the Gruber Collection, we wanted to demonstrate that the great photographers of our time should be equated with all other artists and that the camera is no longer a mere technical aid for creating images that are unforgettable and that have become an integral part of our "musée imaginaire". The present volume is a testimony to the richness of the photographic image, to the creativity of the artists who – with camera in hand – are constantly taking us along on new voyages of discovery. Their artistic experiences are an enrichment of our lives.

The Photography Collection at the Museum Ludwig in Cologne

Reinhold Mißelbeck

The Photography Collection at the Museum Ludwig is the very first collection of photography at a museum of contemporary art in Germany, and it was founded almost simultaneously with the museum itself. Negotiations for founding the Museum Ludwig were completed in 1976, and the acquisition of the Gruber Collection took place barely a year later. Even so, the museum's collection already contained some photographic works before that acquisition occurred, such as *Journeyman* by August Sander, *Studies for Holograms* by Bruce Nauman and two photograms by László Moholy-Nagy. The Wallraf-Richartz-Museum had thus recognized the significance of this medium, and in certain instances it had also acquired individual photographic works. With the Ludwig Collection came a number of major artistic works, such as *Typology of half-timbered Houses* by Bernd and Hilla Becher, *Variable Piece No. 48* by Douglas Huebler, *Birth* by Charles Simonds and *Black Vase Horizontal* by Jan Dibbets. While there was never an emphasis on photography in the Ludwig Collection, these works nevertheless signaled the fact that a photographic collection as part of a museum of modern art has other priorities than a photographic museum per se. The history of photography has never been the guiding theme of the collection's interest. Rather it is the medium of photography as a young field of artistic activity next to painting, sculpture, drawing and printmaking, and as an older one when compared to video, performance or new media. Nevertheless these beginnings can only be considered to be the first hesitant steps of an emerging interest that later matured with the purchase of 887 photographs and the endowment of 200 additional ones from the Gruber Collection.

The Gruber Collection was an auspicious foundation for the museum's photography collection. This single acquisition encompassed an overview of this century's artistic photography, ranging from ebbing Pictorialism, represented by photographs in the work of Heinrich Kühn, Alvin Langdon Coburn and Hugo Erfurth (made in the twentieth century), through American and European Modernism, all the way into the fifties and sixties. This included the most important big names in American straight photography, like Ansel Adams, Edward Weston, Arnold

Newman, Walker Evans, Margaret Bourke-White and Dorothea Lange. But photojournalism was also well represented, with images by Alfred Eisenstaedt, Gordon Parks, Weegee, William Klein and W. Eugene Smith. Experimental trends were represented by the work of László Moholy-Nagy, Man Ray, Herbert List, Philippe Halsman, Chargesheimer, Heinz Hajek-Halke and Otto Steinert. Great names in fashion photography were also included: Cecil Beaton, Richard Avedon, Irving Penn, Horst P. Horst and George Hoyningen-Huene. With a collection of such richness, the Photography Collection of the Museum Ludwig took its place in the vanguard of the most significant photographic collections in Germany, next to those of the Folkwang-Schule in Essen (since 1978 in the Museum Folkwang), the Museum for Arts and Crafts in Hamburg, the first German photographic museum, the Agfa-Foto-Historama in Leverkusen (moved to Cologne in 1986), the photographic collection of the City Museum of Munich (which became the Photographic Museum in 1980). While the last three institutions were photohistory-oriented, and the collections in Essen and in Cologne concentrated on contemporary art, the Museum Ludwig was the only one with a policy of acquiring photographic works by creative artists in addition to fine examples of artistic photography. New acquisitions of images by Ger Dekkers, Peter Hutchinson, Jean Le Gac, Mac Adams and Michael Snow emphatically confirm this policy.

In 1978, another significant selection of photographs arrived in the form of a loan from the Ludwig Collection, consisting of 123 photographs by Alexander Rodchenko and two photograms by El Lissitzky. It was the very first large collection of Russian photographs to be displayed in a German Art Museum. This well-received exhibition and its accompanying publication sent an important signal. Various small exhibitions were also selected from the Gruber Collection, such as "Portraits of Artists" (1977), "Artistic Photography" (1978) and "Reportage Photography" (1979). During these early years, the collection was cared for by Jeane von Oppenheim and Dr. Evelyn Weiss. In 1979, the entire collection of 500 photographs of Cologne architecture by Werner Mantz was acquired, and in the same year the collection was enriched by approximately 2500 prints and their negatives, a part of the Chargesheimer estate.

My task, when I took over the collection in 1980, was to create an inventory of approximately 3000 photographs and to make them grad-

ually accessible to the public. It was during this period that Renate and L. Fritz Gruber made it a custom, highly appreciated by us, to supplement our exhibitions with loans from their collection and subsequently to donate them to the museum. Such was the case with the exhibition "Aspects of Portrait Photography" (1981) and "Glamour & Fashion" (1983). Before then, however, the Mantz Collection had already been curated scientifically in 1982 and presented in an exhibition accompanied by a catalog. This was followed in 1983 by the exhibition "Derek Bennett – Portraits of Germans", which was donated to the collection in its entirety. Then came an exhibition derived from Chargesheimer's estate, which presented an overview of his work and which was also accompanied by a catalog. The Derek Bennett and Chargesheimer exhibitions were the first large traveling exhibitions that were sent on tour by the Photography Collection of the museum.

On the occasion of photokina 1984 we presented a great overview exhibition of the Gruber Collection with the subtitle "Photography of the 20th Century", which was again enhanced by donations. At that time, we also published the first catalog of the entire holdings, with reproductions of the more than 1200 pictures that were currently in the collection. This was the first time that photography in a German photographic collection was curated in the same manner as paintings, sculptures and drawings. Every photograph was accompanied by all the technical data and by specific literature references. The catalog became a reference manual and since then has gone into its third edition. This exhibition, too, went on tour and was displayed in Linz and in Manchester, among other cities. It was the first photographic exhibition which, at the suggestion of Professor Ludwig, was also displayed in East Germany, where it was shown in the gallery of the College for Graphics and Book Art in Leipzig.

The year 1985 was totally dedicated to the planning of the new building and to the move. Even so, it was possible to feature an exhibition of the photographic work of Benjamin Katz, which provided an overview of the set of more than 300 photographs acquired in 1982, which Benjamin Katz had compiled during the course of planning, setting up and displaying the exhibition "Art of the West". There was also an exhibition of architectural photography by Werner Mantz, Hugo Schmölz and Karl Hugo Schmölz, which offered an interesting insight into the work of the three most important architectural photographers in Cologne. Here too,

a selection of the best photographs by the Schmölz father and son team were contributed to the collection. Renate and L. Fritz Gruber graciously joined forces with the photography collection of the museum to prepare an exhibition entitled "Photographers Photograph Photographers", which was displayed at the Musée Réattu during the "International Photography Meeting" in Arles. This fascinating exhibition, too, was donated to the museum and, together with the Benjamin Katz collection, formed the basis for the collection's emphasis today on artists' portraits.

On the occasion of the inauguration of the new building, the photography collection presented an expanded, revised and clarified second edition of the catalog of the holdings of the Gruber Collection, along with a similarly designed catalog of all the works that had been acquired by the Museum Ludwig during the past years. For a brief time, the Photography Collection of the Museum Ludwig could claim that it had presented to the public its complete holdings at that time – 5000 pictures, fully illustrated. Only Chargesheimer was presented merely in the form of a selection. This also attests to the extraordinary quality of the photography collection of the museum, because it is certainly not just the great amount of work nor the necessary financial investment that prevents photography collections from publishing truly complete and fully illustrated catalogs of their holdings – it is mostly the fact that too much would be revealed that does not enhance the respective museum's fame.

The second general catalog of the photography collection covered significant expansions in the field of artistic photographs, such as the two albums contributed by Dr. Oppenhoff, with photographs by Johannes Theodor Baargeld, works by Colette, Ger Dekkers, Roger Cutforth, Bernd and Hilla Becher, Jan Dibbets, Braco Dimitrievic, Joe Gantz, Peter Gilles, David Hockney, Douglas Huebler, Peter Hutchinson, Birgit Kahle, Jürgen Klauke, Les Krims, Astrid Klein, El Lissitzki, Marina Makowski, Gordon Matta Clark, Antoni Mikolajczik, Bruce Nauman, Ulrike Rosenbach, Charles Simonds, Michael Snow, Ulrich Tillmann, Andy Warhol and Dorothee von Windheim. Other significant groups of photographs were later added to this, such as the donation by Jeane von Oppenheim of 11 vintage photographs by Lewis Hine, 30 prints by Erwin von Dessauer, and photographs by Gertrude Fehr, Robert Häusser, Fritz Henle, Walde Huth, Arno Jansen, Benjamin Katz, Erika Kiffl, Manfred

Leve, Bernd Lohse, Gabriele and Helmut Nothhelfer, and also Hugo and Karl Hugo Schmölz. But it was not long before the next donation came along. On the occasion of the inauguration, Renate and L. Fritz Gruber filled a room with photographs by Albert Renger-Patsch, Chargesheimer and Man Ray, imparting a photographic accent to the opening festivities, and to which they gave the title of "Pictures of Stillness". Displayed in that room were photographs of machines by Albert Renger-Patsch, a series on *Basalt* by Chargesheimer and *The Milky Way* by Man Ray, a total of 39 photographs. Only a year later, a new exhibition "German Pictorialists" provided an overview of the work of the older generation of German photographers. That exhibition too, was acquired nearly in its entirety over the years that followed, filling gaps in the museum's holdings of photographs taken from the forties to the sixties with works by Ilse Bing, Walter Boje, Rosemarie Clausen, Gertrude Fehr, Hanns Hubmann, Kurt Julius, Peter Keetmann, Fritz Kempe, Edith Lechtape, Willi Moegle, Regina Relang, Toni Schneiders, Anton Stankowski, Pan Walther and Willi Otto Zielke. Others, like Hermann Claasen, Tim Gidal, Robert Häusser, Fritz Henle, Martha Hoepffner, Bernd Lohse, Hilmar Pabel, Karl Hugo Schmölz, Wolf Strache and Carl Strüwe were present in the collection with only a few examples of their work, but since that time have been represented much more adequately. Chargesheimer's 60th birthday provided an occasion for the museum to present the results of additional research work. The show, entitled "Chargesheimer in Person", was dedicated to Chargesheimer's persona, featuring statements from family and friends, school buddies and colleagues from artistic circles. A portfolio of some of his well-known works was issued, and the second half of his estate, containing his meditation musings and gelatin silver paintings, which had been rejected by the trustees in 1979, was acquired. This provided the foundation for an even more intensive study of the work of this artist, which became the subject of more and more scientific research projects at the Art History Institute of the University of Cologne. The results of these projects, which mostly examined the relationship between his photography of ruins and his gelatin silver paintings, were presented in 1994 in the exhibition entitled "Chargesheimer – Chaos Form Archform".

The 80th birthday of L. Fritz Gruber became a celebration that was further enhanced by a publication coupled with an exhibition entitled "L. Fritz Gruber – Highlights and Shadows". In the accompanying

catalog, L. Fritz Gruber reviewed his encounters with some of the great photographers of his time. The entire exhibition was later donated to the Museum Ludwig.

In the years that followed, more and more attention was paid to Eastern Europe. Contacts with Leipzig culminated with the transfer of a collection of photographs from the former German Democratic Republic to Cologne. Numerous photographs were contributed after the first overview exhibition of contemporary photography in the former Czechoslovakia in 1990. The exhibition of Czech and Slovak photography travelled to 15 locations in Europe and in America, thus becoming the most successful traveling show of the museum's photography collection.

Soon another estate, the work of Heinz Held, was donated to the museum, almost immediately being presented to the public. Heinz Held had much the same interests as Chargesheimer, of whom Held was a contemporary. He was interested in everyday life, in the banal, in the hard-to-describe, so that he became an interesting counterpoint to the more artistically oriented Chargesheimer. These two photographic legacies provided the Museum Ludwig with the very unusual opportunity of studying two diverse photojournalistic approaches to the same subject.

The retrospective exhibition of fashion photographs by Horst P. Horst in cooperation with *Vogue* was not only a glittering social event, but it had a splendid conclusion with the donation of 40 photographs by this great German-American fashion photographer.

In 1991, years of discussions about an archive of 1500 negatives and 1000 vintage prints by Albert Renger-Patzsch reached an auspicious climax when the Schubert & Saltzer company of Ingolstadt transferred this work to the Museum Ludwig as a permanent loan. The City Museum received the largest selection from the existing duplicates, and the Museum Ludwig received 800 photographs as a donation. By trading additional donated duplicate prints, the museum was able to acquire, among others, landscape and architectural photographs by Albert Renger-Patzsch. After the completion of the research, with which the Photography Section once again lived up to its scientific mission by supporting a dissertation, a new chapter was added to the biography of Albert Renger-Patzsch. After the war ended, Renger-Patzsch photographed not just rocks and trees in Wamel as hitherto assumed, but over a period of 20 years he also completed his most ambitious indus-

trial assignment ever. The exhibition and the catalog "Albert Renger-Patzsch – His Late Industrial Work" was opened at the Museum Ludwig in 1993 and later became a traveling exhibition.

The core category of portraits of artists also received a significant boost during that year, when the City of Bocholt contributed 50 portraits by Fritz Pitz. The latter spent many years as a photographer for the Galerie de France making portraits of artists in the French-Belgian-Dutch language region. A one-man exhibition of his work was created on the occasion of this donation. This acquisition included an experimental work that is of very special interest to the museum, because Fritz Pitz is only the second photographer other than Chargesheimer who was already creating large format 150 x 100 cm photochemical paintings in the early sixties.

In 1992, the couple Irene and Peter Ludwig augmented the museum's collection with the loan of a group of 65 works by Russian photographers. These works complemented the photographs by Alexander Rodchenko that were already on hand and expanded the museum's holdings of Russian constructivist art with outstanding photographic examples of that style.

Gaps in the photography collection were filled not only by donated groups of images, but also by the acquisition of individual works like those of Anna and Bernhard Johannes Blume, Rudolf Bonvie, early photographs by Jürgen Klauke, works by Gina Lee Felber, Gottfried Helnwein, Marina Makowski, Harald Fuchs, Annette Frick, A. T. Schaefer, Krimhild Becker, Piotr Jaros, loaned works from the Ludwig collection and installations by Jenny Holzer and Christian Boltanski. For practical reasons however, installations had to be assigned to the sculpture department.

The 85th birthday of L. Fritz Gruber once again was celebrated by Mr and Mrs Gruber with a generous addition to the museum's photography collection. Still more gaps were filled by gifts of more than 700 photographs during the years 1993 and 1994, which included works by, among others, Alfred Stieglitz, Alvin Langdon Coburn, Edward Steichen, Man Ray, Hugo Erfurth, Hermann Claasen, David "Chim" Seymour, Robert Capa, Franco Fontana. Rolf Winquist, Philippe Halsman, Ernst Haas, Andreas Feininger, Karin Székessy, Gottfried Helnwein, Jürgen Klauke, Ulrich Tillmann and Bettina Gruber.

The Gruber Collection, which continues to be the heart of the mu-

seum's photography collection, was once again presented to the public in 1995 in the form of an exhibition entitled "Celebrities' Celebrities", which featured selected portraits of famous personalities made by the best photographers of this century.

A new category, that of nude photography, was added to the subject of artists' portraits in 1995, when Uwe Scheid bestowed a collection upon the museum. In 1991, the Museum Ludwig had displayed an exhibition of photographs from the Uwe Scheid Collection entitled "Picture Lust", which was specially enhanced with images from current work in this field. With the donation of photographs made during the period ranging from the sixties to the nineties and totaling more than 200 images, the museum's photography collection was enriched by additions of major significance: works by Jean Dieuzaide, Lucien Clergue, Joel Peter Witkin, Bettina Rheims, Robert Heinecken, Curt Stenvert, Diana Blok, Toto Frima, Marlo Broekmans, André Gelpke. But the works of earlier photographers such as Wilhelm von Gloeden, Vincenco Galdi, and Franz Roh were also welcome additions. All of this is likely to have made the collection of this topic at the Museum Ludwig the most substantial one in all of Germany. Altogether, not counting the bequest of Heinz Held, the holdings of the photography collection at the Museum Ludwig today cover more than 9300 photographs. The donation by Uwe Scheid gains added significance in light of the fact that the museums of Cologne, which cannot benefit from the financial and political background of state-owned collections, strive to cultivate their 150-year-old tradition of close relations with an art-interested public, with collectors and patrons, whose circles they seek to expand. This is where donations such as that by Uwe Scheid can encourage others to seek a dialog with the Photography Collection at the Museum Ludwig and to enhance its stature.

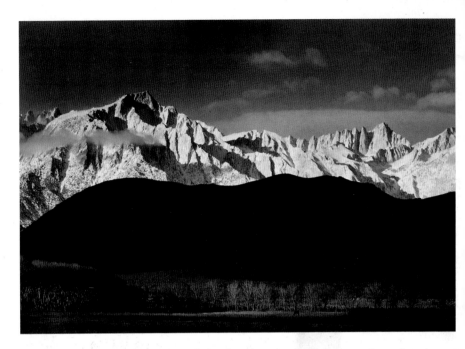

Adams, Ansel

1902 San Francisco
1984 Carmel,
California

▲ Ansel Adams
Sierra Nevada, 1944

Gelatin silver print
23.8 x 33.8 cm
ML/F 1977/24

Gruber Collection

Ansel Adams made his first photographs during a 1916 vacation trip to Yosemite National Park in California. Even then he exhibited the first manifestations of what was to become characteristic of his entire work: a combination of superb photographic skill and a deep admiration for the American landscape.

Adams originally wanted to become a pianist. It was only after an encounter with Paul Strand in 1930 that he discovered that photography was his true medium of expression. Strand's concept of pure photography made a lasting impression on Adams and motivated him to clarify his own intentions. In 1932 he joined photographers Imogen Cunningham, John Paul Edwards, Sonya Noskoviak, Henry Swift, Willard van Dyke and Edward Weston to found the group "f/64". Members of this group dogmatically practiced a style of photography that emphasized the greatest possible depth of field and the sharpest reproduction of details. Fascinated by the precise rendition capabilities of their medium, the photographers particularly favored close-ups of individual subjects. Adams' photograph *Rose on Driftwood* is an example of this tradition.

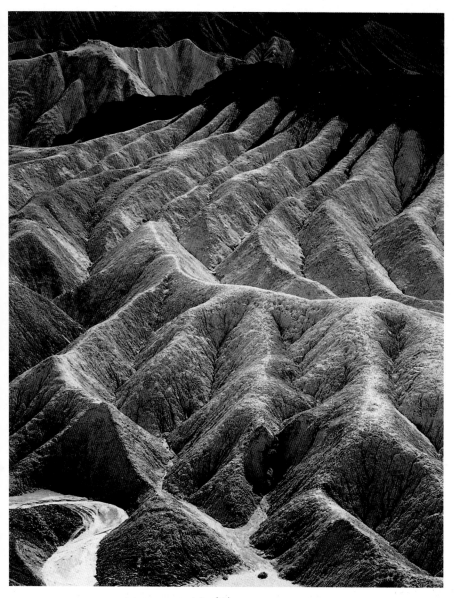

▲ **Ansel Adams**
Zabriskie Point, Death Valley National
Monument, California, 1948

Gelatin silver print, 23.9 x 19 cm
ML/F 1977/30

Gruber Collection

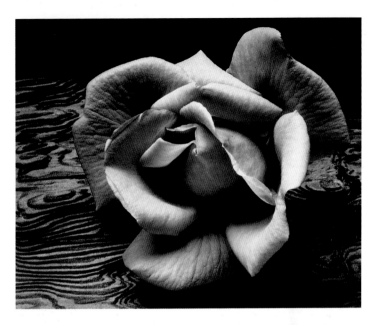

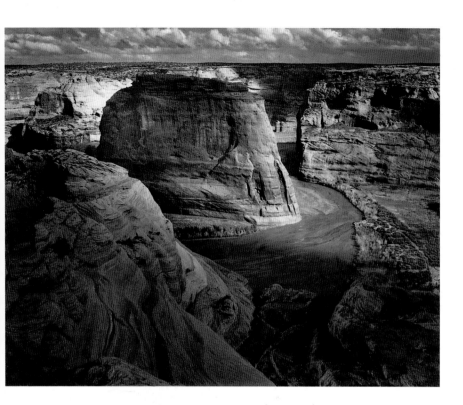

It was in 1941 that Adams created his famous "Zone System", an aid for determining correct exposure and development times for achieving an optimal gradation of gray values. Adams disseminated his photographic ideas and procedures through numerous books and seminars. In 1946 he founded the Department of Photography at the California School of Fine Art in San Francisco. In 1962 he retired to Carmel Highlands.

Adams spent a considerable part of his life as a landscape photographer in America's National Parks, about which he published more than 24 photographic books. During that time, he not only practiced his photography, but he also used his work to generate public interest in the parks, which he supported. He was also instrumental in the creation of new parks. *MBT*

▲ **Ansel Adams**
Canyon de Chelly
National Monument,
Arizona, 1942

Gelatin silver print
37.8 x 47.4 cm
ML/F 1977/26

Gruber Collection

Adams, Mac

1943 Wales
Lives in New York

Photographer Mac Adams, born in Wales in 1943, studied at the Cardiff College of Art from 1961 to 1966 and spent a year at the University of Wales. Later on he moved to New York, where he completed his studies at Rutgers University in 1969. Whereas his early work was very much in the English photographic tradition of the sixties, his *Mystery Environments* are characteristic of his work of the seventies. His preferred subjects are interiors, fictional situations such as *Port Authority (Mystery No. 12)*, which hint at a possible crime. Adams found inspiration for his main subjects in elements of murder mysteries. In *The Toaster,* the shiny metal of this kitchen appliance reflects a woman who, in the second photograph, is already lying on the floor. The toast is burned. This not only suggests a time sequence; the photograph itself also combines objects into a mysterious incident. Adams' conceptual "Narrative Art" also

◄ **Mac Adams**
Port Authority
(Mystery No. 12),
1975

*Gelatin silver print
each 85.5 x 77.5 cm*
ML/F 1979/1352 I-II

includes color photographs and sculptures, whose subjects – an open
cupboard, a revolver and a rope – are combined to produce a symbolic
charge. In his photographs *Port Authority (Mystery No. 12)* of 1975,
Adams used the play of light and shadows to stage people in motion,
making the viewer perceive elements of ambiguity. He is less interested
in the secret than in the manner the information is conveyed by the ob-
jects perceived. He personally characterizes his work as being some-
where between Agatha Christie and Anthony Caro.

Adams has been represented in a number of international exhibi-
tions, such as "documenta VI" in Kassel in 1977, and in Groningen in
1979. The photographer lives and works in New York. *LH*

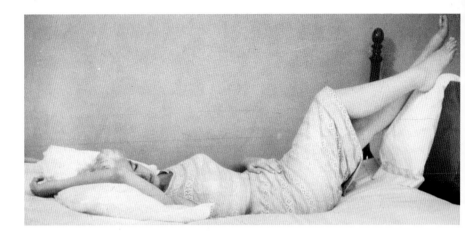

Arnold, Eve

1913 Philadelphia
Lives in London

▲ Eve Arnold
Marilyn Monroe,
1955

Gelatin silver print
16.2 x 33.4 cm
ML/F 1977/34

Gruber Collection

Eve Arnold is one of the earliest "Magnum" photographers. From 1947 to 1948 she studied photography under Alexey Brodovitch at the New School for Social Research in New York. In 1951 she joined "Magnum" and became the first woman to take pictures for that agency. She moved to London in 1961 and spent the years that followed as a photojournalist traveling through the former Soviet Union, Afghanistan, Egypt, and China. During the fifties, Eve Arnold created several photographic essays about women from the most diverse levels of society, of whom she wanted to present a realistic, "unretouched" image. It was in this context that she also produced the picture series about Marlene Dietrich and Marilyn Monroe, from which came the illustrations shown here. When Eve Arnold was present at a recording session with Marlene Dietrich in 1954, she was not interested in a conventional, idealized star portrait. During a production pause, she succeeded in capturing a picture of the actress in a pensive, introspective mood, who even then knew instinctively how to stage her body. In a similar, apparently unobserved moment in 1955, Eve Arnold photographed Marilyn Monroe in Illinois. The actress was exhausted and had stretched out on the bed in the hotel, resting her tired feet on the railing of the bed. When Miss Monroe worried whether the pictures that had just been taken would turn out suitably glamorous, the photographer replied: "No... not glamorous – interesting maybe, but not glamorous." *MBT*

Atget, Eugène

1857 Libourne near
Bordeaux
1927 Paris

▶ **Eugène Atget**
Corsets, Boulevard
de Strasbourg, Paris,
around 1905

Gelatin silver print
23.3 x 17.2 cm
ML/F 1977/9

Gruber Collection

▼ **Eugène Atget**
Versailles, Vase in
Castle Park,
around 1900

Albumen print
21.6 x 18.2 cm
ML/F 1977/14

Gruber Collection

Eugène Atget studied at the Conservatoire d'Art Dramatique in Paris, but he left that school without taking his exams. He went on to act in theaters in the suburbs of Paris, where he met the actress Valentine Delafosse, who was to become his life companion. He had already bought himself a camera in those years and was using it. In 1898, noticing that there was a great demand for photographs of the old Paris, Atget took up photography as a profession. He established a system of working and built up a solid circle of collectors. He initially concentrated on Paris, photographing old buildings, street vendors, architectural details, but especially buildings that were threatened with demolition. In later years, he began to cover the suburbs. As soon as some topics were completed, new ones were started, such as *Parisian Residences, Horse Carriages in Paris* and *Fortifications,* which he initiated between 1910 and 1912. Preoccupied with the safe preservation of his collection, Atget offered it to the Ecole des Beaux Arts in 1920 and received 10,000 francs for his 2621 plates. He then began to produce photographs to serve as subjects for painters, and this took him to the furthest outskirts of Paris. In 1921 he made portraits of a number of prostitutes in the Rue Asselin for the painter André Dignimont.

Atget refused to take pictures with any camera other than his old wooden 18 x 24 cm camera. He felt that the Rolleiflex Man Ray had offered him worked faster than he could think. He therefore continued to travel with a lot of luggage. When his life companion died, he began a pause in his work. Shortly after he made a portrait of Berenice Abbott in her studio, Atget passed away on the 4th of August of 1927. Berenice Abbott, who had acquired the main portion of his estate in 1928, began to evaluate and to publish his work. She arranged for Atget's

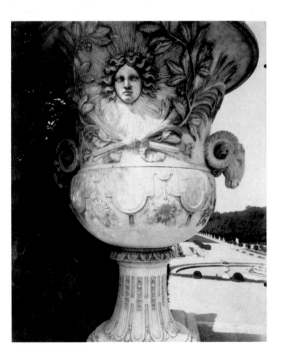

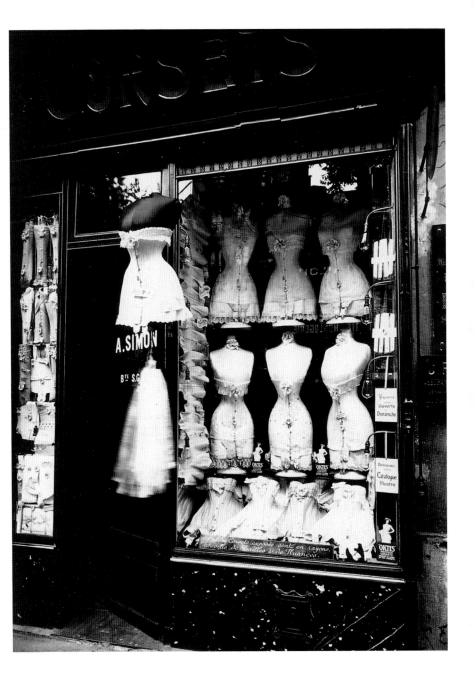

◄ **Eugène Atget**
Prostitute, 1921

Gelatin silver print
23.2 x 17.4 cm
ML/F 1977/1

Gruber Collection

► **Eugène Atget**
Organ Player and
Singing Girl, 1898

Gelatin silver print
21.8 x 16.5 cm
ML/F 1977/3

Gruber Collection

work to be exhibited, and in 1930 together with gallery owner Julien Levy
initiated the first publication of his photographs, which led to interna-
tional recognition of Atget's work. *RM*

Richard Avedon studied philosophy at Columbia University in New York City before he became a self-taught photographer. In 1944 he met Alexey Brodovitch, the legendary art director of *Harper's Bazaar*, with whom he worked for many years to come. He attracted a great deal of attention with his book *Observations*, which was published in 1959. Brodovitch did the layout and Truman Capote wrote the text. The book contained mostly portraits of famous personalities and a few fashion pictures. "Have mercy on me", said Henry Kissinger when he was about to have his portrait taken by Avedon. The starkness of his portraits on a white background that brought the very souls of people to the surface was what first caught the attention of the public and the trade.

Avedon achieved extensive publicity with his fashion photographs, in which he expressed his visions of a lively, lifelike world of pictures. He stopped making photographs in his studio and took his models to the streets of Paris, into the cafés and shows. His photograph *Dovima with Elephants, Evening Dress by Dior, Cirque d'hiver, Paris 1955* is Avedon's best known photograph and certainly one of his most unusual ones. It thrives on contrast and yet it is simultaneously an expression of indescribable elegance. This picture marks the beginning of a new era in staged photography. Avedon's fashion photographs, which steadily diminished over the years, and which during the seventies became similar to his portraits, became the standard for an entire generation of photographers.

Not much later he shocked his audience with a series about the slow death of his father Jacob Israel Avedon. In that series he also documented his own relationship with his father, elicited mimicry and expressions from him that he remembered from his youth and which characterized his image of a father figure. But it is also a powerful series about the gradual deterioration of a strong personality and its withdrawal into itself.

With his book *In the American West*, Avedon wanted to expose the myth of the American West, to break up the romanticized world of idyllic cowboys and show another side of that world: day workers and miners, the unemployed and minor public servants, whites, blacks, South Americans. His disenchanting version of the American West caused anger and was perceived as being destructive.

Next he produced a series about the Louisiana State Hospital, a grainy sequence of pictures of mentally disturbed patients, followed by a

▶ Richard Avedon
Dovima with Elephants,
Evening Dress by Dior,
Cirque d'hiver, Paris,
August 1955

Gelatin silver print
24.2 x 19.4 cm
ML/F 1977/39

Gruber Collection

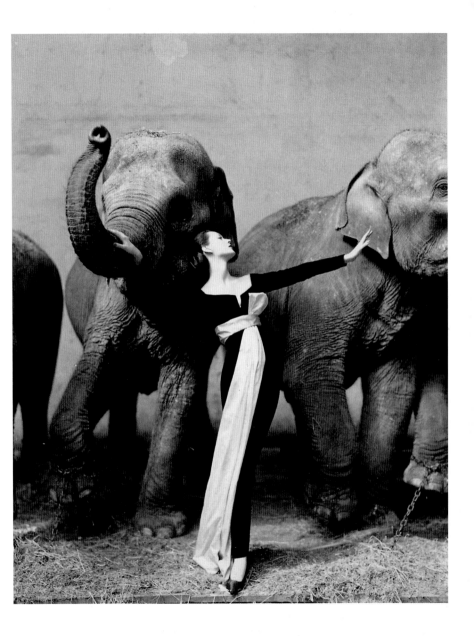

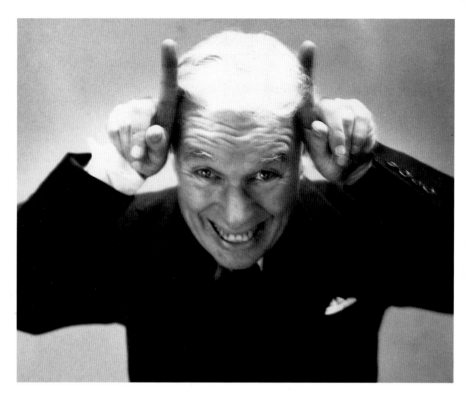

bitter statement against war in the form of a photo essay about victims of napalm in Vietnam. They were his only pictures that showed violence. Avedon was always averse to that subject, because he believed that pictures of violence only bred more violence.

His large format photographic canvasses became a new milestone in the history of photography. Among others, he created portraits of members of the "Warhol Factory", the "Chicago Seven"' the "Ginsberg Family", and the "Mission Council".

His *The Generals of the Daughters of the American Revolution,* 1963, commands a special place among his portraits. With this photograph, Avedon created a group picture with strikingly unconventional composition. Apparently taken during preparations for an official portrait, it is intriguing because of its unusual arrangement and the variety of relationships between the women, who nevertheless remain isolated. The portrait of Charlie Chaplin is equally unconventional, because it sug-

gests a devil. It was created at Chaplin's own request, to express his anger when he had to leave the United States because of his political beliefs. The portrait of the introspective, seemingly painfully concentrating Ezra Pound is the main picture in a series in which that author exposes the full breadth of his emotions and feelings as well as their mimic expression for the camera to record.

On the occasion of the fall of the Berlin Wall, Avedon photographed the jubilant crowd during New Year's Eve 1989. The mood of the pictures of the *Brandenburg Gate* series ranges all the way from boundless

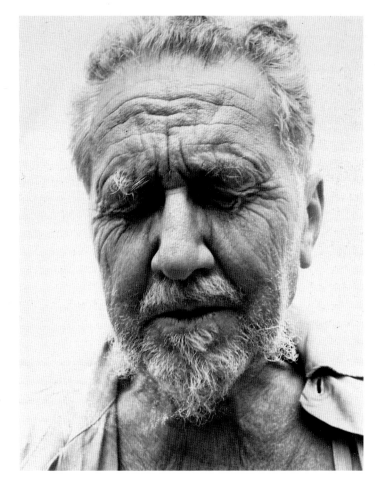

▶ **Richard Avedon**
Ezra Pound, poet, Rutherford, New Jersey, June 30, 1958

Gelatin silver print
34.1 x 27 cm
ML/F 1977/44

Gruber Collection

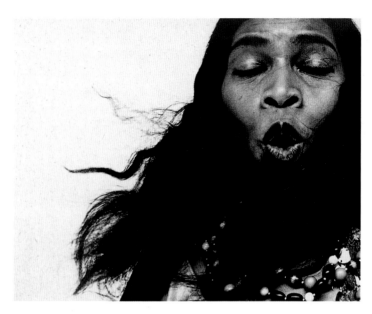

joy to expressions of fear of the future. Instead of documenting what he saw, Avedon made a small selection of symbolic constellations, which culminate in the reduced outline of a bald head against the night sky.

Most recently he has made photographs of the Italian nobility, for which he made use, for the first time, of the possibilities of picture collages. The fact that he once practiced photojournalism only came to light again on the occasion of his retrospective show in 1994.

Avedon is considered to be one of the best living photographers. In New York City alone, he can look back on exhibitions in the Museum of Modern Art, the Metropolitan Museum and the Whitney Museum of American Art. The Museum Ludwig in Cologne displayed a large retrospective of his work and his fashion photographs in 1994. In whatever genre he was working, he has always succeeded in applying his own striking approach. *RM*

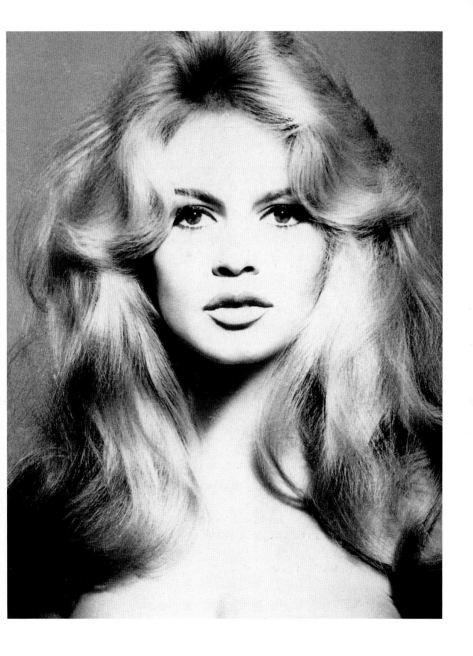

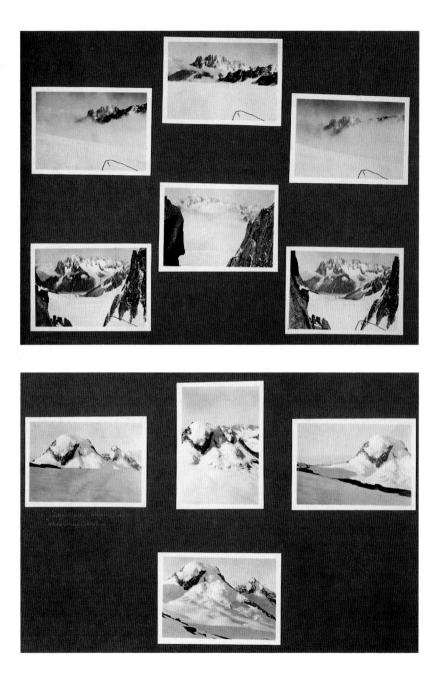

Alfred Emanuel Ferdinand Grünwald was born in Stettin on the 9th of
October 1892. After studying law and political science at Oxford and in
Berlin, he was drafted into military service from 1914 to 1918. Upon his
return, he wrote articles for the magazine *Aktion* and became involved
with the USPD. In addition to his connections with the "Cologne Pro-
gressives", he befriended Max Ernst and Hans Arp, with whom he
founded the Cologne Dada Group. He called himself Theodor Baargeld,
sometimes also Zentrodada or Jesaias. With this Cologne group of
artists he published the magazine *Der Ventilator*, and later on the *Bul-
letin D*. After participating in the exhibition "Early Dada Spring" in
Cologne and the "International Dada Fair" in Berlin, Baargeld returned
to his studies. Upon graduation he joined a Cologne Reinsurance Com-
pany. His albums of mountain photographs contain many of his se-
quence arrangements. Baargeld succumbed to an accident in the French
Alps on the 18th of August 1927. *RM*

**Baargeld, Johan-
nes Theodor**

(Alfred Emanuel
Ferdinand Grünwald)

1892 Stettin, Poland
1927 French Alps

◄ ▲ **Johannes
Theodor Baargeld**
Mountain Photo-
graphs, 1925

*Gelatin silver print
6 x 8.5 cm and
5.7 x 8.4 cm*
ML/F 1985/29
and 30

Dr. Oppenhoff
Donation

◄ **Pavel Banka**
Untitled, 1984

Gelatin silver print
32.7 x 25.8 cm
ML/F 1995/118

Uwe Scheid
Donation

Banka, Pavel

1941 Prague
Lives in Prague

Pavel Banka studied at the Faculty for Electrical Technology in Prague. In 1976 he began working as a freelance photographer. He favored portraits, but concentrated primarily on staged photography, which already earned him recognition beyond the borders of the Czech Republic in the eighties.

On one hand, his staged sets are based on the concept of the photo performance, which he developed beyond the original work of František Drtikol. On the other hand, he injects surreal aspects into his scene designs, he alters size relationships, arranges bodies in the manner of still lifes. Eroticism is present in his pictures only to a very understated extent. Banka maintains a disciplined formality and simplicity in his compositions, avoiding any distractions or descriptive variations. Instead, he concentrates on a few metaphors, with which he transposes his mystical visions into photographs. *RM*

▶ Micha Bar-Am
Collaborators,
Samaria, West Bank,
1967

Gelatin silver print
24.3 x 31 cm
ML/F 1995/98

As a result of his parents' emigration, Micha Bar-Am spent the years 1936 to 1947 growing up in Haifa. In 1944 he worked on the waterfront, dreaming of becoming a seaman. From 1948 to 1949 he fought for the resistance movement as a member of the Palmach Unit. In 1949 he became a co-founder of the Malkya Kibbutz in North Galilee. He moved to the Gesher-Haziv Kibbutz in 1953, where he initially worked as a blacksmith, but where he also began to take pictures with a borrowed camera. During the Sinai War of 1956 he photographed the desert and the war, and he was able to purchase his first Leica. From 1957 to 1966 he worked for the Israeli army magazine *Bahmahane*. In 1961 the government gave him the assignment of photographing the Eichmann trial. He has been active as a freelance photographer since 1966. In 1967 he met Cornell Capa, with whom he photographed the Six Day War. After that, he became a member of "Magnum" and since then he has been working for the *New York Times*. In 1973 he became the curator of photography at the newly founded Photography Department of the Tel Aviv Museum. Today he is once again working exclusively as a freelance photographer. *RM*

Bar-Am, Micha

1930 Berlin
Lives in Il Ramat
Gan, Israel

► **Micha Bar-Am**
Prisoners of War,
Golan Heights, 1970

Gelatin silver print
24.2 x 31.1 cm
ML/F 1995/99

► **Micha Bar-Am**
Return from
Entebbe, Ben Gurion
Airport, 1976

Gelatin silver print
24.3 x 24.1 cm
ML/F 1995/100

Mercedes Barros studied photography at the New England School of Photography and at the School of Visual Arts in New York City. Today she lives in Cologne, Germany.

Mercedes shows nature in her pictures as part of herself, and she regards it as endangered. The techniques she applies in creating her pictures, in part by solarization, in part by the use of chemicals, imparts the same surface of morbid decay to all her photographic work. Mankind and its civilization is connected to nature through this connecting element of the dissolution of appearances, which it surrenders to destruction. The clouds of Chernobyl, which she acknowledged with a sinister picture in 1988, seem to hover over everything.

Treating the surfaces of her photographic images is a way for Mercedes Barros to execute painterly concepts without having to paint in the classical sense. This technique enables her to make use of existing photographic prints and to work on the image of an object instead of the object itself, so as to present the relationship of different things by means of a picture. *RM*

Barros, Mercedes

1957 Rio de Janeiro
Lives in Cologne

▲ **Mercedes Barros**
Chernobyl, 1988

Gelatin silver print, mixed media
82 x 119.5 cm
ML/F 1994/343

◄ **Herbert Bayer**
Metamorphosis,
1936

Gelatin silver print
25.5 x 34 cm
ML/F 1977/56

Gruber Collection

Bayer, Herbert

1900 Haag, Austria
1985 Montecito,
California

Herbert Bayer was a highly versatile artist. He worked as a typographer, an advertising artist, photographer, painter, sculptor, architect and even as a designer of office landscapes. The ideals of the Bauhaus, where Bayer acquired his artistic education, are fittingly reflected in the creative activities that he pursued during various periods of his life. From 1921 to 1925 he studied at the Bauhaus in Weimar under Johannes Itten, Oskar Schlemmer, and Wassily Kandinsky. In 1925, he took over the printing and advertising shop of the Bauhaus in Dessau, where he was also responsible for the design of Bauhaus printed publications. That is also when he began working with photography, which became his preferred means of expression in the thirties, before he emigrated to the United States. With his photographic work he not only presented himself as a representative of the Bauhaus, but he also showed himself to be especially influenced by the ideas of Surrealism. In this vein, for instance, he created his *Self-portrait* in 1932 that was characteristic of Surrealism, because it blended two levels of reality into a single, traumatic image. Bayer also applied Surrealism in his photographic montage entitled *Lonesome Big City Dweller*, in which the artist's hands float in front of the façade of an inner courtyard in Berlin, with his eyes staring at us from the palms of those hands. A ghostly scene, with which Bayer expressed his criticism of the anonymity of the big city. In his photo-

▲ **Herbert Bayer**
Lonesome Big City Dweller, 1932

Gelatin silver print 34 x 26.9 cm
ML/F 1977/54

Gruber Collection

Bayer | 41

◀ **Herbert Bayer**
Self-portrait, 1932

Gelatin silver print
38.5 x 29.4 cm
ML/F 1977/53

Gruber Collection

graphic sculpture *Metamorphosis*, Bayer reverted to his well-known cover of the Bauhaus magazine of 1928 by using geometric bodies such as spheres, cones and cubes as they appeared on that cover. With the tense arrangement of cubic forms with a landscape as background, he expressed the theme of the relationship between geometric and natural forms. *MBT*

Cecil Beaton's interest in photography manifested itself quite early, when he started taking pictures of his sisters under the direction of his nanny, who was an amateur photographer herself. He gradually developed a predilection for arty, stylized portrait photographs, inspired by such illustrious predecessors as Baron de Meyer and Edward Steichen. Beaton constructed elaborate backgrounds using showy materials, like mirrors or cellophane, in front of which he posed members of his family dressed in elegant costumes. In his photographs, Beaton did not place the emphasis on persons or clothing, but on the aesthetic effect of the entire atmosphere of the scene. This already suggested his second great talent, that of a stage and costume designer, which only came to fruition much later, between 1940 and 1970.

His first photographic exhibition, in a little-known gallery in London, was an extraordinary success that led to a contract with *Vogue* magazine, for which he was to remain active as a fashion photographer into

Beaton, Cecil

1904 London
1980 Broadchalke
near Salisbury

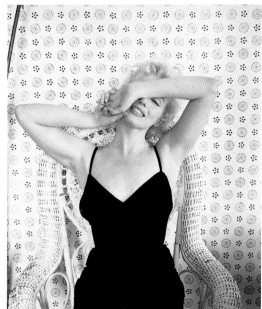

◄ **Cecil Beaton**
Marilyn Monroe,
1956

Gelatin silver print
25.5 x 20.9 cm
ML/F 1977/58

Gruber Collection

▶ **Cecil Beaton**
Princess Natalie
Paley, around 1930

Gelatin silver print
23.2 x 19.8 cm
ML/F 1994/91

Gruber Donation

▼ **Cecil Beaton**
The Marx Brothers,
around 1932

Gelatin silver print
9.9 x 18.9 cm
ML/F 1977/79

Gruber Collection

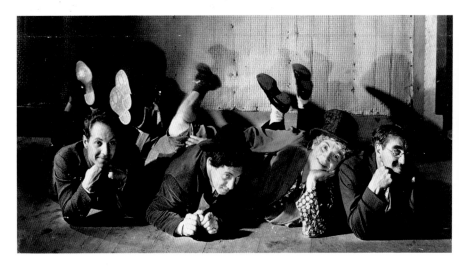

◄ Cecil Beaton
Miss Nancy Beaton,
around 1925

Gelatin silver print
30.5 x 25.5 cm
ML/F 1977/68

Gruber Collection

Ill. p. 48:
Cecil Beaton
Fashion, around
1935

Gelatin silver print
24 x 18 cm
ML/F 1977/74

Gruber Collection

Ill. p. 49:
Cecil Beaton
Fashion Photograph,
1936

Gelatin silver print
23.9 x 17.8 cm
ML/F 1977/73

Gruber Collection

the mid-fifties. He also worked for *Harper's Bazaar*. In the Hollywood of
the thirties, he created portraits of film stars in the somewhat surreal
ambiances of unused stage sets. In 1937 Beaton was appointed court
photographer of the royal family, and during the Second World War he
was active as a war correspondent for the British Ministry of Informa-
tion. The experience gained during the war years influenced the style
of his portraits, which became less whimsical and sumptuous, thus
becoming clearer and more direct. *TvT*

▲ **Cecil Beaton**
Marlene Dietrich, 1935

Gelatin silver print
24.3 x 19.2 cm
ML/F 1977/60

Gruber Collection

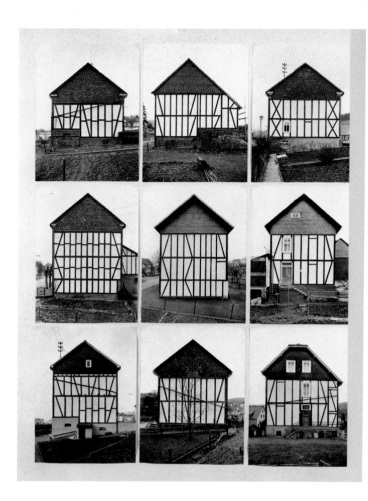

Becher, Bernd

1931 Siegen
2007 Rostock

Becher, Hilla

1934 Potsdam
Lives in Düsseldorf

Bernd Becher was born in Siegen, Germany on the 20th of August 1931. After completing an apprenticeship in decoration, he studied at the State Academies of Art in Stuttgart and in Düsseldorf, where the co-operation with Hildegard Wobeser began in 1959.

She was born in Potsdam in 1934 and had also completed an apprenticeship in photography and studies at the Academy of Art of Düsseldorf. They married in 1961. Together, they developed the concept of systematic industrial photography with an encyclopedic character.

The work of Bernd and Hilla Becher is entirely specialized in archi-

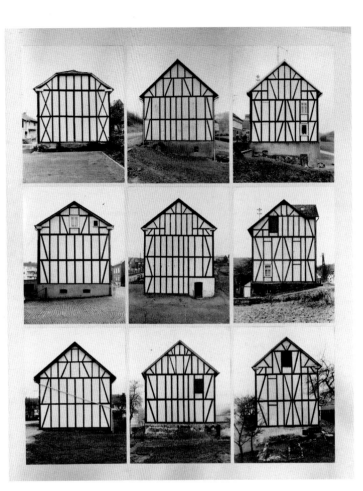

◄ **Bernd and Hilla Becher**
Typology of half-timbered Houses,
1959–1974

*Gelatin silver print
each 40 x 31 cm
in 4 fields of
148.3 x 108 cm*
ML/F 1985/34

Ludwig Donation

tecture. It concentrates on average buildings and industrial structures
that are based on similar basic layouts and designs. These buildings al-
ways have some functional conditions in common, differing only in de-
tails, which may stem from tradition, as in half-timbered houses, or
from technical requirements, as in industrial architecture. The elements
they have in common are usually related to function, whereas the differ-
ences often relate to regional peculiarities or local zoning regulations.
Bernd and Hilla Becher spent 30 years producing a multitude of water-
towers, storehouses, blast furnaces, winding towers, silos and cooling

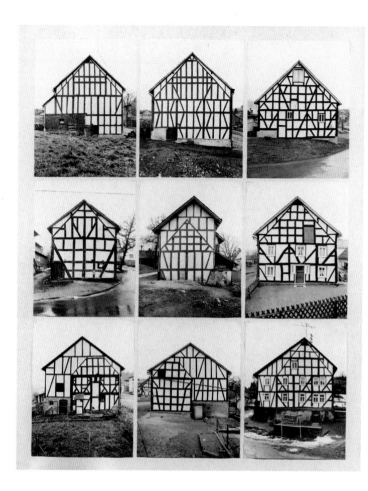

towers, photographed with strictly defined ground rules and systematically arranged in sequences.

It was only the picture sequences that made the methodology of their photographic system apparent. Initially regarded as "Anonymous Sculptures", the conceptional aspect of their photographic work was only discovered by the art trade much later. The recognition of their work sparked attention to the photography of all inanimate objects, generating posthumous public appreciation of the work of artists like Albert Renger-Patzsch or Karl Blossfeldt. The photographic concept of the

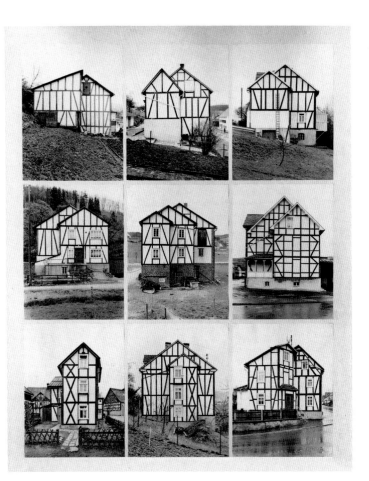

◄ **Bernd and Hilla Becher**
Typology of half-timbered Houses, 1959–1974

Gelatin silver print each 40 x 31 cm in 4 fields of 148.3 x 108 cm ML/F 1985/34

Ludwig Donation

Becher couple continued to be disseminated through their teaching activities at the most distinguished German school of artistic photography. An important effect of that activity was the recognition by the art scene, for the first time, of technically perfect photographic works. Up to then, the art scene had sought to ignore the technical medium by deliberately neglecting the ground rules of photography. The deciding factor for that change was the connection, by the Bechers, of object and conceptual photography. *RM*

**Becker,
Krimhild**

1940 Bonn
Lives in Cologne

▲ **Krimhild Becker**
Untitled, 1989

*Gelatin silver print,
mixed media*
205.2 x 265.4 cm
ML/F 1990/1304

Krimhild Becker studied at the Technical College of Cologne from 1961 to 1965, and she continues working there as a freelance artist.

In the course of her work she developed a specific kind of diptych, in which black-and-white photographs are blended with each other on a silver-colored background. In some of her works, the individual photographs are separated by fluorescent tubes. The illumination of the pictures then corresponds exactly to that of the neon tube, which thus separates and at the same time combines the work. This also imparts a three-dimensional quality to the work. Krimhild Becker speaks through her pictures, if need be she gives the viewer cue words like: *Gravity, Distances, Containers.* Everyday situations and objects are removed from their settings in abstract ways and enhanced into symbols of our being. Removed from their settings of purposeful rationality, Krimhild Becker presents them as cult objects in a world of meanings that confront our functional world. *RM*

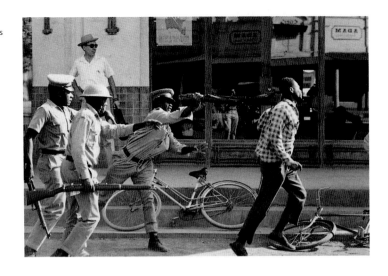

► Ian Berry
Elizabethville, 1960s

Gelatin silver print
24.1 x 35.5 cm
ML/F 1994/98

Gruber Donation

At first, Ian Berry was active as an amateur photographer, dreaming of
a career as a journalist. In 1952 he moved to South Africa, where he
worked as a professional photographer for two newspapers, among
them the *Daily Mail*. His work with Tom Hopkinson for the African
magazine *Drum* lasted for more than a year. He produced photographic
series about the Congo, Algeria, the Near and Far East. Berry regards
his photography mainly as social and documentary reporting, which
can accurately depict situations like no other medium. His perspective
is frontal and aimed directly at the event being shown. Whether it is an
uprising in South Africa or a lonesome old woman, his angles seem to
capture emotions on faces as well as the isolation of individual persons
from a distance with the greatest accuracy. The viewer can read Berry's
photographic testimony like a detailed report. The directness of the ex-
pression is further reinforced by masterful cropping. The photographer
was a member of the "Magnum" agency, of which he became a vice
president in 1978. His publications *The English* and *Black and Whites*.
L'Afrique du Sud attest to Berry's political-social interests. *LH*

Berry, Ian

1934 Preston,
Lancashire
Lives in London

Biasi, Mario de

1923 Belluno, Italy
Lives in Milan

▼ Mario de Biasi
Sardinia, 1954

Gelatin silver print
30.1 x 24.4 cm
ML/F 1991/44

Gruber Donation

Mario de Biasi was a trained radio technician before he became interested in photography. He began his photographic activity during a visit to Nuremberg in 1945 by teaching himself and by taking a one-year apprenticeship in Germany. His first exhibition came as early as 1948 in Milan. In 1953 he received the award for the best photograph of the year. Starting in 1953, he worked as a photojournalist for the magazine *Epoca*, and his picture series made him a leading figure in Italian photojournalism. In 1956 he began creating documentations, among them the war in Vietnam, the revolt in Prague, papal trips and the earthquake in Sicily. He also created essays for *Epoca* on subjects like "The great parks of Europe" or "Places imagined by authors". To de Biasi, the intensity of every subject he photographed, be it the observation of the eruption of a volcano or snow scenes photographed in Siberia at −65° C, became the pictorial essence of reality. As an author of several photographic books, such as *The Photographer's letter*, he demonstrated his proficiency in portrait, sports and industrial photography. Structural elements, such as judicious symmetry, are important to de Biasi. His photographs stand out because of their unconventional perspectives and their graphic distribution of gray values. In his series with the title *The Third Eye of Nature*, de Biasi provided new insights into nature by working with reduced forms and photographs of light reflections. In 1982, de Biasi received the Saint Vincent Award of journalism. *LH*

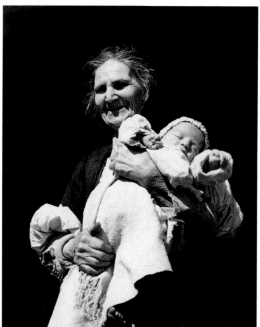

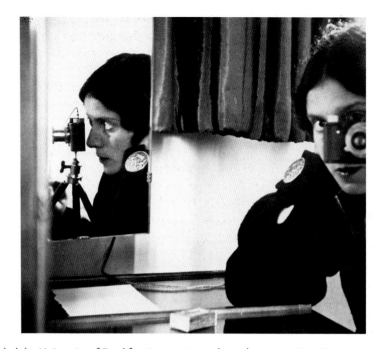

▶ Ilse Bing
Self-portrait with
Mirrors, 1931

Gelatin silver print
26.6 x 29.8 cm
ML/F 1988/178

Ilse Bing attended the University of Frankfurt in 1920 to study math-
ematics and physics, but she soon changed to art history. Planning to
write her thesis about the architect Friedrich Gilly, she began to take pic-
tures in order to facilitate her research. In 1929 she acquired a Leica,
which she used during the 20 years that followed. She started working
for the *Illustrierte Blatt* that same year. Her contacts with the avant-garde
artists of Frankfurt soon began to influence her photography, which
clearly reflected the new way of seeing of the twenties in their choice of
subjects and in their perspectives. She became interested in experi-
mental photography, worked with daring perspectives and croppings,
with the play of shadows and with reflections. One of her most famous
photographs is her self-portrait of 1931, in which she made ingenious
use of mirrors to combine a profile and a frontal view of herself. Im-
pressed by an exhibition by Florence Henri, she moved to Paris in 1930.
There she worked initially for the Hungarian journalist Heinrich Gutt-
mann before she set out on her own to work on photojournalism, archi-
tectural photography, as well as advertising and fashion photography for
such magazines as *Vu, Arts et Métiers Graphiques*, and *Le Monde*. Later

Bing, Ilse

1899 Frankfurt/Main
1998 New York

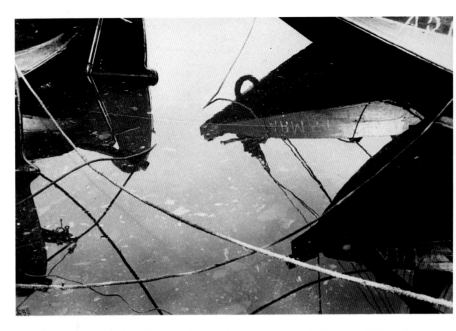

▲ Ilse Bing
Boats and Reflec-
tions on Water, 1931

Gelatin silver print
18.7 x 28.1 cm
ML/F 1988/177

on her photographs also began to appear in *Vogue* and *Harper's Bazaar*.
In 1936 she traveled to New York, where her work was received enthusi-
astically. A year later, in 1937, she married pianist Konrad Wolf, with
whom she emigrated to the United States in 1941. She began working
exclusively in color in 1957, but made all the prints herself. Nevertheless,
it is her black-and-white photography of the thirties and forties that
brought her the greatest recognition. Ilse Bing was a sought-after guest
lecturer, because she had an unforgettably fresh and vivacious way of
motivating young photographers. In Germany, she faded somewhat
from the public eye, until she was rediscovered in the mid-eighties. The
Museum Ludwig in Cologne first displayed her work in 1987 as part of
an exhibition entitled "German Pictorialists". An automobile accident in
1993 almost completely forced her to give up her work and her beloved
travels all over the world during the last two years and to concentrate on
her New York City home. *RM*

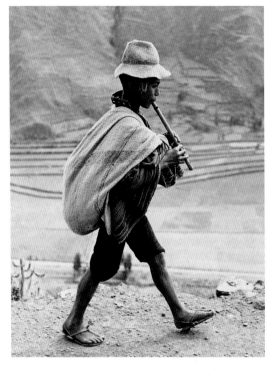

Werner Bischof is regarded as one of the leading international photo-
journalists of the postwar era. He pursued a career that deviated dra-
matically from his original training. From 1932 to 1936 Bischof studied
at the Arts and Crafts School of Zurich, where his mentor was Hans
Finsler, a photographer devoted to the New Objectivity. Accordingly,
Bischof initially followed a path of precisely arranged and perfectionist
fashion- and object photography. In 1942, Bischof became a full-time
member of the editorial staff of the Swiss magazine *Du*, working prim-
arily as a fashion photographer. In 1945, he traveled all over Europe,
using his camera to document the destruction left behind by war. He
then began to take a greater interest in the international press, which
led him to join the "Magnum" group in 1949. Even though Bischof had
to alter his way of working because of his change to photojournalism, he
nonetheless retained his sensitivity for technical perfection, creativity
with light and a formal composition of his pictures. No more the care-
fully staged and thought-out photograph in a studio, but live, spontan-

Bischof, Werner

1916 Zurich
1954 Peru

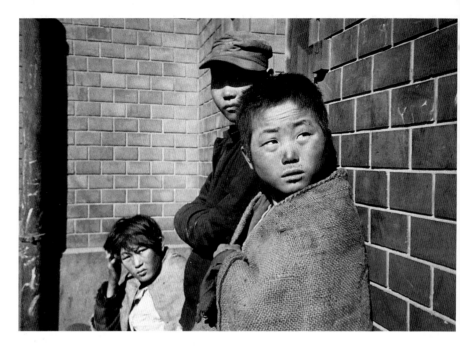

eous moments. In 1951 he received an assignment from the American *Life* magazine to travel to areas plagued by hunger in Bihar province in north and central India. The resulting photographic essay *Famine in India* brought Bischof his first international success. Even though he was deeply moved by the abject poverty of the Indian population, this essay shows him more as an objective observer who maintained his sense of composition even in the most desperate situations. This is exemplified by the accompanying illustration from his India series, in which he rendered the emaciated figures in such a way as to create a powerful composition of vertical and horizontal lines.

In later years Bischof made photojournalistic trips to places such as Japan, Hong Kong, Indochina and Korea, where he became fascinated by children who, despite poverty and war, demonstrated remarkable resilience. In Pusan, Korea, he photographed three youths clad in rags who earned a little money as shoeshine boys at the railroad station. One of Bischof's best known children's photographs is *Boy Playing the Flute near Cuzco, Peru*. Bischof made that photograph only a few days before his fatal accident in the Peruvian Andes. *MBT*

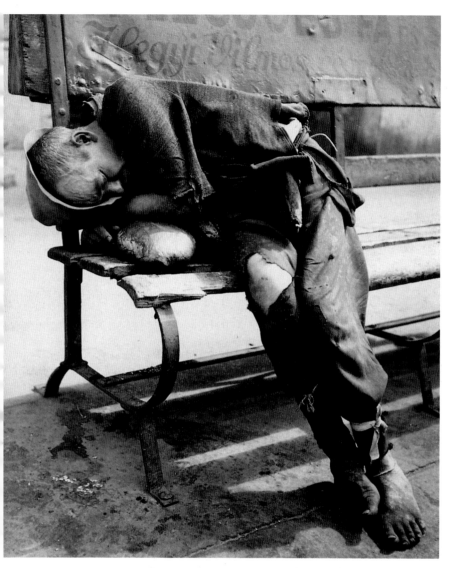

▲ **Werner Bischof**
Hungary, around
1950

Gelatin silver print
33.5 x 28.1 cm
ML/F 1993/124

Gruber Donation

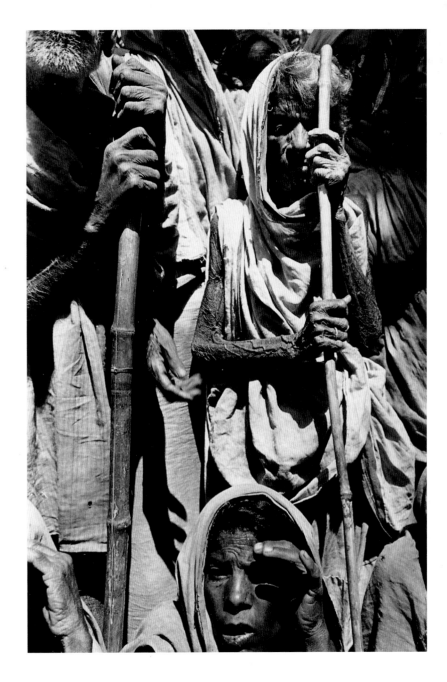

From 1881 to 1884, Karl Blossfeldt completed his apprenticeship as a sculptor and modeler in an art foundry, receiving a scholarship to study at the college of the Royal Prussian Arts and Crafts Museum in Berlin. During numerous study trips to the Mediterranean area, he produced reproductions of plants for educational purposes, there also creating his first photographs of living plants. In 1898 he began to teach at the Arts and Crafts College in Berlin, where he established an archive of plates of plant photographs for use in his teaching activities: "Modeling after living plants", "The plant in the arts and crafts", etc. He continued to expand that archive with the yield from many additional trips. His book *The Original Forms of Art* was published in 1928, two years after his first exhibition, and it made him famous overnight. His second book, *Wonder Gardens of Nature* was published shortly before his death in 1932. TvT

Blossfeldt, Karl

1865 Schielo, Germany
1932 Berlin

Blume, Anna

1937 Bork
Lives in Cologne and
Hamburg

**Blume,
Bernhard
Johannes**

1937 Dortmund
Lives in Cologne and
Hamburg

After reading philosophy at the University of Cologne and fine art at the Düsseldorf Academy, Bernhard Johannes Blume developed his photo-actionistic-metaphorical system of "Ideosculpture" – the pictorial staging of everyday encounters. He began with drawings, photographic sequences and installations (furniture, vases etc.), but his large, spectacular series of photographs *Oedipal Complications?* (Ludwig Collection, Vienna) in 1977 marked the beginning of the exclusive production of such large sequences of photos. The sequences were done in an actionistic and photographic collaboration with his wife, Anna Blume. By 1984 the series *Wahnzimmer* established them on the international scene. It was followed by the series *Küchenkoller, Mahlzeit* (1985), *Trautes Heim* (1985/86) and *Vasenekstasen* (1986), as well as the large sequences of photos from the series *Im Wald* (1982–1990) and *Transzendentaler Konstruktivismus* (1994/95). 1999 saw the completion of their large-scale digital print series *Prinzip Grausamkeit,* based on polaroids taken between 1995 and 1998.

Anna and Bernhard Blume got to know each other while studying at the Düsseldorf Academy. Anna taught until 1985 art and handicrafts at a number secondary schools in Cologne, before working as a visiting lecturer. It is she who is largely responsible for the conception and realization of their large joint exhibition installations. In 1987 Bernhard

Johannes was elected professor at the Hochschule für Bildende Künste in Hamburg.

Most especially the Blumes' black and white series hold up a mirror to the daily madness of "home sweet home", the absurdity of middle class and petty bourgeois institutions, habits and rituals. The accompanying aesthetics are plunged into "chaos" by the rigid formalization of the Blumes' pictures and their ironic, disjointed actionism. The apparent security of this life world becomes easy to see through amidst the scenes of breakdown that they stage.

Since the seventies, and above all since the eighties and the commencement of their collaboration, the two photographers have also produced extensive series and collages using Polaroids. These chiefly consist of "mutual parodistic photo-portraiture", in an often painful combination with a variety of brightly coloured plastic objects, which come to fuse with the various halves of the portraits during the direct or digital collage procedure. In 1990 the artists wrote in this connection in one of their catalogues: "[...] While searching for a mutual ego during our photographic quests, there emerged a different reality with an opposing meaning: the VERY OBJECTS are this I and WE! The form, colour and aesthetics of such things are our fate! Indeed, the objects are related, if not identical, to us! I, YOU, HE, SHE, IT, WE, YOU, THEM." *RM*

▲ Anna and Bernhard Johannes Blume
Bon appétit!, 1986

Gelatin silver print 5 parts, each 126.8 x 91.1 cm
ML/F 1988/19 I-V

Hypo-Bank Donation

◀ **Radovan Boček**
Happening at the
Former Stalin
Monument, 1989

Gelatin silver print
25.3 x 38.5 cm
ML/F 1990/1275

Boček, Radovan

1963 Reykjavík,
Iceland
Lives in Prague

Radovan Boček initially studied foreign trade along with photography at the Public Art College and at the Institute for Applied Photography in Prague. In 1987 he completed his studies of photography at the Motion Picture and Television College (FAMU) in Prague, and in November 1989 he was a co-founder of the "Radost" agency.

Boček at first devoted himself to landscape photography, but he later switched to photojournalism and documentary photography. While his early photographs were very descriptive, later ones conveyed a more vivid impression of the situation, bringing it right to the point. In the autumn of 1989, Boček created a pictorial record of the demonstrations during the peaceful revolution in Prague, describing the situation by means of few pictures and moments. His camera covered the dramatic events from the first intervention by the police to the campaign to elect Václav Havel president of the republic. His photograph *Happening at the Former Stalin Monument* with the undulating star banner and the flag waving above it symbolically expresses the aspirations of people in a powerfully succinct way. *RM*

▶ Hans-Ludwig
Böhme
Body III, 1991

*Gelatin silver print,
mixed media*
59.4 x 49.4 cm
ML/F 1995/86

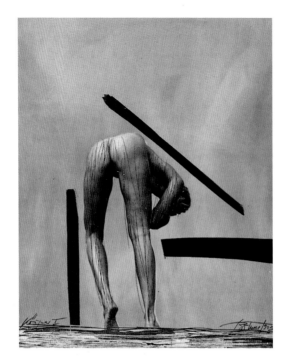

Hans-Ludwig Böhme began studying Germanic and English languages and literature in Jena, and from 1971 to 1982 he was a teacher at the children's and youth sports school in Dresden before turning his passion for photography into his profession. Today he can be described as one of the outstanding German theater photographers. His theater photography does not merely show actors on a stage – it is, in a more realistic sense, choreographed photography. Böhme regards his professional work as being no different from his artistic work. He does not just seek a pictorial record, but pictures in which he uses photography and chemistry as creative means for interpreting the given contents, people, things, spaces and paper collages. The rectangle of a photograph becomes a new stage on which things and people perform. Especially in nude photography, he has been able to use the rectangle of photographic paper to create novel backgrounds for unusual arrangements.
RM

**Böhme,
Hans-Ludwig**

1945 Coswig, Germany
Lives in Coswig

Boje, Walter

1905 Berlin
1992 Leverkusen

▼ Walter Boje
Man and his Desire,
around 1955

Color print
50.5 x 30.3 cm
ML/F 1989/52

Walter Boje, in addition to his studies of applied economics, which he concluded with a doctorate, also dedicated himself to painting. He used this means to further expand the knowledge he had acquired during an apprenticeship with a restorer of paintings. After serving as an adviser at Berlin University, he became general secretary of the German Academy for Air Research. After the war, he made his hobby into his profession and began working as a photographer. His main interest was theater photography, which he began practicing as early as 1950, using color film and available light. Boje made a creative tool out of mastering the challenge of the low-speed films of that era and the resulting long exposure times. He began to capture motion sequences photographically.

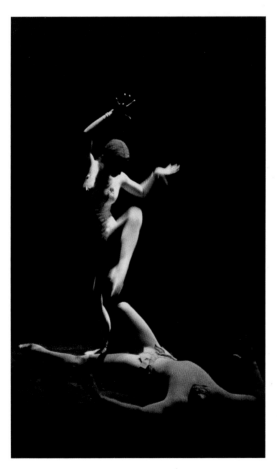

In addition to his practical work, Boje also distinguished himself as an active supporter of professional photography and as an author of numerous articles and books. His 1961 book *The Magic of Color Photography* was probably his most popular one. He performed journalistic work by becoming the editor of the magazine *Der Bildjournalist* and of the *Photoblätter*. Upon completing his activities in the public relations department of Agfa in Leverkusen, he was the director of the Famous Photographers School in Munich from 1969 to 1972. He was the Honorary Chairman of the German Photographic Academy when he passed away in Leverkusen on the 20th of July 1992. *RM*

▶ Gerd Bonfert
D 84-3 (still life),
1991

Gelatin silver print
131.8 x 98.4 cm
ML/F 1992/100

Toyota Donation

For two years now Gerd Bonfert has been applying photography to inter-
pret the phenomenon of the immaterial. The medium he chose for this
purpose is light. At an early stage he scratched light tracks on a blurred
self-portrait, allowing contours to dissipate. In today's pictures light has
become completely independent, separating itself from things. Strictly
speaking, we basically do not see actual objects themselves, only the
diffraction of visible lightwaves around these objects. Thus photography
quite logically does not show the object, but its effects on light. This be-
comes particularly evident in a series with sculptural elements, where
the illuminated edges of geometrical objects seem to float in a room
that constitutes itself before our eyes with a definable depth. The ob-
jects must have been present, otherwise light would not have been
diffracted. As if by magic, their presence is conjured up by the effects of
light, while their material content has disappeared. *RM*

Bonfert, Gerd

1953 Blaj, Romania
Lives in Cologne

Bonvie, Rudolf

1947 Hoffnungstal,
Germany
Lives in
Hoffnungstal

After studying at works schools in Cologne and at the Philosophical Faculty of Cologne University, Rudolf Bonvie first worked on serial projects that dealt with male role clichés. He used a combination of texts and photographs, but he also extended the work into sculptural media and installations, even adding video segments. After various critical artistic commentaries regarding photojournalism, he came upon the problem of human communication in a technical world with its symbols and signals. His photograph *Fighters* stems from that period.

Later on, Bonvie concentrated more and more on the problem of

◀ **Rudolf Bonvie**
Fighters, 1984

Color print
127 x 245 cm
ML/F 1989/198

making portraits, on creating an image for oneself. On one hand, he considers portraits to be a kind of violation of personal integrity, and on the other hand a problem of remembering. In the process, his work becomes more abstract, the photographic part unmasks itself in graininess, while the dubiousness of the authenticity of the photograph documents itself in fragmentation. *RM*

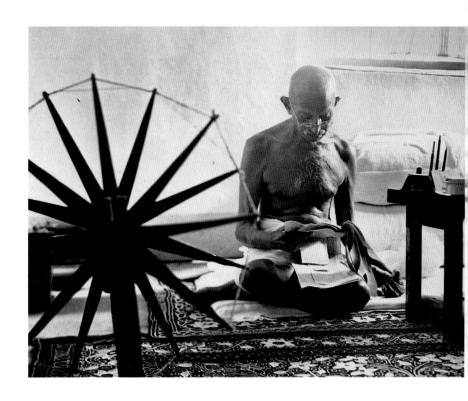

Bourke-White, Margaret

1904 New York
1971 Stanford, Connecticut

▲ Margaret Bourke-White
Mahatma Gandhi, 1946

Gelatin silver print
26.8 x 34.2 cm
ML/F 1977/92

Gruber Collection

The work of Margaret Bourke-White has become symbolic of American political and social-minded photojournalism. Interested mostly in industrial photography since 1928, she received her first major assignment from *Fortune* magazine in 1930, traveling to the Soviet Union, where she became the first foreign reporter to receive permission to photograph Soviet industrial installations. Margaret Bourke-White was one of the founding members of *Life* magazine in 1936, on which her photograph of Fort Peck Dam, then the largest hydroelectric power plant in the world, was used as the first cover picture. During the Second World War, Margaret Bourke-White served as a photographic war correspondent. After the capitulation of Germany, her shocking photographs of liberated concentration camps attracted worldwide attention. In 1946 she traveled to India on assignment from *Life* to document that country's struggle for freedom. In her photograph of Gandhi, she emphasized the spinning wheel, symbol of India's independence, by

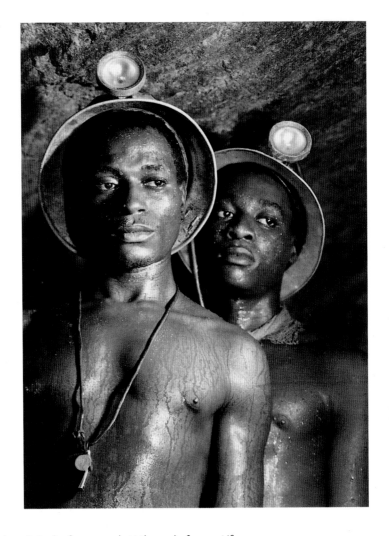

▶ Margaret Bourke-White
Miners, Johannes-
burg, 1950

Gelatin silver print
24.1 x 17.6 cm
ML/F 1977/90

Gruber Collection

placing it dominantly in the foreground. At the end of 1949, *Life* maga-
zine sent Margaret Bourke-White on assignment to South Africa for a
few months. There, in a gold mine near Johannesburg, at a depth of
nearly 5000 feet (1500 m) and in blistering heat, she made the photo-
graph of the two black miners drenched in sweat – a photograph that
she herself declared to be one of her favorite pictures. *MBT*

Brake, Brian

1927 Wellington,
New Zealand
1988 Auckland

▼ **Brian Brake**
Untitled (country
healer in China),
around 1950

Gelatin silver print
25.2 x 17 cm
ML/F 1994/107

Gruber Donation

New Zealander Brian Brake became interested in photography in the late thirties. In 1945 he began an apprenticeship with Spencer Digby. Two years later he worked as a cameraman for the New Zealand Film Unit. In the early fifties, a scholarship for the study of color cinematography techniques took him to London. There he became acquainted with members of "Magnum", and in 1955 he joined that association of photographers. He made freelance photographs for such international magazines as *Life, National Geographic* and *Paris Match*, covering Asia, Africa and the Pacific area. In his color essay *Monsoon*, he presented aspects of the monsoon, partly with large portraits of rain-drenched faces, and this earned him the American photographic prize "The Award of Merit". For a time he worked as a journalist in Hong Kong. In 1967 he switched from "Magnum" to the "Rapho" agency. In the seventies he

participated in the creation of a movie film production unit, and during the five years that followed he created eight motion pictures about Indonesia. Brake primarily documented people, their expressions and their living conditions. It did not matter whether the people were in Nigeria, Tibet or Hong Kong; he preferred to emphasize the individual in his or her particular cultural environment. Brake also photographed objects of art. In his book *The Sacred Image*, published in Cologne in 1979, he used a frontal perspective in his photographs of statues of the Buddha to convey the beauty of their stylistically similar, yet individually personalized faces. Brake returned to New Zealand in 1976 and continued to work as a freelance photographer in Auckland until his death in 1988. *LH*

▲ **Brian Brake**
Chinese ABC,
around 1950

Gelatin silver print
19.9 x 29.8 cm
ML/F 1994/103

Gruber Donation

◄ **Brian Brake**
Hong Kong, 1959

Gelatin silver print
16.8 x 24.8 cm
ML/F 1977/899

Gruber Donation

Brandt, Bill

1904 Hamburg
1983 London

Bill Brandt became interested in photography during a visit to Vienna in the mid-twenties. In 1929 he moved to Paris, where he worked for three months as an assistant in the studio of Man Ray. There he became acquainted with the art and motion pictures of surrealists. In 1931 he returned to London. From 1931 to 1935 he worked as a freelance photographer, creating a photographic documentation of the social life of the English, which he published in 1936 in the form of a book entitled *The English at Home*. Two years later, in 1938, his picture book *A Night in London* became the English counterpart to Brassaï's successful 1932 book *Paris de Nuit*. During the depression years, Brandt documented life in the industrial cities of England. During the war, he worked for the British Home Office creating picture essays about London and recording the ghostly scenery of empty streets during the London Blitz. His photographs of air-raid shelters and underground stations used as shelters were published in magazines along with Henry Moore's *Shelter Sketchbook Images*, which dealt with the same subjects. While Brandt, during the thirties, concentrated mostly on social themes, cityscapes and architecture, during the forties he more and more made a name for himself in portraiture. His subjects were mostly artists and literati, occasionally businessmen and politicians. Another subject that he favored between 1945 and 1950 was the English countryside. His photograph *Stonehenge*, which was published in the 19 April 1947 issue of the *Picture Post*, stems from that period. The dramatic attraction of this photograph comes from the contrast between the white fields of snow and the stark black silhouette of Stonehenge, which gives that photograph a strong graphic effect.

Stimulated by experiments with a wide-angle camera, Brandt, in the mid-forties, discovered the nude photographed from a distorting perspective. In his nude photographs, he usually concentrated on a detail or, as in the accompanying illustration, on a cropped part of the female body. The sparsely furnished rooms, slightly distorted in the picture, in which Brandt positioned his models, imparted a mysterious, surreal atmosphere to the entire scene. In 1961 Brandt published the results of this phase of his work in a book entitled *Perspectives of Nudes*. MBT

▲ **Bill Brandt**
Nude, from the cycle
"Perspectives of
Nudes", 1961

Gelatin silver print
34.9 x 28.9 cm
ML/F 1977/97

Gruber Collection

▲ **Bill Brandt**
Stonehenge, 1947

Gelatin silver print
22.6 x 18.7 cm
ML/F 1977/102

Gruber Collection

▲ **Bill Brandt**
Portrait of a Young
Girl, Eaton Place,
London, 1955

Gelatin silver print
23 x 19.6 cm
ML/F 1977/94

Gruber Collection

Brassaï

(Gyula Halász)

1899 Brasso, Hungary (now Brasvo, Romania) 1984 Beaulieu-sur-Mer, South of France

Gyula Halász, known since 1932 by his pseudonym Brassaï (derived from "de Brasso", his place of birth), came to photography through self-education. He first studied art in Budapest (1918–1919) and Berlin (1920–1922), and soon he was active in circles that included László Moholy-Nagy, Wassily Kandinsky and Oskar Kokoschka. In 1924 he went to Paris as a journalist. There he became acquainted with Eugène Atget in 1925, whose work was to become a constant model for his later work. A year later he met his compatriot André Kertész, whom he often accompanied on assignments and whose photographs he occasionally

◄ **Brassaï**
Sailors' Love, 1932

Gelatin silver print
29.3 x 22.8 cm
ML/F 1977/106

Gruber Collection

▶ **Brassaï**
The Prostitute Bijou
in the Bar de la
Lune, Montmartre,
Paris, 1933

Gelatin silver print
30 x 23 cm
ML/F 1977/109

Gruber Collection

used for the documentation of his own work. In 1929 Brassaï borrowed
a camera and made his very first photographs, and soon afterwards he
decided to purchase his own Voigtländer camera. During his extended
wanderings through night-time Paris, Brassaï began, in 1930, to record
the deserted streets and squares of that city. The results of this work
were published in 1932 in his famous book *Paris de Nuit*. Aside from the
aesthetic fascination of the mysterious and stage-set-like architecture,
the photographer also experienced the technical challenge posed by the
extreme lighting conditions for his night-time photographs. During
these nightly sojourns, Brassaï was also fascinated by the activities of
society. In the bars and in the streets he recorded the night owls of the
city, photographing tramps, prostitutes, lovers, dancers and other color-
ful figures. Among the best known photographs of this period is *The
Prostitute Bijou*. The heavily made-up and opulently bejeweled, heavily-
set Parisian woman attracted Brassaï's camera. However the publica-

▲ **Brassaï**
Dancers, 1933

Gelatin silver print
22.6 x 29.3 cm
ML/F 1977/112

Gruber Collection

▶ **Brassaï**
Hospice de Beaune,
around 1950

Gelatin silver print
29.5 x 22.2 cm
ML/F 1977/107

Gruber Collection

tion of that photograph in his book *Paris de Nuit* incensed the old lady, and it took a few banknotes to placate her ire.

In 1932 Brassaï discovered the graffiti on the walls of Paris, and he covered this subject for many years to come. Through his contributions to the surrealist magazine *Minotaure* during the thirties, Brassaï became acquainted with many writers, poets and artists of Surrealism. He began to work for *Harper's Bazaar* in 1937, and he supplied that magazine with many photographic essays about famous literary personalities and artists. In 1962, after the death of Carmel Snow, the publisher of *Harper's Bazaar*, Brassaï gave up photography altogether. From then on, he kept busy making new prints of his photographs and new editions of his earlier books. *MBT*

◄ Bratrstvo
Harvester's Bride,
1989

Gelatin silver print
23.5 x 17 cm
ML/F 1990/1295

Bratrstvo

(Brotherhood)

Founded 1989 in
Prague
Dissolved 1994 in
Prague

Bratrstvo is not the name of an individual artist, but of a group of artists that existed for about four years and which was closely tied to the peaceful revolution of the former Czechoslovakia. The group, formed in 1989, consisted of young artists like Václav Jirásek, Petr Krejzek, Roman Muselik and Zdenek Sokol, who developed a style of staged photography that took a critical and ironical look at the aesthetics of Socialistic Realism. They caricatured the heroic posturings of agricultural workers and soldiers, workers and civil servants. In the beginning, they consistently declined individual photo credits, using the group's name Bratrstvo instead. The group dissolved in 1994. *RM*

▶ **Marlo Broekmans**
The Wheel or The
Female Christ, 1983

Gelatin silver print
54.7 x 43.1 cm
ML/F 1995/117

Uwe Scheid
Donation

Marlo Broekmans studied at the Pedagogic Academy from 1970 to 1973, and from 1973 to 1977 she studied psychology at the University of Amsterdam. In 1978, she began working as a freelance photographer. From 1979 to 1981 she worked very closely with Diana Blok. This cooperation culminated with the publication of the book *Invisible Forces*. She devised her own themes and followed a specific style, staging her own settings. Marlo Broekmans combined photo-performance with double exposures and used a special way of incorporating the play of light and shadows. These photographs were first published in 1989 as an overview in the book *Marlo Broekmans – The Woman of Light*. Her photographic work concentrates on mythical-psychological aspects, but also on eroticism – an aspect that is especially apparent in her latest work on the subject of "Lovers". Her handling of light diffraction and shadow effects is in the tradition of constructive and cubist worlds of photography. Marlo Broekmans' work found recognition in the eighties not only in the Netherlands, but throughout Europe. *RM*

Broekmans, Marlo

1953 Hoorn
Lives in Amsterdam

Burri, René

1933 Zurich
Lives in Paris

▲ René Burri
Che Guevara,
Havana, Cuba, 1963

Gelatin silver print
23 x 30
(each 6 x 9.3) cm
ML/F 1984/14

Gruber Donation

From 1950 to 1953, René Burri studied photography under Hans Finsler and Alfred Willimann at the Arts and Crafts College in Zurich. In 1953, thanks to a scholarship, he was also able to take up motion pictures. He made small documentary films and, still in 1953, he was the camera assistant to Ernest A. Heininger for one of the first Cinemascope films about Switzerland. Two years later Burri joined the agency "Magnum". During the years that followed, he traveled all over the world. The spectrum of his subjects ranged from political reportage to landscapes, architecture, industry and city reports all the way to portraits of prominent artists, architects, and literary personalities. One of his most famous portraits is that of Che Guevara, which became a symbol of the Cuban revolution. During 1960, Burri worked mostly in Germany preparing material for his book *The Germans*, a compilation of Burri's photographs and texts about the Germans by various authors. In 1965 Burri participated in the establishment of "Magnum Films". Together with Bruno Barbey, he opened the Magnum Gallery in Paris in 1982. He has been the art director of the Swiss magazine *Schweizer Illustrierte* since 1988. *MBT*

Harry Callahan initially studied engineering at Michigan State University, and from 1934 to 1944 he worked at Chrysler Motors. In 1938 Callahan became interested in photography. Having attended a lecture by Ansel Adams in 1941, and after seeing one of his exhibitions, Adams became Callahan's great role model. Callahan then began making photographs with a large-format camera. Beginning in 1946, he taught photography at the Chicago Institute of Design, and in 1949 he took over as director of its Department of Photography. During that period, he became friends with Hugo Weber, Mies van der Rohe, Aaron Siskind and Edward Steichen. In 1961, Callahan became the director of the Department of Photography of the Rhode Island School of Design in Providence, RI.

In his photographic work, Callahan showed a predilection for detail shots, to which he often imparted an abstract effect through tight cropping. He liked to experiment with double exposures, and he also used over-exposures to create a graphic effect in his photographs. *MBT*

Callahan, Harry

1912 Detroit, Michigan
1999 Atlanta, Georgia

▲ **Harry Callahan**
Nature, 1948

Gelatin silver print
17.9 x 24.8 cm
ML/F 1984/16

Gruber Donation

Capa, Cornell

(Kornel Friedmann)

1918 Budapest
2008 New York

▼ Cornell Capa
Boris Pasternak,
1958

Gelatin silver print
34 x 22.6 cm
ML/F 1977/114

Gruber Collection

Cornell Capa, born Kornel Friedmann, distinguished himself in the field of photography in three ways: he himself worked as a photojournalist for more than 30 years, he promoted the work of his brother Robert Capa, and he was the founder and director of the International Center for Photography (ICP) in New York City.

Capa became involved with photography when he went to Paris in 1936 and began developing films and making prints for his brother Robert Capa, David Seymour and Henri Cartier-Bresson. Capa emigrated to New York in 1937, where at first he worked for the picture agency "Pix". In 1938 he moved over to *Life* magazine, where he met many photojournalists, who stimulated him to begin his own photographic activities. In 1946 he became a staff photographer at *Life* magazine. In the years that followed, he created approximately 300 photographic essays for that magazine.

In 1958, Capa spent six weeks in the Soviet Union creating an essay about the Russian Orthodox Church. During that time he also had the opportunity to meet Russian author and lyric poet Boris Pasternak, who had won the Nobel Prize for literature during that same year, and to take pictures in Pasternak's dacha in Peredelkino. Soon afterwards, the Soviet government prohibited Pasternak from receiving foreign visitors and it also refused permission for him to travel to Stockholm to receive his Nobel Prize.

After founding the International Center of Photography in New York and becoming its director in 1974, Cornell Capa gave up work as a photographer. *MBT*

Robert Capa, born André Friedmann, studied political science at the University of Berlin from 1931 to 1933. He was a self-taught photographer, and in 1931 he started working as a photo lab assistant at Ullstein (a publishing house). In 1932 and 1933 he worked as a photo assistant at Dephot (Deutscher Photodienst, a news agency). In 1933 he emigrated to Paris, where he changed his name to Robert Capa and where he began working as a freelance photographer. His photographs of the Spanish Civil War attracted attention to his name in Paris. His very first series already included the picture entitled *Death of a Spanish Loyalist*, which to this day is still his most famous and much discussed photograph. From then on he concentrated on being a photographic war correspondent. He traveled to China, Italy, France, Germany and Israel. On the 25th of May 1954 he was fatally injured in Thai-Binh, Vietnam. His death was the tragic consequence of his own motto "If your pictures aren't good enough, you aren't close enough". His talent for pointedly conveying the feelings and suffering of people in civil wars or rebellions in a single picture earned him great admiration.

A quality that transpires throughout Capa's pictures is his fascination for the fine edge along which humans proceed between the will to

Capa, Robert

(André Friedmann)

1913 Budapest
1954 Thai-Binh,
Vietnam

▲ Robert Capa
D-Day, 1944

Gelatin silver print
22.7 x 34.1 cm
ML/F 1977/115

Gruber Collection

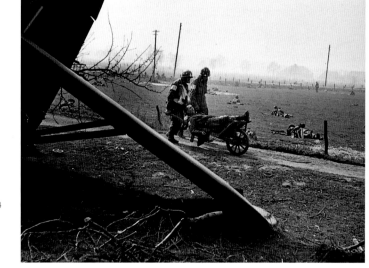

► **Robert Capa**
Sicilian Campaign,
1944

Gelatin silver print
35.6 x 27.9 cm
ML/F 1993/142

Gruber Donation

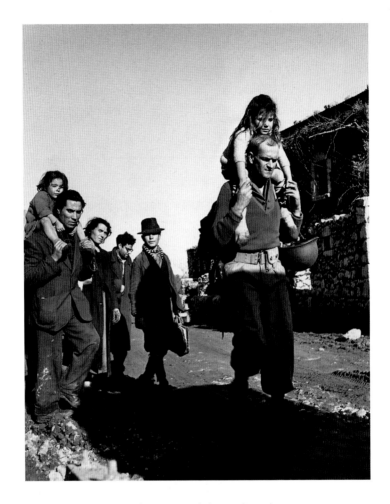

live and the urge for self-destruction. His obsession with his work made
him the most famous war correspondent of this century. But Capa did
not just set standards for photography and perform exemplary work.
His work is also a manifesto against war, against injustice and oppres-
sion. The Robert Capa Gold Medal Award has been presented in his
honor since 1955. The International Fund for Concerned Photography
was initiated by him. His brother Cornell Capa founded the International
Center for Photography in New York partly for the purpose of preserving
the work of Robert Capa and for making it accessible to the public. *RM*

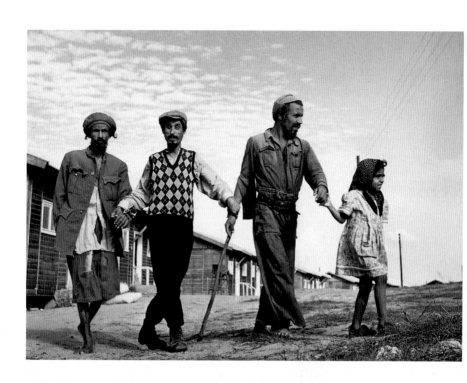

▲ **Robert Capa**
Untitled (Blind
People), 1950

Gelatin silver print
25.3 x 34.6 cm
ML/F 1993/141

Gruber Donation

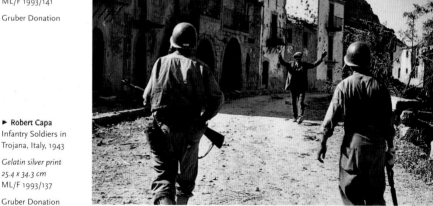

► **Robert Capa**
Infantry Soldiers in
Trojana, Italy, 1943

Gelatin silver print
25.4 x 34.3 cm
ML/F 1993/137

Gruber Donation

▶ **Robert Capa**
A "Time Out" of
War, Sicily, 1943

Gelatin silver print
22.7 x 34.3 cm
ML/F 1993/146

Gruber Donation

▶ **Robert Capa**
March to the Prison
Camp, France, 1944

Gelatin silver print
24.6 x 34.2 cm
ML/F 1993/136

Gruber Donation

Cartier-Bresson, Henri

1908 Canteloup
2004 L'Isle-sur-la-Sorgue

▲ Henri Cartier-Bresson
Sunday on the Banks of the Marne, 1938

Gelatin silver print
27.5 x 39.9 cm
ML/F 1977/141

Gruber Collection

► Henri Cartier-Bresson
Rue Mouffetard, Paris, 1958

Gelatin silver print
37.2 x 25.1 cm
ML/F 1977/126

Gruber Collection

Henri Cartier-Bresson attended the Ecole Fénélon and the Lycée Condorcet in Paris before studying painting under Cotenet from 1922 to 1923 and under André Lhote from 1927 to 1928, both in Paris. After that, he completed his studies of painting and philosophy at Cambridge University. His career as a photographer began in 1931. After participating in an ethnographic expedition to Mexico, he began working as a freelance photographer. In 1932, gallery owner Julien Levy hosted his first solo exhibition. In 1935, he learned about motion picture photography from Paul Strand. After that he worked as a camera assistant for Jacques Becker and André Zvoboda and also for Jean Renoir. In 1937 he made documentary films in Spain, and in 1940 he became a prisoner of war of the Germans in the state of Baden-Württemberg.

After escaping in 1943, he joined the MNPGD, a French underground resistance movement. After 1945 he once again turned to freelance photography. He authored many books illustrated with his photographs, among them *The Decisive Moment, Changing China* and *The World of Henri Cartier-Bresson*. In 1970 he married the photographer Martine Franck.

Cartier-Bresson was a living legend. Hardly any other photographer

▲ Henri Cartier-
Bresson
Seville, Spain, 1933

Gelatin silver print
27.2 x 41.1 cm
ML/F 1977/130

Gruber Collection

has been cited so often as exemplary of one of the great capabilities of photography: capturing a moment. In Cartier-Bresson's view, it is not just any moment, as it is in 99% of the millions of pictures made every day, for him it is "le moment décisif", the decisive moment that expresses the essence of a situation.

This photographer worked for nearly all the great international newspapers and magazines of the world. Together with Robert Capa, David "Chim" Seymour and George Rodger, he founded the "Magnum" group, and his travels took him to India, Burma, Pakistan, China, Indonesia, Cuba, Mexico, Canada, Japan and the former USSR.

Later, Cartier-Bresson stopped taking pictures and returned to his original passion of painting and drawing. Those who lament this may not have taken his earlier pronouncements seriously enough: "Actually, I am not at all interested in the photograph itself. The only thing I want is to capture a fraction of a second of reality."

Thanks to the Gruber Collection, the Museum Ludwig owns some of the most famous photographs by Cartier-Bresson, such as *Prisoner of War Camp in Dessau, Germany*, where he captured the moment when a

◀ **Henri Cartier-Bresson**
Alberto Giacometti, 1961

Gelatin silver print
24 x 16.5 cm
ML/F 1977/151

Gruber Collection

▲ Henri Cartier-
Bresson
Henri Matisse, 1944

Gelatin silver print
26.3 x 39.9 cm
ML/F 1977/143

Gruber Collection

former prisoner recognized the person who had denounced her and
who had brought her into that camp. Or *Rue Mouffetard, Paris,* a street
scene showing a small boy with a proudly raised face bringing home
two bottles of red wine. There is also the frequently published *Seine
Boatman,* showing a glimpse at the cabin of a freight barge, with the
barge master in the foreground looking at his family standing in the
doorway. Even the dog assumed an expectant pose. The most often
published picture, however, has to be *Sunday on the Banks of the Marne,*
a picture that epitomizes the idylls of the Sunday picnic. The river is
as calm as a lake, fishing lines hang from the tied-up boats, and two
couples sit on the grass with their backs to the viewer. The plates have
been eaten clean, the last glass of red wine is just being poured. The
picture expresses tranquility, yet it contains everything that one would
associate with a typical French picnic. Every one of Cartier-Bresson's
photographs contains its own specific tension. In his photograph
Shanghai, one can feel the anxious shoving of the people eagerly trying
to get to the bank counter. It is as if the crowdedness has spilled over
into the picture and the photographer tried to squeeze as many people
as possible into it. The portrait of Giacometti is also particularly charm-

ing. A sculpture in each hand, he is walking across his studio, his blurred, forward-leaning figure resembling the dark sculpture of a thin walking man in the foreground. Those who did not understand Giacometti up to then, will certainly do so after one look at Cartier-Bresson's photograph.

Cartier-Bresson repeatedly emphasized that one could not learn to make photographs. He himself was blessed with an enormous talent for perception and ability to react, and he had the uncanny sense always to be at the right place at the right time in situations that interested him, and then to press the button precisely when he perceived the situation to culminate. He would then have snatched a fragment of reality from passing into oblivion, playing a trick on time, as it were. To Cartier-Bresson, the concept that photography is capable of faithfully reproducing reality, that it contains the possibility of truth, was of major importance. His kind of photography is possible only when the above is the premise. Because the moment in question, the one that is deemed as "decisive", is so only in the situation that was experienced, it requires this direct relationship to reality in order to be understood as "decisive".

In this sense, Cartier-Bresson was an astute observer, a man of the eye, who knew what he wanted and what interested him. He once compared himself to a fisherman who had a fish at the end of his line. The most important thing was to approach his quarry cautiously, and to strike at just the right moment. *RM*

▲ **Henri Cartier-Bresson**
Prisoner of War Camp in Dessau, Germany, 1945

Gelatin silver print
17.2 x 24.5 cm
ML/F 1977/150

Gruber Collection

Chargesheimer

(Karl Heinz
Hargesheimer)

1924 Cologne
1971 Cologne

Karl Heinz Hargesheimer attended the College of Commerce in Cologne, where his teachers noticed his anti-National-Socialist attitudes. In 1942 he had a lobe of one of his lungs inactivated in order to evade military conscription. Based on his abilities, he was then accepted into the photographic curriculum of a Cologne factory school without the respective prerequisites. There are conflicting reports about his life between 1944 and 1947. It is said that he disappeared into the Alsace and that he was in a concentration camp. He himself kept silent about this period. In 1948, on the occasion of a story for the magazine *Stern*, he gave himself the name Chargesheimer. During the late forties, he and his friend Günther Weiß-Margis planned his first publication about the war-ravaged city of Cologne, but the aestheticized nature of his pictures found no willing publisher. His first gelatine-silver experiments and abstract sculptures were also created during that period. From 1950 to 1955 he was a lecturer at the BiKla School in Düsseldorf. In 1956, L. Fritz Gruber exhibited his work at Photokina. In 1957 he started a series of photo books, all of which caused a furore: *Cologne intime, Unter Krah-*

◀ **Chargesheimer**
Konrad Adenauer,
1954

Gelatin silver print
29.2 x 33.8 cm
ML/F 1977/172

Gruber Collection

nenbäumen, *In the Ruhr Region, Romanesque Style on the Rhine, People at the Rhine, Berlin – Pictures of a Big City* and *Interim Balance Sheet.* These books demonstrated to the trade that he not only had a specific outlook, but also new concepts about utilizing his pictures in books and bringing them to people's attention.

This series concluded in 1962, and Chargesheimer dedicated himself to the stage. He was a stage designer and director in Bonn, Cologne, Brunswick, Hamburg, Vienna and Kassel, busied himself with kinetic sculptures, his meditation mills. In addition, he took up his abstract photography and light graphics again, with which he attempted to break into the art trade. But it was not until the eighties that the signific-

▲ **Chargesheimer**
Ruins, around 1947

Gelatin silver print
39.7 x 29.8 cm
ML/F 1982/1196

▲ ▶ **Chargesheimer**
Nord-Süd-Fahrt,
1969

Gelatin silver print
39.6 x 29.7 cm
ML/F 1981/196

ance of this experimental photography was recognized. Chargesheimer received the Cultural Award of the German Society for Photography in 1968 and the Karl Ernst Osthaus Prize from the city of Hagen in 1970. In 1978, his estate was donated to the Museum Ludwig in Cologne, and his meditation mills and light graphics followed in 1989. The scholarship for the furtherance of photography sponsored by the city of Cologne has been named after him since 1986. Chargesheimer, an early exponent of inter-media art, is now recognized internationally for his significance as an avant-gardist. These successes had no bearing on the fact that he became embroiled in a personal crisis that was also heavily fanned by social developments. His book *Cologne 5:30 AM* in which he focused intensely on the spread of concrete in his home town of Cologne from the point of view of a conceptional city portrait, even rejecting a foreword already written by Heinrich Böll, became his legacy. He died under mysterious circumstances on New Year's eve in 1971. *RM*

▲ **Chargesheimer**
Ballet Break,
around 1963

Gelatin silver print
59.4 x 49.5 cm
ML/F 1980/172

▲ **Chargesheimer**
Musical Reflection
(gelatin silver print
painting)
(Wagner), 1949

Gelatin silver print,
mixed media
39.7 x 48.6 cm
ML/F 1994/66

▲ **Chargesheimer**
Untitled (gelatin
silver print painting),
around 1962

*Gelatin silver print,
mixed media*
49.5 x 59.5 cm
ML/F 1994/68

**Claasen,
Hermann**

1899 Cologne
1987 Cologne

Hermann Claasen was only 14 years old when he began making photographic experiments with a camera made from a cigar box. After the collapse of his parents' textile business, where he too had worked, the self-taught Claasen made the daring move to professional photography.

His photographic archive was destroyed during a bombing raid in 1942. During the war he photographed the ruins and the people in Cologne and its surroundings. These photographs are among the most gripping documents of the destroyed city. His unforgettable picture *Christ among the Ruins* is a symbolic memorial against war. Life with crude improvisation, the daily battle for bare necessities, they were all chronicled by Claasen. A selection of these pictures was published in 1947 in the book *Songs in the Furnace,* supplemented by an exhibition in the Eigelsteintor city gate in Cologne under the title "Cologne – the Tragedy of a City". Since his death, the District Savings Bank of Cologne has been sponsoring the Hermann Claasen Prize, a scholarship to foster young photographers. *RM*

▲ **Hermann Claasen**
Christ among the
Ruins, 1945

Gelatin silver print
28 x 38.6 cm
ML/F 1987/170

▶ **Hermann Claasen**
Cologne Cathedral,
seen from the south,
1944

Gelatin silver print
33.3 x 43.2 cm
ML/F 1987/168

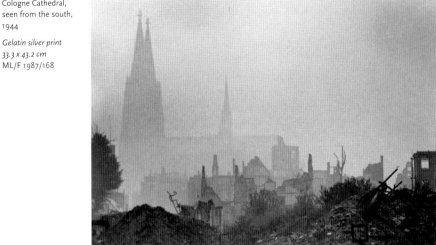

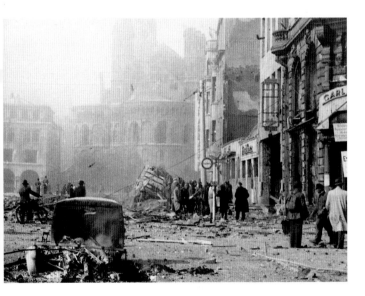

◀ **Hermann Claasen**
Neumarkt Square in
Cologne, first day-
light bombing raid,
1944

Gelatin silver print
30.4 x 40.4 cm
ML/F 1993/156

Gruber Donation

Clausen, Rosemarie

1907 Berlin
1990 Hamburg

▶ Rosemarie Clausen
"Endgame" by
Samuel Beckett, 1968

Gelatin silver print
59.8 x 45.1 cm
ML/F 1989/42

▼ Rosemarie Clausen
Marcel Marceau,
1964

Gelatin silver print
58 x 45 cm
ML/F 1989/40

After first studying art, Rosemarie Clausen began an apprenticeship in photography in Berlin in 1925. She took a special interest in the theater and until 1933 worked with theater photographer Elli Marcus. She soon became a familiar person in theater circles, having the opportunity to photograph the great actors and actresses of her time. She established her own studio and worked primarily at the state playhouse at the Gendarmenmarkt, where Gustaf Gründgens became the director in 1934. In 1938 she published her first picture book, *People Without Masks*, in which she presented her theater photography. After the end of the war, Rosemarie Clausen moved to Hamburg, where she practiced photography at the Hamburg Studio Theatres, at the Theater in the Room, and in the German Playhouse. In 1947 she met the playwright Wolfgang Borchert and photographed the premiere of his play *The Man Outside* in the Hamburg Studio Theatres. In 1968, Samuel Beckett staged his *Endgame* on the workshop stage of the Schiller Theater in Berlin. Rosemarie Clausen photographed that play in dim light, in many gradations of grainy gray values, occasionally applying unsharpness.

Rosemarie Clausen's work stretched over more than half a century, largely elevating theater photography into a concept of its own. She worked in two of the most important theater centers of Germany, over the decades photographing and interpreting many great actors in the most diverse roles. Her pictures are optically frozen moments of thespian poetry, with a profound sensitivity for the expressiveness of human mimicry. *UP*

Clergue, Lucien

1934 Arles
Lives in Arles

After finishing high school, Lucien Clergue began to take pictures in his spare time. In 1954, he had his first public exhibition with 50 portraits of actors, all of them impersonating Julius Caesar. Next he produced a series of photographs of traveling acrobats, taken in the wartime ruins of Arles, and a series of pictures of dead animals. In 1956 he started his series *Nudes of the Sea* which made him known around the world. They represented a novel interpretation of bodily shapes and of the treatment of surfaces in combination with water and light. By candidly staging eroticism in his pictures, Clergue furthermore openly broke with the tradition of prude rendition of nudes that dominated photography in the fifties. He did not place chaste young women in the landscape, neither did he aim for the usual untouched landscape and untouched femininity. Instead he used water, light and waves to impart a sensuous radiance to the female body. In 1957 he illustrated the book *Memorable Bodies* by Paul Eluard. In 1959 he began his intensive photographic study of the Camargue, its swamps, plants, and its waters. In this subject, too, he bridged the distances to the objects, creating an extraordinary immediacy of things in his pictures. He also worked on a photographic series about the topography of Arles, and he kept a daily photographic log for

▲ Lucien Clergue
Bullfight, around
1960

Gelatin silver print
24.7 x 37.3 cm
ML/F 1984/23

Gruber Donation

► **Lucien Clergue**
From the series:
Nudes of the Sea,
around 1975

Gelatin silver print
49.9 x 60.6 cm
ML/F 1995/119

Uwe Scheid
Donation

Jean Cocteau's film "The Testament of Orpheus". Over a period of many years, he used his camera to observe Picasso at work, and he also photographed bullfights in the arena. In 1961 he took many trips abroad and decorated a hall in the Rockefeller Center in New York. In 1962 he visited Brasilia and Rio de Janeiro, beginning a new series of his *Nudes of the Sea*. In 1971 he made a film for his friend Pablo Picasso for Universal Pictures. In 1970 he founded the Rencontres Internationales de la Photographie in Arles, which he served as artistic director for 25 years. The Rencontres Internationales de la Photographie were captivating because of their liveliness and freshness, which were greatly enhanced by the quaint southern charm of the city of Arles. He has been teaching at the University of Marseilles since 1976. In 1979 he became the first person to receive a doctor's degree in photography, and since then he has been teaching at the New York School for Social Research. In 1980 he was named "Knight of the National Order of Merit" of France. *RM*

Coburn, Alvin Langdon

Alvin Langdon Coburn belongs to the generation of photographers who brought about the change from the pictorialism of the 19th century to an avant-garde-oriented style of photography.

It was during a visit in 1899 to a distant cousin in London, art photographer Fred Holland Day, that Coburn became definitely fascinated with photography. As early as 1902 he opened his own studio in New York. There Coburn became acquainted with Alfred Stieglitz, in whose magazine *Camera Work* he published some of his photographs as photogravures. Through the circle of artists around Stieglitz, Coburn soon became familiar with the avant-gardistic trends of the art. Inspired by that trend, he began to explore new forms of expression with photography. He experimented with extreme perspectives and developed a strong interest in structures and abstract formations. In 1912 he left New York and went to Great Britain, where he remained to the end of his days. There he had friendly contacts among members of the English group of cubists founded by Ezra Pound and called "Vorticists". This connection inspired Coburn's "Vortographs", in which he achieved a cubist fragmentation of forms by using reflecting prisms.

In addition to his avant-garde creativity, Coburn also made a name for himself with portraits of famous contemporary personalities, which he published in 1913 and 1922 in his two volumes entitled *Men of Mark*. *MBT*

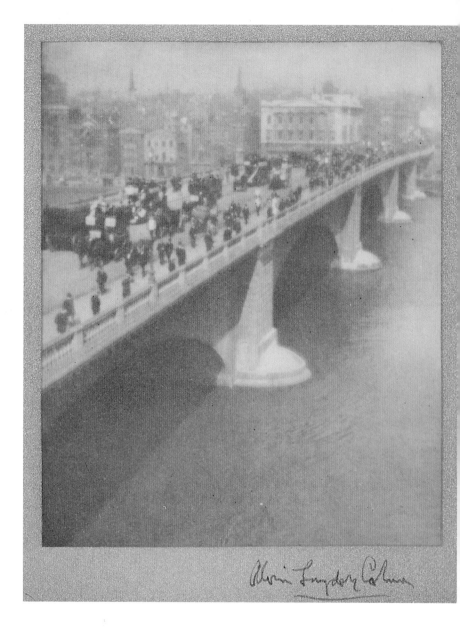

▲ **Alvin Langdon Coburn**
London Bridge, 1905

Photogravure, 12.2 x 10 cm
ML/F 1993/165
Gruber Donation

▲ **Alvin Langdon Coburn**
The Bridge at Ipswich,
around 1904
Photogravure, 19.4 x 15 cm
ML/F 1995/7
Gruber Donation

◀ **Serge Moreno Cohen**
Marie-Jo Lafontaine, 1991

Color print
40.3 x 32.6 cm
ML/F 1993/168

Gruber Donation

Cohen, Serge Moreno

1951 Portes-Les-Valence, France
Lives in Paris

Aside from a six-month period as an assistant to Daniel Frasnay in Paris, Serge Cohen is a self-taught photographer. After various auxiliary jobs and a few black-and-white assignments for the supplement of the *Frankfurter Allgemeine Zeitung,* he had the opportunity of proving his talent to art director Willy Fleckhaus. In 1982, his first picture essay was published in the *Frankfurter Allgemeine Magazin,* for which he has since become a staff photographer.

Cohen is active in architectural and landscape photography and in photojournalism, but it is his staged portrait photography that made him famous. He succeeds in creating a portrait that stays on one's mind and that remains associated with the sitter. He provokes by de picting the sitter in roles that spring from his imagination after an intense study of his subject. *UP*

▶ **Serge Moreno**
Cohen
Richard Avedon,
1994

Gelatin silver print
25.8 x 30.7 cm
ML/F 1994/124

Gruber Donation

◀ **Serge Moreno**
Cohen
Jasper Johns, 1986

Color print
27.7 x 40.4 cm
ML/F 1993/169

Gruber Donation

Colette

1947 Tunisia
Lives in New York
and Munich

▲ Colette
Real Dream, 1975

Mixed media
82 x 197 cm
ML/F 1994/1

Uwe Scheid
Donation

Colette began painting while she was still in her youth. In the year 1970, she completed her first performance with *Hommage à Delacroix*, which was the beginning of an artistic career devoted to the oneness of art and life. Then came street works, actions and performances on streets and public squares, followed by her "living environments" and the "windows", in which she remained motionless in a selected pose with an elaborate arrangement of fabrics and lace. Her titles were *Cinderella's Dream, Rag Doll* or *Justine as Joan of Arc*. Meanwhile, her home became a "living environment". There her activities produced sculptures, objects and photographic works that should not be regarded as relics of those activities, but as parallel developments. Colette is unquestionably a multi-media artist who assumes various roles of historical women for certain phases of her work, which she then combines directly with her everyday life. Colette has convincingly implemented Marcel Duchamp's idea of aesthetic behavior throughout her entire artistic career. In recent years, she has withdrawn somewhat from performance art, working more intensively in the fields of object art, painting, and photographic work. Some of her more recent themes have been *Call C for Scandal, Mata Hari and the Stolen Potatoes* or *The Bavarian Adventure*. Her "Magic Code", which threads through her artistic work like a credo, simultaneously signals her personal creed: "T. M. for Deadly Feminine". *RM*

Stephen D. Colhoun's career as a professional photographer began in
1950. He soon became a well-known glamour photographer for leading
magazines and advertising agencies. His advertising assignments
ranged from watches to automobiles, but he became best known for his
fashion photography.

Colhoun's photograph *Laughing Woman with Cup* was taken for an
advertisement for brassieres. While the fore- and background are pleas-
antly blurred, a band of sharpness diagonally traverses the center of the
picture. Here we see the neckline of a woman, with her head leaning
back so far that only her wide open, laughing mouth is visible in the pic-
ture. This ingenious contrast between sharp and blurred areas, visible
and hidden elements place the observer in the role of a voyeur. *MBT*

**Colhoun,
Stephen D.**

Born in 1921

Cosindas, Marie

Born in Boston, Massachusetts
Lives in Boston

▼ Marie Cosindas
Still Life with
Flowers, 1976

Polaroid
24 x 19 cm
ML/F 1984/26

Gruber Donation

Marie Cosindas studied design at the Modern School of Fashion Design in Boston and painting at the Boston Museum School. From 1945 to 1960 she worked as an illustrator and designer. In 1960 she established herself as a photographer in Boston. She attended photography workshops conducted by Ansel Adams (1961) and Minor White (1963/1964). In subsequent years she herself taught courses in photography, including the Colorado College Summer Photo Workshops in Colorado Springs from 1972 to 1978, and she also taught at various American Institutions.

As a trained painter, it was in keeping with Marie Cosindas' temperament to be intrigued by color, so that it is not surprising that she took up color photography at a time when black-and-white photography was still the favorite with most photographers. She began experimenting with this medium in the early sixties and sought to achieve the greatest possible brilliance and perfection with colors. She dispensed with artificial light, used various filters and experimented with different developer times and temperatures. In 1962, Marie Cosindas became one of the first photographers to explore the possibilities of Polaroid instant print material successfully. She was always very meticulous with technical aspects of her work. Cosindas paid the same painstaking attention to her compositions, which she organized to the last detail. Her portrait sessions became well known for her thorough familiarization with her subjects and for the quality of the resulting portraits themselves. In addition to human faces, Marie Cosindas was fascinated by old dolls, masks and fabrics, which she arranged in romantically enchanting still-life tableaus. *MBT*

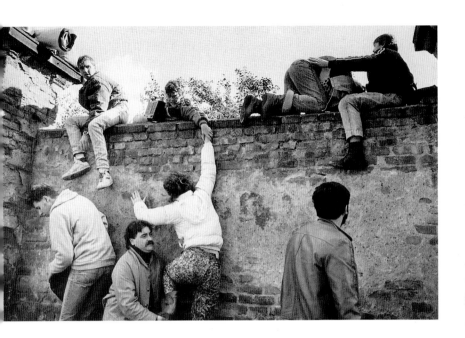

Carel Cudlin studied social law before entering the College for Film and Television (FAMU) in Prague. From 1988 to 1989 he was a staff photojournalist for the weekly newspaper *Mlady Svet,* and since then he has been working for picture agencies in Prague and in Paris. In 1989, Cudlin used his camera to record the mass exodus of citizens of the German Democratic Republic, and he documented the crowds at Lobkovicz Palace, the West German Embassy in Prague. His photographs show people helping one another to climb over walls, they show the draining of a state. In his photographs of the "velvet revolution" in Czechoslovakia in November 1989, Cudlin concentrated on gestures of solidarity and moments of poignant symbolism, such as the removal of a Soviet star from a building, or the cutting of barbed wire at the Hungarian border. Cudlin has a keen sensitivity for the power of expression of certain gestures and actions, and he has a refined talent for conveying this in his photographs. *RM*

Cudlin, Carel

1960 Prague
Lives in Prague

▲ Carel Cudlin
At the German Embassy, Prague, 1989

Gelatin silver print
22.6 x 34.2 cm
ML/F 1990/1326

Cutforth, Roger

1944 England
Lives in Terlingua,
Texas

Roger Cutforth studied at the Nottingham College of Art from 1962 to 1966 and at the Ravensbourne College of Art from 1963 to 1966. After emigrating to New York he taught drawing and photography at various colleges.

Cutforth created his first photographic sequences in the early seventies, calling them *Personal Space*. With the size of the figure remaining unchanged, he enlarged the surrounding field in order to demonstrate the proportional relationships among things. In films that he made between 1973 and 1975, Cutforth conducted similar investigations of the relationship of human beings with the image space surrounding them.

In 1977 and 1978, Cutforth continued to utilize the medium of photographic sequences for his landscape photography. He sought out hard-to-reach locations in the American west, far removed from civilization. There he photographed a particular part of the scenery at different times of the day, usually early in the morning, at noon and in the early evening. His sequences always consisted of three landscape photographs with identical cropping. The appearance of the landscape is different in each picture as a result of different lighting conditions, but because of the identical cropping, the information about the formation of the landscape remains unchanged. By means of such a juxtaposition of the changed and the unchanged, the observer is stimulated to compare nuances and variations that are to be discovered especially in the changes in color, shadows and light. Unlike a motion picture, such a photographic sequence does not convey a seamless description of the evolving scene. The charm of the photographic sequence lies more in the intervals of time between exposures, which serve to enhance the illustration of the passing of time by means of changes in the rendition of the subject. *MBT*

▲ **Roger Cutforth**
Bighorn Canyon,
Montana, 1978

Color print
3 photographs,
each 61.2 x 61.2 cm
ML/F 1979/1354 I-III

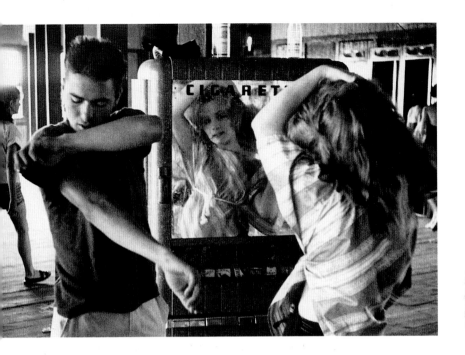

After an apprenticeship in photography, Bruce Landon Davidson studied photography at the Rochester Institute of Technology in Rochester, NY in the early fifties. Following that, he studied painting, philosophy and photography under Herbert Matter, Alexey Brodovitch and Josef Albers at Yale University in 1955. After that he worked as a freelance photographer in New York, Paris and Los Angeles, serving such international magazines as *Live, Esquire* or *Vogue*. He has been a member of the "Magnum" group since 1958, and he also teaches at a variety of institutions.

Davidson concerns himself with subjects of everyday reality. He photographs drug addicts and criminals, and he documents street scenes and demonstrations. He followed the changes in America during the late fifties and early sixties with great empathy. He had a special interest in social groups like the beatniks, precursors of the hippies with unconventional attitudes, in suburban environments and other contemporary subjects. Davidson's photographs convey impressions that are typical of our times. *UP*

**Davidson,
Bruce Landon**

1933 Oak Park,
Illinois
Lives in New York

▲ **Bruce Davidson**
Young Couple, 1958

Gelatin silver print
16.9 x 24.2 cm
ML/F 1977/909

Gruber Donation

Dekkers, Ger

(Gerrit Hendrik
Dekkers)

1929 Borne,
Netherlands
Lives in Giethoorn

Gerrit Hendrik Dekkers studied at the Art Academy in Enschede in the
Netherlands from 1950 to 1954. Before that, he served in the Dutch
Army in Indonesia from 1948 to 1950. In 1954 he married Hilda Hart-
suiker, with whom he had two children, Henriette and José. Between
1954 and 1976, he worked as a freelance artist in Enschede, and since
then in Giethoorn.

Dekkers first attracted public attention in 1969 with an exhibition of
his precise, sober landscapes at the Stedelijk Museum in Amsterdam.
In 1971 he started his serial photography, which enabled him to depict
evolving events. These photographic series can illustrate changes in a
cultural landscape that are due to the intervention of mankind, but they
can also illustrate spatial shifts such as a change of the artist's position
within a given space, or the clarification of scenic relationships. To ac-
complish this, he uses the square format and color photography, com-
pletely dispenses with the presence of any human beings, and positions
the horizon precisely in the center. In a horizontal arrangement of the
pictures, the horizons line up, forming a continuous line that traverses
all the pictures. When the photographs are arranged in a square field,
he achieves a regular image pattern that pervades the entire picture
arrangement. Dekkers utilizes this method of pictorial recording, which
dispenses with subjective decisions and which always abides by these
established rules, and he focuses on the cultivated landscape of the
Netherlands, on tree plantations, hedges, fields, gardens and dikes. The
alignments and the perspective of regularly stepped rows cause the ob-
server to be consciously aware of the landscape and to study it. In par-
ticular the new polders, which were created entirely by human hands,
provide Dekkers with manifold possibilities for analysis. The polder is,
for all intents and purposes, paradigmatic for cultivated landscapes.

Orchard near Emmeloord, photographed in the first of the new polders, with which the original plan called for the Ijsselmeer to be completely drained in a series of steps, is one of the best known examples of these alignings. It is symmetrical around an axis, both in the horizontal as well as in the vertical direction, the only difference being that a row of trees, parallel to the horizon, moves into the picture in seven steps from left to right.

Dekkers' art can be classified as lying somewhere between conceptual art and land art, with photography being utilized with a documentary purpose. But since Dekkers arrived at such a concept from a background of photography, he places significantly more emphasis on the technical perfection of his photographs than many of his artistic colleagues. Dekkers' work proves that the differentiation between artists who make photographs and conceptually working photographers can no longer be defined, and that it can only be established biographically.

In his own work, he distinguishes between series that show a close relationship to land art, because they depict situations in which the soil has obviously been cultivated and altered by human hands, and other photographic series, which he regards as "objets trouvés" in the context of landscapes. But it is only through his photography that we become aware of them and acknowledge them with their sometimes surreal appearance. In spite of the occasional determinisms that are a priori in Dekkers' endeavors, his work is not guided purely intellectually by reflective thought processes. He is enough of a photographer to accept the eye and perception as the second important axiom of his work and to let the visual experience precipitate the decision for a particular picture subject. *RM*

▲ **Ger Dekkers**
Orchard near
Emmeloord, 1974

Color print
50 x 50 cm,
altogether 50 x 350 cm
ML/F 1985/35

◄ **Erwin von**
Dessauer
Children on the
Beach, around 1933

Gelatin silver print
28 x 25.3 cm
ML/F 1983/182

Dessauer,
Erwin von

1907 Valparaiso,
Chile
1976 Rio de Janeiro,
Brazil

Erwin von Dessauer studied photography under Willy Zielke at the
Bavarian State College for Photographic Imaging. In 1933 he accepted
an offer from a magazine to settle in Rio de Janeiro. His photographs
depicting the life of simple people were created during numerous trips
across the South American continent. It is evident from his photo-
graphs, especially from his pictures of religious ceremonies like
macumba, that he had a talent for being accepted by people. He was
particularly interested in genre portraits, which he produced on an ex-
tensive scale for the "Ballet Folklórico Brasileiro". It can be detected in
many of his photographs that his eye was trained by a master of object
photography. In spite of their seemingly incidental nature, photographs
like *At the Water* and *Children on the Beach* are composed with great pre-
cision. *RM*

▲ Erwin von Dessauer
At the Water, around 1939

Gelatin silver print, 35 x 27 cm
ML/F 1983/181

Dibbets, Jan

1941 Weert
Lives in Amsterdam

After studying to become an arts teacher at the Academy for Creative and Constructive Arts in Tilburg, Jan Dibbets began his career as a minimalist painter in Amsterdam. In 1967 he received a scholarship to study in England. There he discovered photography and made it the mainstay of his now conceptually oriented art. Still young at the time, the Dutch artist achieved international recognition with a series of photographs entitled *Perspective Correction* (1967-1969). With this series, he questioned the illusion of perspective in paintings, at the same time challenging the notion that the camera cannot lie. One of the photographs from this series, for example, shows a trapezoid that Dibbets had painted directly on a white wall of his studio. But perspective distortion in the picture makes the trapezoid appear as a square. With photographs such as this one, Dibbets assured himself a place among the spiritual fathers of photographic concept art – next to artists like John Baldessari, Douglas Huebler and Ugo Mulas.

One of the significant objectives of concept art is to illustrate a scientific abstract notion in a descriptive, clarifying manner. This is to bring phenomena of reality determined with a scientific method closer to the direct range of human experience and perceptual capabilities. For Dibbets, the phenomenon of movement in and through time is the subject of numerous works. Dibbets is concerned with the visualization of this phenomenon, which, although it can be verified scientifically, is not readily visible. Jean-Christoph Ammann wrote the following about this artist: "Dibbets does not question reality in photography, he questions the reality of photography itself. In doing so, he does not address the object, but the 'way of seeing' of the camera [...]. For Dibbets, to uncover the seeing mechanism of the camera means to introduce a recognition process that causes reality to be perceived as a photographic reality, not as a surrogate."

In his photographic work *Film-Painting: Black Vase Horizontal* (1972), Dibbets moves a motion picture camera past a vase at a uniform distance. This movement, which takes places in a room in a timed sequence, is visualized objectively by the simultaneous display of the film strip. With each new location of the vase within the picture area, it simultaneously indicates the respective position of Dibbets as he moves past the vase.

The course of time and an action taking place during that course of time are graphically illustrated by simultaneously showing – and this is

not possible in real time – the successive progression of a time sequence. For Dibbets' artistic endeavors, the motion picture camera is assigned the role of a measuring instrument that records the slightest changes that occur in space and time. *GG*

▲ **Jan Dibbets**
Film-Painting: Black Vase Horizontal, 1972

80 photographs mounted on aluminum plates, each 24 x 19 cm, altogether 190 x 192 cm
ML/F 1985/36

Ludwig Donation

Dieuzaide, Jean

1921 Grenada-sur-
Garonne
2003 Toulouse

Jean Dieuzaide's career as a photographer began on the 19th of August 1944, when he took pictures of the liberation of his home town of Toulouse. In 1945, he began working as a photojournalist for various newspapers and weekly magazines. In 1951 he settled down as a photographer in Toulouse. His famous picture of the great surrealist *Dalí in the Water, Cadaquès,* was made during a 1953 trip to Spain.

During the fifties, Dieuzaide discovered his predilection for the structures of things. His close-up pictures of sea mud, in which the photographer found fascinating formations, became his most famous photographs of this genre. In 1974 he published this series under the title *My Adventure with Tar.* In 1963 Dieuzaide was among the founders of the "Libre Expression" group, which believed in "subjective photography" and in the ideas of Otto Steinert. Until 1981, Dieuzaide operated a gallery in Toulouse, in which he provided a display forum for members of the "Libre Expression" group. Dieuzaide closed his studio in 1986. *MBT*

▲ Jean Dieuzaide
Nude in the Woods,
1975

Gelatin silver print
30.3 x 40.3 cm
ML/F 1995/120

Uwe Scheid
Donation

▲ Jean Dieuzaide
Dalí in the Water, Cadaquès, 1953

Gelatin silver print, 31 x 24.5 cm
ML/F 1984/31

Gruber Donation

◀ Herbert Döring-
Spengler
Untitled, 1990

Cibachrome
50.5 x 50.5 cm
ML/F 1995/181

Uwe Scheid
Donation

**Döring-
Spengler,
Herbert**

1944 Cologne
Lives in Cologne

Since the mid-eighties Herbert Döring, a self-taught photographer, has
been exploring the possibilities of the Polaroid. He began to make
notches in the fresh film and to separate the layers. He also combined
Polaroid with video, making references to art-historical models and
utilizing unusual materials. His method of working might best be de-
scribed as an attempt to break down the media at his disposal into their
component parts, to search out previously undiscovered elements, and
finally to recombine the whole. The blending takes place emotionally, in
the light of his feelings, not in accordance with any rational considera-
tions. He is one of the most creative personalities in his field, ever cap-
able of springing a surprise, and always intent on moving on to new
ground. His pictures start out as simple photos or video sequences, are
subjected to color changes, are captured on Polaroid, heated, ripped
apart, dried, in turn employed together with their new carrier as a slide,
or re-photographed, finally to yield up a Cibachrome print. *RM*

▶ **Robert Doisneau**
Café des Halles,
Paris, Tramp, 1952

Gelatin silver print
29.9 x 23.9 cm
ML/F 1977/209

Gruber Collection

Originally trained as a lithographer, Robert Doisneau embraced in 1929 a new interest as a self-taught photographer. He regarded photography as the ideal medium for recording life during his wanderings through Paris. His career as a professional photographer began in 1934 at the Renault works in Billancourt, where he was employed until 1939 as an industrial and advertising photographer. Also in 1939 he decided to become an independent photojournalist, but still in that same year the war forced him to give up his dream of becoming a freelance photographer. He served in the French army until 1940, and from then until the end of the war, he worked for the résistance. Even so, he did not entirely interrupt his work as a photographer. Instead, he tried to earn a little money by producing postcards. In 1949, Doisneau signed a contract with the fashion magazine *Vogue,* for which he worked as a full-time staff photographer until 1952 and from then on as a freelance photographer. Through his activities for *Vogue,* the photographer became acquainted with high-society circles, for which, however, he did not have as much sympathy as he did for the common people in the streets. He also did

Doisneau,
Robert

1912 Gentilly
near Paris
1994 Paris

▲ **Robert Doisneau**
The Bride near
Gégène, 1948

Gelatin silver print
30.5 x 23.9 cm
ML/F 1977/204

Gruber Collection

► **Robert Doisneau**
Gate of Hell,
Boulevard de Clichy,
Paris, 1952

Gelatin silver print
30.4 x 24 cm
ML/F 1977/211

Gruber Collection

not enter the annals of photography as a fashion photographer. What made Doisneau famous was his "street photography". In countless snapshots, he humorously, but not without empathy, documented life in the suburbs of Paris.

This resulted in a number of photographs that have become icons of the French way of life. The most famous example is the *Kiss in front of the Palace of City Hall,* which has been reproduced by the million, and which more than any other picture became the symbol of young, boisterous love in a big city. As a "street photographer", Doisneau was on

▲ **Robert Doisneau**
Pablo Picasso in Val-
lauris with Françoise
Gilot, around 1950

Gelatin silver print
21.9 x 18.9 cm
ML/F 1977/213

Gruber Collection

► **Robert Doisneau**
The Little General,
1950

Gelatin silver print
27.9 x 23.9 cm
ML/F 1977/215

Gruber Collection

the same level as Brassaï, Willy Ronis and Izis, with whom he shared a
joint exhibition at the Museum of Modern Art in New York in 1951. Like
Brassaï, Doisneau loved to wander through the streets of night-time
Paris in order to record the life of marginal society. It was during such
nightly excursions that he made the well-known photograph of the hobo
Coco, a failed soldier of the Foreign Legion, and the photograph of a
dock worker lying on his bed dreaming of the pin-up girls of his wall
decorations. Doisneau himself called this picture a parody of a mascu-
line man. *MBT*

▲ **Robert Doisneau**
Dreams of a Tattooed Man, 1952

Gelatin silver print, 27.3 x 23.9 cm
ML/F 1977/205

Gruber Collection

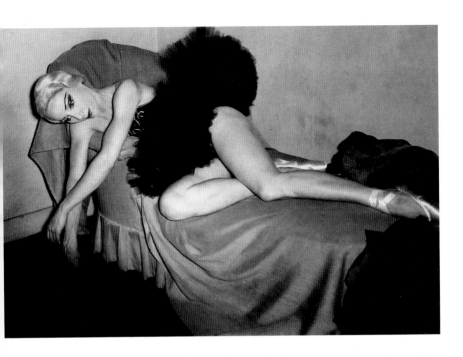

At the beginning of this century, when Dora Kallmus, who later worked under the name Madame D'Ora, decided to become a photographer, this was an unconventional choice of profession for a woman from her social level. That is why she was only permitted to take courses in theory at the Graphic Education and Experiments Institute in Vienna, and she was not allowed to take practical courses. In spite of this obstacle, Madame D'Ora decided to open a studio in Vienna. She learned the fundamentals of portrait photography from Nicola Perscheid in Berlin. In 1907, together with Arthur Benda, whom she met at Nicola Perscheid's place in Berlin, she opened her studio in Vienna. Benda took care of the technical part of photography. Madame D'Ora dedicated herself to the arrangement and the staging of the photographs, for which she was influenced by the Viennese Art Nouveau. In 1917 Benda designed a lens that softened the contours in a picture. This soft-focus effect became a trademark of Madame D'Ora's early photographs, which sometimes gave the impression of having been taken through a frosted glass plate. She continued to use this technique when she opened a studio in Paris in 1924. It was only after the Second World War

Madame D'Ora

(Dora Kallmus)

1881 Vienna
1963 Frohnleiten,
Styria, Austria

▲ **Madame D'Ora**
Rosella Hightower,
1955

Gelatin silver print
21.3 x 30.9 cm
ML/F 1984/32

Gruber Donation

that Madame D'Ora changed from soft focus to precise sharpness. She used this new technique between 1953 and 1955, when she produced an extensive series of photographs of the Marquis de Cuevas and his dance theater.

There was also a change in her choice of subjects after the war. She was no longer interested just in glamour and the good life. For instance, she took her camera to Paris slaughterhouses. Fascinated by this subject, she sought to create abstract views of it, arranging it in virtually poetic still-life compositions. *MBT*

▶ **Madame D'Ora**
Marquis George de
Cuevas, 1955

Solar Print
23.7 x 15.6 cm
ML/F 1977/221

Gruber Collection

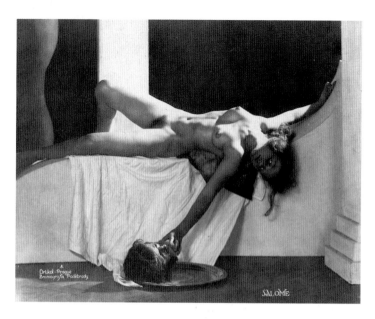

◄ František Drtikol
Salome, 1923

Bromoil print
22.8 x 28.7 cm
ML/F 1984/34

Gruber Donation

► František Drtikol
Nude, around 1920

Gelatin silver print
11.8 x 8 cm
ML/F 1993/172

Gruber Donation

Drtikol,
František

1883 Príbram,
Bohemia
1961 Prague

František Drtikol was one of the most famous photographers of the twenties and thirties in the former Czechoslovakia, and he also enjoyed an international reputation. His work was largely forgotten after he gave up photography in 1935, only to gain renewed recognition in the early seventies.

From 1901 to 1903, Drtikol enjoyed a well-founded education at the Bavarian State Institution for Photography in Munich. In 1910, after completing his military service and after spending three years in Príbram, Drtikol went to Prague, where he experienced public recognition of his work for the first time. Drtikol specialized in portraiture and nude photography, showing himself stylistically influenced by Romanticism and Symbolism. It was during this period that the feminine figure of Salome first appeared in his photographs, which continued to fascinate him during his entire work. During the twenties, Drtikol's style underwent significant changes: he began to emphasize and arrange space with man-sized geometrical forms, he developed the creative possibilities of light into virtually expressionistic dramaturgy, and he reduced his nudes to torsos or individual limbs. *MBT*

◀ Harold
E. Edgerton
Milk Drop, 1936

Gelatin silver print
39.5 x 49.9 cm
ML/F 1977/229

Gruber Collection

**Edgerton,
Harold E.**

1903 Fremont,
Nebraska
1990 Boston

Harold E. Edgerton studied at the University of Nebraska from 1921 to 1925 and at the Massachusetts Institute of Technology in Cambridge, MA from 1926 to 1927, where he began to teach in 1928. As an independent photographer he developed stroboscopic photography of high-speed kinetic action. A large number of his photographs became milestones of "high speed photography" and he received numerous international awards.

Stroboscopic photography is a technique for capturing and depicting kinetic action and timed events in distinct steps. Edgerton used strobe flash for recording fast action on film. The photographs were made in a darkened room, using numerous exposures per second. This also became a scientific tool, because it made the fine details of such fast-occurring events become visible for the first time.

One of Edgerton's most famous photographs is his *Milk Drop*, which shows the delicate, crown-shaped form created by a milk drop when it strikes a thin layer of milk on a plate. A physical event that is familiar to scientists is transformed into a liquid sculpture that can only be made visible by means of Edgerton's photographic technique. *UP*

▲ **Harold E. Edgerton**
Tennis Player, 1938

Gelatin silver print
24 x 19 cm
ML/F 1977/224

Gruber Collection

Alfred Eisenstaedt was only 13 years old when he began taking pictures with a Kodak camera that he had received as a gift. During the inflation period after the First World War, he made a living as a belt and button salesman for a company in Berlin. In his spare time he practiced photography as a hobby and began to experiment with cropped photographic enlargements. His activities as a freelance photographer began when his photograph of a female tennis player was published in the *Weltspiegel*, followed by other publications in the *Berliner Tageblatt*. In 1929, he decided to make photography his profession, and he began to work for the "Pacific and Atlantic Picture Agency".

His first assignment, a photographic report of the awarding of the Nobel Prize to Thomas Mann in 1929, already earned him great recognition. During those years he made many portraits that became famous, of such personalities as, among others, Marlene Dietrich, George Bernard Shaw, but also Joseph Goebbels, Hitler and Mussolini. In addition, he also produced a report about the war between Italy and Ethiopia. He worked for the *Berliner Illustrierte Zeitung* and other tabloids in Berlin and Paris.

Eisenstaedt, Alfred

1898 Dierschau, Germany
1995 Oak Bluffs, Massachusetts

▲ Alfred Eisenstaedt
American Ballet, 1938

Gelatin silver print
16.2 x 24.1 cm
ML/F 1977/237

Gruber Collection

◄ Alfred Eisenstaedt
V-Day, 1945

Gelatin silver print
24 x 15 cm
ML/F 1977/242

Gruber Collection

◄ **Alfred Eisenstaed**
Marlene Dietrich,
1928

Gelatin silver print
24.7 x 26.8 cm
ML/F 1977/247

Gruber Collection

Concerned about the political situation in Germany and hoping for better work opportunities, Eisenstaedt emigrated to America in 1935 and began working for *Harper's Bazaar, Vogue* and *Town and Country*. Eisenstaedt arrived in New York just as *Life* magazine was being launched, and he became a member of its full-time staff right from its beginning in early 1936. Up until 1972, when *Life* magazine temporarily ceased publication, he had worked on more than 2500 assignments, and he produced photographs for more than 90 cover pages. As a photojournalist, Eisenstaedt was not specialized in a specific field. Nevertheless, his

photographs of people were the ones that earned him a place in photographic history. He not only photographed countless famous personalities in politics and culture, but also unknown people in everyday situations. One of his most famous photographs is *V-Day*, a snapshot of a passionate kiss during a victory parade of sailors on Times Square at the end of the Second World War. Eisenstaedt is regarded as a pioneer of available light photography, because early on he dispensed with flash photography in order to preserve the ambiance of natural lighting. Peter Pollack wrote the following comment about Eisenstaedt: "The strength of his photographs lies in the simplicity of their composition. Eisenstaedt's portraits clearly reveal the spirit and the character of a person, regardless of whether that person is famous or unknown. The intimacy of his pictures make the viewer feel like a participant, as if he was present, standing next to the photographer."

Eisenstaedt was honored with numerous international awards and he counts among the most published photojournalists in the world. *TvT*

Elsken, Ed van der

1925 Amsterdam
1990 Edam

▲ Ed van der Elsken
Hongkong, 1960

Gelatin silver print
31 x 40.5 cm
ML/F 1988/79
Gruber Donation

▶▲ Ed van der Elsken
Girl Refugee,
Hongkong, 1960

Gelatin silver print
15.8 x 23.4 cm
ML/F 1977/252
Gruber Collection

▶ Ed van der Elsken
Durban, South Africa,
1960

Gelatin silver print
23.9 x 30.2 cm
ML/F 1977/255
Gruber Collection

Dutchman Ed van der Elsken completed his studies of art in his home town, later moving to Paris to work as a freelance photographer. He also became a correspondent for a Dutch newspaper. Many of this politically active photographer's socio-critical pictures and films were made during a trip around the world. At first he worked only in black-and-white, taking up color later on. In a photographic series about jazz, created between 1955 and 1961, he did not use flash illumination, because he considered it important to preserve the atmosphere and the emotions of the moment in natural light conditions. Elsken published *Sweet Life* in 1963, along with numerous photographic books about Amsterdam, Japan and China. Elsken expressed the drama of social injustice in a pictorially concentrated manner with photographs like the one of the care-worn, strained face of a Chinese girl, or the one of the South African apartheid situation. Both with genre studies of the subculture of Amsterdam as well as the photographic short story *Love on the left Bank,* Elsken expressed his interest in people on the margins of society, who are never shown in representative reports about a country. *LH*

**Engelskirchen,
Hein**

1908 Krefeld
1985 Krefeld

After an apprenticeship in a home-weaving shop, Hein Engelskirchen made a trip to Paris, during which he discovered the camera and thus his later profession. After serving in the war, he was exceptionally admitted to an examination at the handicrafts chamber, and he spent the rest of his life as a successful photographer, creating illustrations for advertising and for industry. Their richness in color, but also the combined precision of detail and panorama-like overview, in particular of his photographs of the Bayer-Uerdingen works, are reminiscent of a way of seeing industrial installations that later became known worldwide, especially through the Becher school.

▲ Hein
Engelskirchen
Bayer-Uerdingen,
around 1965

Color print
29.4 x 40 cm
ML/F 1993/91

Engelskirchen worked with enormous energy, and he never sought publicity. That is why some of his photographs, like *Wallpaper Designer,* are world-famous classics whose author is not generally known. His estate was divided among the Kaiser Wilhelm Museum in Krefeld, the Museum Ludwig in Cologne, and the archive of the Photographic Academy in Leinfelden. *RM*

▲ **Hein Engelskirchen**
Wallpaper Designer,
around 1955

Gelatin silver print
24.9 x 40.5 cm
ML/F 1993/97

Erben, Li

1939 Blauda,
Czechoslovakia
Lives in Munich

▼ Li Erben
Daoist Temple,
Mount Taishan, 1986

Color print
30.3 x 23.8 cm
ML/F 1987/104

After a photographic apprenticeship with Stuttgart fashion photographer Walde Huth, followed by studies at the Institute for Photojournalism, Li Erben began to photograph Munich life in its beergardens and streets, in parks and in the hustle and bustle of its carnival. After that she found her strength in the field of portrait photography of personalities from the arts, music and literature. She made portraits of Ingmar Bergman and Liv Ullmann, Isabel Adjani and Roman Polanski, Federico Fellini and Jane Birkin, Arthur Rubinstein and Marc Chagall. During that time she met stage director Victor Vicas, whom she later married in Paris. During her time in Paris, she worked primarily as a still photographer in movie productions, but she also continued making portraits of actors, and she began working as an assistant stage director. When her husband passed away, she became a stage director herself, and in

the eighties she specialized in international co-productions. She took advantage of her countless trips to create pictorial reports. Among these was the colorful series about China and Chinese life: people who camp in railway stations, hikers on Taishu mountain, old men who take their caged birds to parks to let them sing, the dense throng of cyclists, rituals and processions. Li Erben presents a lively image of China in the mid-eighties, in its transition from communist uniformity to the liberalization of customs. Today she lives with the architect Dieter Walz in Munich. *RM*

▲ Li Erben
Kufu, 1986

Color print
30.3 x 23.8 cm
ML/F 1987/108

◀ Li Erben
The First of May in
Tiananmen Square,
Beijing, 1986

Color print
30.5 x 23.8 cm
ML/F 1987/99

Eremin, Yuri

1881 Kasanskaja on the Don
Died 1948

▼ Yuri Eremin
Street in Buchara
with Camels, 1928

Gelatin silver print
37.8 x 26.3 cm
ML/F 1992/121

Ludwig Collection

Parallel to the constructivist and realistic tendencies of the Russian avant-garde, pictorial photography in the Soviet Union also enjoyed a revival in the twenties. This was the time during which Yuri Eremin was successful with his impressionistically poetic photographs. Trained as a painter at the Moscow School of Painting, Art and Architecture, he later dedicated himself entirely to photography. As a staff member of the magazine *Fotograf*, which was published between 1926 and 1929, Eremin was of the opinion that photography should be regarded as one of the creative arts. He preferred to work with a soft-focus lens and bromoil techniques, thus assuming a stylistic position that was contrary to the photographic avant-garde of his country. Beginning in the mid-thirties, Eremin was active as a reporter and correspondent for the magazines *Izvestiya*, *SSSR na stroike*, ("USSR under Construction"), *Ogonek* and *Smena*. Eremin specialized in the subjects of landscapes and architecture, but he was also inspired by genre scenes of cities during his extensive trips through Russia and Western Europe.

In the photograph *Street in Buchara with Camels*, Eremin documented the oriental atmosphere of this city in the south of the USSR. With the view of a street through a shaded archway, Eremin imparted a special charm to his picture: the darkened figures and the portion of the archway in the foreground create a foil-like contrast with the bright, sun-drenched background, enhancing the impression of depth in the picture. *MBT*

Stefan Erfurt studied French literature at the Sorbonne in Paris from 1978 to 1980. From 1980 to 1981, he worked as an assistant in a photography and video studio. From 1981 to 1987, he studied photography under Professor Inge Osswald at the University of Essen. Since 1985 he has been contributing regularly to the *Frankfurter Allgemeine Magazin*, and also to *Vanity Fair* and to the *Sunday Times*. Erfurt stood out particularly because of his unconventional photographic reports. He dared to distance himself from the customary style of photojournalism and to let motion blur become part of his pictures. In his view, the essence of a picture lay not in the precision of reproduction, but in its expression of atmosphere and vitality. His search for the fusion of the moment with the subjective perception of the photographer found an incentive with his discovery of Polaroid instant imaging material as the medium best suited to his interests. These large format images are even more dedicated to forever preserving the fleeting moment than his black-and-white reportages. *RM*

Erfurt, Stefan

1958 Wuppertal
Lives in New York
and Berlin

▲ **Stefan Erfurt**
The Odeon, 1985

Gelatin silver print
25.6 x 37.7 cm
ML/F 1985/32

Erfurth, Hugo

1874 Halle on the
Saale
1948 Gaienhofen on
Lake Constance

Hugo Erfurth was one of the most significant portrait photographers of his time. In 1895 he began an apprenticeship under court photographer Wilhelm Höffert, and in 1896 he took over the Schröder Studio in Dresden. In 1906 the photographer purchased the Lüttichau Palace in Dresden, in which he installed a studio for "modern and artistic photographic pictures", the so-called Erfurth imagery. Here he welcomed personalities from politics, business and the arts as his clients.

Erfurth cultivated a rather sober style of portraiture. He usually dispensed with characterizing or decorative settings, choosing instead to concentrate entirely on the face of the sitter.

In 1934 he moved to Cologne and opened a studio that was destroyed during the 1943 bombing raids on that city. After the war, the photographer retired to Gaienhofen on Lake Constance. *MBT*

▲ **Hugo Erfurth**
Mrs Fähndrich, around 1930

Oil pigment print, 48.8 x 38.3 cm
ML/F 1977/258
Gruber Collection

The artist Max Ernst studied philosophy, psychology and art history in
Bonn. In 1919 he was a co-founder of the Dada movement in Cologne,
and in 1921 he joined the surrealists of the Paris avant-garde under
André Breton. Ernst utilized a great variety of techniques to express his
visions, among them collages, scraping, decalcomanias and oscillation.
Ernst invented the frottage (rubbings), which makes chance the liber-
ator of fantasy. He discovered this technique by accident when he trans-
ferred the texture of a wooden floor to paper by rubbing it with a pencil.
He incorporated this picture fragment in his work and subjected it to
his creativity.

A process that constitutes a combination of drawing and photo-
graphy is the cliché verre, which is a handmade glass cliché that is
printed and reproduced with light. Ernst also utilized this technical
variation of the etching. *UP*

Ernst, Max

1891 Brühl
1976 Paris

◄ **Walker Evans**
Children in Alabam
1936

Gelatin silver print
18 x 22 cm
ML/F 1984/39

Gruber Donation

Evans, Walker

1903 St. Louis,
Missouri
1975 New Haven,
Connecticut

Walker Evans, who originally wanted to become a writer, discovered his passion for photography at the end of the twenties. He began his career as a photographer with picture series about Victorian architecture in America and a reportage about the political unrest in Cuba in 1933. His early work already exhibited his objective, highly detail-conscious outlook, which was to earn him his fame as one of the most talented documentary photographers of his time. He himself described his photographs as "documentary in style", and he gave himself the challenge of maintaining the purity of the art of photography. In October 1935, Evans joined the Farm Security Administration (FSA), which was a federal authority during the Roosevelt era that developed aid programs for small farmers and tenant farmers during the years of the Great Depression. In this project, photography was used as evidence, documenting the abject poverty of the rural population for dissemination to a broader public – a project that combined political and socio-critical, documentary and aesthetic interests in an unprecedented manner. His efforts for the FSA became the most important segment of Evans' work. Using the same objective precision with which he had earlier photographed the architecture of his country, Evans was now recording the life of the poor. It was

Walker Evans
Louisiana, 1936

Gelatin silver print
24.2 x 18.9 cm
ML/F 1984/38

Gruber Donation

during this period that he made the photograph of the skeptical but proud farm worker who appears in the picture entitled *Louisiana,* as well as the photograph of the two children dressed in meager rags who appear in the photograph entitled *Children in Alabama.*

In 1938, one year after Evans had finished his work for the FSA, the Museum of Modern Art in New York honored the achievement of this photographer with a solo exhibition, the very first that this museum dedicated to a photographer. *MBT*

Fehr, Gertrude

1895 Mainz
1996 Lausanne

▶ **Gertrude Fehr**
Solarised Torso,
around 1935

Gelatin silver print
41 x 29 cm
ML/F 1987/158

▼ **Gertrude Fehr**
Odile, around 1940

Gelatin silver print
20.3 x 25.5 cm
ML/F 1987/159

Gertrude Fehr studied photography in the studio of Eduard Wasow and at the Bavarian State Educational Institute for Photography in Munich. She then operated a studio for theater and portrait photography in the Schwabing area of Munich until 1933. During the Third Reich era she moved to Paris, where she and her husband, the painter Jules Fehr, opened their own school of photography, which they called PUBLI-phot Influenced by the Paris art scene, with which she maintained close contact, she began to experiment. She was particularly fascinated by the work of Man Ray, which motivated her to work with techniques like solarization, collages and abstractions. In doing so, she ventured into a type of work that is extremely unconventional for professional photographers. When the circumstances of war forced her to close the school she clung to the idea of a photographic school and, immediately following her move to Switzerland, she founded a new school for photography, which she called "Ecole Fehr".

In 1945, she turned the school over to the public domain represented by the Ecole des Arts et Métiers in Vevey, where she continued to teach for another 15 years. Gertrude Fehr radiated a great influence as a teacher. Among her pupils were such successful photographers as Monique Jacot, Yvan Dalain and Jeanloup Sieff. From 1960, Gertrude Fehr limited her work to freelance photography, devoting herself mostly to portraiture. In Germany, her work remained forgotten for a long time. Exhibitions in the City Museum of Munich and at the Museum Ludwig in Cologne brought it back to the attention of the German public. Gertrude Fehr remained active into her advanced age and even changed residence and studio once again at more than 90 years of age. She died in 1996 in Lausanne. *RM*

Feininger, Andreas

1906 Paris
1999 New York

▼ Andreas Feininger
Detail of a Bivalve
Clam, around 1972

Gelatin silver print
34.5 x 27 cm
ML/F 1993/185

Gruber Donation

Andreas Feininger spent his youth in Germany, where he studied at the Bauhaus in Weimar and at the State School of Architecture in Zerbst. At first he worked as an architect in Dessau and in Hamburg, but towards the end of the twenties he began to be interested in photography. His first publications about photography appeared in 1930. In 1932 Feininger emigrated to Paris, where he initially worked for Le Corbusier. Later on he founded his own company for architectural and industrial photography in Stockholm. In 1939 he moved to New York and devoted himself entirely to photography. He worked for *Life* magazine and was considered to be one of the founders of contemporary photojournalism. After that period, he concentrated exclusively on the publication of his own books.

Feininger had a unique way of combining picture contents with formal criteria such as structures, picture composition and perspective. His photographs of New York are always structured architectonically, conforming to the rectangle of the picture, and never seeming like views

through a frame. The basic principle of his photographic work is especially evident in the example of picture composition, which he himself described as "clarity, simplicity and structure". But he simultaneously demanded that pictures must say something to the observer. To him, technical perfection was never an end in itself. Photographs like *The "United States" setting off for Europe* (1950) or *New York, Midtown Manhattan at 42nd Street* (1947) convey his architectonic outlook, the rigorous structure and the intensity of his pictures in a powerful way.

In his photojournalistic work for *Life* magazine, Feininger placed particular emphasis on a judicious combination of picture content and picture expression.

According to Feininger, the story has to be told by the pictures them-
selves, so that the accompanying text can be reduced to a minimum. If
the content is the prerequisite for a picture, then its organization and its
composition determine its quality. Feininger himself observed this fun-
damental principle of journalistic work during his many years at *Life*
magazine, thus helping to shape the image of this publication.

Feininger's photography covers the entire spectrum of photographic
activity: from lively street scenes to carefully composed city views, from
nearly abstract landscapes to minute details of plants, stones, shells or
sculptures. He mastered the narrative as well as the strictly composed
picture, and he accomplished the blending of both criteria in his photo-
journalistic reports. *RM*

▲ Andreas Feininger
New York, Entrance
to a Discotheque,
around 1964

Gelatin silver print
26.5 x 34.1 cm
ML/F 1993/193

Gruber Donation

▲ Andreas Feininger
The "United States"
setting off for
Europe, 1950

Gelatin silver print
26.7 x 34.2 cm
ML/F 1993/192

Gruber Donation

▶ Andreas Feininger
New York, Midday,
around 1964

Gelatin silver print
26.6 x 34 cm
ML/F 1993/191

Gruber Donation

▲ **Andreas Feininger**
New York, Midtown
Manhattan at 42nd
Street, 1947

Gelatin silver print
25.3 x 34.2 cm
ML/F 1993/190

Gruber Donation

▶ **Andreas Feininger**
New York, Brooklyn
Bridge, 1948

Gelatin silver print
26.6 x 34.1 cm
ML/F 1993/195

Gruber Donation

Felber, Gina Lee

1957 Zweibrücken,
Germany
Lives in Cologne

Gina Lee Felber, a graduate of the Technical College of Cologne, developed a quiet, restrained style of staged photography. Her work is representative of the fictitious, of the arranged in two ways. Her self-built picture objects originally served the exclusive purpose of being photographed. In the meantime, however, they have become exhibition subjects in their own right. They are unreal interiors, rooms populated with strange wire figures and objects made of paper and glue, artificial miniature worlds, which she fits out, illuminates, and then photographs.

This introduces a second abstraction, a second staging through the kind of illumination, because Gina Lee Felber does not employ her photography to obtain an exact reproduction of the miniature worlds created, but uses them only as a model for the creation of a sort of shadow play. Hardly anything recognizable is recorded in her photographs. One senses a solid wall, yet in another spot it turns out to be transparent. A tapestry of threads, grids, figures and heads unfolds in front of us, about whose correlations the titles, such as *Evocation, Night Moth* or *Shadow Conversation* also provide no clues. We are faced with events in three-dimensional space, even if the latter regularly converts into a plane. Because of this interpretive and altering photography, her wire sculptures have absolutely no disillusioning effect on her photographic work. But this also proves that neither one is a by-product of the other, or that the sculptures and photographic works speak an entirely different language independently of each other. *RM*

◄ **Gina Lee Felber**
Evocation, 1991

Gelatin silver print
128 x 188 cm
ML/F 1991/685

◀ Erwin Fieger
Sadhu, from: Living
and Dying on the
Ganges, India, 1983

Color print
42.2 x 61 cm
ML/F 1993/198

Gruber Donation

▶ Erwin Fieger
Starving Child, 1963

Color print
56.6 x 40 cm
ML/F 1993/197

Gruber Donation

Fieger, Erwin

1928 Toplei,
Czechoslovakia
Lives in Castelfranco
di Sopra, Italy

After moving to Germany, Erwin Fieger was drafted into the army in 1944. He then studied graphic design and typography at the State Academy for the Creative Arts in Stuttgart. In 1960 he resolved to make photography his profession and settled in Italy and in Germany. He concentrated on color photography and undertook extensive journeys through England, Japan, Mexico and India, always following his own conceptions. Fieger was not willing to accept assignments that restricted his conceptions. He worked only for a few selected magazines, such as *Life*, *Réalités, Queen, Town* and *twen*. He always worked with a view to publications, which he meticulously serviced and published. Fieger also made a name for himself as a sports photographer at numerous Olympic Games, and he published books about the Olympiads in Sapporo, Munich, Innsbruck and St. Moritz. His book about India, which he planned over a period of many years as a journey from the source of the Ganges river all the way to its mouth, and which was lavishly printed, is magnificent. *RM*

Finkelstein, Nat

1933 New York
Lives in Amsterdam
and New York

Nat Finkelstein learned photography from Alexey Brodovitch, the legendary art director of *Harper's Bazaar*. During the sixties he worked as a photojournalist for the picture agency "Black Star", reporting primarily on the political developments of the subculture of New York City. In the course of this work he met Andy Warhol, whom he photographed with his co-workers at the Warhol Factory. Because of his constant presence, he was able to make photographs of great intensity and intimacy, furnishing an insider's view of that famous studio.

After his break with Warhol, Finkelstein turned to political activities, and it was only in the early eighties that he returned to photography. He again devoted himself to the underground, but he developed a style that could be interpreted as a revival of pop art principles. He delved into the new media, mixed video and color photography and manipulated the pictures with a computer. Today many of his originals are laser prints. In many of his important works, pictures of the subculture are arranged into a solemn altar composed of still and moving pictures. *RM*

▲ Nat Finkelstein
Warhol Factory,
1964/1967

Gelatin silver print
30 x 40 cm
ML/F 1994/5 b

▲ **Nat Finkelstein**
Warhol Factory,
1964/1967

Gelatin silver print
30 x 40 cm
ML/F 1994/5 e

◄ **Nat Finkelstein**
Warhol Factory,
1964/1967

Gelatin silver print
30 x 40 cm
ML/F 1994/5 f

Fischer, Arno

1927 Berlin
Lives in Leipzig

▲ Arno Fischer
Berlin, 1958

Gelatin silver print
33.4 x 50.1 cm
ML/F 1991/171

Arno Fischer is considered to be one of the most outstanding exponents of classical photojournalism in eastern Germany. He had studied in the drawing and sculpture class of the Käthe Kollwitz School in Berlin, later continuing his studies of sculpture under Professor Drake at the Art College of Berlin and under Professor Gonda at the College for the Creative Arts in Berlin Charlottenburg. Encouraged by his teacher, he came upon photography, to which he later devoted all his attention. He photographed people in their social environment, dramatically describing everyday situations and scenes in the German Democratic Republic, but also in the USA. The scene in Berlin showing people, isolated and depressed, sitting among the ruins, is an impressive document of the postwar situation in Germany. Fischer worked for numerous publications, such as *Sybille*, *Freie Welt* and *Das Magazin*, and in 1967 he was a member of the "Direkt" group. In 1985, following various teaching assignments in Berlin and Leipzig, he became a professor of photography at the College for Graphic design and Book Art in Leipzig. *RM*

▶ Hannes
Maria Flach
Nude, around 1922

Bromoil print
39.6 x 27 cm
ML/F 1984/40

Gruber Donation

Hannes Maria Flach completed an apprenticeship as a businessman, after which he found a job as a representative at the AEG firm in Düsseldorf. In his spare time he was an active amateur photographer and he became a member of the German Association of Amateur Photographers. In 1925 he participated for the first time in a photographic exhibition. In 1928 he opened his own studio in Cologne-Zollstock. He worked as a freelance photojournalist, which enabled him to give up his job as a representative. Flach's work is strongly characterized by the Cologne progressives. He died in 1936 as a result of maltreatment by a member of the SS. *RM*

Flach, Hannes Maria

1901 Cologne
1936 Cologne

◄ Franco Fontana
Crouching Back
Nude, 1983

Color print
34 x 22.5 cm
ML/F 1993/205

Gruber Donation

► Franco Fontana
Nude, 1984

Color print
34 x 22.3 cm
ML/F 1988/99

Gruber Donation

Fontana, Franco

1933 Modena
Lives in Modena

In 1961, Franco Fontana devoted himself completely to photography. In 1964, the magazine *Popular Photography* published his first portfolio, and in 1970 he published his first book, *Modena una Città*. In the seventies his most important subjects were landscapes, which he reduced to abstract basic structures. The horizontal is usually the structural element which, in the form of a horizon, the border of a field, a street or a beach, subdivides the picture area. Restrained and rigorous as the composition was, it was invigorated by intensive, even luminous colors, a creative principle that he also applied to other subjects. In addition to his photographic activity, Fontana also made a name for himself as the organizer of the San Marino International Photomeeting. *RM*

◄ **Franco Fontana**
Beach and Ocean,
1973

Color print
20.2 x 29.4 cm
ML/F 1977/917

Gruber Donation

► **Franco Fontana**
Puglia, 1971

Color print
20.2 x 29.7 cm
ML/F 1977/916

Gruber Donation

► **Annette Frick**
The Toiletries of
Venus, 1990

Color print
212.5 x 142.3 cm
ML/F 1994/2

Uwe Scheid
Donation

Annette Frick studied art in the motion picture class of Robert van
Ackeren. Aside from her artistic work, she campaigned vehemently for
work opportunities for young and alternative artists, founded the Har-
bor Salon, and was one of the initiators of artistic life on the Cologne
Rheinau Harbor.

 Annette Frick's photographic works deal with feminine history and
feminine sexuality in an aggressive way. This challenging attitude stems
from the consideration that suppression is actually a result of fear, so
that it is not a matter of demanding rights, but of grabbing them and
publicly demonstrating this fact. In this context, Annette Frick's art is
highly political, though she does not misunderstand her art as propa-
ganda. She understands and utilizes the suggestive power of symbolic
images. *RM*

Frick, Annette

1957 Bonn
Lives in Cologne

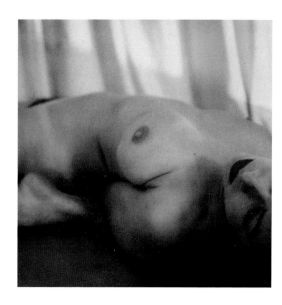

◄ **Toto Frima**
Untitled, 1985

SX 70 Polaroid print
8 x 8 cm
ML/F 1993/217

Gruber Donation

► **Toto Frima**
Untitled, 1988

Polaroid print
87.5 x 56 cm
ML/F 1995/125

Uwe Scheid
Donation

Frima, Toto

1953 The Hague
Lives in Amsterdam

After quitting her studies at an agricultural school, Toto Frima moved to Amsterdam. From 1970 to 1979 she lived there with a painter, for whom she also posed as a model. It was during this period that she created her first Polaroid images, which were to become her most important medium throughout her entire career. During the first years, she used a Polaroid SX 70 camera, with which she recorded her staged sets on the small square format. While doing that, she did not slip into other roles, but always remained herself. She demonstrates how this self changes and is finally converted into the woman herself by means of the multitude of views. This is magnified by her adopting the 50 x 50 cm Polaroid format, which requires more careful staging and more intense working, because the camera is not constantly and arbitrarily available. On the other hand, Toto Frima developed a type of multi-part work steps, in which framed photographic components are assembled into diptychs or triptychs, with the cut edges remaining visible. This reduction into individual elements reduces the tendency of de-individualizing the pictures within their assemblage. Toto uses herself to introduce us to woman as the universe. *RM*

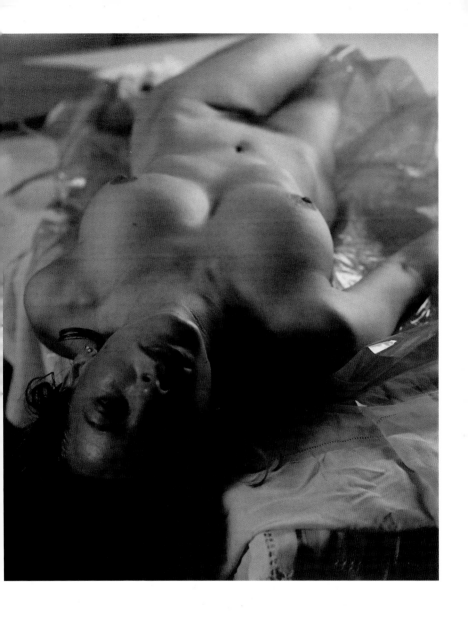

Fuchs, Harald

1954 Rehau
Lives in Cologne

From 1974 to 1978 Harald Fuchs studied graphic design under Professor Erwin Grießel at the Technical College in Würzburg. He continued his studies of graphics from 1978 to 1982 with Professor Rudolf Schoofs at the State Academy for the Creative Arts in Stuttgart and then settled down as an independent artist in Cologne.

In his work, Fuchs concerns himself with natural science research, with astronomy, geometry, anthropology, and with the myths that are also traditionally associated with these subjects. The purposeful association of these elements results in pictures that challenge the views from the former as well as from the latter premise. Fuchs is keenly interested in models of seeing, understanding and interpreting given situations. For the content of his large format photographic works, his installations and lightboxes, he selects not nature itself, but culturally conditioned views of nature. With their penetration of multi-layered levels of imagery, they elucidate the relativity of understanding natural contexts, demonstrating at the same time the extent to which they are related. *RM*

▲ Harald Fuchs
Ashes, from the
series: Structural
Superiority, 1986

Gelatin silver print
78 x 114 cm
ML/F 1988/190

▶ Peter H. Fürst
Hat with Flower,
1971

Color print
50.1 x 39.8 cm
ML/F 1987/27

Peter H. Fürst received his training in his parents' photographic studio. He later visited the Graphic Educational and Experimental Institute in Vienna, working also in the Agfa testing laboratory and in the studios of several photographers. In 1960 he opened his own studio in Cologne. In the years that followed, he dedicated himself to architectural, industrial, and advertising photography. He enjoyed his first big success with a photographic series about the Père Lachaise cemetery in Paris, which he produced on his own initiative.

But his breakthrough as an internationally recognized photographer came in the field of fashion and beauty photography. As the leading photographer of underwear in Germany, he soon earned the nickname "Prince of Lingerie". He was a trendsetter in this field. He lifted it out of the boudoir atmosphere and arranged settings of an entirely different sort, as he did in his series *Hommage à Anton Räderscheidt*. His photograph from that series *Danielle in a Black Basque* was printed as a sensational picture in all the major newspapers. *RM*

Fürst, Peter H.

1939 Leoben,
Austria
Lives in Cologne

▲ **Peter H.Fürst**
Danielle in a Black Basque –
Hommage à Anton
Räderscheidt, 1983

Gelatin silver print
50 x 40 cm
ML/F 1989/181

► **Hideki Fujii**
Untitled (Tableau of
four photographs),
1970s

Color print
14.3 x 9.4 cm
ML/F 1993/219
V, II, V, I

Gruber Donation

Hideki Fujii was already interested in photography while he was still in school. He began his studies at Nihon University in Tokyo in 1954 and even then assisted Japanese portrait photographer Shotaro Akiyama in his studio. In 1957 Fujii joined the magazine *Fukuzo (Costume)* as a fashion photographer. Three years later, in 1960, he changed over to the Nihon Design Center, which is an advertising agency, and began working there as a commercial photographer. After another three years, in 1963, he became an independent photographer. In 1980 Fujii started a series about Japan and its geishas. In 1984 he became acquainted with Max Factor, who introduced him to the model Hiromi Oka, with whom the photographer went on to work for several years. Hideki Fujii was honored as a fashion and advertising photographer through many exhibitions and awards well beyond the borders of Japan. *MBT*

Fujii, Hideki

1934 Tokyo
Lives in Tokyo

Gantz, Joe

1954 Cincinnati,
Ohio
Lives in Los Angeles

▲ Joe Gantz
Homage II, from:
The Possibility for
Love, 1985

Color Print
77 x 92.8 cm
ML/F 1995/130

Uwe Scheid
Donation

Joe Gantz had an early interest in writing, and this motivated him to study literature at the University of Wisconsin. He then delved into socio-critical research, which he supplemented with photographic documentation. In 1983 he founded the "View Film and Video" company, in which he produced a number of video series with his brother Harry Gantz. The series all addressed the subject of socio-critical research in a novel conceptual way. "People Arguing" and "Taxicab Confessions" were produced along similar guidelines, as was his photographic sequence *Couples.* He would come over with video and photographic equipment whenever one of his volunteer models contacted him by telephone. Earlier, with his photographic series *Inching towards a Leap of Faith, If it's done right, it is* and *The Possibility for Love,* he had investigated various aspects of human relationships. In his latest sequence, Gantz uses a computer to explore Christian and mythological subjects in a hyperrealistic way. *RM*

▶ **Joe Gantz**
From the series:
Self-portraits, 1985

Color print
50.7 x 60.8 cm
ML/F 1986/82

◀ **Joe Gantz**
From the series:
Self-portraits, 1985

Color Print
50.8 x 60.8 cm
ML/F 1986/210

Garanger, Marc

1935 Ezy-sur-Eure,
Normandy
Lives in Paris

Marc Garanger's photographic career began during the time of his military service, which he absolved in Algeria in 1960. At the time, the French army was using all the means at its disposal in its efforts to suppress the Algerian independence movement. In order to gain better control of the population, citizens were to be given French personal identification papers. Garanger was given the assignment of photographing local citizens. He made his pictures outdoors, using a white wall as a neutral background. This resulted in nearly 2000 portraits, at times 200 per day. The majority of the people he photographed were women, who were first compelled to unveil their faces in public. In a sense, this transformed the camera into a weapon with which the population was being culturally demeaned. Later on Garanger made the following comment about these unusual photographs: "I could feel the silent but intense resistance from close proximity. And I want my pictures to be a testimony to that. All the photographs that I made during two years in Algeria should protest against the terror that I have seen." The photographer published a selection of these pictures in his 1982 book *Algerian Women*.

▼ Marc Garanger
Algerian Woman,
1960

Gelatin silver print
40.4 x 30.4 cm
ML/F 1984/51

Gruber Donation

In April 1989, Garanger traveled to Louisiana at the invitation of Kodak to test its new Ektar color film. As a result of this trip, Garanger, in cooperation with the author Yves Berger, published the photographic book *Louisiana, Between Heaven and Earth*, in which he documents the fascinating nature and the lively doings of the population of this southern American state. *MBT*

► Jack Garofalo
Wedding, 1972

Gelatin silver print
39.9 x 28.8 cm
ML/F 1977/282

Gruber Collection

Jack Garofalo became known primarily for his social documentary
reports about Pakistan and about the USA. In his 1971 photographic
series *Conflicts in Pakistan* he presented gripping pictures of the war and
of the violent anarchy.

 His approach was different when he recorded life in the slums in
big American cities. Then it became critical, yet affectionate. He shows
cheerful children's faces amongst garbage and ruins, youths dancing
in front of a movie house, others forming a defensive group. All these
pictures are filled with tension and movement, including those of the
wedding of a black couple, which he photographed in 1972. The smiling
couple and the bridesmaids and flower children are standing in a
shower of rice and flowers. The brilliant white dresses of the women are
in sharp contrast with the dark suits of the men, and all of them are
smiling under a drizzle of rice. *NZ*

Garofalo, Jack

Born 1924
Lives in Paris

◀ André Gelpke
Pin-up Wall Self-
portrait, 1984

Gelatin silver print
25.3 x 25 cm
ML/F 1995/113

Uwe Scheid
Donation

Gelpke, André

1947 Beienrode,
Germany
Lives in Zurich

From 1969 to 1974, André Gelpke studied photography under Otto
Steinert at the Folkwang School of Composition in Essen. In 1975,
Gelpke, together with Rudi Meisel and Gerd Ludwig, founded the
"VISUM" picture agency, which Gelpke left only one year later in order
to work as a freelance photographer. He made many trips, which took
him across Europe, to North and Central America, and to India and
Nepal. Gelpke relies less on "found" pictures, preferring to photograph
situations he has deliberately sought out. His type of photography set
the style for the development of "visualism" in Germany, especially dur-
ing the seventies. His many years as a photojournalist become evident
in his choice of subjects. In his work, Gelpke distinguishes between two
complementary categories: monologues (in the sense of self-observa-
tion), and dialogs (the relationship with the surroundings). *TvT*

When Arnold Genthe traveled to the United States after completing his studies in philology, he had no intention of settling there, nor was he thinking of becoming a photographer. He had accepted an invitation to teach for two years as a private tutor in San Francisco. Fascinated by this city, particularly by the lively hustle and bustle of Chinatown, he soon decided to buy a camera in order to record his impressions. His first photographs were already so successful that he was able to display them in several exhibitions on the west coast. In 1897 he became independent and established his own studio in San Francisco. He rapidly gained a reputation as an outstanding portrait photographer, and his premises were visited by many prominent personalities.

In April 1906 Genthe lost his entire property during the great earthquake in San Francisco. Only his negatives of Chinatown survived, because they were stored in the safe of a bank. Soon after the catastrophe, Genthe bought himself a new camera, with which he proceeded to create an impressive documentation of the aftermath of the disaster. These photographs, and those of Chinatown, are today valued for their great historical relevance.

In 1908 Genthe moved his studio to New York, where he continued to be recognized as a talented portrait photographer. This is were he made, among many others, his well-known portraits of Greta Garbo.

Genthe, Arnold

1869 Berlin
1942 New Milford, Connecticut

▲ **Arnold Genthe**
San Francisco, Earthquake, 1906

Gelatin silver print
24.7 x 33.5 cm
ML/F 1993/283

Gruber Donation

◄ **Arnold Genthe**
Anna Pavlova,
around 1925

Bromide print
33.5 x 24.3 cm
ML/F 1977/287

Gruber Collection

► **Arnold Genthe**
Greta Garbo, 1925

Bromide print
33.6 x 23 cm
ML/F 1977/288

Gruber Collection

Genthe photographed her before she had her great successes, and it is
said that his portraits were a decisive factor in bringing about the dis-
covery of this star. Another field of special interest for Genthe was dance
photography. He photographed numerous famous dancers, among
them Anna Pavlova and Isadora Duncan. *MTB*

Gibson, Ralph

1939 Los Angeles
Lives in New York

▼ Ralph Gibson
From: The Somnam-
bulist, 1968

Gelatin silver print
31.4 x 20.8 cm
ML/F 1988/84

Gruber Donation

Ralph Gibson studied photography from 1956 to 1960, while he was still doing his military service in the US Navy. After his discharge, he attended the San Francisco Art Institute from 1960 to 1961. In 1962 he became an assistant to the famous social documentary photographer Dorothea Lange. In 1969 Gibson went to New York, where he became an assistant to Robert Frank, who was making the film "Me and My Brother". Still in that same year, he founded "Lustrum Press", a publishing house through which he published his own books as well as those of other photographers.

In his photographic work, Gibson first concentrated on black-and-white photography. He especially preferred grainy films in order to lend a more graphic effect to his photographs. For subjects, he had a preference for fantastic and surrealistic scenes, which he staged with fragments and excerpts from reality. He liked to use a wide-angle lens for deliberate spatial distortion in order to accentuate the dynamics and tension in his pictures. One of his most successful "Ghost" series was *The Somnambulist* of 1968, which included the picture of the silhouette of a hand in bright light coming through a partly opened door. According to L. Fritz Gruber, this photograph has become the photographer's "signature icon". *MBT*

► Ralph Gibson
From: The Somnam-
bulist, 1968

Gelatin silver print
24 x 15.6 cm
ML/F 1993/226

Gruber Donation

Gidal, Tim N.

(Ignaz Nachum Gidalewitsch)

1909 Munich
1996 Jerusalem

▼ Tim N. Gidal
Cheerful Self-portrait, 1940

Gelatin silver print
17.5 x 12 cm
ML/F 1989/68

Ignaz Nachum Gidalewitsch, son of an eastern orthodox Jewish family, became an early member of the Zionist movement, where he also experienced his first photographic impulses. From 1928 to 1931 he studied law, art history and history at the Universities of Munich and Berlin. After succeeding in having one of his pictures published in the *Münchner Illustrierte Presse* in 1929, he adopted the name Tim N. Gidal and dedicated himself entirely to photojournalism. He left Germany in 1933 and continued his studies in Basle, concluding them in 1935 with a thesis on photojournalism and the press. During the same year, he spent two months in Palestine, emigrating there shortly afterwards. Working as a freelance photographer, he soon belonged, together with Kurt Hübschmann and Felix H. Man, to the team of photographers of the *Picture Post*. The photographic reports of that time became the core of the magazine. His photograph *Face* shows a world premiere: the very first television transmission in the Deutsches Museum in the year 1930. In 1940, Gidal returned from a trip to Asia with a reportage about Mahatma Gandhi, which earned him worldwide success. In 1942 he joined the British Army as a volunteer and worked until 1944 as the chief reporter for the army magazine *Parade*. In 1947 Gidal returned to work as a freelance photographer in Jerusalem, from where he traveled throughout Europe. In 1948 he settled in the USA, where he worked for *Life* magazine and where, beginning in 1955, he lectured at the New School for Social Research. Gidal died in 1996 in Jerusalem. *RM*

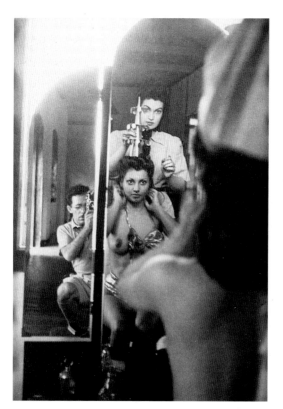

▲ **Tim N. Gidal**
Face, 1930

Gelatin silver print
24.5 x 19.2 cm
ML/F 1989/72

◄ Krzysztof
Gieraltowski
Andrzy Gwiasda
Inzyniew, 1981

Gelatin silver print
59.9 x 40 cm
ML/F 1991/127

Gieraltowski,
Krzysztof

1938 Warsaw
Lives in Warsaw

Krzysztof Gieraltowski is regarded as one of Poland's leading photo-
graphers. He studied in Gdansk and Lodz. Beginning in 1961, he be-
came more involved with the subjects of industry and fashion in con-
nection with numerous advertising campaigns in Europe. Since 1976 he
has concentrated on portraiture, photographing portraits of politicians,
writers, musicians, actors, scientists, including many members of the
opposition party Solidarnosc. Over time, this has resulted in a fascinat-
ing portrait of the Polish intelligentsia, of a society in turmoil. He con-
centrates on the depiction of facial features and what they express about
the individual. To that end, he asks his subjects to reveal something
about themselves through facial expressions and gestures, and he usu-
ally stages his pictures in motion, dramatically and full of tension. *RM*

Peter Gilles
Regression, Action
Relic, Museum Lud-
wig, Cologne, 1985

*Gelatin silver print,
mixed media*
216.5 x 126.5 cm
ML/F 1986/221

Peter Gilles attracted attention in the seventies through actions that in-
volved the spilling of his own blood. The myth that has been conjured
by blood, especially by human blood, since the dawn of mankind motiv-
ated him to an intensive intellectual investigation of ancient African
cultures. In this quest, he came upon the fields of physical and psychic
borderline situations and the opportunities they presented for making
photographs of extreme sensitivity and intense tension. These pictures
are the direct outpouring of feelings, of fear and of emotion. *RM*

Gilles, Peter

1953 Cologne
Lives in Cologne

**Gloeden,
Wilhelm von**

1856 Volkshagen,
Germany
1931 Taormina, Sicily

▼ Wilhelm von
Gloeden
Taormina, 1901

Gelatin silver print
16.9 x 22.3 cm
ML/F 1995/114

Uwe Scheid
Donation

Wilhelm von Gloeden studied art history in Rostock and painting in Weimar until a lung ailment compelled him to move to Taormina in Sicily in 1877/1878. The experience in that small village was to become a turning point in his life. Von Gloeden was fascinated by the natural pride of its inhabitants and by the liberal atmosphere that he encountered there. He learned photography from a cousin in Naples, Wilhelm von Plüschow, who was already established as a portrait and nude photographer, and from Giovanni Crupi. In 1880 he began to photograph landscapes and typical scenes for postcards. His first outdoor nude pictures were made in 1890, when he began photographing young men from Taormina in classical antique poses. He used landscapes, the seashore, terraces and inner courtyards to stage his visions of these youngsters in an ideal, Homeric-idyllic life. In 1899 the Photographic Society of Berlin invited him to present a lecture on outdoor photography. He became known internationally towards the end of the 19th century. In 1908 he photographed the big earthquake in Sicily and Calabria.

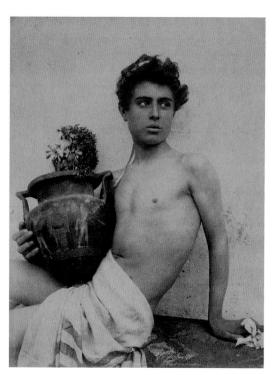

Von Gloeden's prominence lasted until the outbreak of World War I, at which time he was forced to leave Taormina for four years. The fascists condemned his photographs as obscene, and they destroyed the greatest part of his glass negatives and prints after he died in the thirties. It was only in the late sixties and the early seventies that von Gloeden was rediscovered. The cult of the androgynous propelled him into fame as one of the outstanding nude photographers of this century. *TvT*

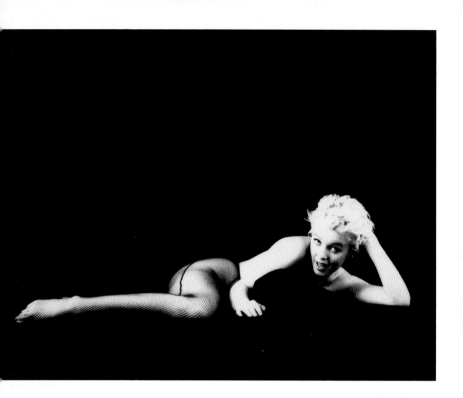

Milton H. Greene began taking pictures when he was 14 years old. He was an assistant to Eliot Elisofon, Maurice Baumann and Louise Dahl-Wolfe. He was only 19 when he established his own studio, in which he later photographed stars like Judy Garland, Cary Grant, Grace Kelly, Elizabeth Taylor, Sammy Davis Jr. and Marlene Dietrich. Greene worked for a particularly long time with Marilyn Monroe, whom he met in 1953 during a photographic assignment for *Look* magazine. With her co-operation he founded "Marilyn Monroe Productions" and over a period of four years he created a large quantity of photographic icons of this star. The two movies "Bus Stop" and "The Prince and the Showgirl" were also made during that period. Greene was active on an international level as a fashion and portrait photographer for such magazines as *Life*, *Vogue* and *Harper's Bazaar*. *TvT*

**Greene,
Milton H.**

1922 New York
Died in 1985

▲ Milton H. Greene
Marilyn Monroe,
1956

Gelatin silver print
34.2 x 26.3 cm
ML/F 1995/121

Uwe Scheid
Donation

Gruber, Bettina

1947 Cologne
Lives in Cologne

Bettina Gruber studied at the College for the Creative Arts in Berlin and then concentrated on photography and video. She was also active as a professional writer. Her artistic work is infused with poetic humor. She skillfully uses historical events, myths or everyday occurrences to create picture stories, either as film and music presentations or compressed into a single photographic image.

For a time she cooperated with Ulrich Tillmann and Maria Vedder in order to work on campaigns. She developed joint video concepts with Maria Vedder, with whom she created the videos *Mama's Little Pleasure* (1984), *Big Brother Blues* (1986), *Catfish Tango* (1986) and *Anubis' Heart Attack* (1988), for which they were jointly awarded the 3rd Marler Video Prize.

Up to then it had not been noticed how slyly caustic these films were, in their contents and also with regard to the perfectionist television industry. Her settings with children's toys, hand-cobbled props and lighting manipulations presented fantasy worlds that were also lateral swipes against the hidden directive that video art would be much more attractive if it could avail itself of the same technical possibilities as videoclips.

▼ Bettina Gruber
Creatures of the
Night, 1990

Color print
14.8 x 14.5 cm
ML/F 1990/235

Gruber Donation

With her video work, Bettina Gruber proved that it is not necessary to work perfectly with the medium, or to have perfect technical equipment in order to develop an independent artistic visual language with video. Bettina Gruber often created her photographic work in conjunction with her video work by selecting some of the best situations and then isolating them in the form of photographs. Her photograph *Creatures of the Night* evolved from one of these video projects, and it shows her with an indispensable component of her art: her dog Flicki. *RM*

▸ **Ara Güler**
Allah (God), 1956

Gelatin silver print
6.5 x 28.8 cm
ML/F 1988/70

Gruber Donation

Ara Güler is considered to be one of the most widely-known international creative artists. He met Marc Riboud and Henri Cartier-Bresson in 1956 and became a member of the "Magnum" agency. In 1961 a number of photographic editors selected Ara Güler as one of the seven best photographers in the world. "Time Life" chose him at that time to become their Middle East correspondent. Not much later, he was also appointed by *Paris Match* and the German magazine *Stern* to become their photographic reporter in the Middle East.

In the eighties, Güler was already able to look back on trips all over the world.

Güler supplied the press in Europe and in America with a different kind of picture of people, but also of art and archaeology – pictures like the one of two dark-robed figures contrasted against a white wall with the sweeping Arabic writing spelling the word "Allah". *NZ*

Güler, Ara

1928 Istanbul
Lives in Istanbul

Gursky, Andreas

1955 Leipzig
Lives in Düsseldorf

Andreas Gursky studied at the Folkwang School of Creativity in Essen and at the State Art Academy in Düsseldorf, where he became a master pupil of Bernd Becher in 1985. His large-format color photographs are heavily influenced by the work of his mentor. They radiate audacity and dynamism, and contain an intense if frozen energy. Gursky's pictures stand out because of his unusual attention to small details, events, figures and patterns, as compared to the drawing-like objects and isolated forms that are so typical of Becker's work. Gursky's subjects are topical situations and landscapes. His pictures capture the intensity and density of human activities as well as the pace of their movements.

Gursky's large-format color photograph *Paris-Montparnasse* (1993) shows an anonymous multi-story housing block for the working class, a

characteristic symbol of life in a post-industrial megalopolis. As in
Richard Estes' photo-realistic paintings of depopulated big cities, in
Gursky's portrait of an apartment house complex, too, human beings
play a subordinate role. The composition of the picture is systematic
and conceptual, cold and distant. There is no staging by the artist, the
young Becher scholar merely presents, without comment, that which
already exists. But the bleakness and isolation of his objective photo-
graphy convey, even without any critical commentary by the artist, a
clear and unequivocal point of view. *GG*

▲ **Andreas Gursky**
Paris-Montparnasse,
1993

*Color print,
mixed media*
180 x 350 cm
ML/F 1995/97

Ludwig Collection

Haas, Ernst

1921 Vienna
1986 New York

Ernst Haas discovered his passion for photography early on – in his own words, when he was still a child. His emotional photographs of the arrival of the first train with returning prisoners of war in 1950, when he was a freelance journalist for the magazines *Der Film* and *Heute*, earned him a lot of attention. Soon afterwards, he joined the "Magnum" agency. Beginning in 1951, Haas used primarily color film as a freelance photographer for *Life, Look, Vogue* and *Holiday*. This resulted in the reportage about New York entitled *Images of a Magic City* and the sports reportage *The Magic of Color in Motion*. Haas began to distance himself more and more from sensationalistic photojournalism. In 1964 he produced "Days of Creation" for John Houston's film "The Bible". The corresponding book *Creation* was published in 1971. Now the photographer began to experiment with audiovisual techniques. *Flower Show* and the portfolio *Flowers*, produced in 1983, demonstrate that details of flowers were important subjects in his late work. Shortly before he died unexpectedly in 1986, Haas presented his audiovisual show *Abstracts. NZ*

▲ Ernst Haas
Rose, 1970

Color print
28 x 35.3 cm
ML/F 1993/241

Gruber Donation

◄ **Ernst Haas**
Time Life Building,
around 1955

Color print
56.5 x 37.8 cm
ML/F 1983/125

Gruber Donation

Ill. p. 214/215:
Ernst Haas
Homecoming,
1947–1950

Gelatin silver print
ca. 18 x 12 cm
ML/F 1983/122, 123,
124 and
1993/245, 246, 249,
252, 253

Gruber Donation

Häusser, Robert

1924 Stuttgart
Lives in Mannheim

Robert Häusser grew up in Stuttgart, and it was there that in 1934 he bought his first camera obscura for 1 German mark. After graduating from high school, he studied at the College for Graphic Design in Stuttgart from 1941 to 1942. He was a soldier in 1944 and 1945. In 1946 he married Elfriede Meyer, with whom he had a daughter named Renate. From 1946 to 1952 he lived as a farmer on his parents' farm in the Brandenburg Marches. It was there that he made his first portraits of farmers from the surrounding area. In 1950 he began to study under Professor Heinrich Freytag and Professor Walter Hege at the School of Applied Arts in Weimar. He became a member of the German Society of Photographers (GDL), where he was active as a member of the jury and of the presiding committee. In 1952 he moved to Mannheim, where he established a studio for photography.

▼ Robert Häusser
The 21 Doors of
Benito Mussolini,
1983

*Gelatin silver print
each 39 x 28, (alto-
gether 140 x 200) cm*
ML/F 1986/93

In 1969 he was a founding member of the Association of Freelance Photodesigners (BFF). Häusser was also very active in cultural politics, and he was a member of the German Association of Artists, the Mannheim Academy for the Creative Arts, the "Darmstadt Secession". In the German Society of Photographers (GDL), he held the office of vicepresident.

Within the framework of these functions, he initiated a program-matic reorientation of this society, a self-critical examination of its role in the Third Reich, and its reorganization as the German Photographic Academy (DFA).

Häusser made his living with the publication of numerous pictorial books about cities and landscapes, as well as with his work on behalf of artists. This led to close friendships and to the accumulation of an out-standing collection of art. But his main interest lay in his own artistic endeavors, which can be classified into various phases of work. During the first phase of his work, his photographs were mostly narrative, but with a dramatic, heavy and somber expression. During the years 1952 to 1954 he changed to a bright period, creating light and delicate pictures that often seemed more like drawings than photographs. As a result of his work on the parental farm in Brandenburg, farm life always inter-

▲ **Robert Häusser**
In the Housemaid's
Room, 1960

Gelatin silver print
48.8 x 59.3 cm
ML/F 1993/285

Gruber Donation

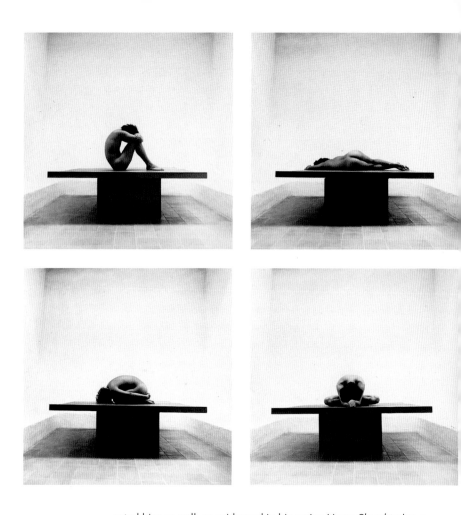

ested him as well, as evidenced in his series *Home Slaughtering*, a photographic essay in six pictures. Häusser became more and more interested in political subjects and in human fringe situations, like loneliness, bleakness, desperation and death.

His series *The 21 Doors of Benito Mussolini* is one of his principal works. The 21 doors represent the 21 years of the Mussolini government, and they were all in the Duce's villa, just as Häusser photographed them. The pictures are accompanied by the Mussolini statement: "When a man fails together with his system, then the case is ir-

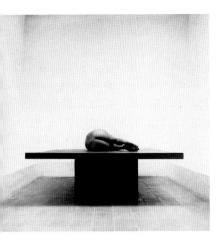

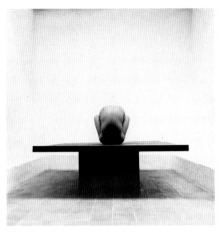

◀▲ **Robert Häusser**
Wing 1-7, 1976

Gelatin silver print
45.5 x 44 cm
ML/F 1993/284

Gruber Donation

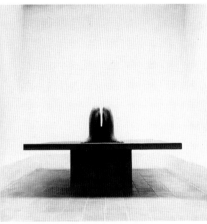

revocable." His sequence *Wing* shows his interest in formal composi-
tions and sequential work. In recent years, numerous publications and
retrospective exhibitions have brought his work to greater public atten-
tion. For his accomplishments in photography and its recognition as an
art form, and for his cultural-political commitment, as well as for his
overall artistic achievements, Häusser was awarded the title of Pro-
fessor. *RM*

Hajek-Halke, Heinz

1898 Berlin
1983 Berlin

▼ Heinz
Hajek-Halke
A Dealer's Shirt, 1955

Gelatin silver print
23.6 x 17.7 cm
ML/F 1977/1006

Gruber Donation

Heinz Hajek-Halke spent his early childhood in Argentina. Returning to Berlin, he studied at the Royal School of the Arts from 1915 to 1917. After serving in the army, he continued his studies under Professor Ortik and the engraver Baluscheck. He started designing posters for movie companies and worked for the publishing house Dr. Dammert. From 1923 to 1925 he was a fisherman in Hamburg. His first attempts at photography stem from the year 1924. He worked as a press photographer, receiving much inspiration from the photojournalist Willi Ruge. In 1925 he began making his first experimental photographs.

Beginning in 1927, he worked together with the publisher of the *Deutsches Lichtbild*. In 1933 he began his scientific research in the field of microorganisms and macrophotography. In 1937 he traveled to Brazil, where he produced a pictorial essay about a snake farm. In addition, he created abstract pictures and photograms. Starting in 1939, he worked for the German army as an industrial and aerial photographer at the Dornier works. In 1945 he became a prisoner of war of the French, but he escaped and started a snake farm for the production of poison for the pharmaceutical industry. In 1947 he went back to working as a photojournalist and experimental photographer. In 1949 he was a co-founder of the "fotoform" group in Saarbrücken, with whom he participated in their exhibitions. In 1955 he began teaching at the College for the Creative Arts in Berlin as a professor of graphic design and photography. Hajek-Halke is considered to be one of the leading German photographers of the postwar era, who successfully represented photography as an art form, especially with his photomontages and photograms.
RM

Before entering the photographic profession, Chadwick Hall worked as an editor and theater critic for the magazine *The Nation*. At first he worked for *GQ* and *Esquire* magazines as a fashion photographer and portrait photographer of famous personalities. In 1965 he and his wife, photographer Christa Peters, moved to Europe, where he worked for the magazines *Harper's Bazaar, Elle, Vogue, Queen* and *Stern*. Hall attended events at the College of Design in Ulm, and he also gave lectures in New York. As founder and former president of "The Photographers' Association", he directed the production of advertising films before becoming more specialized in documentary films. He is under contract to the William Morris agency as a scriptwriter. In 1969 he produced a documentary film about Leni Riefenstahl. *MTB*

Hall, Chadwick

1926 New York
Lives in London

▲ **Chadwick Hall**
Untitled, 1976

Color print
35.8 x 23.6 cm
ML/F 1994/155

Gruber Donation

Halsman, Philippe

1906 Riga, Latvia
1979 New York

▲ Philippe Halsman
Dalí Atomicus, 1948

Gelatin silver print
26.6 x 33.3 cm
ML/F 1977/300

Gruber Collection

Philippe Halsman is one of the most original and inventive portrait photographers of our century. Before he turned to photography, Halsman studied electrical engineering in Dresden. It was only in 1928, when he went to Paris, that he established himself as an independent fashion and portrait photographer. In 1940 he emigrated to the USA, where he took on numerous assignments for *Life* magazine. In 1959 he published his successful series entitled *Jump Pictures,* which were photographs of prominent personalities performing jumps in front of his camera. This series is characteristic of the witty humor that permeated all his work. Equally characteristic is the surrealistic touch of his work, which can be ascribed to his friendship with Salvador Dalí. Halsman worked jointly with Dalí on various projects for more than 30 years, expressing the painter's ideas with the medium of photography. *MBT*

▲ **Philippe Halsman**
Dalí's Skull of Nudes,
around 1950

Gelatin silver print
10.8 x 8.8 cm
ML/F 1993/268

Gruber Donation

▲ **Philippe Halsman**
One-Eyed Dalí, 1954

Gelatin silver print
10 x 7.9 cm
ML/F 1993/269

Gruber Donation

▶ **Philippe Halsman**
Mona Lisa Dalí, 1953

Gelatin silver print
33.9 x 23 cm
ML/F 1977/304

Gruber Collection

▲ **Philippe Halsman**
Dancer, around 1946

Gelatin silver print
34.1 x 28 cm
ML/F 1977/302

Gruber Collection

▲ **Philippe Halsman**
Untitled (Pregnant
Woman and Cat),
around 1950

Gelatin silver print, 11.5 x 9 cm
ML/F 1993/273
Gruber Donation

Hamaya, Hiroshi

1915 Tokyo
1999 Tokyo

▼ Hiroshi Hamaya
A Rice-planting
Woman, 1955

Gelatin silver print
29.7 x 19.9 cm
ML/F 1977/312

Gruber Collection

Hiroshi Hamaya started taking pictures at the age of 15. He founded a photographic club in 1933 and in the same year began working for the "Oriental Photographic Manufacturing Company". In 1937 he established himself as an independent freelance photographer. Hamaya quickly became known and in 1940, like many of his colleagues, he went to Manchuria as a photographic war correspondent. Between 1945 and 1952 Hamaya lived in Takada, later moving to the town of Oiso near Tokyo. In 1960 he joined the "Magnum" agency. During the years that followed, Hamaya made many trips to America and Europe.

Hamaya documented the life of his countrymen in many photographic essays. One of the best known of these essays was his series about the Niigata region. Over a period of about 20 years, Hamaya repeatedly photographed the simple life in this countryside, which is covered with snow for three quarters of the year.

In addition to such photographic essays, Hamaya also made a name for himself with his aerial color photographs of landscapes, which he made from an aircraft. Quite unlike Hamaya's photographic reportages, human beings no longer play any roles in his aerial views. The imposing formations of nature speak for themselves in these impressive documents of natural history.
MBT

► Hiroshi Hamaya
Women Washing,
around 1955

Gelatin silver print
29.9 x 20 cm
ML/F 1977/323

Gruber Collection

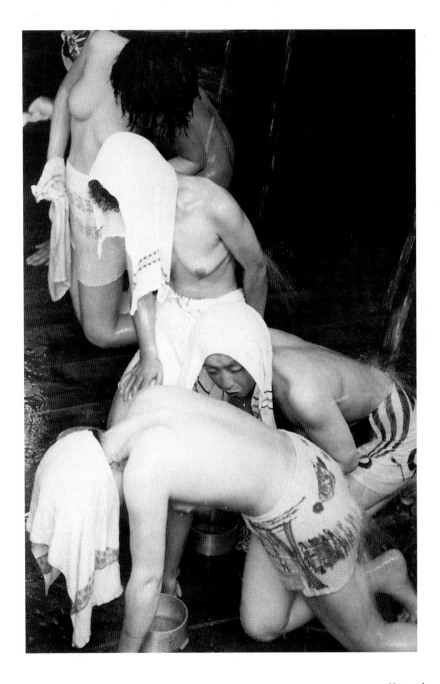

Heinecken, Robert

1931 Denver,
Colorado
2006 Albuquerque,
New Mexiko

After completing his studies at the University of California at Los Angeles, Robert Heinecken began teaching drawing, design and laboratory techniques there in 1960. In addition to his teaching activities at several American universities and art colleges, Heinecken also worked as a freelance photographer since 1960. In his work he delved into the subject of elementary human drives and behavior patterns, such as sexuality, violence or social competitiveness. Occasionally he combined sexual images with pictures from social and political realms, thus establishing connections between individual and collective behavior.

Heinecken enjoyed using pictures from a variety of media, including magazines, television, even mail-order catalogs. He used the visual methods of advertising in order to impart a comparable subliminal effect to his work. With the changes of color and black-and-white, photograph and contour line, Heinecken concentrated precisely on those signals of the advertising industry with whose props he composed many of his pictures. The broad spectrum of his techniques included gelatin silver print, printing on existing picture material, collage, lithography, photogram, photographic emulsions on canvas and environment. Heinecken often combined pictures with texts. The versatility and the provocative effect of his works were echoed in the verdicts of art critics, who have labeled him as typically American, a satirist, chauvinist, guerrilla, dadaist, surrealist and anti-purist.

▼ Robert Heinecken
Porno Photo Litho,
1969

Mixed media
24.3 x 24.9 cm
ML/F 1995/115

Uwe Scheid
Donation

In his work *Porno Photo Litho* Heinecken utilized existing pornographic pictures and layered them until they became unrecognizable. In the tangle of seemingly abstract and dark forms, it is only upon a closer look that one can discern faces and female body shapes. *TvT*

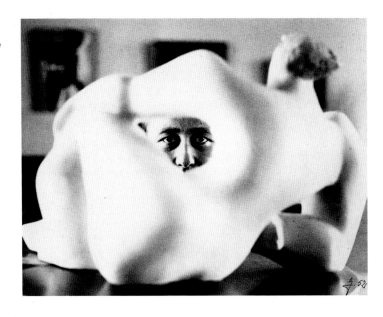

Heinz Held
Willy Fleckhaus be-
hind a Henry Moore
Sculpture, 1953

Gelatin silver print
23.4 x 30 cm
ML/F 1988/60

Gruber Donation

At the end of the forties, Heinz Held was the manager of an art gallery in Cologne and a freelance journalist before an exhibition arranged by Otto Steinert entitled "Subjective Photography" inspired him to begin taking pictures himself. It was not long before photography became his most important activity after writing. He worked as a freelance photographer and journalist for a variety of German and European newspapers and magazines and he published several art travel guides. Numerous journeys took him through nearly all the European countries and to Africa, America and the Middle East. Between 1960 and 1963, Held operated the first private photographic gallery in Germany, in which he exhibited mostly journalistic photography.

Held's philosophy about photography is evident in several of his essays and in his book *The Magic of the Banal*, published in 1960. Held was sensitive to the ethical problems of photography, and he generally photographed people from a judicious distance. In addition, he did not pursue the culminating "decisive moment", but the less dramatic, sometimes melancholy human expression that is found in unspectacular everyday situations and actions. *TvT*

Held, Heinz

1918 Zeitz, Germany
1990 Cologne

▲ Heinz Held
Untitled (Girl with
Balloon), around 1960

Gelatin silver print
29.8 x 23.8 cm
ML/F 1995/95

► Heinz Held
London, Picadilly
Circus, 1946

Gelatin silver print
29.5 x 22.8 cm
ML/F 1995/96

▲ **Heinz Held**
Untitled (Lovers and
Policeman),
around 1960

Gelatin silver print
22.2 x 29.1 cm
ML/F 1995/94

► **Heinz Held**
Dortmund, 1948

Gelatin silver print
16.4 x 22.5 cm
ML/F 1995/91

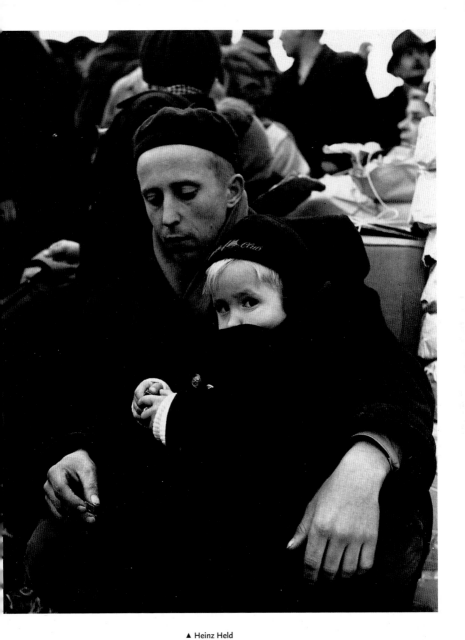

▲ Heinz Held
Hungarian Refugees,
Andau, 1956

Gelatin silver print
29.4 x 22.9 cm
ML/F 1995/93

Helnwein, Gottfried

Gottfried Helnwein studied at the College for Graphic Design and Research in Vienna from 1965 to 1969. The first modest perfomances took place during this time. From 1969 to 1973 he studied painting at the Academy for the Creative Arts in Vienna and, concerned about everyday violence tolerated apathetically by the public, began a series of hyperrealistic paintings of injured children. In 1970 he and two fellow students staged a performance under the slogan *The Academy is on Fire*. In 1973 he created his first magazine cover for the publication *Profil*. In 1981 he began a series about trivial heroes of the present, and he also initiated a photographic working group whose work was later published under the name *Faces*. Helnwein worked with the media of painting and photography, created stage sets and performances, and campaigned for doing away with the separation of art into categories such as entertaining art and serious art. With this in mind, he published his work on posters and on the covers of large magazines. He also took his art to the streets, as he did in 1988 with *The Night of the Ninth of November* on the occasion of the "International Photo Scene Cologne" between the Museum Ludwig building and the main railway station in Cologne. Helnwein is regarded as one of the most important, politically committed artists in Germany, considering public reaction to be part of his artistic work in the sense of conceptual art. He is always seeking new ways to disseminate that work. *RM*

Henle, Fritz

1909 Dortmund
1993 Virgin Islands

▶ **Fritz Henle**
Pablo Casals, 1972

Gelatin silver print
23.4 x 23.9 cm
ML/F 1990/230

▼ **Fritz Henle**
Grandma Moses,
around 1947

Gelatin silver print
31 x 27.4 cm
ML/F 1977/332

Gruber Collection

Fritz Henle was only 15 years old when he began taking pictures. After a brief period as a physics student in Munich, he turned to photography. The first publication of one of his photographs, a view of a blast furnace in his home town, took place when he was only 20. Hannah Seewald noticed his work and arranged for his admission to the Bavarian State College for Photography in Munich, where he completed his studies with an honors diploma. Soon afterwards he spent a year in Florence working on an assignment to photograph art treasures of the Renaissance.

The pictures he made of the Toscana during that same period attracted the attention of the steamship line "Lloyd Tourismus", for whom he traveled all over Italy during 1934. In the years 1935 and 1936 he was able to make photographs in China and in Japan. In 1936 he photographed on assignment for "Time-Life", and his pictures were published in *Fortune* magazine. His subsequent trip to America enabled him to establish connections with *Life* magazine, which facilitated his emigration to the USA. He became a US citizen in 1942. Henle photographed the USA as a freelance photojournalist working for a variety of magazines, such as *Fortune, Life* and *Harper's Bazaar*. From the beginning, the Rolleiflex camera was his trademark and America his subject. He mastered the square format with great skill, combining in it both balance and tension. During his active years, he became known as "Mr. Rollei", the personification of the professional photographer.

In 1958 he gave up his studio in New York and settled in St. Croix on the Virgin Islands, where he married his favorite model. Henle, who always strove to accentuate the positive aspects of life and to emphasize them in his pictures, found pristine beauty on the islands, and he considered it his special duty to pass it on. Fritz Henle achieved outstanding fame as a nude photographer, especially in the fifties, and this was

To the artist photographer
Fritz Henle

Pablo Casals

1972

▲ **Fritz Henle**
Frida Kahlo with
her Monkey, 1943

Gelatin silver print
21.5 x 21.7 cm
ML/F 1989/100

the subject of his book *Fritz Henle – Figure Studies*. But he also made
portraits of great personalities of our century, cultivating a special
relationship with the two Mexican artists Diego Rivera and Frida Kahlo.
His uncomplicated philosophy of life enabled him to retain his vitality
and his energy into the last years of his life.

From St. Croix, Henle frequently visited Europe for extended
periods, because he did not want to lose contact with his homeland,
his colleagues, and museums. In 1989 he succeeded in having his
photographs of Paris published, which were made within a short

period of time in 1939. Soon afterwards, his home town of Dortmund organized a large retrospective of his work at the Museum of Art and Art History. He had already donated his archive many years earlier to the University of Texas at Austin, TX, where he had been cataloging it over the years and where he rediscovered many pictures that he had long since forgotten. *RM*

▲ **Fritz Henle**
Nievis, one of Diego Rivera's models, 1943

Gelatin silver print
23.2 x 22.5 cm
ML/F 1989/137

Henri, Florence

1893 New York
1982 Compiègne,
France

Florence Henri became known in the twenties and thirties as a trendsetting photographer of the New Vision. Her first artistic endeavors were in the medium of painting. Florence Henri studied painting in Berlin and Munich, and in 1924 she went to Paris to attend the Académie André Lhotes and the Académie Moderne, which were directed by Fernand Léger and Amédée Ozenfant. In 1927 she successfully applied for the preparatory course at the Bauhaus in Dessau. There she was inspired in particular by László Moholy-Nagy, under whose influence she began to take an interest in photography. While her course was still in progress, she already began familiarizing herself with the creative possibilities of this medium, and under the guidance of her teacher experimented with unconventional perspectives, multiple exposures, montages, reversal of tonal values and the like.

▼ **Florence Henri**
Günther and Carola
Peill, 1957

Gelatin silver print
17.3 x 16.7 cm
ML/F 1983/13

Carola Peill
Donation

Florence Henri returned to Paris in 1929. At this point, she had already earned broad recognition for her photographic work and was invited to participate in such important exhibitions as "Contemporary Photography" in Essen and "Film and Photo" in Stuttgart. Photography caused her painting to recede more and more into the background. In Paris Florence Henri began to specialize in portraiture. Her models were mostly celebrities from the artistic and intellectual circles of Paris. In addition, she also created a series of anonymous portraits, so-called *Portrait Compositions.* Utilizing unusual perspectives and rigorous and intimate croppings in these pictures, the photographer overcame any distance she might have had towards portraiture.

Another important category in the work of Florence Henri consists of her *Compositions with Mirror.* In these dense arrangements of fruit, plates, reels of thread, perfume bottles or purely geometric objects that were thought out to the last detail, and by the use of one or more mirrors, she succeeded in upsetting the familiar central perspective spatial

arrangement of photography. With this fragmentation of picture planes, Florence Henri reverted to the cubist form elements of her early abstract paintings on one hand, and on the other she showed the definite influence of Constructivism in her clear, constructed still-life compositions with the resulting structuring line arrangements. In her 1957 portrait of Günther and Carola Peill, Florence Henri still made use of this style of visual expression of the twenties and thirties by positioning the couple behind the banister of a staircase. The rods of the banister thus became a constructivist structuring element of the picture's composition.

Florence Henri left Paris in 1963 to retire in the small village of Bellival in Picardy, where she gave up photography altogether and devoted herself entirely to her original vocation of abstract painting. *MTB*

Hill, David Octavius

1802 Perth, Scotland
1870 Edinburgh

▼ David
Octavius Hill
Self-portrait,
around 1843

Calotype
19.8 x 14.6 cm
ML/F 1977/336

Gruber Collection

David Octavius Hill, who entered history as one of the most important portrait photographers, was actually a landscape painter and lithographer. He resorted to photography only as an aid for executing an unusual assignment that he was given in 1843. He was commissioned to paint a group portrait of the 457 men and women who participated in the founding convention of the Free Church of Scotland in Edinburgh. At the suggestion of his friend Sir David Brewster, Hill decided first to photograph all the delegates individually, and then to use the resulting pictures as guides for rendering their facial features correctly in the painting of the group. He was fortunate in securing the cooperation of a competent photographer, Robert Adamson, who had opened a photographic studio in Edinburgh a short time earlier. Even though the photographs were initially intended as a sort of memory aid, the two men did not concentrate exclusively on the facial features of their clients. Instead they created elaborate and well-composed portraits in the style of painted portraits of their time. Some of their portraits, those that show ladies robed in luxuriant silk garments, are even reminiscent of Dutch painting of the 17th century. Nearly all the portraits were made outdoors, with exposure times of several minutes. As backdrops they used an open-air studio on Carlton Hill and the baroque monuments of Greyfriars Cemetery.

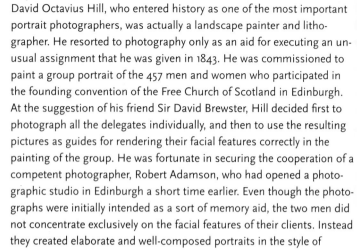

► David
Octavius Hill
Mr Rintoul, Editor
of the *Spectator*,
1844–1848

Photogravure
21.6 x 15.9 cm
ML/F 1995/26

Gruber Donation

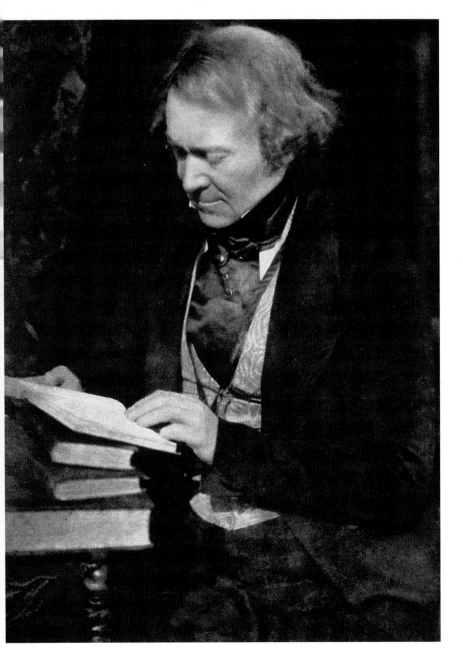

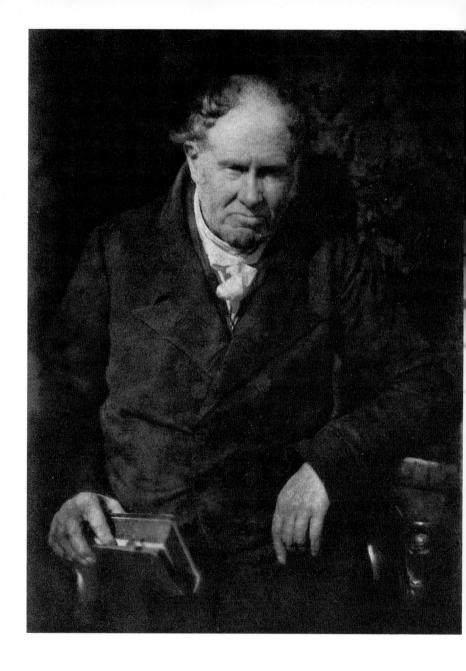

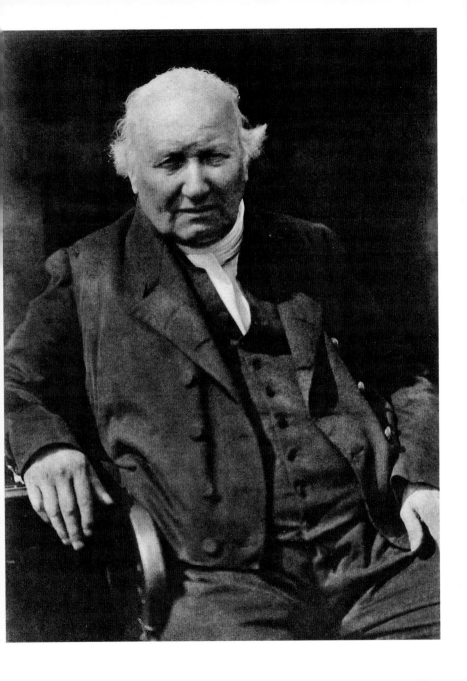

Hill and Adamson worked as a team. Hill was regarded as the project leader and as the one who set the artistic tone. Yet Adamson's role, too, appears to have been greater than that of a mere craftsman. Be that as it may, Hill gave up his photographic activities for a time when Adamson died prematurely in 1848. Photographs that Hill made later with a new partner did not reach the quality of earlier photographs made with Adamson's creative input. *MBT*

Hilsdorf, Jacob

1872 Bingen,
Germany
1916 Frankfurt on
Main

▼ Jacob Hilsdorf
Cosima Wagner, 1911

Gelatin silver print
22.5 x 16 cm
ML/F 1993/290

Gruber Donation

Along with Rudolf Dührkoop, Nicola Perscheid and Hugo Erfurth, Jacob Hilsdorf was one of the great portrait photographers of the turn of the century. Unfortunately his work, unlike that of his colleagues, lay forgotten for decades, until it was rediscovered and newly appreciated at the end of the seventies.

Jacob Hilsdorf, like his brother Theodor, learned the craft of photography in the studio of his father Johann Baptist Hilsdorf in Bingen. After completing his apprenticeship, he served as an assistant for a time with Nicola Perscheid in Leipzig. In 1897 Hilsdorf took over his father's studio, and he soon made a name for himself as a talented portrait photographer. His clientele was made up of personalities from the nobility, politics, high finance and the creative arts. His contemporaries particularly appreciated Hilsdorf's talent for conveying something of his sitter's character and psyche in his photographs. During lengthy portrait sittings, which often took place in the model's home rather than in the studio, he would strive to elicit the most natural expression by engaging the sitter in intensive conversation.

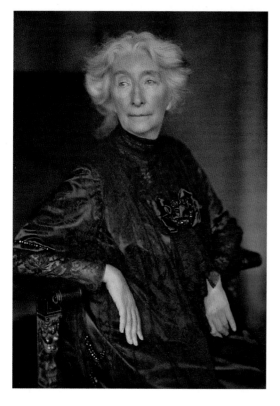

During the controversy about the artistic recognition of photography that raged around the turn of the century, Hilsdorf assumed "a forceful front against the 'artist delusions' affected by some of his colleagues" (*German Art and Decoration*). On one hand, Hilsdorf had no ambition to impart a painterly look to his photographs by doing subsequent work on them. On the other hand, he suffered from the "limitations" of photography as compared to painting, lamenting: "It will remain a hybrid art." *MBT*

▶ Siegfried Himmer
The Release on
the Apple, Bettina
Gruber, 1974

Gelatin silver print
40 x 30 cm
ML/F 1995/227

Gruber Donation

Siegfried Himmer completed his apprenticeship in photography in
Wunsiedel and proceeded to study under Professor Hannes Neuner at
the State Academy for the Creative Arts in Stuttgart. From 1965 to 1972
he worked with four partners who called themselves the "Graphicteam
Köln". He operated his own studio as of 1972, working on assignments
from Lufthansa, Bayer AG, Hapag Lloyd, Köln-Düsseldorfer, Adam Opel
AG, and also published his work in the magazine *Capital*. Himmer
stands out because of the great precision of his photographs, and also
because of his unconventional pictorial interpretations. In his still-life
photographs, he combined classic arrangements with dramatic use of
color in order to generate strong expressiveness in his pictures. His
picture *The Release on the Apple* is a satire of the surreal picture ideas of
the seventies, particularly those associated with the name Sam Haskins.
RM

**Himmer,
Siegfried**

1935 Dresden
Died in 2003

Hine, Lewis Wickes

1874 Oshkosh,
Wisconsin
1940 New York

▲ Lewis W. Hine
Untitled, around
1910

Gelatin silver print
11.8 x 16.9 cm
ML/F 1986/139

Jeane von Oppen-
heim Donation

▶ Lewis W. Hine
Glass Factory, 1908

Gelatin silver print
16.7 x 11.8 cm
ML/F 1986/138

Jeane von Oppen-
heim Donation

Lewis W. Hine was the outstanding exponent of social documentary photography in America. He dabbled in various fields before enrolling in the University of Chicago, and in 1900 he moved to New York City to study at New York University. He returned for one summer to the University of Chicago and then went back to New York City to study social work at Columbia University. Encouraged by his friend Frank A. Manny, Hine began to take photographs in 1904. He realized that the camera was an important instrument, both for his investigations as well as for the evaluation of the findings of those investigations. He concluded his pedagogical studies in 1905. He taught at a photographic club, which he also managed and which two years later was joined by Paul Strand. He started working for the National Child Labor Committee (NCLC) in 1906 and he continued working with that organization until approximately 1917. In 1908, under the auspices of the NCLC, he photographed children working in coal mines and factories. In 1909, the Child Welfare League used his photographs in its campaign against child labor. During further travels throughout the USA, Hine documented the social conditions of children, and he also gave lectures on behalf of the Na-

▲ **Lewis W. Hine**
New England
Country Store,
around 1910

Gelatin silver print
12 x 17 cm
ML/F 1986/135

Jeane von Oppen-
heim Donation

▶ **Lewis W. Hine**
Untitled (Hickory,
North Carolina),
1908

Gelatin silver print
11.8 x 16.9 cm
ML/F 1986/140

Jeane von Oppen-
heim Donation

▲ Lewis W. Hine
At Work in a Glass-
blowing Works, 1909

Gelatin silver print
11.7 x 16.8 cm
ML/F 1986/136

Jeane von Oppen-
heim Donation

◀ Lewis W. Hine
Newsboys, 1909

Gelatin silver print
11.4 x 16.6 cm
ML/F 1986/143

Jeane von Oppen-
heim Donation

ional Child Labor Committee. In 1918 Hine joined the Red Cross, which dispatched him to France. From there he also traveled to Italy and to Greece, returning to New York in June 1919. There he changed his emphasis from an objective, clear documentation without emotion to a more interpretive style of photography. His advertising was now headlined "Lewis Wickes Hine, Interpretive Photography". With his photographs of workers he sought to demonstrate that it was not the machine, but man who created affluence. In 1930, Hine was given the assignment of documenting the gigantic construction project of the Empire State Building. The resulting images, which Hine regarded as "Industrial Interpretation", are probably the most famous of Hine's photographs. *MBT*

▲ **Lewis W. Hine**
Oyster Openers, 1913

Gelatin silver print
9.2 x 11.4 cm
ML/F 1986/141

Jeane von Oppenheim Donation

◄ **Lewis W. Hine**
Untitled, around 1910

Gelatin silver print
16.9 x 11.9 cm
ML/F 1986/145

Jeane von Oppenheim Donation

Hockney, David

1937 Bradford,
England
Lives in London
and Los Angeles

▲ David Hockney
Two Lemons and
Four Limes, 1971

Color print
18 x 24 cm
ML/F 1983/109

▶ David Hockney
Yves Marie Sleeping,
1974

Color print
24 x 18 cm
ML/F 1983/108

David Hockney studied at the Bradford College of Art and then, from 1959 to 1962, continued his studies at the Royal College of Art in London. Starting in 1963, he taught at several universities in the USA. Together with his academic colleagues Allan Jones, Ronald B. Kitaj and Peter Phillips, Hockney developed an English variant of American Pop Art. It is distinguished by its inclusion of ironic and playful elements in its art. In his swimming-pool pictures, Hockney combines accuracy of rendition with the dissolution of the picture surface in the water.

Hockney's photographic work remained unknown to the public for a long time. In his large format collages of Polaroid SX 70 images, which were exhibited worldwide during the eighties, Hockney made use of cubist elements, such as penetration of picture surfaces, repetition, and the shifting and reversal of values within the composition. *RM*

Hoepffner, Marta

1912 Pirmasens,
Germany
2000 Lindenberg
(Allgäu)

▶ **Marta Hoepffner**
Absurd Canyon, 1950

Gelatin silver print
39.5 x 29.8 cm
ML/F 1989/76

▼ **Marta Hoepffner**
Firebird, 1940

Gelatin silver print
29.7 x 22.2 cm
ML/F 1989/82

In her youth, Marta Hoepffner was interested in the natural sciences. Her first artistic inspiration came from a relative named Hugo Ball. After her parents moved to Frankfurt on Main in 1928, Marta Hoepffner earned her tuition money by doing office work. After one semester at the Arts and Crafts School in Offenbach, she began studying painting, graphic design and photography at the School for the Arts in Frankfurt on Main, where she derived a great deal of motivation from her teacher, Professor Willi Baumeister. This is also where she became aware of photography as an artform. When the Nazis discharged Baumeister, Marta Hoepffner left the art school and opened her own studio in 1934, where she conducted photographic experiments and created photographic montages and abstract photograms in addition to running her photographic business. After her studio was destroyed in wartime 1944, she moved to Hofheim in the Taunus Region. Here she created her first interference pictures with polarized light. Many of her photographs were inspired by the composition principles of contemporary artists such as Giorgio Morandi and Wassily Kandinsky. In 1949 she was joined by her sister in founding the private Marta Hoepffner Photographic School. The curriculum, which also included theory, was based on the principles of the Bauhaus. The first color photograms were created in 1956. In 1966 she developed her first "variochromatic light objects". In 1971 she moved to Kressbronn on Lake Constance and gradually turned her teaching activities over to her assistant Irm Schoffers. From 1975 she was only freelancing. *RM*

▲ **Marta Hoepffner**
Composition with
Bottles, 1945

Gelatin silver print
34.8 x 28 cm
ML/F 1989/79

► **Marta Hoepffner**
Nude, Movement,
Solarization, 1940

Gelatin silver print
39.6 x 26.7 cm
ML/F 1989/78

(Paul Bohrmann)

1906 Weißenfels,
Germany
1999 New York

▶ **Horst P. Horst**
Mainbouchet Corset,
Paris, 1939

Gelatin silver print
24.2 x 19.2 cm
ML/F 1984/66

Gruber Donation

▼ **Horst P. Horst**
Coco Chanel, Paris,
1937

Gelatin silver print
20.6 x 19.7 cm
ML/F 1977/340

Gruber Collection

After a short-lived interest in architecture and an apprenticeship with Le Corbusier in Paris that bored him, Horst P. Horst was attracted to photography through his friend George Hoyningen-Huene. Janet Flanner of the *New Yorker* discovered his pictures in a small exhibition in a bookstore in Paris-Passy. This led to his first job at *Vogue*, the magazine to which Horst was to remain loyal as a fashion photographer for the rest of his life.

Horst may not have revolutionized fashion photography, but he certainly perfected it. The second generation in fashion photography still had to define fundamental concepts for the photographic approach to fashion. How representative or realistic should a fashion photograph be, how much should the respective fashion design be the center of photographic interest, and how much could the photographer's creative concept prevail over these precepts?

What characterizes Horst's photography is his conception of beauty. Horst had undertaken intensive studies of classical poses, he studied Greek sculpture and classical painting, and he devoted particularly meticulous attention to details such as the positioning of hands, because he was aware of the fact that most people did not know what to do with their arms and hands during photography. The combination of judicious poses and bearings, sparse accessories and simple but skillful lighting is typical of what is often described as Horst's illusionist talent. He magically transformed simple boards of wood into exquisite furniture. cardboard rolls into antique columns and plaster figures into marble sculptures. Whatever he photographed, he transformed everything into elements of his classical, idealized world. But in no way did he suggest that this idealized world now is reality. He left it as fiction, as the projection of an ideal conception of beauty. His beauty is distant, cool

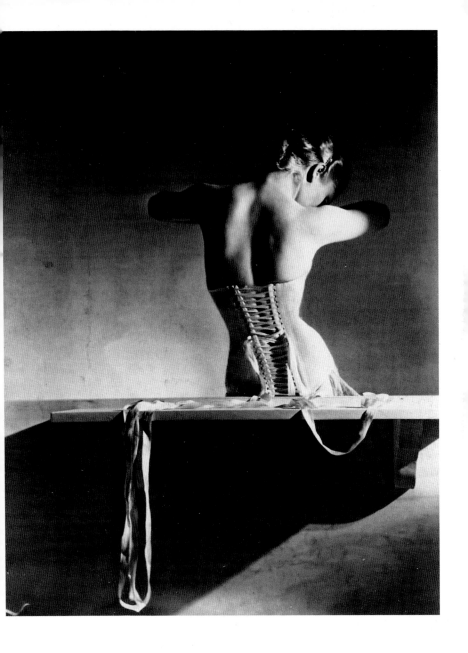

◄ **Horst P. Horst**
Elsa Schiaparelli, Paris, 1937

Gelatin silver print, 35.2 x 27.5 cm
ML/F 1992/181

R. Wick Donation

▲ **Horst P. Horst**
Helen Bennett, Paris, 1936

Gelatin silver print, 35.2 x 27.5 cm
ML/F 1992/198

R. Wick Donation

Horst | 269

▲ Horst P. Horst
Vogue Cover, 1938

Color print
41 x 41 cm
ML/F 1992/199

R. Wick Donation

and unapproachable, erotic and seductive, but only as a figment of the mind, like a dreamworld far beyond all animal instincts. This distance between his photographs and reality makes him an artist of his time, who, even though he loved the material world, the illusions of advertising, of beauty and of fashion, and photographed it with devotion, was aware of its illusory character and for that very reason revered it. *RM*

▲ **Horst P. Horst**
Around the Clock,
New York, 1987

Gelatin silver print
35.2 x 27.5 cm
ML/F 1992/196

R. Wick Donation

Horvat, Frank

1928 Abbazia, Italy
Lives in Boulogne-
sur-Seine

▶ **Frank Horvat**
In the Dressing
Room, 1963

Gelatin silver print
39 x 26 cm
ML/F 1977/346

Gruber Collection

▼ **Frank Horvat**
Fellini and a Model,
1963

Gelatin silver print
39.9 x 27.1 cm
ML/F 1977/345

Gruber Collection

Frank Horvat, whose father was a physician, fled to Lugano in 1939 and attended high school there. In 1944 he sold his stamp collection in order to buy a used camera. After returning to Italy, he studied drawing at the Accademia di Brera in Milan. In 1951 he submitted his first photographic essay about southern Italy, which was published by the magazine *Epoca*. His very first color photograph was on the cover. That year he traveled to Paris for the first time, where he met Robert Capa and Henri Cartier-Bresson. In 1952 he traveled to India at his own expense. The photographs that he made there were published by *Paris Match, Picture Post* and *Life* magazine. In 1955, Edward Steichen selected some of his pictures for the legendary exhibition "The Family of Man". In 1958 Frank Horvat began working for *Jardin des Modes, Elle* and *Vogue*. He became a member of the "Magnum" agency in 1959, but remained there for only three years. In 1964 he started working for *Harper's Bazaar, twen* and *Elle*. During those years, he began to concentrate more and more on fashion photography.

Horvat is a highly versatile photographer who masters the most varied subjects, ranging from landscape and fashion photography to portraits. He is also very interested in experimentation. He began to stage his settings in the style of old masters, and more recently he has been using computers for picture montages in the surrealistic tradition. *RM*

1900 St. Petersburg
1968 Los Angeles

▶ George
Hoyningen-Huene
Bathing Suits by
Izod, 1930

Gelatin silver print
28.8 x 22.6 cm
ML/F 1992/207

R. Wick Donation

▼ George
Hoyningen-Huene
Greta Garbo, 1951

Gelatin silver print
34.2 x 26.6 cm
ML/F 1977/349

Gruber Collection

George Hoyningen-Huene is considered to be one of the great expo-
nents of fashion photography of the twenties and thirties. His career be-
gan after he moved to Paris in 1920, where he took up a great variety of
jobs. He worked as a movie extra and studied painting. It was during
this period that he also developed close contacts with the Paris art
scene, befriending such legendary figures as Kiki de Montparnasse and
Jean Renoir. He soon made a name for himself as a talented fashion
draftsman, and his work was published in *Harper's Bazaar* and
Fairchild's Magazine. In 1925 he was hired by *Vogue*. It was approximately
at that time that he began to turn more and more to photography, start-
ing to work as an assistant to the American photographer Arthur
O'Neill. A year later Hoyningen-Huene made his first fashion photo-
graphs for *Vogue* and thus gained entry into this field, in which he was
particularly active in the years from 1926 to 1945. Many of his photo-
graphs from this period reflect his fascination with Surrealism and his
interest in Greek antiquity. Flawless compositions with well-balanced
lighting are as much a trademark of this photographer as are the inclu-
sion of classical Greek props and
surrealistic effects.

In 1935 Hoyningen-Huene
moved to New York, and in 1936
he began working almost exclus-
ively for *Harper's Bazaar*. In 1943
he published his picture books
Hellas and *Egypt*. In 1946 he went
to Hollywood, where he became a
sought-after portrait photo-
grapher of American movie stars,
and where he also became active
in motion pictures, especially
short features. *MBT*

◀ **Hanns Hubmann**
Willy Brandt kneel-
ing at the Monu-
ment to the Warsaw
Ghetto, 7 Dec.1970

Gelatin silver print
49.9 x 49.8 cm
ML/F 1987/174

▶ **Hanns Hubmann**
Reception in Beverly
Hills, Zsa Zsa Ga-
bor, Curd Jürgens
and Louella Parsons,
the Hollywood gos-
sip columnist, 1957

Gelatin silver print
31 x 22.5 cm
ML/F 1987/179

Hubmann, Hanns

1910 Freden
1996 Ulm

Hanns Hubmann studied at the Technical College in Darmstadt, but he soon became interested in photography, and in 1931 moved to Munich in order to study photography at the Bavarian State Institute for Photography. His first Leica photographs already brought him success. Upon his return to Germany from working for the administration of the St. Moritz health resort, he was arrested for alleged propaganda lies against the Nazis. Barely avoiding a concentration camp, he went underground for a while, reappearing in 1935 to work for the *Berliner Illustrierte Zeitung*. In 1936 he moved to Berlin, from where he traveled to America. In 1937 he published a reportage about the Spanish Civil War. In 1939 he began working for *Life* magazine and in 1941 he was drafted to become a war correspondent for *Signal*. In 1945 he began working for the latter's American equivalent, the *Stars and Stripes*. He traveled to every continent, interesting himself primarily in political and sports events. His photograph of *Willi Brandt kneeling at the Monument to the Warsaw Ghetto* is a picture that became synonymous with an event and which was published around the world. *RM*

**Huebler,
Douglas**

1924 Ann Arbor,
Michigan
1997 Truro,
Massachusetts

Like Allan Kaprow and Joseph Kosuth, Douglas Huebler was both an artist as well as an art critic and theoretician. In Huebler's conceptual work of the seventies the documentation of his projects played a significant role – not least because that is the only way they are perceivable to a viewer.

As an example, for his *Variable Piece No. 48* (1971), Huebler assembled documentation of an art project. In a statement that is as much a part of the work as a series of photographs, a road map, a letter to New York gallery owner Leo Castelli and a sketch of the arrangement of the photographs, Huebler described the idea behind the project. On the 13th of May 1971 he made more than 650 photographs along the way from his adoptive home town of Bradford, Massachusetts, to the Leo Castelli Gallery in New York City.

These pictures document the totality of the optical impressions that he encountered on his way. Every photograph was made from a specific

◄ Douglas Huebler
Variable Piece
No. 48: Document
for the entire visual
"Appearance" as far
as the eye can see,
1971

Collage, Gelatin silver
print, printed piece,
sketches
210 x 97 cm
ML/F 1985/37

Ludwig Donation

spot on the highway, in the direction of travel and looking as far as the eye could see. Huebler then had someone else select the "most aesthetic" view from the entire crop of photographs and he displayed an appropriately enlarged print of that view along with the rest of the documents.

Huebler was not especially interested in aesthetic problems, even if the enlargement of the New York bridges still had a particular photographic appeal. In general, less emphasis was placed on the quality of the photographs than on the best possible capture of the various optical phenomena. According to Huebler, "These documents are not necessarily interesting on an aesthetic level, meaning that they are not intrinsically 'works of art'. I use these documents to record a condition of absolute coexistence between 'picture' and 'language'." *GG*

◀ Peter Hutchinson
J-Blue Jay, 1974

Color print
50.5 x 75.7 cm
ML/F 1979/1351 I

**Hutchinson,
Peter**

1930 Thornton
Heath, Surrey, UK
Lives in New York

Like Joseph Kosuth, conceptual artist Peter Hutchinson is interested in the abstract definition of words and things. Together with Jean Le Gac, Bill Beckeley, Mac Adams and Roger Welch, Hutchinson belonged to a subgroup of Concept Art that became known in New York during the seventies as narrative or descriptive art. These artists combined the systematic analysis of art with poetic stories in which the artist/author often also acted as the main protagonist.

With his three-part work *J-Blue Jay* (1974) from his *Alphabet Series*, Hutchinson explores the connotation of the letter "J". He combined photographic images, anecdotal text and three-dimensional letter shapes in order to explore their elementary properties. In his text about the letter "J", the artist wrote: "I had been reading 'Memories, Dreams and Reflections' by Carl Jung and was sitting outside my cottage in Provincetown trying to 'let go' as Jung described it, 'sink into my unconscious and have a mystical, mythical experience'. Nothing happened except that my head began to throb strangely. At that moment a bird alighted on the seat of my bicycle a few feet away. It was a Blue Jay. It looked at me for a few moments as though it carried some important message." *GG*

▶ **Peter Hutchinson**
-Blue Jay, 1974

Handwritten text
panel
50 x 75.7 cm
ML/F 1979/1351 II

<u>Blue Jay</u>

<u>The letter "J" from the Alphabet Series</u>

I had been reading "Memories, Dreams and Reflections" by Carl Jung and was sitting outside my cottage in Provincetown trying "to let go" as Jung described it, "sink into my unconscious and have a mystical, mythical experience. Nothing happened except that my head began to throb strangely. At that moment a bird alighted on the seat of my bicycle a few feet away. It was a Blue Jay. It looked at me for a few moments as though it carried some important message.

▶ **Peter Hutchinson**
J-Blue Jay, 1974

Wood, ceramics
ca. 35.5 x 23 x 2.5 cm
ML/F 1979/1351 III

Huth, Walde

1923 Stuttgart
Lives in Cologne

▼ Walde Huth
Ambre, from:
Fashion of the
Times, 1962

Gelatin silver print
51.7 x 50.5 cm
ML/F 1989/107

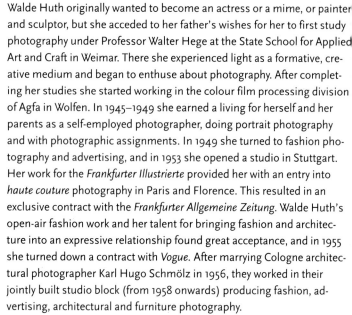

Walde Huth originally wanted to become an actress or a mime, or painter and sculptor, but she acceded to her father's wishes for her to first study photography under Professor Walter Hege at the State School for Applied Art and Craft in Weimar. There she experienced light as a formative, creative medium and began to enthuse about photography. After completing her studies she started working in the colour film processing division of Agfa in Wolfen. In 1945–1949 she earned a living for herself and her parents as a self-employed photographer, doing portrait photography and with photographic assignments. In 1949 she turned to fashion photography and advertising, and in 1953 she opened a studio in Stuttgart. Her work for the *Frankfurter Illustrierte* provided her with an entry into *haute couture* photography in Paris and Florence. This resulted in an exclusive contract with the *Frankfurter Allgemeine Zeitung*. Walde Huth's open-air fashion work and her talent for bringing fashion and architecture into an expressive relationship found great acceptance, and in 1955 she turned down a contract with *Vogue*. After marrying Cologne architectural photographer Karl Hugo Schmölz in 1956, they worked in their jointly built studio block (from 1958 onwards) producing fashion, advertising, architectural and furniture photography.

After Karl Hugo Schmölz passed away in 1986, she gave up his additional large studio and concentrated entirely on making photographs according to her own conceptions. Her photographic cycles *100 Unwritten Letters. Photographic Modulations, 100 frozen Steps. Photographic Sequences, Eyed Existence, Aphrodite, Became a Figure* or *Optical Delicacies* exemplify her very individual approach to staged photography, to photographic found objects, and to serial photography. *RM*

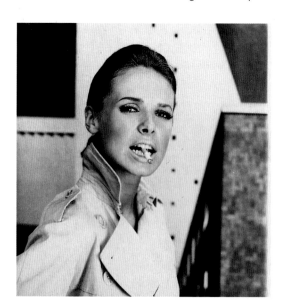

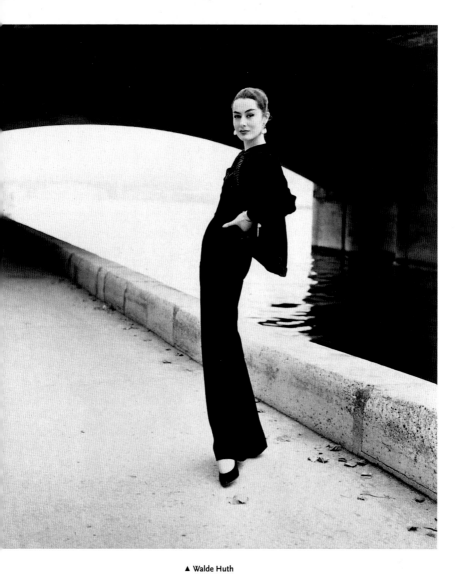

▲ **Walde Huth**
Patricia, Evening
Robe by Jacques
Fath, Paris 1953

Gelatin silver print
57.4 x 49.7 cm
ML/F 1989/110

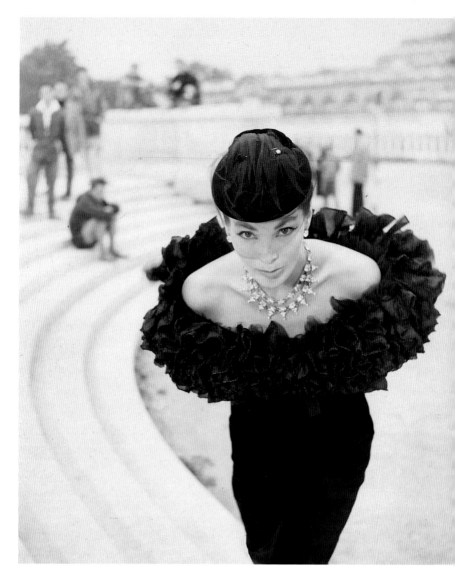

▲ Walde Huth
Lucky Décolleté,
Dress by Dior,
Paris, 1955

Gelatin silver print
35.2 x 21.9 cm
ML/F 1983/110

Gruber Donation

Walde Huth
3rd letter from the
cycle: One Hundred
Unwritten Letters,
1979

Color print
40.5 x 28.5 cm
ML/F 1982/16

Walde Huth
7th letter from the
cycle: One Hundred
Unwritten Letters,
1979

Color print
40.5 x 28.5 cm
ML/F 1982/5

Walde Huth
51st letter from the
cycle: One Hundred
Unwritten Letters,
1979

Color print
40.5 x 28.5 cm
ML/F 1982/20

Walde Huth
9th letter from the
cycle: One Hundred
Unwritten Letters,
1979

Color print
40.5 x 28.5 cm
ML/F 1982/7

Ignatovich, Boris

1899 Lutzk, Ukraine
1976 Moscow

▲ Boris Ignatovich
Hermitage, 1929

Gelatin silver print
36.7 x 45 cm
ML/F 1992/131

Ludwig Collection

Boris Ignatovich began his professional career as a newspaper editor and journalist in Moscow in 1918. From 1922 to 1925 he worked mostly for humor magazines like *Lore* or *The Laughing Man*. In 1923 he also took up photography and during the years that followed worked as a photographer and correspondent for various magazines. He achieved his first success with a photographic essay about village subjects. In the late twenties, Ignatovich had close contacts with Alexander Rodchenko, with whom he founded the photography section of the "October Group" in 1930. The friendly relationship with Alexander Rodchenko had a marked influence on Ignatovich's photographic style. He enjoyed taking pictures from extremely low or high camera positions, and through these unconventional viewing angles he discovered a new way of looking at everyday life. A sightseeing flight over Leningrad presented him with new opportunities in his search for unconventional perspectives.

▲ **Boris Ignatovich**
Isaac Cathedral,
1930

Gelatin silver print
19 x 24 cm
ML/F 1992/124

Ludwig Collection

◄ **Boris Ignatovich**
Smokestacks and
Factories of a
Leningrad Industrial
Complex, 1931

Gelatin silver print
13 x 18 cm
ML/F 1992/125

Ludwig Collection

He created bird's-eye views such as *Smokestacks and Factories of a Leningrad Industrial Complex,* in which architecture is rendered as an abstract-constructivist composition.

After 1929 Ignatovich was the leading photographer, together with Rodchenko, of the magazine *Daijosch*. During that period, Ignatovich particularly enjoyed the use of symbols, slogans and picture captions, which he applied not just as intellectual supplements to his photographs, but in which he also saw forms with their own graphic appeal.

After the war Ignatovich devoted himself especially to landscape and portrait photography, concerning himself also with the opportunities of color photography. *MBT*

Ionesco, Irina

1935 Paris
Lives in Paris

▼ Irina Ionesco
Nude with Two
Doll's Heads,
around 1973

Gelatin silver print
39.2 x 39.4 cm
ML/F 1984/69

Gruber Donation

Irina Ionesco spent her childhood in Romania and moved to Paris in 1951. She traveled for several years and busied herself with painting before becoming interested in photography. In March 1974 she exhibited her photographs in the Nikon Gallery in Paris and attracted a great deal of attention. In the years that followed, her pictures were published in numerous publications, such as *Femmes sans tain, Nocturnes* and *Temples aux miroirs*. In many of her picture series she alludes to situations reminiscent of those described in the novels of Alain Robbe-Grillet, in particular *Memories of the Golden Triangle*: lavishly dressed women, bedecked in jewels and in motionless poses, provocatively offering themselves partly disrobed, often wearing leather chokers, bracelets, gloves or corsages to conjure hints of possibly impending or perhaps already existing violence. In her photographs, Irina Ionesco conjures up a world of beautiful women in connection with eroticism and death. Irina Ionesco's photographs became controversial because

she used her own pubescent daughter as a model, depicting her in poses that were no less erotically suggestive than they would be with more mature models. Her photography always seemed to move along the fine line between purely erotic pictures and artistic compositions, and she had to struggle for the recognition of her earnestness. Today the content of her photographs is closer to the spirit of the times than ever before, and at present her pictorial expression can even be considered as restrained. In this respect she can be regarded as a trendsetter in her field. *RM*

Gottfried Jäger completed an apprenticeship as a photographer and studied at the State College for Photography in Cologne. In 1960 he became a lecturer in photographic technology at the School of Arts and Crafts in Bielefeld. In 1973 he became a professor of artistic fundamentals of photography and photographic design at the Professional College of Bielefeld. Jäger devoted himself to experimental photography and the effects of light, concentrating on a so-called "generative photography". He concerned himself with photographic series and with investigations of vision and perception, and he created the concept of "image-conveying photography" on a systematically constructive basis. In 1970 he developed so-called "apparatus art" and since 1980 he has been delving into color developments, color cycles and color spectra as well as the plain colorfulness of photographic paper.

Jäger was also a very successful teacher, and he founded a school in Bielefeld that has significant influence on the development of contemporary artistic photography in Germany. Aside from that he was an effective president of the German Photographic Academy (formerly "GDL", the Society of German Photographers), whose new orientation he was instrumental in bringing about. His writings, particularly "Image-conveying Photography" are regarded as standards in the field of experimental and fundamental photography. *RM*

Jäger, Gottfried

1937, Burg near
Magdeburg
Lives in Bielefeld

▲ **Gottfried Jäger**
Two Squares, a
three-part photo-
graphic work, 1983

*Gelatin silver print
each 24.5 x 24.5 cm*
ML/F 1985/161 I-III

Arno Jansen grew up in Düsseldorf, and in 1959 he began studying photography under Professor Otto Steinert at the Folkwang School in Essen. In 1974 he became a professor at the Technical College in Cologne. During the years of his teaching tenure, the Technical College of Cologne graduated numerous artists who today are known internationally and who devote themselves to photography.

Jansen grew up in a generation that, even though it was based largely on "subjective photography", more and more followed impulses emanating from America, for instance from Ralph Gibson or Lee Friedlander, who brought "visualism" to Europe in the seventies. While "visualism" possesses certain parallels to "subjective photography", it is however less constructive and rational, oriented less towards the Bauhaus. Instead, it is more emotion based and it observes less from the outside than it does from the inside. Jansen dedicated himself to this sensitive outlook on evolution and decay, he assisted a little with arrangements, and beyond that he observed with calm but also with anticipation the changes taking place around him in time, eventually making his photographs when time had left sufficient traces. Jansen thus evolved into a master of the clear transposition of the natural chaos that he observed. As much as he did not like to intervene in the events of his decaying still-life arrangements, his pictures are equally strongly characterized by his insistence on perfection. From the judiciously undertaken, well-balanced illumination to the carefully selected camera position, everything was designed to achieve a maximum of clarity in the composition. Jansen pursued his main subject of still-life photography both in black-and-white as well as in color, which he kept very subdued, although he also did not shirk from a saturated blue color as a background.

In the eighties, Jansen discovered another subject: portraits of mature women. They intrigued

▼ Arno Jansen
Heating Period, 1975

Gelatin silver print
40.3 x 30.5 cm
ML/F 1988/92

Gruber Donation

him for the same kind of reasons as his still-life pictures did: the tension-filled relationship of still evident beauty and feminine radiance and approaching decline.

With the closing of the Technical College of Cologne, Jansen lost his professorship, whereupon he devoted himself entirely to his own pursuits. *RM*

▲ Arno Jansen
My Ex, 1975

Gelatin silver print
40 x 30.1 cm
MLF 1994/183

Gruber Donation

◄ **Piotr Jaros**
Embrace, 1994

Gelatin silver print
191 x 200 cm
ML/F 1994/9

Jaros, Piotr

1965 Myslenice

Piotr Jaros studied at the College of Art in Cracow until 1989, and since then he has been working in the fields of photography and installations. An important theme in his staged photographs are the relationships and interactions between people. The large-format black-and-white enlargements from his series *Embraces* depict couples sitting in stiff poses in front of a neutral background. Familiar from Christian iconography, the subject of Madonna and Child is applied to same-sex and opposite-sex relationships. A paradoxical effect is generated by the fact that the individuals appear indifferent and unemotional, in spite of the proximity and intimacy signaled by their bodily contact. Because they are life-size, the portraits in the exhibit situation combine with the space of the observer and confront him with their static presence. *TvT*

► Dimitri Jermakov
Tiflis on the Banks
of the Kura River,
around 1895

Gelatin silver print
22 x 28.8 cm
ML/F 1994/339

Gruber Donation

Dimitri Jermakov completed his training at the Military School of Topo-
graphy. In 1870 he made a number of photographs of Georgian archi-
tectural monuments, which he signed on the back as "Artistic Photo-
graph by His Highness the Shah of Persia". In the same year, Jermakov
opened a photographic studio in Tiflis. Between 1870 and 1915 he trav-
eled through Persia, the southern coast of the Crimea, Central Asia and
the Northern Caucasus. Jermakov worked on new methods for the man-
ufacture of collodion plates and he also made sketches for a mobile la-
boratory. In 1874 he was decorated by the French Photographic Society.
During the war between Russia and Turkey, between the years of 1877
and 1878, Jermakov was a photographer for the military mail depart-
ment of the general staff of the Caucasus Army. In 1883 he was named
Art Photographer of the Archaeological Society of Moscow. Commis-
sioned by the French expert on oriental matters Jean Mourier, he made
photographs of wall paintings in various churches in 1884. In 1889 he
published his *Historical Photo Album of Georgia*. During his active time,
Jermakov assembled a total of 127 albums. Today a large collection of
his work and his equipment is in the Historical Museum of Georgia.
MBT

**Jermakov,
Dimitri**

around 1845/48
Tiflis, Georgia
around 1915/17 Tiflis

**Johnston,
Alfred Cheney**

1885 New York
1971 Oxford,
Connecticut

Alfred Cheney Johnston was already an amateur photographer while he was studying art at the School of Fine Arts in New York City. His career as a glamour photographer began when Flo Ziegfeld hired him as the official photographer of his show dancers, the Ziegfeld Girls. Johnston perfected a wonderfully titillating skill of making his dressed models look nude. He photographed all the silent movie stars of the twenties, among them the Dolly Sisters, Gloria Swanson, Mae Marsh, the Fairbank Twins, as well as Lillian and Dorothy Gish.

His photographs shaped the image of Hollywood of that decade. Johnston was a master of the art of draping, of only partially covering models with fabrics and lace, so that the stars did not have to undress and still appeared disrobed to their fans. That skill soon earned him the nickname "Mr Drape".

With the end of the silent movie era, his fame also began to fade. Other photographers followed in his steps and portrayed the heroines of the new era. Johnston's work lay forgotten for many years and it was only recently rediscovered in the USA. There is practically no demand for his photographs in the art market. The L. Fritz Gruber Collection is

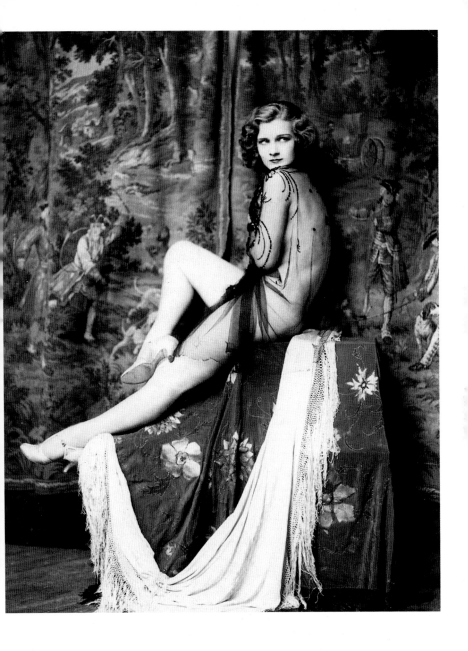

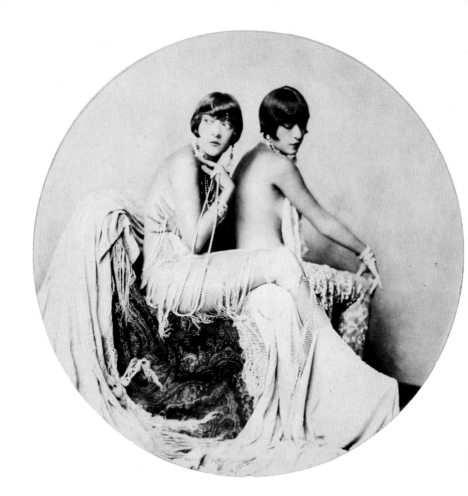

▲ **Alfred Cheney**
Johnston
Dolly Sisters, 1923

Gelatin silver print
Diameter: 26 cm
MI /F 1977/354

Gruber Collection

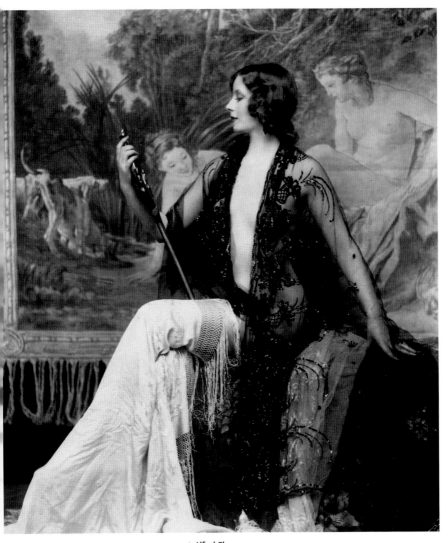

▲ **Alfred Cheney Johnston**
Blanche Satchell,
1925

Gelatin silver print
32.5 x 26.3 cm
ML/F 1977/363

Gruber Collection

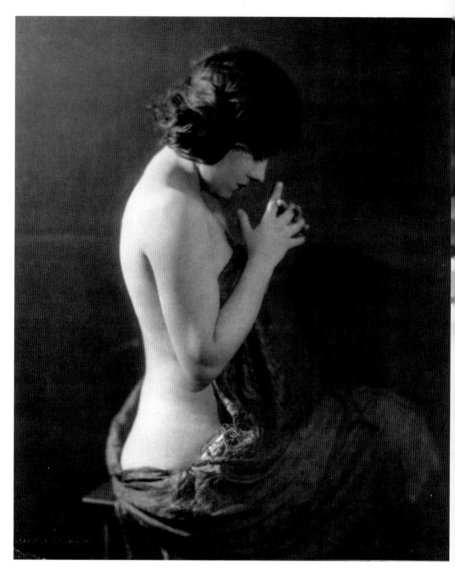

▲ **Alfred Cheney Johnston**
Gloria Swanson, 1920

Gelatin silver print
34 x 26.5 cm
ML/F 1977/359

Gruber Collection

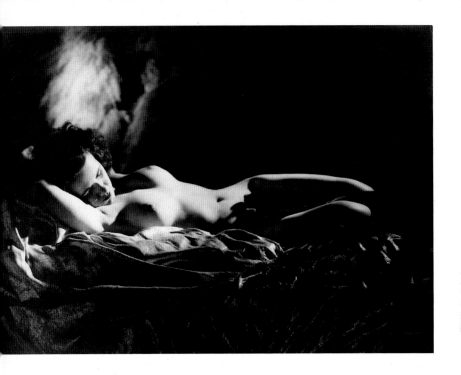

one of the very few European collections that can boast a large body of his work and that has regularly exhibited and published it since 1983.

Johnston continued his work for another seven years after Ziegfeld passed away, and in 1940 he retired to his country home in Oxford, CT, where he devoted himself to nude photography until he died. *RM*

▲ **Alfred Cheney Johnston**
Reclining Nude, around 1950

Gelatin silver print
24 x 32.9 cm
ML/F 1977/366

Gruber Collection

Burkhard Jüttner studied photography with Arno Jansen at the Cologne Factory Schools. In 1972 he embarked on study tours to Spain and Northern America. In 1974 he became an assistant to Professor L. Fritz Gruber, in charge of artistic aspects of Photokina. In 1975 he undertook study tours of Northern Africa, Spain, and France. Following his exams he became a master student under Professor Arno Jansen. From 1978 to 1981 he taught at the Technical College of Cologne. Since then he has been working as photojournalist based in Bonn. In 1980 he founded a portrait studio with a workshop gallery for artistic photography. In 1983 he founded a photographic production company. In 1995 he expanded its scope by adding an on-line imaging agency called "Vintage" for artistic photography with emphasis on travel photography and artistic portraiture.

Since taking his first photographs, Jüttner – in the tradition of visualism – pursued a type of photography following an underlying conceptualism. Thus his thematic picture sequences of the seventies were later increasingly structured on the laws of immanent contradiction. Jüttner took pictures of bathing beaches and hot-dog stands in opposite seasons and formulated starkly composed views of absolute emptiness. He

▼ Burkhard Jüttner
The Queen of Fried
Foods, 1987

Gelatin silver print
13.9 x 25 cm
ML/F 1989/3

contrasted truncated advertising billboards with their adjacent environment – the pavement, a landscape or a fence in the background. Jüttner's photographs appear to obey the strict laws of the documentary and still be pure products of imagination. In particular his beach scenes satisfy a high degree of what could be called "photographic minimalism". Frequently, his comparisons are so astounding that they appear to be stage productions. Still, Jüttner has never allowed himself to be affected by current trends such as the large format or image manipulation, but, once he had discovered it, has remained faithful to the small format, to "straight photography", and to the principle of technical perfection. *RM*

▲ **Burkhard Jüttner**
Roncalli Circus, 1976

Gelatin silver print
21.5 x 14.5 cm
ML/F 1994/187

Gruber Donation

▲◄ **Burkhard Jüttner**
War Veterans, 1975

Gelatin silver print
22.3 x 15.2 cm
ML/F 1977/950

Gruber Donation

Julius, Kurt

1909 Hanover
1986 Kirchheim

► **Kurt Julius**
Margot Hielscher,
1949

Gelatin silver print
38.9 x 29.2 cm
ML/F 1991/100

▼ **Kurt Julius**
Hildegard Knef, 1947

Gelatin silver print
40.5 x 30.3 cm
ML/F 1991/96

Kurt Julius studied photography at the Bavarian State Educational Institute for Photography in Munich. Upon completing his education with distinction, he worked nationally, as well as internationally, in various photographic studios from 1931 to 1938. After receiving his diploma as master photographer he took over his father's studio in Hanover. In 1943 his apartment and studio were destroyed during an air raid and Julius lost his entire archive. He spent 1944 in a labor camp from which he managed to escape in 1945. After the end of the war he returned to Hanover, set up a new studio and devoted subsequent years to portrait, advertising, architectural and theatrical photography. In addition, he acted as photojournalist at movie studios in Göttingen, Hamburg, and Munich.

The first edition of *Stern* magazine in 1948 showed a portrait by Julius, the famous face of the young actress Hildegard Knef. Between 1949 and 1979 Julius documented all the opera and ballet performances and stage plays of the National Theater of Lower Saxony in Hanover.

In 1980 he finished his contract work, and he and his wife moved back to Kirchheim in the vicinity of Munich. There, he continued to work exclusively on a freelance basis, mostly portrait studies, for example, a series on his neighbors or his photographer colleagues. His portraits are composed unconventionally and frequently imply an individual's ambiance in an understated manner. *RM*

Kahle, Birgit

1957 Cologne
Lives in Cologne

▲ **Birgit Kahle**
Untitled, 1983

Gelatin silver print
50.7 x 50.7 cm
ML/F 1985/138

Birgit Kahle began her collaboration with performance artist and painter Peter Gilles toward the end of the seventies. In part she documented his performances in photographs, in part she included herself, while sometimes she made herself the object of photographic productions. This latter idea, finally developed into her own artistic methodology. Her first cycle, *Fear is Man's Best Friend*, which was directed at external threats, as well as at internal ones brought about by disease, resulted in immediate success in the arts world. In the years following she developed her projections with increasing simplicity, arrived at cuts and tears in large for-

mats, and in later series re-composed her image fragments to create new collage-like works. Finally, in her Polaroid series she arrived at the question of the perceptibility of the beyond and its existence, conveyed through the perceptibility of the pictures themselves. Being an artist couple, Birgit Kahle and Peter Gilles thrive on the constant, reciprocal stimulation of their work. *RM*

▲ **Birgit Kahle**
Untitled, 1984

*Gelatin silver print
each 50.7 x 50.7 cm*
ML/F 1984/134 I-V

◄ **Yousuf Karsh**
Jawaharlal Nehru,
around 1949

Gelatin silver print
31.3 x 25.3 cm
ML/F 1977/376

Gruber Collection

Karsh, Yousuf

1908 Mardin,
Armenia
2002 Ottawa,
Canada

"The never-ending fascination for the people I photograph rests in what I call their internal strength. It is part of the hard-to-define secret hidden within everyone, and the attempt to capture this on film has been my life's work." This is how portrait photographer Yousuf Karsh has described the attraction of his work.

In 1924, aged 16, Karsh emigrated to Canada, where he came under the care of his uncle, George Nakash, an established photographer. That is when Karsh discovered his enthusiasm for photography and, with the aid of his uncle, learned the fundamentals of the art. In 1928 George Nakash succeeded in securing an apprenticeship for his nephew with Boston portrait photographer John H. Garo, to whom Karsh owes a well-trained observant eye for the great masters of painting and art in general. In 1932 Karsh opened his own portrait studio in Ottawa. There, he quickly acquired the reputation of an exceptionally talented portrait photographer, whose clientele included high-ranking individuals in politics, science and the arts. In 1941 Karsh achieved his international breakthrough with his famous portrait of Winston Churchill. This pic-

▲ **Yousuf Karsh**
Winston Churchill,
1941

Gelatin silver print
31 x 25.3 cm
ML/F 1977/369

Gruber Collection

◄ **Yousuf Karsh**
George Bernard
Shaw, 1943

Silver bromide print
33.8 x 26.9 cm
ML/F 1977/372

Gruber Collection

ture of a grouchy, critical Churchill appeared on the title page of *Life* magazine and to this day it is still one of the most reproduced portraits.

In his work Karsh did not restrict himself to his own studio. He actually preferred to take portraits of his sitters in their own familiar environment. Karsh published his portraits in numerous photographic volumes and frequently revealed the pictures' histories in brief anecdotes. *MBT*

▲ **Yousuf Karsh**
Martha Graham, around 1959

Gelatin silver print
32.6 x 26.4 cm
ML/F 1977/375

Gruber Collection

Katz, Benjamin

Benjamin Katz moved to Berlin in 1956. There he studied at the Academy of Fine Arts under professors Jaenisch, Böhm and Lortz. Between 1958 and 1959 Katz was a member of the youth ensemble under the direction of Thomas Harlan. In 1963 he and Michael Werner founded the Galerie Katz/Werner. After barely one year he and his partner separated and he operated the gallery by himself until 1969. His staged over 60 exhibitions, showing artists such as Markus Lüpertz, Georg Baselitz, Marcel Broodthaers, and Antonius Höckelmann. In 1972 Katz settled in Cologne and made photography his medium of choice. He evolved into the chronicler of the Rhine art scene, with Cologne and Düsseldorf as the main centers.

Benjamin Katz did mostly freelance work, but especially during the eighties he also frequently collaborated with museums, in particular the Museum Ludwig in Cologne, where he was commissioned to document the large exhibition "Art of the West" in 1981. However, he also documented other large events in great detail, such as the exhibitions "From Here On", "Picture Fight" and "documenta IX".

Even after turning to photography, his artist friends from his gallery days remained an important subject for him. He took pictures in studios and pubs, at exhibitions, gallery openings and artists' parties and documented exhibition set-ups and performances. Katz is not only an

outstanding portrait photographer, he has also developed essay-like pic-
ture sequences to perfection. Situations come alive when three or four
closely related image sequences capture the gist of a situation in an al-
most movie-like manner. He often recognizes something in otherwise
inconsequential moments that is characteristic of the people who are
involved. It is in those situations at the periphery of action that his ex-
traordinary sense for the essence blossoms out.

By now his archive has developed into an inexhaustible source for
all those who organize exhibitions or who publish books. There is hardly
anyone in the art scene, be it artist, collector, gallery owner, museum
director, critic or journalist, who has not been captured by his camera at
least once. *RM*

▲ **Benjamin Katz**
Nam June Paik and
Reinhold Mißelbeck
with Shigeko Kubo-
ta's Buddhas, 1986

Gelatin silver print
30.5 x 24 cm
ML/F 1987/132

► **Benjamin Katz**
James Lee Byars,
1981

Gelatin silver print
30.9 x 23.9 cm
ML/F 1982/189

►► **Benjamin Katz**
Joseph Beuys, 1981

Gelatin silver print
23.9 x 30.9 cm
ML/F 1982/196

◄ Peter Keetman
Reflecting Drops,
1950

Gelatin silver print
23.2 x 30.3 cm
ML/F 1989/46

► Peter Keetman
Thousand and One
Faces, 1957

Gelatin silver print
30.3 x 23.3 cm
ML/F 1989/48

Keetman, Peter

1916 Wuppertal-
Elberfeld, Germany
2005 Marquartstein

Peter Keetman received his first photographic inspirations from his father, who was a serious amateur photographer. At the age of 19 he attended the Bavarian State Educational Institute for Photography in Munich, where he obtained his apprentice's diploma in 1937. After two years at the studio of Gertrud Hesse in Duisburg he worked as an industrial photographer for the C. H. Schmeck Company in Aachen. In 1944 he returned from military service seriously wounded and unable to work. Nevertheless he continued his studies at the aforementioned Institute in the master's program and then studied under Adolf Lazi in Stuttgart. Following his legendary exhibition in Neustadt/Hard in 1949, Keetman was one of the founding members of the "fotoform" group. Together with the other members of this group (Toni Schneiders, Wolfgang Reisewitz, Ludwig Windstoßer, Siegfried Lauterwasser and Heinz Hajek-Halke) he showed his first pictures at Photokina in 1950. Keetman became known internationally through his experimental work, in particular *Reflecting Drops*. *RM*

◄ Peter Keetman
Volkswagen Plant,
1953

Gelatin silver print
30.2 x 23.1 cm
ML/F 1989/49

▲ Peter Keetman
Screw Pump, 1960

Gelatin silver print
30.2 x 23.6 cm
ML/F 1989/44

Keetman | 323

Keiley, Joseph Turner

1869 New York
1914 New York

▼ Joseph T. Keiley
A Small Piece of
Paris, 1907

Glycerin Platinotype
19.1 x 14 cm
ML/F 1995/35

Gruber Donation

Joseph Turner Keiley began as a lawyer on Wall Street in New York City before turning to photography and participating in amateur exhibitions. In 1899 he became a member of the "Camera Club" and, as one of four American members elected to the "Linked Ring" in London, he participated in this club's photographic salon exhibitions. He and Alfred Stieglitz were friends. Together they worked on improving tone values in the development of platinum prints. In addition, they experimented with mercury and uranium salts in order to impart platinum prints with more realistic flesh tones. Keiley wrote phototechnical and historical articles for *Camera Notes*, a journal which Stieglitz had been publishing since 1896. In 1902 Stieglitz founded "Photo Secession", and Keiley was among the founding members, who included such famous photographers as Frank Eugene, Gertrude Käsebier and Edward J. Steichen. The object of "Photo Secession" was, among other things, to "promote photography as a means of artistic expression". In 1903 Keiley participated in the Salon Photographique des Photo-Clubs Paris. At the same time he was a member of the editorial committee of Stieglitz's publication *Camera Works*. This unique journal published not only the works of "Photo Secession" members but also of European photographers, including Heinrich Kühn, Hans Watzek, Frederick H. Evans and Julia Margaret Cameron, who was already dead at that time. *AS*

▲ Joseph Turner
Keiley
The Last Hour, 1901

Photogravure
12.1 x 19.2 cm
ML/F 1995/31

Gruber Donation

▶ Joseph Turner
Keiley
Portrait of Miss de
C., (Mercedes de
Cordoba), 1902

Photogravure
12 x 16 cm
ML/F 1995/32

Gruber Donation

◄ **Fritz Kempe**
Karl Hugo Schmölz,
1970

Gelatin silver print
32.6 x 22.2 cm
ML/F 1990/49

► **Fritz Kempe**
Lucia Moholy, 1980

Gelatin silver print
32.7 x 22.4 cm
ML/F 1990/41

Kempe, Fritz

1909 Greifswald,
Germany
1988 Hamburg

Following an apprenticeship in photography with his father, Fritz Kempe set up his own studio for industrial and advertising photography in Berlin. In 1945 he settled in Hamburg, where he worked as an editor and publisher. Between 1949 and 1974 he was director of the State Regional Picture Center Hamburg. In 1952 he founded the Hamburg Collection for the History of Photography which has its present home in the Museum of Fine and Industrial Arts. This made him the founder of one of the first photographic collections in a museum. His photographic works have concentrated on portraits, although he is mainly credited for his organizational and publishing activities. His publications have contributed significantly to the recognition of photography as an artistic medium. *RM*

Keresztes, Lajos

1933 Budapest
Lives in Nuremberg

After graduating from high school, Lajos Keresztes worked in a graphic arts office in Budapest. However, when the Soviets crushed the 1956 uprising, he fled to Austria and then to Germany. In 1957 he began to study architecture in Munich and, in the context of graphic design, discovered photography. Following his studies of photography at the Technical College of Cologne, Keresztes settled in Nuremberg in 1963, where he set up a studio and devoted himself to subjects such as fashion, cosmetics, calendars, magazine illustrations and advertising.

In his photography he continued in the realm of graphic design. In particular in his series *Light-Symbols-Language* he combined linguistic, photographic and graphic media. Symbols and photography were largely interwoven. At times the photograph was reduced to geometric forms, at times these forms were painted or drawn on the image. Texts were used as counterpoints.

In subsequent years, Keresztes concentrated mainly on purely photographic work, although he remained faithful to his interest in minimal images, cropped sections, geometric forms, simple symbols, and color relationships. In the tradition of visualism, the incidental, for example a colored area, is pushed to the center, drawing the eye to the incidental. The picture *Atlantis, Signals of Imagination* from the year 1982 shows just such a structured and colored relationship. It is also an example of his talent for using close croppings for making a picture come to the point. Since handing his professional studio over to his son in 1992, he has devoted himself exclusively to subjects of his own preference. *RM*

▼ Lajos Keresztes
Titicaca, Bolivia, 1988

Color Print
50 x 40 cm
ML/F 1995/90

▲ Lajos Keresztes
Atlantis, Signals of
Imagination, 1982

Color Print
30.5 x 41.1 cm
ML/F 1993/303

Gruber Donation

Kertész, André

1894 Budapest
1985 New York

▼ André Kertész
Esztergom, Hungary,
Swimmer, 1917

Gelatin silver print
19 x 24.7 cm
ML/F 1977/394

Gruber Collection

As a young man André Kertész found a photographic manual in an at-
tic and decided to become a photographer. After the death of his father,
however, he first attended the Academy of Commerce and, like his fos-
ter father, worked in the Budapest stock market. In 1913 he acquired his
first camera, an Ica. In 1914 he served in the Austro-Hungarian army.
One year later he began to work seriously as a photographer. He was
wounded and for a year was paralyzed. All of his negatives were des-
troyed in 1918 and he returned to the stock market. In 1922 he received
an honorary diploma from the Hungarian Association of Photography.
Between 1922 and 1925 he lived in Paris, where he sold prints for 25
francs in order to make a living. During this time he began his collab-
oration with the *Frankfurter Illustrierte*, the *Berliner Illustrirte*, the *Natio-
nale de Fiorenza, Sourire, Uhu*, and *Times*. In Paris he began his series
Distortions. In 1927 he had his first solo exhibition and in 1928 met Bras-
saï, whom he introduced to photography. Kertész acquired his first Lei-
ca and did documentaries for *Vu*. In 1933 he married Elisabeth Sali and
published his first book on children. Three years later he emigrated to
New York and signed a contract with Keystone. In 1937 his began his as-

sociation with *Vogue, Harper's Bazaar, Collier's, Coronet*, and many other magazines. In 1944 he became an American citizen. He attempted to bring over his negatives from Paris, but more than half were lost in transit. From 1949 to 1962 he worked continuously for Condé Nast.

After a serious disease, Kertész decided to cancel all his contracts and work exclusively as a freelance photographer. In addition to many honors, he received an honorary doctorate from the Royal College of Art and he was also made a member of the French Legion of Honor. Many of Kertész's photographs, for example *The Fork, Esztergom, Swimmer,* the *Park Bench*, or *Mondrian's Atelier*, are now among the most famous photographs of this century. *RM*

▲ **André Kertész**
The Fork, 1928

Gelatin silver print
19.4 x 24 cm
ML/F 1977/381

Gruber Collection

◄ **André Kertész**
Paris, 1930

Gelatin silver print
19.4 x 23.5 cm
ML/F 1977/391

Gruber Collection

► **André Kertész**
My Friend Brassaï,
1963

Gelatin silver print
24.5 x 17.7 cm
ML/F 1977/388

Gruber Collection

► **André Kertész**
Park Bench, 1962

Gelatin silver print
16.6 x 24.7 cm
ML/F 1977/383

Gruber Collection

▲ André Kertész
Avenue Junot, 1927

Gelatin silver print
24.2 x 19.6 cm
ML/F 1977/389

Gruber Collection

▶ André Kertész
Champs Elysées, 193◀

Gelatin silver print
24.5 x 18 cm
ML/F 1977/384

Gruber Collection

Kiffl, Erika

1939 Karlsbad,
Western Bohemia
Lives in Düsseldorf

▲ Erika Kiffl
Untitled, from:
Stone Age, 1979

Gelatin silver print
22.5 x 22.5 cm
ML/F 1986/207

▲▶ Erika Kiffl
Untitled, from: The
Kingdom of Signs –
Homage to Roland
Barthes, 1984

Gelatin silver print
80 x 80 cm
ML/F 1986/179

Between 1957 and 1959 Erika Kiffl studied under Joseph Fassbender at the Technical College of Krefeld. Thereafter, until 1961, she studied graphic arts, layout and photography under Walter Breker at the Arts Academy of Düsseldorf. Until 1965 she was art director of the magazine *Elegante Welt* in Düsseldorf. Since 1978 she has been a freelance photographer. The Museum Ludwig owns several of her works of the late seventies showing artists in their studios and still-life pictures. Erika Kiffl has been dealing with this topic for 20 years. "Artists' studios and what takes place there have always held an exceptional fascination which both paralyzed and inspired me." In 1990 the "Rounds 1979 – 1989" was published, presenting a selection of over 600 photographic works resulting from photos of this art academy. Scenes in studios appear sensitive and discreet. In particular when the artist is not pictured, the atmosphere is shaped by work, transition, and openness. Erika Kiffl's works reflect creativity, be it in the form of an unfinished piece of art, an artist in motion, or material in a space. The works from the group *Stone Age* show excerpts of sculptures photographed by her in museums in Europe and the USA. By emphasizing a part of a sculpture – a dynamic view from below or light cast over parts of it – stones appear to trade their static nature for a moment of dynamism in a temporary release from rigidity brought about by the photographer. *AS*

▲▲ **Erika Kiffl**
Gerhard Richter,
1977

Gelatin silver print
22.5 x 22.5 cm
ML/F 1986/200

▲ **Erika Kiffl**
Joseph Beuys'
Studio, 1978

Gelatin silver print
22.5 x 22.5 cm
ML/F 1986/185

▲▲ **Erika Kiffl**
Ulrike Rosenbach
during her Perfor-
mance: My Power is
my Lack of Power,
1978

Gelatin silver print
22.5 x 22.5 cm
ML/F 1986/182

▲ **Erika Kiffl**
Konrad Klapheck

Gelatin silver print
22.5 x 22.5 cm
ML/F 1986/194

Kimura, Ihei

1901 Shitaya, Tokyo
1974 Tokyo

► Ihei Kimura
Basket Carriers, 1957
Gelatin silver print
26.2 x 17.2 cm
ML/F 1977/389
Gruber Collection

▼ Ihei Kimura
Child in Playpen, 1957
Gelatin silver print
26 x 17 cm
ML/F 1977/401
Gruber Collection

Ihei Kimura learned photography in the autodidactic manner. In 1924 he opened his own photostudio in Nippori, Tokyo. Together with Iwata Nakayama and Yasuo Nojima, both experimental photographers, he founded *Koga* (photo image), a photographic journal. Right from the publication of the first issue *Koga* was intended to be regarded as an instrument of pure photography – away from abstraction and experiment without camera, but aimed at the world of objects and the art of realism called "Shashin". In 1933, together with Yonosuke Natori, graphic artist Hiroshi Hara and others, Kimura founded the "Nihon Kobo" (Japan Studio) Association, which fostered the integration of photography with other crafts. In the first exhibition of the "Nihon Kobo", group action photographs by Kimura were shown. In so doing, the group promoted photography as art for a specific purpose. Within one year of the group's founding, basic discussions among group members led to defections and new foundations. Together with other defectors, Kimura formed "Chuo Kobo". Like "Nihon Kobo", this group stood for realism and the close connection between photography and society, but it took a more radical stance. Following the foundation of the International Society for Culture, an institution for the dissemination of Japanese culture internationally, Kimura became a member of the photographic section in 1934. In 1938 and between 1940 and 1944 Kimura was in Manchuria as a war photographer. In the fifties he worked as a reportage photographer on several trips to Europe. *MBT*

Klauke, Jürgen

1943 Kliding
Lives in Cologne

Jürgen Klauke studied at the College of Art and Design in Cologne and at first worked mainly in the field of drawing. In 1970 he began working with photography, using himself as a model. In 1971, in his book *I and I, Day Drawings and Photographic Sequences,* he provided an insight into his work hitherto. He considered provocation to be an important tool for compelling the consumer of art to contemplate. In his earlier self-portraits he presented himself decorated with the accessories of a society hungry for sex yet incapable of love. Remarkably early on he used himself as an object of the androgynous, a topic which is currently ubiquitously dominant in society, the arts and media. He realized many of his topics in the form of videos, but the photographic sequence remained his central medium. From the very beginning, his sequences dealt with questions of sexuality, the psyche, identity relative to the body and its marketing, seeing his own body only as a stand-in and as an example. Even political behavior, belief in authority and obedience play a part in some of his sequences. Of essence, however, is also the humor which has been added to serious subjects and which ultimately suggests despair, as if laughter were the only way to deal with one's inability to effect change.

His cycle *Formalizing Boredom,* created between 1979 and 1980, was Klauke's breakthrough to international fame. He developed a pictorial language of stricter, yet less transparent rules of behavior that were characterized by isolation and by an inability to communicate, but which were followed by the protagonists who appeared in the pictures. This was the first time he laid out his cycles in the form of multi-part, tabular displays, which added a meditative and simultaneously prosaic tone. In Klauke's art there is an exceptional congruence between work and person or art and life, which other artists often labor strenuously to achieve. With him this is a matter of course and effortless. Klauke frequently gives the impression of being one of the last bastions of rebellious resistance to the excessive laxness and comfort of present-day society. His presence at his performance art has a persuasive effect, because his art and its message are obviously important to him. One of his more recent cycles, *Pro Securitas,* for the first time distanced itself somewhat more from his own person and, at the same time, pursued the goal of penetration and formal strength. By linking a skeletal reduction of forms to monumental size, it is not only the self-portrait that allows an association with relics. *RM*

▲ **Jürgen Klauke**
Formalizing Boredom, 1979–80

Gelatin silver print
each 180 x 110 cm
ML/F 1985/40 I-V

▲ **Jürgen Klauke**
Self-performance,
1972/73

*Gelatin silver print
each 56.8 x 41.9 cm*
ML/F 1987/128

▲ **Jürgen Klauke**
Self-portrait, from:
Pro Securitas, 1987

Gelatin silver print
60.8 x 51.6 cm
ML/F 1993/304

Gruber Donation

Klein, Astrid

1951 Cologne
Lives in Cologne

Between 1973 and 1977 Astrid Klein attended college in Cologne. At the beginning of the eighties, when she went public with her large-format black-and-white works, she struck the nerve of the times. Just as it became fashionable no longer to let photographs stand on their own, but to edit and manipulate them, she presented photographic work that made precise statements, that took a stand and that showed clear reasons for having been manipulated.

Astrid Klein was not striving for painterly effects, for a blurring of photographic contours, but edited her photographs in order to achieve a greater clarity of content. She used mostly already printed, screened images, related them to topics picked up by the tabloid press, cut them out, enlarged, singled them out and reassembled them so that abstract or systematic relationships in the pictures would suddenly become transparent and obvious. Still, there is always a disquieting residue, because editing is obvious, screening is too distinct and the authenticity of

a straight photograph is lost. With her treatment, the message by the press denounces itself as piecework, as pretense and as fiction, containing only fragments of truth. Astrid Klein has maintained and improved this approach to her art for nearly two decades, at times scaled down and then again enhanced and embellished. *RM*

▲ **Astrid Klein**
30.1.33, 1983

Gelatin silver print
126 x 345 cm
ML/F 1983/157

◄ **Astrid Klein**
Installation,
Kunsthaus Kassel,
1983

*Gelatin silver print,
mixed media, wall
painting*
220 x 294.5 cm and
220 x 290 cm
ML/F 1995/22

Donation
Prof. Jacobs

Eine peinigende Vorstellung: daß von
einem bestimmten Zeitpunkt ab die
Geschichte nicht mehr *wirklich*
war. Ohne es zu merken, hätte die
Menschheit insgesamt die Wirk-
lichkeit plötzlich verlassen; alles,
was seitdem geschehen sei, wäre gar
nicht wahr; wir könnten es aber nicht
merken. Unsere Aufgabe sei es nun,
diesen Punkt zu finden, und so lange
wir ihn nicht hätten, müßten wir in
der jetzigen Zerstörung verharren.

Klein, William

1928 New York
Lives in Paris

▲ William Klein
Rome, Guard at
Cinecittà, 1959

Gelatin silver print
27.4 x 30.4 cm
ML/F 1977/418

Gruber Collection

With his shots of the fifties and sixties, William Klein created an uncompromising rejection of the then prevailing rules of photography. His artistic career began in 1948 in Paris, where he trained as a painter. He discovered his passion for photography in the early fifties. Initially Klein utilized it as an abstract tool of expression, but he soon became fascinated with its possibilities for dealing with the real world. In 1954 Alexander Liberman, then art director at *Vogue*, hired the young photographer for his fashion magazine. This launched Klein's career as a fashion photographer, a journey marked by his ambivalent and ironic approach to the world of fashion. He did not want to continue with mundane fashion poses, but wanted to take "at last real pictures, eliminating taboos and clichés". Klein worked with unconventional wide-

◄ **William Klein**
Fashion, around
1960

Gelatin silver print
30.6 x 21.9 cm
ML/F 1977/415

Gruber Collection

▶ **William Klein**
Japanese Action
Painter, 1961

Gelatin silver print
36.5 x 25 cm
ML/F 1977/406

Gruber Collection

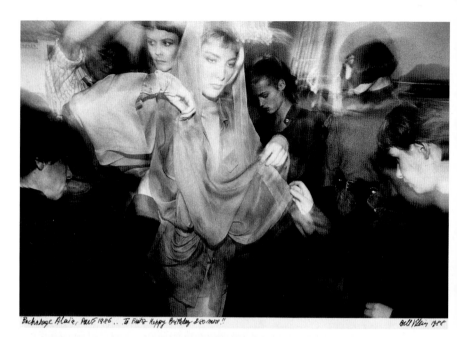

Backstage Alaïe, Paris 1986... To Fritz Happy Birthday & comise!! Bill Klein 1988

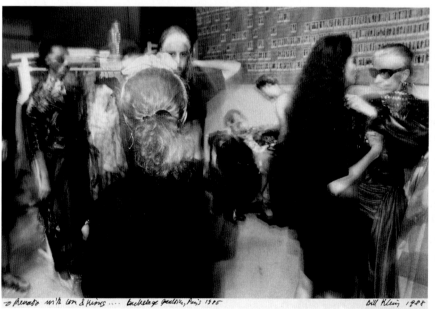

To Renata with love & kisses Backstage Gaultier, Paris 1985 Bill Klein 1988

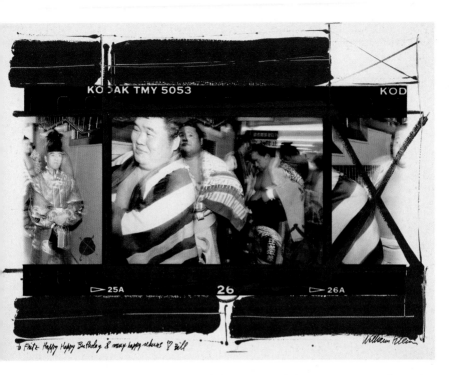

to Fritz Happy Happy Birthday & many happy returns ♡ Bill

angle and telephoto pictures, with unconventional lighting and flash effects and with intentional motion blurs. Although he worked for *Vogue* until 1966, he did not consider fashion photography to be his real calling but rather what he calls "serious photographs". By that he meant uncompromising, unadorned documentaries about large cities like New York, Rome, Moscow, and Tokyo. Books about these cities enabled him to enjoy great successes. Around 1961 Klein gave up still photography – with the exception of a few jobs for newspapers and advertising – in favor of motion pictures. His politically committed and unconventionally produced motion-picture contributions put him in the position of a maverick. Only at the beginning of the eighties did Klein start to take still pictures again. At this time his earlier shots were rediscovered and given recognition. *MBT*

▲ **William Klein**
Entrance to a Sumo Arena, Tokyo, 1987

Gelatin silver print, mixed media
30.4 x 40.4 cm
ML/F 1994/194
Gruber Donation

◀▲ **William Klein**
Backstage, 1988

Gelatin silver print
30.5 x 40.3 cm
ML/F 1993/306
Gruber Donation

◀ **William Klein**
Backstage, 1985

Gelatin silver print
30.3 x 40.5 cm
ML/F 1993/307
Gruber Donation

◀ **Barbara Klemm**
Peter Handke, 1973

Gelatin silver print
28.5 x 39.5 cm
ML/F 1984/146

Gruber Donation

Klemm, Barbara

1939 Münster
Lives in
Frankfurt on Main

Photojournalist Barbara Klemm received her training in a photographic studio in Karlsruhe. At the beginning of 1959 she found employment with the *Frankfurter Allgemeine Zeitung (FAZ)*, starting as an engraver. Since 1970 she has been a photographer on the editorial staff, concerned mainly with the features section and politics. In this capacity Barbara Klemm documents daily events in the fields of economics, politics, and culture. Her works are usually titled only with location and year, a sign of her attitude of being an observer who participates, but who does not take a superior stand by means of an unusual perspective. Barbara Klemm's individual shots depict events of historical value and political arenas which, despite their modesty, illustrate characteristic moods of the moment. Her work, including the travel supplement of the *FAZ* keeps this journalist frequently on the move. The collection includes the photograph *Leonid Breschnev with Willy Brandt* from 1973. The people she photographs act unobserved, the camera appears not to exist. Still, the situations captured by Barbara Klemm are distinguished by their surprising perspectives and moments. Her method of cropping gives a feeling of balance based on aspects of form and composition, irrespective of the spontaneity of the moment when the picture was taken. In the eighties, Barbara Klemm's portraits of artists revealed another dimension of her work. Her photographs of her father, the painter

Fritz Klemm, in 1968, of George Segal in 1971, and of Peter Handke in 1973 place her subjects in their environment from a distance, conveying an impression of their work and attitudes. *LH*

Koelbl, Herlinde

1939 Lindau
Lives in Munich

Herlinde Koelbl is a self-taught photographer who began taking pictures in 1975. She has worked for magazines such as *Stern, Zeit Magazin, New York Times,* and other illustrated magazines. As a photojournalist she traveled to many countries and on one such occasion produced a documentary on the Intifada that included pictures reminiscent of Biblical scenes.

Her artistic work has always focused on publications. The subjects she chose were always treated with a view to publication. Her very first book *The German Living Room* created a sensation in 1980. Without disclosing their full names, she took pictures of well known as well as unknown people in their homes providing a surprising look into their "expanded self". In her publication *Fine People* she removed the mask of High Society after attending receptions, parties, gallery openings, and fashion shows with her camera and by observing not the activities themselves, but the people, their clothes and their behavior. In this way the title proved to be ironic. The book revealed a broad spectrum of not so fine appearances. Ranging from vain self-presentation and greed at

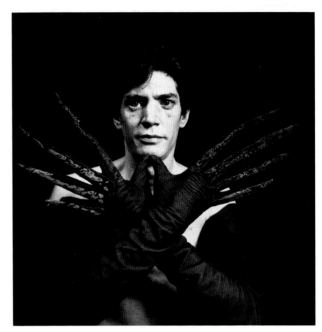

the buffet to older gentlemen who surround themselves with decorative young women, *Fine People* is a book about human weaknesses and vices.

One of her first picture cycles called *Men* caused a furor because it depicted male nudes photographed by a woman. They showed clearly that a woman photographs men in a different manner than a man. This does not involve concentrating only on the gender. There are photographs of intellectuals with bodies untouched by body building, or gentle photographs of old men. Herlinde Koelbl takes pictures not only of bodies, body parts or skin surfaces; she takes pictures first and foremost of human beings, thereby making her male nudes significantly different from the ubiquitous female nudes.

One of her most comprehensive and labor-intensive projects was *Jewish Portraits*. Herlinde Koelbl did not restrict herself to finding Jewish personalities of German intellectual history all over the world in order to make portraits of them. She created her portraits based on an intense dialog, which required that she prepare herself thoroughly with the sub-

▲ **Herlinde Koelbl**
Robert Mapple-
thorpe, 1983

Gelatin silver print
22.7 x 22.6 cm
ML/F 1985/101,
102, 103

Gruber Donation

▲ Herlinde Koelbl
A Light Beat Con-
cerning the Subject
of Man, 1983

Gelatin silver print
15.2 x 21 cm
ML/F 1993/317 A

Gruber Donation

▶▲ Herlinde Koelbl
Gaza Strip, Intifada,
1987

Gelatin silver print
23.7 x 30.3 cm
ML/F 1993/313

Gruber Donation

▶ Herlinde Koelbl
Gaza Strip, Intifada,
1987

Gelatin silver print
23.7 x 30.3 cm
ML/F 1993/312

Gruber Donation

stantial works of her subjects. As a result, *Jewish Portraits* became an overview of still living German-speaking Jewish intellectual greats and also an intelligent introduction to their work as provided by the records of the conversations.

In her most recent, very brief and completely differently conceived – large format – picture sequence of Turkey, she uses the subject of slaughter as a reminder of old myths associated with that topic. Different from the high-tech abattoirs in industrial countries, in the rural areas of Turkey sheep and lambs are still slaughtered ritually as they have been for hundreds of years. With a few large color pictures Herlinde Koelbl seeks to awaken memories of such events in us. *RM*

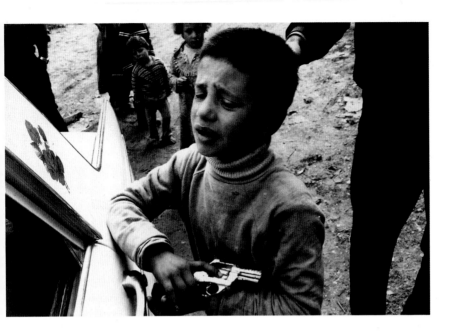

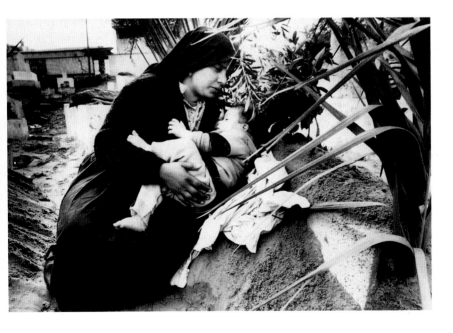

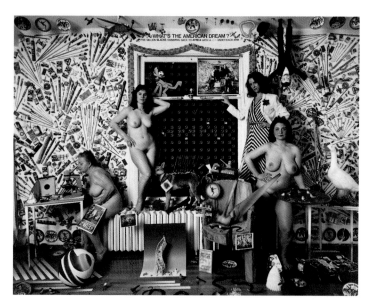

◄ Les Krims
A Marxist View;
Madam Curious;
Bark Art; Art Bark
(for Art Park); a
Chinese Entertain-
ment; Irving's Pens;
Something to Look
at Spotting Upside
Down; Hollis's
Hersheys; and
4 Women Posing,
1984

45.2 x 34.1 cm
ML/F 1995/126

Uwe Scheid
Donation

Krims, Les

(Leslie Robert
Krims)

1942 New York
Lives in New York

Beginning in 1960, Les Krims studied fine arts at the Cooper Union School of Art and Architecture and at the Pratt Institute in New York. He began taking pictures at this time, and by 1966 he had had his first solo exhibition. He held several teaching positions in photography at a number of fine arts colleges. Since 1967 Krims has been working as a freelance photographer. Between 1971 and 1972 he produced three conceptual series, all published at the same time: *Little People of America* describing people of short growth, *The Deerslayers* featuring hunters and *The Incredible Case of the Stack O'Wheat Murders* on imaginary murders. His works are provocative, sometimes exhibiting a rough, dark humor and a disturbing mercilessness. His Polaroid shots of the project *Fictcryptokrimsographs* of 1975 show his sexual fantasies. They are at once grotesque and fascinating. Krims is provocative in order to bare the complexities of the "American Way of Life" and thus to rub salt in the wounds of the observer. *AS*

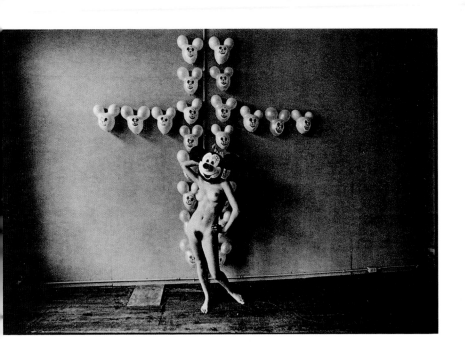

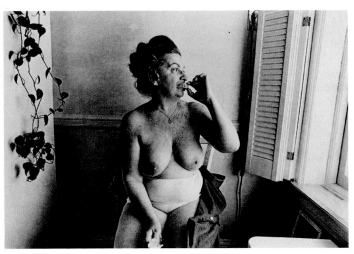

▲ **Les Krims**
The Static Electric
Effect of Minnie
Mouse On Mickey
Mouse Balloons,
1969

Gelatin silver print
11.4 x 17.2 cm
ML/F 1982/1086

◄ **Les Krims**
Untitled (Mummy's
Teeth), 1971

Gelatin silver print
11.4 x 16.8 cm
ML/F 1982/1088

Krull, Germaine

1897 Wilda-Posen,
Poland
1985 Wetzlar,
Germany

▼ **Germaine Krull**
Pont Transbordeur,
Marseille, 1926

Gelatin silver print
19.8 x 14.4 cm
ML/F 1980/2 XI

Germaine Krull left her home in 1916 and moved to Munich in order to study photography. She opened her first portrait studio in Munich in 1919, and one year later she started one in Berlin. During subsequent years Germaine Krull worked in Amsterdam for magazines such as *Der Querschnitt, Die Dame,* and *Varieté.* During her tours of the harbor, the photographer was impressed by the gigantic cranes, which she photographed. When Germaine Krull moved to Paris in 1924, she first worked as a fashion photographer, even though from the very beginning she was interested in the observation of technical constructions and buildings. Germaine Krull's pictures of the Eiffel tower in Paris appeared in the very first issue of the magazine *Vu.* She was one of the first women photographers to create a new type of technical product without spectacular imaging rhetoric. Her first book entitled *Metall* was published in

1927. Germaine Krull's friendship with Sonia and Robert Delaunay, Man Ray, André Kertész, and Eli Lotar created a foundation for close cooperation at various newspapers and on various projects. She received advertising projects from Citroën and Columbia Records. Similarly, she insisted on unconventional realism and shots capturing the moment. During the War Germaine Krull spent time in Brazil and Africa for the organization "France Libre". In 1946 she worked as a war correspondent in Indochina. After 1965 she lived in seclusion in a Tibetan enclave in Northern India, taking hardly any pictures at all. Germaine Krull's last works were small experimental color photographs called "Silpagrams". *LH*

Michel Szulc Krzyzanowski was born in the Netherlands in 1949 as the son of Polish parents. Until 1969 he studied at the St. Joost Academy in Breda and the Royal Academy at Den Bosch. After purchasing a Leica M3 in 1970 he began to concentrate on two subjects. On one hand he produced photographic sequences in black-and-white with details of people in front of lonely landscapes, and on the other hand he devoted himself to sociological reportage. In 1971 Krzyzanowski participated in an exhibition for the first time. In the years that followed, he produced sequences entitled *Women in Camden, London,* in 1972, *People in the Street, s'Hertogenbosch,* and *Living and Working, Arles,* in 1974. The last title refers to a sociological project by Krzyzanowski, for which he took pictures of the same man, at work and at home with his family, in similar poses but with a changed social background. In 1976 he created the sequence *Being Naked, Amsterdam,* and the series *Neem nou Henny.* Krzyzanowski's interest lies in social phenomena, which he examines in a conceptual manner and then brings into an aesthetic form. This aspect is expressed in particular in his last work on authors in Surinam *Deep Rooted Words,* where he expands the sequence into an essay. *LH*

Krzyzanowski, Michel Szulc

1949 Oosterhout, Netherlands
Lives in Amsterdam

▲ **Michel Szulc Krzyzanowski**
Untitled (Nude in the Water), around 1985

Gelatin silver print
19.8 x 29 cm
ML/F 1993/322

Gruber Donation

Kudojarow, Boris

1898 Tashkent,
Usbekistan
1974 Moscow

▲ Boris Kudojarow
October Revolution
Celebration, around
1935–1940

Gelatin silver print
26 x 37 cm
ML/F 1992/153

Ludwig Collection

From 1917 to 1920 Boris Kudojarow was a member of the Red Army, afterwords working for several years as an amateur photographer. Starting in 1926 he became a professional photographer for *Russfoto* (later *Union-foto*). In 1931 he became a foreign correspondent for the magazine *Sojusfoto*. Between 1930 and 1932 Kudojarow was a member of the "October" group, an association of artists of various genres and different avant-garde media. Bold perspectives and cropping place his photographic works of the thirties firmly in the tradition of photographic Constructivism, stylistically oriented to the photographs of Alexander Rodchenko and Boris Ignatowich. During the Second World War Kudojarow became famous for his shots of life in beleaguered Leningrad (now St. Petersburg). After the War he worked as a photojournalist for *TASS. MBT*

▲ **Boris Kudojarow**
Dynamo Soccer
Game, around
1935–1940

Gelatin silver print
23.6 x 38 cm
ML/F 1992/154

Ludwig Collection

◄ **Boris Kudojarow**
Five Young Sports-
women, 1930s

Gelatin silver print
26.2 x 40.1 cm
ML/F 1992/150

Ludwig Collection

► Heinrich Kühn
Alfred Stieglitz, 1907

Gum bichromate print
29.6 x 23.2 cm
ML/F 1977/426

Gruber Collection

◄ Boris Kudojarow
Dakistanes Sitting with Legs Crossed and Drinking Tea, around 1935–1939

Gelatin silver print
36.3 x 25.7 cm
ML/F 1992/155

Ludwig Collection

Already during his school years, at the age of 13, Heinrich Kühn conducted his first photographic experiments by casting collodion plates himself and printing his pictures on salt paper. In 1894 at the "Vienna Camera Club" he met photographers Hugo Henneberg and Hans Watzek. From this meeting evolved a lively and close cooperation. Together they perfected printing with precious materials and introduced color gum bichromate printing into artistic photography. Beginning in 1897 they signed their photographs with a clover leaf. Alfred Stieglitz, among others, was an important partner for Kühn in the exchange of ideas, because both fought for the ideas of artistic photography. Later on their views evolved in different directions. Stieglitz was open to photographic trends influenced by modern art, whereas Kühn appeared to adhere to his ideas that meanwhile had become conventional. In 1914 Kühn attempted to pass on his endeavors by founding a school for artistic photography. *MBT*

Kühn, Heinrich

1866 Dresden
1944 Birgitz, near Innsbruck

▲ **Heinrich Kühn**
Miss Mary, 1908

Gum bichromate print
29.3 x 23.6 cm
ML/F 1977/425

Gruber Collection

► **Hans-Wulf Kunze**
From: Living Spaces,
1982

Gelatin silver print
23.9 x 35.5 cm
ML/F 1991/136

Hans-Wulf Kunze grew up in Magdeburg. Between 1977 and 1982 he studied photography under Helfried Strauß at the College for Graphic Design and Book Art in Leipzig. Then he worked as a freelance photographer in Magdeburg. During this time he created his photographic series *Living Spaces*, in which he offered a spotlight-like insight into the living conditions of people in the former German Democratic Republic (GDR). Kunze developed a photographic concept built on the official doctrine of documentary photography, but with a different outlook. There is no longer a trace of the glorification of the feats of Socialism and a depiction of happy people. His perspective is subjectively critical, the tone of his photographs always gloomy. Kunze created a somber picture of society in the GDR. Beyond the general image of the GDR, he dealt with specific projects in those years, in particular the photographic challenge of various factories and the Mansfeld Combine. In 1991, together with the author Ludwig Schumann he launched the project *Border Spaces*. In 1992 he continued his studies under Helfried Strauß at the College for Graphic Design and Book Art in Leizpig. *RM*

**Kunze,
Hans-Wulf**

1955 Dresden
Lives in Magdeburg

Lange, Dorothea

1895 Hoboken,
New Jersey
1965 San Francisco

▲ Dorothea Lange
Field Worker,
Texas, 1936

Gelatin silver print
24.5 x 32.5 cm
ML/F 1977/440

Gruber Collection

"Hands off! I do not molest what I photograph, I do not meddle and I do not arrange." That was one of the principles of American photographer Dorothea Lange, whose work has provided one of the most committed social documentaries of photography in the 20th century.

Following her studies at Columbia University in New York under Clarence H. White between 1917 and 1919, Dorothea Lange started out as an independent portrait photographer in San Francisco. Shocked by the number of homeless people in search of work during the Great Depression, she decided to take pictures of people in the street to draw attention to their plight. In 1935 she joined the Farm Security Administration (FSA) and reported on living conditions in the rural areas of the USA. In an unflinchingly direct manner she documented the bitter poverty of migrant workers and their families. Dorothea Lange's pictures not only showed the hopelessness and despair, but also the pride and dignity with which people endured their circumstances. One of the most famous and most frequently published photographs of the FSA

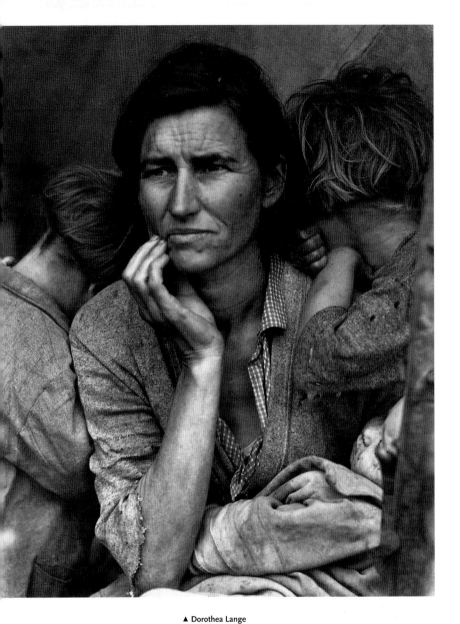

▲ **Dorothea Lange**
Migrant Mother,
California, 1936

Gelatin silver print
32.8 x 26.1 cm
ML/F 1977/442

Gruber Collection

◄ **Dorothea Lange**
Toqueville, Utah,
1953

Gelatin silver print
25.8 x 23.4 cm
ML/F 1977/437

Gruber Collection

project is *Migrant Mother*, the portrait of a Californian migrant worker
with her three children. The face of the young woman is marked by
wrinkles, the gaze full of worry directed in the distance. To the right
and left the two older children, seeking protection, lean against her
shoulders, hiding their faces from the camera, while the small baby has
fallen asleep on its mother's lap. This highly concentrated, tightly com-
posed image has made Dorothea Lange an icon of socially committed
photography. *MBT*

▲ **Dorothea Lange**
White Angel Bread-
line, 1933

Gelatin silver print
31.1 x 25.6 cm
ML/F 1977/435

Gruber Collection

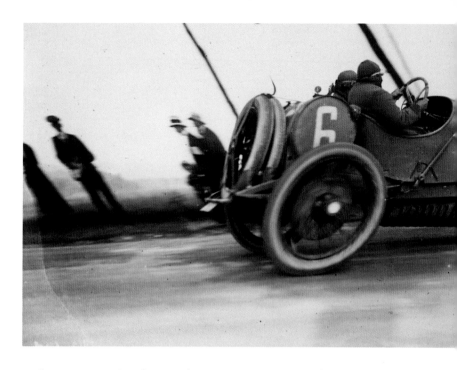

Lartigue, Jacques-Henri

1894 Courbevoie, France
1986 Nice

▲ Jacques-Henri Lartigue
Delaye Grand Prix, 1912

Gelatin silver print
20.8 x 28.7 cm
ML/F 1977/431

Gruber Collection

"People say: 'I do not trust my eyes'. Myself, I always trust them, my eyes. But there are days when they bring me slightly too much astonishment." This was expressed by French photographer Jacques-Henri Lartigue at the age of only 15. His father, a passionate amateur photographer, introduced him to photography when he was only six years of age and had him take his first pictures. Two years later he received his first camera as a gift. From then on he recorded everything he liked. This included the remarkable activities and hobbies of the well-to-do Lartigue family, such as kite-flying, racing with automobiles, home-made motorcycles and steerable bobsleds. Equipped with increasingly better and more sophisticated cameras, Lartigue was able to take his first action shots in 1904. He was particularly fascinated by the possibility of freezing motion in a picture. Accordingly, he photographed friends, members of his family or the household staff at play with a ball, hunting butterflies, playing tennis or simply jumping in the air. Another subject he pursued with passion was airplanes. Between 1908 and 1910 he created a collection of shots of all types of airplanes and numerous pion-

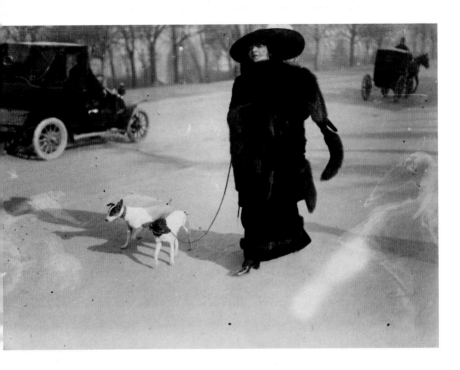

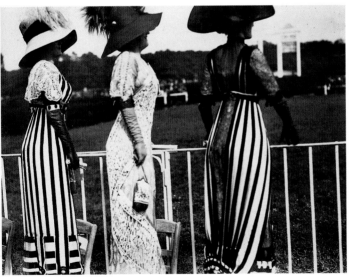

▲ Jacques-Henri
Lartigue
Bois de Boulogne,
1911

Gelatin silver print
21.1 x 29.2 cm
ML/F 1977/430

Gruber Collection

◄ Jacques-Henri
Lartigue
Auteuil, 1912

Gelatin silver print
22.2 x 29.1 cm
ML/F 1977/433

Gruber Collection

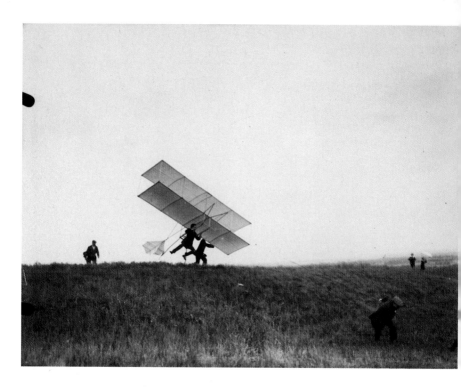

eers of aviation. When the family moved to Pairs in 1911, Lartigue dis-
covered the eccentric world of fashion in the Bois de Boulogne. Cour-
tesans, worldly ladies and actresses became his favorite subjects. In
1915 Lartigue decided to become a painter, which was not, however, a
detriment to his enthusiasm for photography. More and more he de-
veloped into a photographic chronicler of society and cultural life, which
he captured beginning with the Belle Epoque, through Art Déco and
into the eighties. In 1963 Lartigue's work was honored with a large
solo exhibition in the Museum of Modern Art in New York. As a result,
his photographic activities were also recognized internationally be-
cause, significantly, this retrospective was dedicated not to Lartigue the
painter but to Lartigue the photographer. *MBT*

► **Jacques-Henri Lartigue**
Beach Games, Biarritz, 1905

Gelatin silver print
9.3 x 20 cm
ML/F 1977/427

Gruber Collection

Lawler, Louise

1947 Bronxville,
New York
Lives in New York

▼ Louise Lawler
Two Pictures, 1992

Gelatin silver print
42 x 55 cm
ML/F 1994/4a

Ludwig Collection

Louise Lawler belongs to a generation of post-modern artists who revea
the position of art and its mechanisms in modern society. The main
topic of her works is the presentation of art in the context of the world
of art. In her photographic "picture collages" she shows, for example,
works of art in public and private environments and, in so doing, refers
to the place of art and artist's place in the market economy. The artist
introduces a gallery, a museum or a private collection, whereas usually
the opposite applies. She brings the social traditions of art to the fore-
ground – features which determine the function, location, and import-
ance of a piece of art. Photographs such as these, which document the
"Arrangement of Pictures" in private or museum collections, illustrate
the societal purpose to which art is subjected once it has left the artist's
studio. When these so-called installation photographs are shown in mu-
seums or private collections, i.e., when the documentation itself be-
comes art, the problems involved assume an additional dimension.
Who should be credited with the work? The artist herself or the artists
whose works are depicted in the photograph? Or possibly the museum
which acquired the works and has arranged them in a different context?

Did You Get What You Deserved?
More Than You Deserved? Less?

► Louise Lawler
Two Pictures, 1994

Gelatin silver print
42 x 55 cm
ML/F 1994/4b

Ludwig Collection

In this way the mechanisms of presentation are questioned, and the claim of originality has become irrelevant. The reversal of roles illustrated by Louise Lawler's installations and photographic works, however, is of a symbolic nature because it still takes place within a traditional context of art. The relationship between artist and institution is reflected and questioned, but it remains intact. Like a spy, the photographer sabotages the mechanisms of museum presentation of art. At the same time, however, her own works take these mechanisms into account. "An exhibition, that is the selection of pieces of art by a curator, is based on work which has already been accomplished. I believe that the work of an artist is part of a cumulative endeavor. It is 'made possible', presented/recognized by the dominant culture. It is victim (product) as well as perpetrator (producer)", writes Louise Lawler. GG

Lazi, Franz

1922 Munich
1998 Stuttgart

▼ Franz Lazi
Willi Baumeister,
1955

Gelatin silver print
29 x 23.2 cm
ML/F 1977/960

Gruber Donation

Franz Lazi completed his apprenticeship in photography under his father, Adolf Lazi, who is considered to be the "old master" of large-format object photography and who founded the Lazi School in 1950. After completing his training, Franz Lazi was in military service from 1941 to 1945 and an American prisoner of war until 1947. The richness of his understanding and experience is owed to extended studies in the USA. In 1947 he earned his master's diploma in Stuttgart and began working out of his own studio as an independent industrial and advertising photographer. He is a member of the German Society of Photographers, the German Society for Photography and many international photographic associations. The portrait he made of Willi Baumeister substantiates Franz Lazi's interest in dealing with art and the artist. His partially cropped face becomes part of an abstract composition that establishes a relationship with the work of Willi Baumeister. For his many photographic works produced outside Germany, Lazi has received the German Federal Cross of Merit. In addition to participating in many exhibitions he has given lectures in Great Britain, Northern Ireland, Switzerland, and the USA. Since 1965 Lazi has also devoted himself to motion pictures, producing experimental and advertising films, films for television, and films of virgin landscapes. His shots of volcanic eruptions were carried out under sometimes life-threatening conditions, resulting in fascinating images. During this time he has traveled throughout the world, including Greenland and the Antarctic. In 1979 he published his book *Antarctic.* He began taking pictures early on, in particular in color: "I was one of the first photographers after the war who developed their color films themselves." *AS*

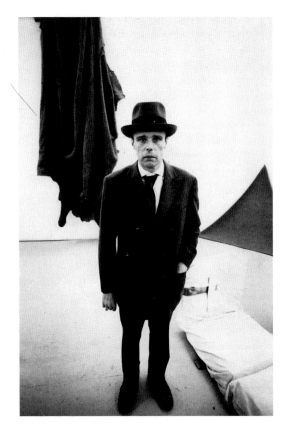

▶ Robert Lebeck
Joseph Beuys, 1968
Gelatin silver print
30.5 x 20.2 cm
ML/F 1977/456
Gruber Collection

Robert Lebeck studied political science in Zurich and in New York. His 23rd birthday was a turning point in his life. On that day his wife presented him with a Retina 1A camera. On July 15 1952, Lebeck had his first photograph published in the *Heidelberger Tagesblatt*. His first great success came in 1955 – the publication of a report in *Revue* magazine. The same year he was appointed director of the Frankfurt office of *Revue*. His breakthrough came in 1960, in Africa, with his work for *Kristall* magazine. In 1966 Lebeck joined *Stern*.

His earlier photographic documentaries in black and white and his later ones in color were produced by this self-taught photographer with a minimum of technology. Pictures like *The Stolen Sabre* or *Robert Kennedy's Funeral* went around the world. Lebeck's photography characterized the style of *Stern* photojournalism in a lasting manner. *NZ*

Lebeck, Robert

1929 Berlin
Lives in Berlin

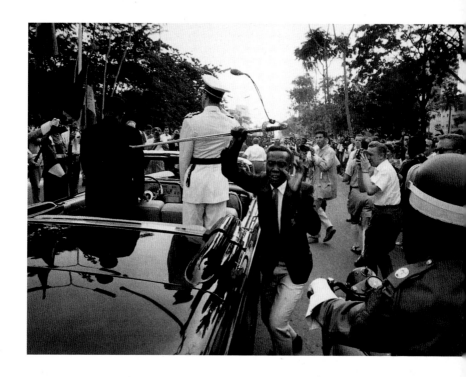

▲ **Robert Lebeck**
The Stolen Sabre,
Leopoldville, 1960

Gelatin silver print
50.7 x 60.7 cm
ML/F 1991/256

▶ **Robert Lebeck**
Robert Kennedy's
Funeral, 1968

Gelatin silver print
23.9 x 30.4 cm
ML/F 1988/61

Gruber Donation

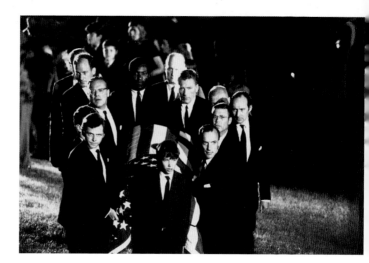

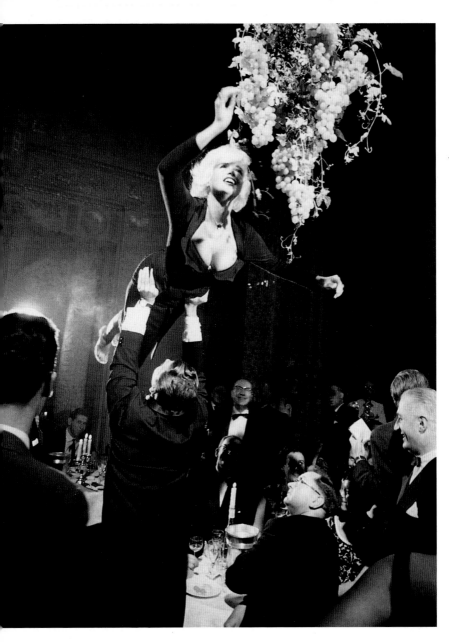

▲ Robert Lebeck
Jayne Mansfield, Berlin, 1961
Gelatin silver print, 61.4 x 50.7 cm
ML/F 1991/257

Lechtape, Edith

1921 Herne
2001 Strasbourg

Between 1941 and 1942 Edith Lechtape trained as an actress under Heinz Moog in Bochum. Afterwards she worked for one year at the German Theater Lille, then at the National Theater in Weimar, the People's Stage in Dresden and the State Theater in Dresden. In the mid-fifties she acted at the Hamburg Studio Theaters and on the city stages of Bochum, Dortmund, Essen, and Wuppertal. She played mostly character roles. For example, she played the parts of Clytemnestra and Mother Courage.

In 1967 she met Antoine Weber, who had been taking an interest in photographic techniques for 20 years. He encouraged Edith Lechtape to turn to photography as well. Since 1972 they have created painted-over and drawn-over photographs. Edith Lechtape went public for the first time at an exhibition in 1974. In 1977 she developed her first sculpture-pictures, which are collages of portrait sculptures which she had photographed. These works incorporate predominantly the parts of her face – eyes and mouth. The works were first shown at an exhibition in 1978. After Weber's death in 1979 she continued her photographic work by herself. Her assembled works appear to resemble a conglomeration of bunched-up paper more than a planned collage. Eyes, mouth, and nose are the only constants. She sees her self-portraits as an extension of her acting, an act of change and disguise, slipping into the most varied faces. *RM*

▼ **Edith Lechtape**
LXVIII/10, 1983

Gelatin silver print
57 x 49.3 cm
ML/F 1990/236

▲ **Edith Lechtape**
LXV/4/Z 6 U, 1983

Gelatin silver print
50.6 x 41.9 cm
ML/F 1990/232

L' ANTENNE
EN HAUT
DE L'ARBRE
ET LE
FUTUR GARAGE
étaient ce que
l'on voyait tout
d'abord en arri-
vant chez le
peintre au début
de son installa-
tion à Étampes
dans les années
1972-1973.

L'INFERNALE ZONE INDUSTRIELLE EN AVAL DE ROUEN
Entre les voies l'endroit où le peintre fut mêlé
à des évènements d'un ordre particulier n'ayant
rien à voir avec l'art et qui,bien que personne
en définitive ne portât plainte contre lui,contri-
buèrent à assombrir cette période de sa vie.
Il ne reviendra à l'art que dans les années 70.

FRONTISPICE DE : "LE PEINTRE AUX SCABIEUSES",
le meilleur ouvrage consacré à l'artiste.
"... J'étais très jeune et prêt à être impressionné
durablement par n'importe quelle forme d'art quand
le hasard me fit passer devant la vitrine d'un mar-
chand de tableaux."

UN PEINTRE PHOTOGRAPHE !
Cette unique photo prise par le peintre au cours
d'un long voyage devait beaucoup amuser les siens
quand la précieuse pellicule une fois développée
fut découverte presque vierge !

Le Gac, Jean

1936 Alès, France
Lives in Paris

Jean Le Gac belongs to a subgroup of Concept Art which became known in the seventies in New York as narrative or story-telling art. On numerous trips the French artist composed diaries and records, documents of the remarkable and everyday. Between 1968 and 1971 his art consisted of performance, travel, and activities documented with photographs, picture postcards, and texts in so-called "notebooks". In the seventies he shifted his interest to the problems of reality and fiction, on which Le Gac produced ironic comments, for example, by intertwining his own biography with the fictitious character of Florent Max. In his series *The Scabious Painter* (1977) he combined photographs and writing. "In the

CE QUI RESTE
DU CHATEAU
DE
ROBERT LE DIABLE
où,parmi les cou-
leuvres lourdes,
lentes,et les lé-
zards à qui il
sifflait pour les
charmer "Gloria,
alleluia...",le
peintre faisait
ses premières po-
chades sur des
cartons de chemi-
serie.

LA MARE PAR TEMPS DE NEIGE(Photo conservée par la famille)
C'est là,qu'une nuit,ils virent au moment de la pon-
te une telle procession de crapauds que le peintre
plein de répugnance,voulant quand même franchir l'
obstacle à grandes enjambées,vit le jeune Storge
descendre de la voiture et comme un petit démon,é-
carter du chemin à pleines mains les étrons vivants.

LE CHEMIN DES DOUANIERS QUI DOMINE
L'ANSE DE THEGUEZ (Finistère)
où à l'âge de quatre ans on retrouva tout en
sang le peintre,grimpé sur un banc,terrorisé
par d'hypothétiques lions !

VU DES REMPARTS L'ETAT ACTUEL DU JARDINET
Le 6 avril 1951 c'est de cet endroit,qu'assis les
pieds dans le vide et dessinant sur un carnet ce
qu'ils appelaient "Les Etranges Figures du Jardin
Roques",qu'un camarade de lycée du peintre tomba
accidentellement et se tua.

linguistic forms of everyday media and tools of illustration he makes the observer a detective in search of the artist's fictitious 'vocation'. He offers the photograph as a means for reporting and, with the installation and film as a tool for simulation, can disclose events, encounters, memories discussed by the corresponding text without disclosing the ficti-tious 'painter'." (Quoted from: Jean Le Gac, "The Phantom Painter", 1992). *GG*

▲ Jean Le Gac
The Scabious Painter,
1977
Color Print
85.5 x 85.5 cm
ML/F 1979/1353 I-VIII

Leibovitz, Annie

1949 Warterbury,
Connecticut
Lives in New York

Annie Leibovitz spent her childhood and youth in different states of the USA. During this time she experienced her first significant encounter with photography by way of her family's photo albums. Her earliest role models among prominent photographers were Henri Cartier-Bresson and Jacques-Henri Lartigue. In 1970 Annie Leibovitz began her studies of fine arts and photography at the San Francisco Art Institute. In the same year she submitted a portfolio to the art director of *Rolling Stone* magazine, Robert Ingsbury, and scored her first success. Jann Wenner, publisher of the magazine, took the young photographer with him to New York, where she was to take pictures during an interview with John Lennon. Within one month her Lennon portraits were published on the cover of *Rolling Stone*. In 1973 Annie Leibovitz became chief photographer of this magazine until she switched to *Vanity Fair* in 1983.

"It is really fun to take pictures with me. Sometimes I put people in mud. Sometimes I hang them from the ceiling." This is how Annie Leibovitz sees herself working. Indeed, her portraits of stars from the world of music, motion pictures, the theater, the arts, literature or politics catch the eye because of their original, lively arrangements. She does not portray a sober, serious hailing of the stars, rather she adds a dose of wit, humor, and irony to the picture. Annie Leibovitz, who is currently considered the American photographer of the stars, prepares her portrait sessions very meticulously and usually consults with her subjects many days prior to the portrait appointment date. Only because of her intense and personal interaction with her models is this photographer successful in cajoling her subjects into the desired, frequently fun and humorous poses. "When I say I want to take a picture of someone, it really means I want to get to know that person."

Annie Leibovitz' photographic sequence of the collector couple Renate and L. Fritz Gruber is undoubtedly an unusual example of her work: she dispenses with all elaborate staging and captures the lovingly embracing couple with an apparently spontaneous "snapshot". *MBT*

Annie Leibovitz
Renate and L. Fritz
Gruber, 1989

Gelatin silver prints
photographs,
ach 21.2 x 25.2 cm
ML/F 1993/324-326

Gruber Donation

Le Va, Barry

1941 Long Beach,
California
Lives in New York

▲▶ **Barry Le Va**
Extensions, 1971

*Gelatin silver prints
18 photographs,
each 16 x 23.5 cm*
ML/F 1985/38

The art of Barry Le Va does not readily follow any particular direction or movement. Rather it is related to ideas and questions posed in other areas such as psychology, physics, or architecture. Between 1969 and 1971 Le Va worked with photography in exterior space. In this context he explored problems of dimensions, the location of the observer, the determination of locality, and position. Le Va's concern was "to use an external situation which is normally not viewed as a cohesive form or mass and create a consciousness for its essential elements – volume, edges, height, length, width – by means of one specific act which I would shoot from different distances" (Le Va). Such "landscape" work represents the attempt to move as far away as possible from the production of objects. The problem of the continuum of space and time plays an important part in this case because this continuum cannot be captured in a physical object. In this manner the process of seeing becomes a subject of its art. It deals with the expansion of the sculptural, which allows a comparison of his work with that of his sculptor-colleagues Richard Serra, Carl Andre, or Robert Morris. *GG*

Leve, Manfred

1936 Trier
Lives in Nuremberg

Manfred Leve grew up in Düsseldorf and studied law, Middle Eastern cultures, art history, and philosophy at universities in Cologne, Freiburg, Munich, and Berlin. Since then he has been working as a lawyer. He is currently employed at the Federal Institute of Labor in Nuremberg.

He has been interested in the arts since his youth and he began observing the art scene in Düsseldorf in his early school days. He already enjoyed photography during those years and began to record art events with his camera. He gained contact with artists and became friends with Sigmar Polke, whose life and work he has documented extensively. He attended the performance and Fluxus concerts at the gallery Parnass in Wuppertal and recorded these unrepeatable events. In the course of the years he developed a comprehensive archive of the art scene around Düsseldorf, including artists' portraits, openings, and performance. Leve's coarse-grained images focus on the fleeting, transient aspects of the moment, and they show that photography is the only medium that can prolong the lifespan of an art event. *RM*

▲▲ **Manfred Leve**
Wolf Vostell at Paik's
Record-Shashlik,
from: Exposition of
Music, Parnass
Gallery, Wuppertal,
1963

Gelatin silver print
23.8 x 16.2 cm
ML/F 1986/125

▲ **Manfred Leve**
Untitled, from: Expo-
sition of Music, Par-
nass Gallery, Wup-
pertal, 1963

Gelatin silver print
16.2 x 23.8 cm
ML/F 1986/127

▲▲ **Manfred Leve**
Untitled, from: Expo-
sition of Music, Par-
nass Gallery, Wup-
pertal, 1963

Gelatin silver print
16.2 x 23.8 cm
ML/F 1986/119

▲ **Manfred Leve**
Nam June Paik,
Karl Otto Götz,
from: Exposition of
Music, Parnass
Gallery, Wuppertal,
1963

Gelatin silver print
16.2 x 23.8 cm
ML/F 1986/106

 ▲ **Manfred Leve**
Untitled, 1986

Color print
50.8 x 60.9 cm
ML/F 1986/215

 ▲ **Manfred Leve**
Sound Object, 1986

Gelatin silver print
16.2 x 23.8 cm
ML/F 1986/117

Lissitzky, El

1890 Portchinok,
near Smolensk
1941 Moscow

▲ El Lissitzky
Composition with
Spoon, around 1924

Gelatin silver print
23.4 x 29 cm
ML/F 1979/1404

Ludwig Collection

As early as the twenties El Lissitzky was one of the outstanding artists of the Russian avant-garde. Trained as an architect, he made a name for himself in painting, typography and photography as an innovative intellectual, contributing significantly to the implementation and dissemination of constructivist and suprematist ideas. He became famous for his *Proun* work. *Proun* was a "project to affirm the new", with which Lissitzky envisioned the utopia of constructing a new space which was also intended to be the symbolic image of a new societal order to be established.

Lissitzky experimented in the field of photography from the early twenties and he was mainly interested in photomontages and photograms. He arranged preferably everyday objects such as spoons, pliers, glasses, and lace doilies on photographic paper, but unlike László Moholy-Nagy, he did not attempt to create an immaterial light space. In an article published in 1929 he summarized his ideas on photogram

▲ El Lissitzky
Composition with
Pliers, around 1924

Gelatin silver print
23.4 x 29.1 cm
ML/F 1979/1405

Ludwig Collection

methodology, in which he acknowledged the greater expressive force of photographic images: "The language of photography is not the language of the painter, and the photograph has properties which are not accessible to painters. These properties are intrinsic in the photographic material itself and must be developed if photography is to be turned into art, into a photogram."

Lissitzky utilized photograms and montages to design advertisements and posters. One of his most monumental projects in the area of photomontage was the photographic frieze he assembled of newspaper clippings and photographs for the Soviet pavilion at the international press exhibition "Pressa" in Cologne (1928). *MBT*

List, Herbert

1903 Hamburg
1975 Munich

▼ Herbert List
Athens, 1937

Gelatin silver print
30.7 x 23.8 cm
ML/F 1977/972

Gruber Donation

Herbert List entered photographic history as a master of the "fotografia metafisica". He started out with an apprenticeship in business and, between 1926 and 1928, traveled to South American coffee plantations, before returning to work as an attorney and partner in his father's business in Hamburg. Besides his profession he was always interested in the artistic life of his environment. At the end of the twenties he discovered his passion for photography. His friend Andreas Feininger, who had just completed his architectural studies at the Bauhaus, introduced him to the technical fundamentals of his field. Fascinated by the paintings of the Surrealists, List took advantage of their ideas and magical image changes in his photographs. He placed objects in alien, unfamiliar contexts or staged encounters between uprooted fragments of reality and attempted "to capture the magic of appearance in the picture". In 1936 political circumstances forced List to leave Germany, his home. Without means he went to London and made his hobby his profession. Already by the end of the thirties he could record a breakthrough as a

successful photographer. In 1937 List and photographer George Hoyningen-Huene traveled to Greece. List's interest in Greek mythology and his preference for Surrealism were especially nurtured among antique ruins. On Lycabettos' hill in Athens he shot a series on the topic of covering and uncovering. An individual covered in a white robe posed in the habit of theatrical stage appearances in the landscape and played with the ambiguity of front and back, male and female. In the case of the picture shown here, List allowed confusion to reign supreme by using a mirror to play reality and its mirror image against each other.

After the War List returned to Germany and settled in Munich,

▲ **Herbert List**
Santorin, 1937

Gelatin silver print
28.5 x 23.1 cm
ML/F 1977/969

Gruber Donation

▲ **Herbert List**
Lycabettos, 1937

Gelatin silver print
28.1 x 23.2 cm
ML/F 1977/971

Gruber Donation

► **Herbert List**
George Hoyningen-
Huene, Glyphada,
1937

Gelatin silver print
28.9 x 22.5 cm
ML/F 1977/968

Gruber Donation

using it as a base for many trips in the years that followed. In 1962
he gave up photography and devoted himself to the collection and
identification of Italian drawings. *MBT*

Lohse, Bernd

1911 Dresden
1995 Burghausen

▲ **Bernd Lohse**
That's Life in the
USA, 1937

Gelatin silver print
16.1 x 23.4 cm
ML/F 1989/94

▶ **Bernd Lohse**
Bookkeeper at the
Minolta Company,
Osaka, 1951

Gelatin silver print
39 x 28.5 cm
ML/F 1985/147

By the age of 14 Bernd Lohse had already established himself as a picture and text author on the subject of photography. Following his studies he began training at Scherl, a large publishing house, where he soon advanced to editor in picture services. His photographic essays appeared mostly in the *Neue IZ* and in the *Berliner Illustrirte*. Soon Lohse was part of a small group of top-notch German reporters.

His topics never included sensational events or the world of politicians and the famous. Instead he strove to present the reader with the characteristics of everyday life in other countries. During World War II Lohse was drafted as a photojournalist. He was wounded and discharged before the war ended, and he moved to Bavaria.

There, in 1946, he was hired as editor of *Heute* magazine. In addition, he produced the *Foto-Spiegel* and later *Foto-Magazin* for Heering, a publishing house. As a reporter he toured Japan, Korea, the USA, and numerous other countries.

In 1955 Lohse became chief editor at a book-publishing company. In addition, in 1964, he and Walter Boje became editors of *Photoblätter* and later of the *Bildjournalist*. After retiring, Lohse devoted himself mostly to

Bernd Lohse
Old Scotland Lives,
1936

*Gelatin silver print
23.5 x 16.5 cm
ML/F 1989/97*

Bernd Lohse
French Married
Couple, 1938

*Gelatin silver print
23.3 x 17.5 cm
ML/F 1989/93*

book reviews. Today his library, the "Visual Collection", is part of the
photographic library of the Museum Ludwig in Cologne. *RM*

Lynes, George Platt

1907 East Orange, New Jersey
1955 New York

Before becoming interested in photography, George Platt Lynes was fascinated by the idea of becoming a writer. He sought contact with the literary avant-garde and, in the twenties, set out to write a novel. In 1925, at the age of 18, he took his first trip to France and, while staying in Paris, became friends with Gertrude Stein, Jean Cocteau, and the painter Pavel Tchelitchew. A desire emerged in him to become the publisher of the most important authors of his time. After his return to New York he actually did publish books by Gertrude Stein, René Crevel, and Ernest Hemingway. In 1927 Lynes, under the guidance of a local professional photographer, began to take pictures of his numerous famous friends. A year later he exhibited these portraits in his Park Place Book Shop. Photography gradually became his profession, and in 1932 he was able to open his first professional studio in New York. One year later he began to publish his portraits and fashion shots in magazines such as

▲ **George Platt Lynes**
Two Nudes, around 1940

Gelatin silver print
24.2 x 19.5 cm
ML/F 1977/482

Gruber Collection

▲ George Platt Lynes
Female Nude by a
Stone Block, 1944

Gelatin silver print
25.1 x 20.3 cm
ML/F 1977/472

Gruber Collection

Town and Country, Harper's Bazaar, and Vogue. Lynes' style took its lead from the European avant-garde and, in particular, Surrealism. In 1942 Lynes left New York, moved to Hollywood and became director of the Vogue studio. In 1947, deeply in debt, he returned to New York. Lynes was unable to regain his earlier commercial success and wealth. During his later years Lynes focused increasingly on erotic male nudes. This brought him neither compensation nor fame, but it increasingly continued to dominate his work. Just before his death Lynes destroyed a large number of his negatives and archived documents because he feared that many of his photographs might be misunderstood. *MBT*

▲ **George Platt Lynes**
Nude in the Mirror, around 1945

Gelatin silver print
19.4 x 24.1 cm
ML/F 1977/470

Gruber Collection

Macků, Michal

1963 Bruntál,
Czech Republic
Lives in Olomouc

▲ Michal Macků
Untitled (No. 6),
1989

Gelatin silver print
51.5 x 64.5 cm
ML/F 1991/101

Michal Macků studied at the Technical Faculty of the Technical College at Brno and then worked at the Sigma Research Institute in Olomouc. Between 1986 and 1989 he studied photography in Prague and at the Public College of Fine Arts in Olomouc. Macků is one of the young Czech photographers who, following their first public exposure in Europe as part of the exhibition "Contemporary Czechoslovak Photography" at the Museum Ludwig in Cologne, were met with immediate enthusiasm and then passed on from one festival to the next, receiving numerous invitations to exhibitions. His pictures of naked people in stretched poses are indeed impressive: the photosensitive layer of the photographic paper has been peeled off, creased, and replaced to give the appearance that the subject's skin has been removed. Macků's expressive experimental photography struck many people's core of current existential fears in a time of political and economic change. *RM*

▲ **Michal Macků**
Untitled (No. 8),
1989

Gelatin silver print
36.8 x 47.8 cm
ML/F 1995/124

Uwe Scheid
Donation

◄ **Michal Macků**
Untitled, 1989

Gelatin silver print
49 x 63 cm
ML/F 1995/248

Uwe Scheid
Donation

◀ **Eva Mahn**
From: Shadow
Images, 1983

Gelatin silver print
48.1 x 48.1 cm
ML/F 1995/123

Uwe Scheid
Donation

Mahn, Eva

1947 Aschersleben,
Germany
Lives in Halle/Saale

Between 1965 and 1970 Eva Mahn studied art history, history, and art pedagogy at Ernst-Moritz-Arndt University in Greifswald and at the University of Leipzig. Then she became an academic assistant in the departments of teaching, research, and publications at the College of Fine Arts and Design, Burg Giebichenstein in Halle. After earning her doctorate she became director of the art collection at the college. Between 1969 and 1974 she collaborated with Günter Rössler in the area of photography and since then she has been active as an independent photographer. For a while she concentrated on erotic photography and on the subject of shadow images. Between 1977 and 1984 she worked for the cultural monthly *Das Magazin*, designed posters, theater programs, and worked in the pharmaceutical industry. Between 1992 and 1993 she participated in the project *Departure to Freedom* which she used to address the situation of young people in East Germany. In 1994 she received a scholarship at the Ahrenshoop Artists' Residence, where she created the series *Cross-border Commuters – Ahrenshoop Portraits*, which dealt with the employment situation after the opening of the border between East and West Germany. Her most recent series again deals with the young generation, which is adapting to the situation quite differently from her own generation. This is a photographic approach to young people following the theme *Departure to Freedom – A Document of Change.* RM

In 1978 Marina Makowski gave up being a book dealer and devoted her-self to the arts. From the very beginning she concentrated on photo-graphy and, one year later, she began to participate in exhibitions. To this day she adheres firmly to the formal creative principles on which her art is based. Her literary roots manifest themselves in her large-for-mat, black-and-white triptychs in the form of text passages of different lengths, which mostly read like excerpts from fantasy or science fiction novels. Yet these are not descriptions that she found somewhere; they are her own, individually tailored to the specific situation shown in a pic-ture. Her severely rastered photographs are mostly taken from video and television movies, and they show the characteristic structures of these media. Her texts and images describe intimidating situations, scenes of threats, and of being exposed. They are about anonymous power, technology devoid of a soul, or a government that monitors everything, where people are pigeonholed, either as blind executive power or as victims. *RM*

Makowski, Marina

Born 1956
Lives in Berlin

ZUM ERSTEN MAL GESTATTETE MAN IHR DIE TEILNAHME AN DEN VERSUCHEN. IHR PLATZ LAG ETWAS ERHÖHT, UND SIE KONNTE AUF DAS GESCHEHEN HINUN-TERBLICKEN, OHNE DIE ANDEREN DURCH IHR DABEISEIN ZU STÖREN. IN DER VOR-HERGEGANGENEN LANGEN ZEIT DES WAR-TENS AUF DIESEN MOMENT HATTEN DIE DINGE (DIE SIE NUN ERLEBTE) IN IHRER VORSTELLUNG EINE MYSTISCHE, IRREALE DIMENSION ANGENOMMEN; STUNDEN-LANG HATTE SIE SICH DIESEN ANGENEH-MEN UND SIE SCHAUDERND MACHENDEN VISIONEN HINGEGEBEN UND FÜHLTE SICH WÄHRENDDESSEN WEIT FORT VON IHREM TATSÄCHLICHEN AUFENTHALTSORT UND DEN DAMIT VERBUNDENEN WIRKLICHKEI-TEN. GLEICHZEITIG EMPFAND SIE IHREN KÖRPER ALS DEN DEUTLICHEN BEWEIS EI-NER ANWESENHEIT, DIE FÜR SIE JEGLICHE BEDEUTUNG VERLOREN HATTE. TATSÄCH-LICH LIESS MAN SIE BEI DIESEM ERSTEN MAL NOCH NICHT WIRKLICH EINBLICK NEHMEN; VÖLLIG AM RANDE STEHEND WAR SIE WEDER DEN TABUS NOCH DEN RI-TUELLEN VORSCHRIFTEN UNTERWORFEN, DIE DEN HINTERGRUND BILDETEN ZWI-SCHEN DER HANDLUNG UND DEM WISSEN DARUM.

◄ **Marina Makowski**
75/86 I-III, 1986

Gelatin silver print
each 79 x 109 cm
ML/F 1990/62 I-III

Toyota Donation

Mantz, Werner

1901 Cologne
1983 Eijsden,
Netherlands

When he was only 14 years old Werner Mantz began to take pictures with an Ernemann camera, and he achieved his first financial success with the sale of his own picture-postcards of the flood disaster of 1920 in Cologne. Following his studies at the Bavarian Education and Research Institute for Photography in Munich, he opened his first studio in Cologne in 1921, where he made portraits and advertising photographs. In 1926 he met Wilhelm Riphahn in conjunction with a project for the Pickenhahn barber salon and within a short period of time became his "house photographer". This led him to the Gemeinnützige Aktiengesellschaft für Wohnungsbau (a residential construction corporation). He subsequently took pictures for all its member architects. In 1968 Mantz withdrew to Eijsden in the Netherlands, where he embarked on his second career as a photographer of children. *RM*

**Mapplethorpe,
Robert**

1946 New York
1989 New York

▲ R. Mapplethorpe
Self-portrait as a
Woman, 1980

Gelatin silver print
35.2 x 35 cm
ML/F 1984/76

Gruber Donation

At first Robert Mapplethorpe wanted to become a musician, but he eventually decided to study painting at the Pratt Institute in Brooklyn. In 1968 he met the singer Patti Smith with whom he moved to the now legendary Chelsea Hotel in Manhattan in 1970. Under the influence of his friend John McEndry, curator for printed art and photography at the Metropolitan Museum of Art, New York, Mapplethorpe began to take an interest in photography, collecting old photographs. Initially he only made montages from photographs that he found, but in 1972 he began to take pictures with a Polaroid camera.

Mapplethorpe's preferred subjects were classical themes such as still-life scenes, flowers, portraits, and nudes, all of which he recorded in rigorous compositions with an extremely precise photographic style. He caused a sensation in particular with his nudes, which defined eroticism and homosexuality with a virtually relentless arrogance. The openness with which Mapplethorpe approached in particular the male gender, and which disclosed his own homoerotic tendencies even resulted in the confiscation of his photographs at one of his exhibitions. *MBT*

▲ Robert
Mapplethorpe
Untitled (male
nude), 1980

Gelatin silver print
35.4 x 35.4 cm
ML/F Dep. 1989/208

Jeane von
Oppenheim
Donation

► **Charlotte March**
Satyric Dancer, in
memory of André
Kertész, 1985

Cibachrome print
30.9 x 20.7 cm
ML/F 1991/273

From 1950 to 1954 Charlotte March attended the Alsterdamm School of
Art in Hamburg. Since 1956 she has been an assistant professor at the
Master School of Fashion in Hamburg. In 1955 she spontaneously de-
cided to take up photography, and since 1961 has had her own studio in
Hamburg. She works mostly in fashion and advertising photography in
Germany, France, and England. A series entitled *Girls and Fashion* from
the sixties shows Charlotte March's style. The models frequently look
directly at the viewer. They embody personality, self-confidence, and a
certain aloofness. In 1973 Charlotte March said: "I am uninhibited
when I take pictures of nude girls. I find that as normal as photograph-
ing a coffee pot. I would be rather more inhibited photographing an un-
dressed man, because of the eroticism between man and woman." Four
years later her book *Man oh Man! A Proposal for the Emancipation of the*

March,
Charlotte

1929 Essen
2005 Hamburg

▲ **Charlotte March**
Trevor in Bathing
Trunks for "twen"
magazine, 1967

Cibachrome print
61 x 50.8 cm
ML/F 1991/280

Attractive Man was published. In this book we read: "A beautiful man is still suspect. In particular, of course, among men." She took photographs of men in all kinds of poses: in the style of classic pin-ups, childlike playing with rabbits, like fauns cavorting through nature, stripping, swimming, in bed. The descriptions deal with the subject in the liberated speech of the seventies as cultivated by magazines like Pardon and twen. Nude men – photographed by a woman – caused this book to become quite a sensation. AS

▲ **Charlotte March**
Donyale Luna with Earrings for "twen" magazine, 1966

Gelatin silver print
40 x 39.9 cm
ML/F 1991/276

Gruber Collection

◄ **Mary Ellen Mark**
Untitled, 1972

Gelatin silver print
25.6 x 17.4 cm
ML/F 1994/213

Gruber Donation

Mark,
Mary Ellen

1940 Philadelphia
Lives in New York

After studying art and completing her university studies in photojournalism, Mary Ellen Mark has been working as a freelance photographer since 1966. Her genre is social documentary photojournalism, and her intention is to photograph fringe groups of society in an explanatory and direct style. Her reports are never sensation-mongering, and they always seek to be compassionate and not to denigrate the dignity of those portrayed. This is true of the prostitute in India in her project *Falkland Road* (1981) and of a photographic series of the eighties with children living in the Bronx, the homeless, junkies, and the handicapped. Her technically perfect and creative photos are rooted in the tradition of W. Eugene Smith and Dorothea Lange. In 1994 she was awarded the Erich Salomon Prize by the German Society for Photography (DGPh). AS

► **Mary Ellen Mark**
The Dam Family,
Los Angeles, 1987

Gelatin silver print
26.6 x 26.4 cm
ML/F 1994/212

Gruber Donation

▼ **Mary Ellen Mark**
Women for
Women's Sake, 1972

Gelatin silver print
20.9 x 29.9 cm
ML/F 1994/214

Gruber Donation

Gordon Matta Clark studied architecture at Cornell University in New York and literature in Paris in 1963. Being an architect, he was interested not only in new buildings but also in the problems of social tensions in cities, the destruction and demolition of buildings. In his work he combines drawing, sculpture, architecture, photography, motion pictures, and performance art. In the early seventies he made movies of demolition events and from 1973 photographed sections of houses. Empty buildings, just before being torn down, were his subjects. His intervention snatched them from oblivion and made them a reference to history and to the destruction of their continuity. The *Office Baroque* project was created in 1977 in an abandoned office building in Antwerp in memory of the 400th birthday of Peter Paul Rubens. Because officials would not give him permission to carry out his original changes to the façade of the building, he prepared new plans for its internal rooms. In September he explained: "My first five-story building offered unique opportunities and I wanted to elicit an almost musical phrase, i.e. a fixed set of elements should permeate all the stories. On account of an unexpected event – rings left by a teacup on a drawing – I ended up grouping the piece around two semi-circular areas with slightly different diameters. They began on the first floor and created the guiding motif, limited by floors and the roof. Wherever these circles intersected, a peculiar rowboat-like hole was formed, which changed from one story to the next, defined by beams and existing space. In this project, now called 'Office Baroque', the arrangement of large spaces (large, open offices at the bottom; small interconnected rooms at the top) defines how the formal elements of uninterrupted round disks change into shrapnel-like splinters and pieces, in particular in the areas where they abut to borders and walls. In addition to the element of surprise and the loss of orientation caused by this work, it provides a particularly satisfying intellectual model." At the same time, the photographic work is reflected formally by the "splittings" of the house – the film material was cut into pieces and reassembled: "The camera is not meant to capture the moment but act as a stage for a plot which has not yet been completed." *AS*

► Gordon Matta Clark
Office Baroque, Antwerp, 1977

Cibachrome print
102 x 77 cm
ML/F 1983/1

Maywald, Willi

1907 Kleve
1985 Paris

▼ **Willi Maywald**
Jacques Heim,
Fashion Photo-
graphy, 1950s

Gelatin silver print
27.2 x 23.9 cm
ML/F 1993/336

Gruber Donation

From 1925 to 1928 Willi Maywald attended fine arts schools in Cologne and Krefeld. From 1928 to 1931 he studied at the College of Creative Arts in Berlin, earning his living during this time as an assistant in motion picture studios. In 1931 he moved to Paris, where he worked with Harry Meerson, a photographer, until 1934. He then opened his own studio for portraits, journalism, architecture, and fashion. He began collaborating with a number of magazines, including *Femina, Harper's Bazaar, Vogue, Réalités, Picture Post, Life, Elegante Welt,* and *Photo Prisma.* Between the years 1935 and 1942 he spent his summers in Cagnes-sur-Mer where he shot the sequences *Renoir's Garden* and *Monet's Garden* which were first published in *Verve* magazine. Between 1939 and 1940 he was interned in several camps in France. In 1942 he began his portrait series of famous people from the worlds of theater, the fine arts, and literature. Among others, he shot portraits of Marc Chagall, Le Corbusier, Pablo Picasso, Joan Miró, and Jean Cocteau. Between 1942 and 1946 he lived in Switzerland, where he contributed to a number of magazines. Finally, in 1946 he opened a new studio in Paris and became a photographer with Christian Dior. He is equally as famous for his fashion photography as for his portraits – with his artists' portraits being exceptional. In 1949 he compiled them into a book entitled *Artists at Home,* published at the time when an exhibition with the same title was opened, which met with immense public response. Shortly before his death in 1985 Maywald published his memoirs. *RM*

▲ **Willi Maywald**
Dress by Jacques
Fath, 1950s

Gelatin silver print
30.3 x 24 cm
ML/F 1993/343

Gruber Donation

McBean, Angus

1904 Newbridge,
South Wales
1990 Suffolk

▼ **Angus McBean**
Audrey Hepburn,
1951

Gelatin silver print
27.9 x 22.3 cm
ML/F 1977/487

Gruber Collection

Angus McBean discovered his passion for photography when he was quite young. However, before embarking on becoming a professional photographer, he worked in an antiques business in London's West End, where he learned how to restore old furniture. At the beginning of the thirties McBean went to the theater and became successful as a make-up artist and set designer. In 1934 he worked as an assistant in the studio of Hugh Cecil, opening his own studio in London the following year. Soon he earned a reputation as being an excellent theater photographer and portrait photographer of famous actors. At this time McBean's work was marked by wit and great inventive imagination, and his elaborate productions reflected the photographer's interaction with the art of Surrealism.

When the theaters in London were forced to close during World War II, McBean moved to Bath. In 1945 he opened a new studio in London and became number one among British theater photographers. Even after the war he maintained his humorous, surreal style as evidenced by *Self-portrait* from the year 1947: The grinning head of the photographer

appears like a ghost on the stairs. One of his most famous photographs of the post-war era was the portrait of the as yet unknown Audrey Hepburn. She emerges like an antique bust from a desert divided by classical columns. As an advertising poster for a cosmetic product, this portrait was seen in display windows throughout the country and it ultimately provided the young model with access to the motion picture studios of Hollywood, thereby marking the beginning of a meteoric career.

In the fifties and sixties, in addition to his theater photographs, McBean also took numerous photographs for album covers of pop records. His most popular shot

▲ **Angus McBean**
Margot Fonteyn,
1951

Gelatin silver print
37.6 x 29.8 cm
ML/F 1977/485

Gruber Collection

◄ **Angus McBean**
Penelope Dudley-
Ward, 1938

Gelatin silver print
28.8 x 23.9 cm
ML/F 1977/486

Gruber Collection

in this area was undoubtedly his picture of the laughing Beatles as they leaned over the railing of a balcony. This picture traveled around the world on the cover of the LP "Please, Please Me".

In the early seventies McBean sold his house in London and his studio in Islington. A large number of his photographs went to Harvard University. At the age of 70 he finally retired from the business of photography altogether. *MBT*

▲ **Angus McBean**
Self-portrait, 1947

Gelatin silver print
28.8 x 23.4 cm
ML/F 1977/484

Gruber Collection

McBride, Will

1931 Saint Louis,
Missouri
Lives in Frankfurt
on Main

Will McBride started out by studying art and art history in New York. At the same time he trained as an army officer, ending up stationed in Würzburg. Even though he had dealt with photography during his studies, McBride learned to value photography as an independent medium of expression in Germany. His first topic was the life of soldiers in the Würzburg barracks.

In 1956 he took up residence in Berlin as an independent photographer. From there he produced photographic reports for the magazines *Life, Stern, Quick*, and especially *twen*. In the sixties he developed more and more into one of the most significant photographic chroniclers of the political and social scene – especially of student protests – in the Federal Republic of Germany of that era. In this context he not only dealt with public events. Many of his works provide insight into the intimate spheres of human existence.

For him, photography always meant the challenge of people and things, and the capture of continuous change. Not least for this reason, it was characteristic of his working style that he conveyed history with a photo essay in the form of a sequence or series of images.

In 1972 McBride moved to Tuscany where he continued working as a photojournalist. In 1980 he returned to Germany where he resumed painting and sculpting. *MBT*

◄ **Will McBride**
Konrad Adenauer,
1965

*Gelatin silver print
26 x 39.4 cm*
ML/F 1977/905

Gruber Donation

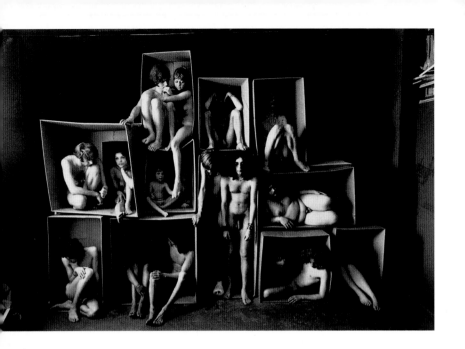

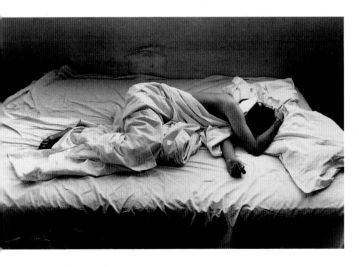

▲ **Will McBride**
Overpopulation,
around 1969

Gelatin silver print
26.7 x 40.5 cm
ML/F 1995/122

Uwe Scheid
Donation

◄ **Will McBride**
Barbara in our Bed,
1959

Gelatin silver print
24 x 37.2 cm
ML/F 1977/489

Gruber Collection

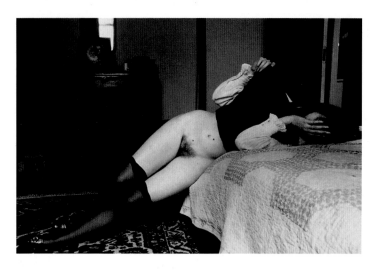

◄ **Duane Michals**
Nude, 1972

Gelatin silver print
12.1 x 17.8 cm
ML/F 1977/513

Gruber Collection

► **Duane Michals**
Paradise Regained,
1968

Gelatin silver prints
6 photographs,
each 16.6 x 24 cm
ML/F 1977/510

Gruber Collection

Michals, Duane

1932 McKeesport,
Pennsylvania
Lives in New York

Duane Michals is not one of those photographers who use photography
to create an image of reality. Instead, he has tried repeatedly to cross
the borders of reality, to blend reality and dream. He himself once said:
"I believe in the invisible. I do not believe in the visible For me, reality
resides in intuition and imagination, and in the small voice in my head
which says: 'Isn't that extraordinary?!'"

Between 1951 and 1953 Michals studied at the University of Denver
and in 1956 attended the Parson School of Design in New York. He took
his first photographs in 1958 on a trip through the Soviet Union. Toward
the end of the fifties he settled in New York as a freelance photographer,
worked for fashion and entertainment magazines such as *Vogue, Es-
quire, Mademoiselle, Show,* or *New York Times,* and specialized in portrait
photography. Even at that time his sense for cryptic, at times dream-like
productions showing his interest in Surrealism manifested itself. In
1963 Michals visited René Magritte, whose paintings he had long found
exciting. The series of portraits of this artist is considered a peak of
Michals' art because he succeeded in portraying not only Magritte the
person but also his world of artistic ideas.

Especially Michals' self-staged photo sequences became famous,
which sought to overcome the restrictions of the single picture. "I was
not satisfied with the individual picture because I could not bend it to
provide additional disclosure. In a sequence the sum of pictures indic-

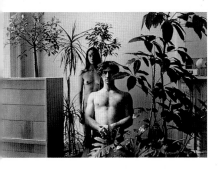 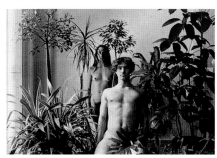

ates what cannot be said by a single picture." Michals used three to fifteen shots to compose picture stories which, however, were not usually complete narrations but mysterious events meant to raise questions and to entice the viewer into further contemplation. By using photo sequences Michals translated picture stories, frequently accompanied by descriptions, of everyday events so ubiquitous in the photojournalism of the fifties and sixties into an artistic statement.

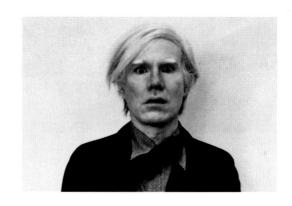

◄ **Duane Michals**
Andy Warhol, 1973

*Gelatin silver prints
3 photographs,
each 8.7 x 12.3 cm*
ML/F 1988/47

Gruber Donation

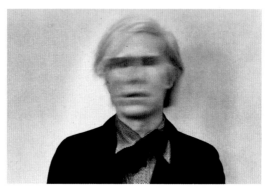

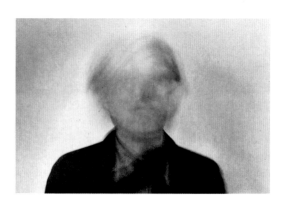

In 1966 Michals began to provide his photographs with hand-written titles which he then expanded into more and more detailed explanations. In some cases they even became independent literary texts. With these verbal elaborations Michals wanted to increase the recognition value of his otherwise strictly visual story-telling skill. At the same time he provided the "mechanical" imaging tool of photography with a personal, graphic touch. Later on he enhanced this effect in his photo-paintings, in which he combined photography with graphics and painting by overpainting his pictures. *MBT*

▲ **Duane Michals**
Ludmilla Tshernina,
1964

Gelatin silver print
12.3 x 18 cm
ML/F 1993/359

Gruber Donation

◄ Antoni
Mikolajczyk
Light-Drawing, 198c

Gelatin silver print
60 x 67 cm
ML/F 1982/1380

Mikolajczyk,
Antoni

1939 Siemianowice,
Poland
Lives in Lodz

Between 1962 and 1967 Antoni Mikolajczyk attended the Visual Arts Department of the University of Torun. From 1964 to 1969 he was a member of the group "Zero 61". Between 1967 and 1969 he was assistant for visual projects at the Visual Arts Department of the University of Torun. Thereafter, from 1971 to 1977, he was a professor at the Academy of Arts at Lodz and since then he has been teaching at the Academy of Arts at Posen. Mikolajczyk deals with space and light in his sculptural as well as his photographic work. His camera captures the motion of light in space, yet in other series, like *Light-Drawings*, it itself moves in order to allow static light to draw lines. In a third variant, the motion of the camera strikes that of space. This results in images of great expressiveness, which includes the use of color. Already in the seventies Mikolajczyk was in contact with Western institutions that staged exhibitions, which is why his work is linked more closely with those artistic traditions than the work of many of his colleagues. *RM*

► Willi Moegle
Ulm, View of the
Cathedral Square,
1933

Gelatin silver print
39.8 x 55.6 cm
ML/F 1985/1

Willi Moegle completed an apprenticeship in chemigraphy. In 1922 he
worked for the State Office for Historical Preservation in Stuttgart and
began to take photographs there. In 1927 Moegle set up his own studio
and took pictures for architects, interior architects, and graphic design-
ers. In 1944 his studio was destroyed during an air raid and he worked
with his step-brother, Arthur Ohler, for five years. In 1950 he was able to
open a new studio of his own, where he mainly took pictures for porcel-
ain and glass manufacturers and also for furniture companies. In the
fifties his reserved factual style impacted the appearance of the advert-
ising of numerous companies in Germany. In 1959 Moegle set up his
studio in Obereichen. He entrusted his long-time associate Hansi
Müller-Schorp with its management. His activities on behalf of the
German Society of Photographers (GDL) have had a lasting influence
on this organization of photographers working in the artistic field. *RM*

Moegle, Willi

1897 Stuttgart
1989 Leinfelden

Ill. p. 438:
Willi Moegle
Silk-Spinning Plant
in Biberach/Riss,
1948–1949

Gelatin silver print
42.5 x 32.8 cm
ML/F 1991/119

Ill. p. 439:
Willi Moegle
Prototypes –
Apothecary Bottles,
1954

Gelatin silver print
59.8 x 35.8 cm
ML/F 1991/125

Moholy, Lucia

1894 Karolinenthal,
near Prague
1989 Zollikon, near
Zurich

▲ Lucia Moholy
Wassily and Nina
Kandinsky in their
Dining Room, 1926

Gelatin silver print
19.4 x 25.1 cm
ML/F 1988/59

Gruber Donation

Lucia Schulz studied art history and philosophy and in 1915 began work as an editor for various newspapers and publishing houses. In 1920 she met László Moholy-Nagy, whom she married in 1921. Beginning in 1922 the couple worked together on photographic experiments. After her husband was called to the Bauhaus in Weimar, Lucia Moholy began an apprenticeship as a photographer and produced numerous portraits of Bauhaus teachers and friends. In 1926 she documented the construction of the new Bauhaus in Dessau and took numerous product pictures for Bauhaus workshops. In 1928 she and Moholy-Nagy went to Berlin, where they continued to work together until their separation in 1929. In 1933 Lucia Moholy emigrated to London. There, in 1933, she published a much-cited cultural history of photography entitled *One Hundred Years of Photography. MBT*

▲ Lucia Moholy
Bauhaus Dessau,
Workshop Wing, 1926

Gelatin silver print
34.7 x 28.4 cm
ML/F 1977/523
Gruber Collection

◀ László
Moholy-Nagy
Bauhaus Balconies,
1925

Gelatin silver print
8.2 x 6.1 cm
ML/F 1977/1144

Gruber Donation

**Moholy-Nagy,
László**

1895 Bácsborsod,
Southern Hungary
1946 Chicago

Although the Hungarian László Moholy-Nagy considered himself a painter and not a photographer, he is now considered as one of the pioneering innovators in photography in the twenties.

Initially Moholy-Nagy had decided on a career as a lawyer, but this plan was interrupted by World War I. In 1914 he was drafted for war duty into the Austro-Hungarian army. During his stay in a military hospital in 1915 he made his first chalk and ink drawings.

After the war he decided to devote himself to the arts entirely and abandoned his legal studies. In 1920 Moholy-Nagy went to Berlin, where he established contacts with the "Sturm" group, dadaists, and constructivists. There he met Lucia Schulz, who was to become his wife and with whom he worked on photographic experiments during the years that followed. He became famous, however, because of his photograms, the earliest of which can be dated back to the fall of 1922.

▲ László
Moholy-Nagy
Ascona, 1926

Gelatin silver print
37.8 x 30.3 cm
ML/F 1977/531
Gruber Collection

Das Tänzerpaar Olly & Dolly Sisters

In 1923 Walter Gropius invited Moholy-Nagy to go to the Bauhaus
in Weimar. There he directed first the metal workshop and then the
preliminary courses after Johannes Itten had left the Bauhaus. Although
there was no independent photographic course at the Bauhaus at the
time of Moholy-Nagy (it was instituted only in 1929 after the arrival of
Walter Peterhans), he is considered to be one of the pioneers of this
medium, becoming the representative of Bauhaus photography per se.
Among other things, he owes this reputation to his publication *Painting,*

Photography, Motion Pictures, which he published in 1925 as the eighth volume of the *Bauhaus Books*.

This constituted the publication of the first definitive text on the topic of photography at the Bauhaus. Moholy-Nagy tried to clarify the relationship between painting and photography, promoting a clear separation between the two media. While he considered painting as creating with color, he used photography for the examination and depiction of the phenomenon of light. For him photography was not mainly an auxiliary tool for intensifying human vision – as was frequently the case in the twenties – but a new artistic medium. In his aforementioned book *Painting, Photography, Motion Pictures* Moholy-Nagy also coined the term "photo sculpture or relief" for his photomontages. He understood them to be the following: "They are composed of different photographs, a [...] method for testing simultaneous illustration, compromising penetration of the visual and the humor of the word, mysterious connection of the most realistic imitative means growing into the imaginary. Yet, they can tell stories at the same time, be concrete, truer to life 'than life itself'."

◀ László
Moholy-Nagy
Joseph and Potiphar
1925

Gelatin silver print
17.7 x 12.4 cm
ML/F 1977/1143

Gruber Donation

▶ László
Moholy-Nagy
Wishful Dreams of
a Girls' Boarding
School, 1925

Gelatin silver print
16.9 x 12 cm
ML/F 1977/1140

Gruber Donation

Ill. p. 450:
László Moholy-Nagy
How Do I Stay
Young and Beautiful
1926

Gelatin silver print
15.4 x 11.8 cm
ML/F 1977/1136

Gruber Donation

After the Bauhaus had moved to Dessau in 1926, Moholy-Nagy remained there for two more years as a teacher, before moving to Berlin in 1928. In 1929 he participated in assembling the famous Stuttgart Werkbund exhibition "Film and Photo" (FIFO), where he himself was represented with 97 photographs, photoreliefs, and photograms. In 1934 Moholy-Nagy emigrated to Amsterdam and from there to London. In 1937 he moved to Chicago, where he became director of the newly founded Association of Arts and Industries design school, which he renamed the New Bauhaus. Only one year later, the New Bauhaus closed down. In 1939 he and other artists founded their own School of Design.

In addition to his artistic work, Moholy-Nagy left behind comprehensive theoretical works dealing with questions of painting and photography. He always endeavored to make photography a medium with the same artistic value as painting. *MBT*

▲ László
Moholy-Nagy
The Spiral Turn of
the Room, 1925

Gelatin silver print
13.4 x 18.3 cm
ML/F 1988/101

Gruber Donation

Ill. p. 452:
László Moholy-Nagy
Photogram, 1924

Gelatin silver print
39.8 x 29.8 cm
ML/F 1971/53

Ill. p. 453:
László Moholy-Nagy
Photogram, 1924

Gelatin silver print
39.7 x 29.8 cm
ML/F 1971/54

Morath, Inge

1923 Graz
2002 New York

▼ Inge Morath
Antonio Ordoñez,
1954

Gelatin silver print
25.4 x 16.8 cm
ML/F 1977/517

Gruber Collection

After studying Romance languages and literature in Berlin and Bucharest, Inge Morath worked as a journalist for the press and radio before turning to photography and studying under Simon Guttman in London, who is considered to be one of the fathers of modern photojournalism. She has been a member of the "Magnum" group in Paris and New York since 1953. Inge Morath has worked with Ernst Haas and with Henri Cartier-Bresson, whose assistant she was from 1953 to 1954. In 1956 she had her first solo exhibition and her first book *War on Sadness*. Photographic journeys took her to Europe, Africa, the Orient, the USA, the USSR, China, Japan, Thailand, and Cambodia. Her photographic reports appeared in well-known magazines such as *Life, Paris Match, Holiday*, and the *Saturday Evening Post*. She has been married to the American author Arthur Miller since 1962. He wrote the text for her book *In Russia* (1969). Inge Morath's photographs are characterized by great sensitivity. In 1975 she herself characterized her work: "Before I tackle a project, I want to know its background, immerse myself in its civilization and at least learn the fundamentals of its language. Then I have more freedom to reach what Cartier-Bresson calls the decisive attitude of the photographer. He took his pictures with one eye open, observing the world through a viewfinder, and the other eye closed, looking into his own soul." *AS*

▶ **Martin Munkacsi**

Torso, 1944

Gelatin silver print
3.8 x 27.4 cm
ML/F 1977/541

Gruber Collection

The Hungarian Martin Munkacsi taught himself photography. His work as painter and sports reporter for a Budapest newspaper was helpful in that endeavor. In 1927 he worked for the Ullstein publishing house in Berlin as a photojournalist for the magazines *Dame, Studio,* and *Berliner Illustrirte.* Later Munkacsi freelanced for international newspapers. In 1933 he emigrated to the USA, where he worked as a fashion photographer for *Harper's Bazaar* and in 1936 he became a full-time staff member of *Life* magazine. In the forties Munkacsi became one of the most highly paid and sought-after photojournalists in the USA. Munkacsi's action shots captured spontaneity and used unconventional viewing angles. He applied his experience in sports photography to fashion photography. He took pictures from extreme angles, frequently bird's eye views, of professional models as well as ordinary people outdoors and in motion. His photographs of masses of people and of individuals appear natural, presenting fashion without artifice in daily life and within real contexts. Until his death Munkacsi was also active as a cameraman and light designer in motion pictures. *LH*

Munkacsi, Martin

(Martin Marmorstein)

1896 Koloszvar, Hungary
1963 New York

Muybridge, Eadweard

(Edward James Muggeridge)

1830 Kingston-upon-Thames, England
1904 Kingston-upon-Thames

▲ Eadweard
Muybridge
Motion Studies/
Animal Locomotion,
Plate 48, 1887

Photo print
32.7 x 25.3 cm
ML/F 1977/543

Gruber Collection

Eadweard Muybridge left England in 1850 in order to seek his fortune in America. There he met the daguerreotypist Silas Selleck, who won him over to this medium. Between 1856 and 1867 he again lived in England, but he returned to San Francisco where he formed a partnership with Selleck in a gallery. He became famous for his landscape views of the Yosemite Valley taken with a large plate camera. These were followed by views of the Pacific Coast, an Alaskan expedition, and his specialization in industrial photography. Muybridge became famous for his motion studies, which he began in 1872 by attempting to capture a galloping horse in photographic pictures. In 1877 he expanded his experiment by placing twelve cameras next to each other in order to be able to record the running horse in all its phases of movement. His books *Animal Locomotion* and *The Human Figure in Motion* appeared during his lifetime. Fastened next to each other and viewed in a zoetrope, photographs became moving pictures for the first time. Muybridge himself used similar equipment to project his images on a screen and is therefore considered to be a pioneer of cinematography. *AS*

In 1884 Moisei Nappelbaum began an apprenticeship at the Boretti Studio. In 1887 he left Minsk and undertook an extensive journey through Russia, Poland, and the USA, where he worked in New York, Philadelphia, and Pittsburgh. In 1895 he returned to Minsk and opened a studio for portrait photography. In 1910 he worked in St. Petersburg for the newspaper *The Sun of Russia*. In 1919, when the government moved to Moscow, Nappelbaum set up the first state photographic studio. In the twenties he participated in many international exhibitions and in the thirties became one of the most successful portrait photographers of famous party leaders and personalities from the cultural and artistic realm. In 1935 he became the only Soviet photographer to receive the title "Artist of Merit of the Republic" for his 50 years of work. In 1958 he published his autobiography *From Trade to Art*. *MBT*

Nappelbaum,
Moisei

1869 Minsk
1958 Moscow

Nauman, Bruce

1941 Fort Wayne,
Indiana
Lives in Pasadena,
California

Bruce Nauman is one of the most significant practitioners of Concept Art in the USA. Although he frequently used photography and film, in particular in the years from 1967 to 1970, he viewed these media merely as forms of documentation for capturing his "Body Art". For Nauman, photography constituted an interesting alternative to traditional media because it offered the advantage of being fast, technologically simple, and (still) unencumbered by the prejudices of the art world.

His *Studies for Holograms* (1970) are based on a 1967 motion picture entitled "Thighing". In 1968 he created his first series of holograms projected on glass and gave it the title *Making Faces*. In 1967 Nauman created a drawing of five unnatural lip positions. On this drawing he wrote the note: "Both lips folded toward the outside; mouth open, upper lip pulled down by the right forefinger; both lips stretched tightly over teeth – mouth open. As above, but with mouth open. Both lips are compressed from the side with the thumb and the forefinger of the right hand." In the series of hologram studies Nauman pulled his face in a similar manner, expanded and stretched in exaggerated forms ending in the absurd. These studies are reminiscent of child's play or abnormal behavior. "I think I was interested in doing something extreme", Nauman said about this work. "Had I only smiled, it would not have been worth a picture. It would have been sufficient to make a note that I did it. I also could have made a list of things which one can do. But then there was the problem with holograms which require an expression strong enough that one would not think so much of the technical aspect."

In a series of motion pictures he explored the problem of hiding behind a mask. About the motion-picture "Art Make-Up" (1967–1968) Nauman said: "'Make-Up' is not necessarily anonymous, but still somehow distorted; something behind which one can hide. It does not advertise or reveal anything. The tension in the work frequently tells of that. One does not get what one does not get."

◀▲ **Bruce Nauman**
Studies for
Holograms, 1970

Screen prints
5 sheets,
each 66.2 x 66.2 cm
ML/F 1970/32 I-V

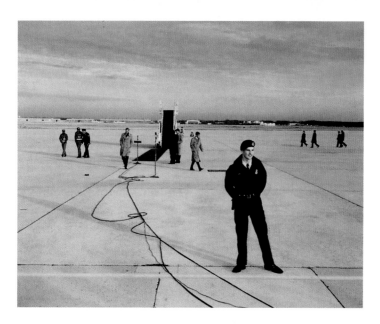

◄ **Angela Neuke**
Secretary General
Gorbachov is
expected, Andrews
Air Force Base,
Washington, DC,
1987

Color print
50.6 x 61 cm
ML/F 1993/363

Gruber Donation

Neuke, Angela

1943 Berlin
Died in 1997

Between 1963 and 1966 Angela Neuke studied photography under Otto
Steinert at the Folkwang School of Creativity in Essen. In 1967 she be-
came independent and worked for various magazines and newspapers.
In 1980 she became a professor at the General College of Essen. Her
series *National Theater – Media Circus* was much acclaimed. Angela
Neuke observed the preparations for the obligatory photographic pic-
tures at official government receptions and similar events. However,
because she did not wait for the backdrops to be finished or take the
prescribed position of the photographers, she documented not only the
expected perspective with staged groupings but also the preparations
for the production. In this way she unmasked the arrangement as such,
denouncing as theater what appears so relaxed and normal in news-
paper photographs. In particular Angela Neuke's color photographs
show a distinctly new language of imaging and a specific topic which
exposes and questions what is apparently known. *RM*

► Floris Michael
Neusüss
Artificial Landscape,
1985

Color print
17.8 x 25.8 cm
ML/F 1988/45

Gruber Donation

Floris Michael Neusüss studied photography at the Arts and Crafts School of Wuppertal and at the Bavarian State Educational Institute for Photography in Munich. In 1960 he completed his photographic training with Heinz Hajek-Halke at the College of Creative Arts in Berlin. Already in 1957 he was interested in free, artistic photography. He began with surreal photomontages and photograms, and, in the seventies, developed the nudogram – life-size shadow outlines of nudes, and later of clothed people.

Since the early seventies Neusüss has been conducting a class for experimental photography at the Art Academy of Kassel. There he founded the college gallery as well as the collection and edition of "Fotoforum" Kassel. Both in theory and practice, he dealt with the relationship of photography and art.

His exhibitions featuring environmental pollution with pictures like *Photo Recycling Photo* and *Photography, Patience, and Boredom* between the years 1982 and 1985 caused quite a furor.

At the beginning of the eighties he created *Artificial Landscapes*, abstract chemical works which looked like reduced excerpts of landscapes or large horizons. Beginning in 1986 he created a new series, his *Night Images*, photographs which are arranged outdoors at night. With his

**Neusüss, Floris
Michael**

1937 Lennep,
Germany
Lives in Kassel

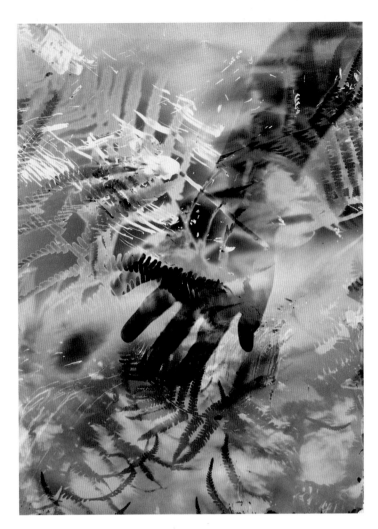

◄ **Floris Michael Neusüss**
Night Images I, 1988

Gelatin silver print
50.5 x 37 cm
ML/F 1993/364

Gruber Donation

artistic work, teaching and publications, Neusüss has significantly stimulated discussion about the imaging tradition of experimental, in particular camera-less, photography. *RM*

◀ **Floris Michael**
Neusüss
Nudogram, 1966

Gelatin silver print
on canvas
231 x 104 cm
ML/F 1979/1155

Gruber Donation

**Newhall,
Beaumont**

1908 Lynn,
Massachusetts
1993 Santa Fe,
New Mexico

Beaumont Newhall studied art history at Harvard University, in Philadel-
phia, and in Paris. Between 1933 and 1934 he was an associate in the De-
partment of Arts and Crafts of the Metropolitan Museum of Art in New
York. In 1935 he became librarian of this museum. During this time he
was able to prepare his legendary exhibition "Photography 1839 to 1937",
which opened to the public in 1937. In conjunction with this exhibition
he wrote and published the catalog *History of Photography*. In it he de-
scribed in an exemplary manner not so much the technical development
of the medium, but rather the artistic accomplishments of the photo-
graphers, their aesthetics and their approaches, from the perspective of
an art historian. *History of Photography* was kept up to date with numer-
ous revisions and new editions until the seventies, and to this day it is
considered to be the standard reference in photographic history.

In 1940 Newhall was placed in charge of the photographic division
of the Museum of Modern Art, working as its curator until 1945. In 1948
he went to the George Eastman House in Rochester, New York, acting
as its director from 1958 to 1971. In 1967 he was one of the founding
members of "The Friends of Photography at Carmel" and he also lec-
tured at various universities. In 1971 Newhall moved to the University
of New Mexico to become a professor of art. *MTB*

Since his childhood and youth, Arnold Newman exhibited a talent for drawing and painting. After completing school he began the study of art at the University of Miami, which he had to interrupt because of financial difficulties. At the age of 20 he took a job in a portrait studio in Philadelphia. This was to be the beginning of his successful career as a photographer. Between 1938 and 1942 Newman concentrated on social documentary work, which he shot in the black districts of West Palm Beach, Philadelphia, and Baltimore. In the early forties he specialized more and more in portraits, becoming the star photographer of artists, literary personalities, musicians, and other famous people. Newman developed his own particular style in this field called the "environmental portrait". This refers to Newman's peculiarity of including in the portrait objects characteristic of the portrayed person and of taking the photograph in an environment typical of that person, thereby associating the subject with his work and with the world of ideas. Newman, who did not want to feel himself restricted to the concept of the "environmental portrait", considered the symbolic content of his pictures to be of particular importance. Of his work he said: "I am not so much interested in documentation, but would like to use the means of the steadily expanding language of my medium to express my impressions of the individual."
MBT

Newman, Arnold

1918 New York
2006 New York

▲ **Arnold Newman**
Igor Strawinsky, 1946

Gelatin silver print
18.3 x 34.4 cm
ML/F 1977/557

Gruber Collection

**Newton,
Helmut**

1920 Berlin
2004 Los Angeles

Helmut Newton, a German by birth living in Monaco under an Australian passport undoubtedly was a cosmopolitan who cultivated this image with relish. The fact that many of his photographs were created in hotel suites is certainly part of this image. Newton trained with Yva, a Berlin photographer who was famous for her fashion, portrait, and nude photographs. Following his training, he spent several years in Australia and Singapore, and then lived in Paris for 25 years. He worked for the French, British, American, and Italian issues of *Vogue*, but also for *Elle, Marie Claire, Jardin des Modes, American Playboy, Nova,* and *Queen*. In addition, he took regular assignments for *Stern* and *Life* magazines.

There are not many photographers who managed to polarize the art world quite like Newton. It is divided into his community of fans, who admire his pictures, and his bitter enemies, who want to qualify him as fashion gadfly or woman-hater. In fact, in fashion, beauty, and nude photography Newton has created a new style which is successful be-

▲ Helmut Newton
They Are Coming,
1981

Gelatin silver print
22.6 x 22.8 cm
ML/F 1984/132

Gruber Donation

cause it betrays a deep sense for the signs of the time. His linking of
offensive self-portrayal and voluntary subjugation with a preference for
tall, large-boned, and self-assured women strikes the nerve of the di-
lemma in which women and the women's movement are still mired –
to have their share of participation in society and still not want to relin-
quish the traditional identity of a woman, or to experience the fact that
the process of redefinition is difficult and painful. Masculine women,
the trend to the androgynous, is his response to the not yet found iden-
tity of the new role. Newton's photography demonstrates the most di-

erse facets of types of women who have developed in this situation. He
did not do this in a critical but in a sensuous manner, thus drawing the
wrath of the women's movement, which has resulted in many a lawsuit.
RM

▲ **Helmut Newton**
They Are Coming,
1981

Gelatin silver print
22.4 x 22.8 cm
ML/F 1984/133

Gruber Donation

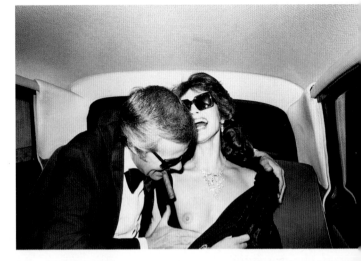

► **Helmut Newton**
Untitled, Paris, 1973

Gelatin silver print
30.3 x 40.5 cm
ML/F 1993/370

Gruber Donation

▼ **Helmut Newton**
Roselyne,
August 1975

Gelatin silver print
90 x 134 cm
ML/F 1990/68

Gruber Donation

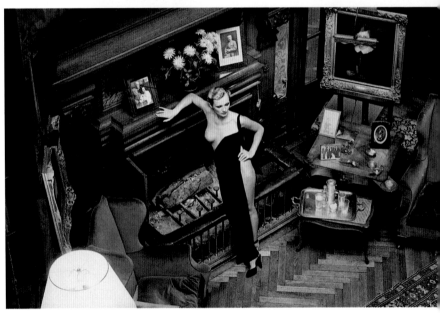

► **Helmut Newton**
Violetta des Bains,
1979

Gelatin silver print
40.3 x 30.3 cm
ML/F 1993/368

Gruber Donation

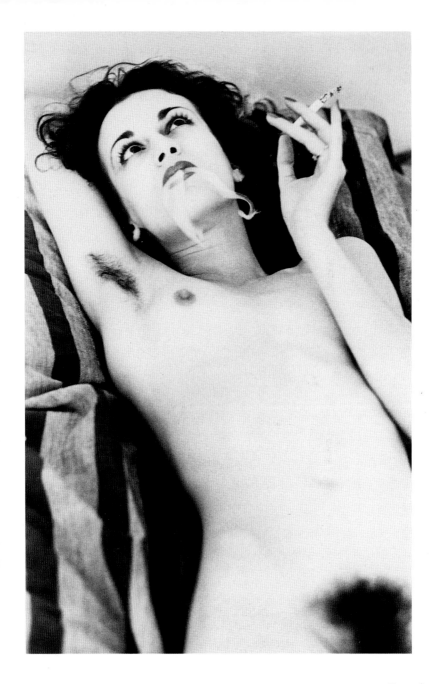

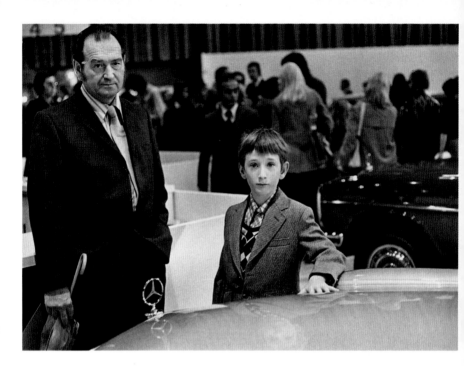

**Nothhelfer,
Gabriele**

1945 Berlin
Lives in Berlin

**Nothhelfer,
Helmut**

1945 Bonn
Lives in Berlin

▲ Gabriele and
Helmut Nothhelfer
Father and Son at
the Industrial Fair,
1974

Gelatin silver print
21 x 29.5 cm
ML/F1985/25

Between 1967 and 1969 Gabriele and Helmut Nothhelfer studied at the Lette School in Berlin and between 1969 and 1970 at the Folkwang School of Creativity in Essen. They have been living in Berlin since then, and in addition to doing freelance assignments they work at the Technical University of Berlin and at the Free University of Berlin. Gabriele and Helmut Nothhelfer have been working on a portrait of the Germans since the early seventies. They photograph them in public, at events, festivities, and demonstrations. Conspicuous in their pictures is the loneliness of those portrayed, even in crowds of people and at happy occasions, at a rock festival, or even while dancing. The stereotypical answer of the satiated post-war German to the question of how things are going becomes evident: "they must". Loneliness as the result of inner emptiness and lack of perspective in times of outward wealth create the tenor of the contemplative mood of the Nothhelfers' photography. *RM*

▲ **Gabriele and
Helmut Nothhelfer**
Dancing Couple
at Whitsuntide
Concert, Berlin, 1974

Gelatin silver print
21 x 29.5 cm
ML/F 1985/24

▶ **Gabriele and
Helmut Nothhelfer**
Roman Catholic
Man, Feast of
Corpus Christi,
Berlin, 1974

Gelatin silver print
21 x 29.5 cm
ML/F 1985/23

◄ **Hilmar Pabel**
Heinrich Böll in
Prague, 22 August
1968

Gelatin silver print
41.1 x 59.7 cm
ML/F 1977/564

Gruber Collection

► **Hilmar Pabel**
Returning Home,
1947

Gelatin silver print
top left: 23.9 x 17 cm
top right: 29.1 x 20.6 (
bottom left: 29 x 20.5
bottom right:
29.4 x 20.4 cm
ML/F 1994/14-17

Pabel, Hilmar

1910 Rawitsch,
Silesia
2000 Rimsting,
Germany

Hilmar Pabel grew up in Berlin and studied Germanic languages, liter-
ature and Journalism under Prof. Dovifat between 1930 and 1932. Until
1933 he worked as photojournalist for, among other publications, *Neue
Illustrierte* magazine. He was drafted as a photographer during World
War II and worked primarily for *Signal* magazine. Pabel became famous
worldwide on account of his missing child tracing efforts in cooperation
with the Bavarian Red Cross and Rowohlt publishing company: "Miss-
ing Children Look for their Parents." After the war he began working as
a photojournalist for *Quick* magazine, traveling around the globe and
visiting countries such as Japan, Syria, Indochina, India, Pakistan,
Mexico, the USSR, the People's Republic of China, Saudi Arabia, and
Egypt. In the sixties he worked exclusively for *Stern* magazine, then as a
freelance photographer. His reports on Mother Theresa, the Vietnam
War, and the Prague Spring traveled around the world. Individual fates
on the fringes of world politics were always most important to him be-
cause they reflect the consequences of politics most dramatically. In
1985, 50 years after Sven Hedin, he led a small team along the Silk Road.
Immediately afterwards this indefatigable photographer set himself a
new goal: "Around the world at the age of 80". *RM*

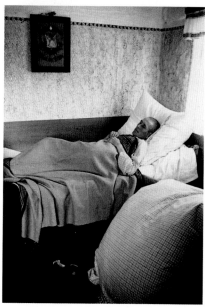

Parkinson, Norman

(Ronald William Parkinson Smith)

1913 London
1990 London

▼ Norman Parkinson
Fashion photograph, around 1965

Gelatin silver print
36.6 x 26.9 cm
ML/F 1977/562

Gruber Collection

Between 1931 and 1933 Norman Parkinson trained with court photographer Splaight Sons. One year later he opened a studio together with Norman Kibblewhite. Parkinson worked for *Harper's Bazaar* magazine and *The Bystander*, a society newspaper. At the end of the thirties this fashion and portrait photographer distinguished himself with new standards of capturing a "natural aura" in his models, and he strove to suggest action and activity in his photographs. Still, Parkinson did not view himself as an artist but as an implementer who knew how to use his camera. Starting in 1945, he spent five years making photographs for *Vogue*. His wife, actress Wenda Rogerson, presented haute couture in Parkinson's new, unpretentious style. Following the European lead, he strove to get away from static photographs. Thus he placed his models in front of unusual props and presented them in special imaging perspectives. For example: hat fashions in front of skyscrapers. Parkinson took a similar approach in his portrait series of famous people in 1951.

One example is the shot of Algernon Blackwood, an author, whose close-up picture was taken on his balcony. The shot of Wenda Rogerson in an exquisite cashmere suit next to a cowboy has a similar surreal effect; attention is drawn by high-contrast confrontation. Parkinson also took portraits of well-known actors and singers such as Audrey Hepburn, the Beatles, and every member of the British royal family. After 1963 he worked as an independent photographer for international newspapers. *LH*

► **Gordon Parks**
Gloria Vanderbilt,
1960

Gelatin silver print
34.3 x 25.9 cm
ML/F 1977/576

Gruber Collection

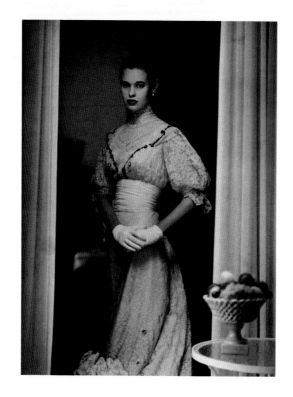

Gordon Parks is the son of a day laborer and he is the youngest of 15 children. He grew up in his sister's house in Minneapolis until his brother-in-law threw him out at the age of 16. He made a living as a busboy and musician until, seeing pictures of the Farm Security Administration and a weekly newsreel with photographer Norman Alley, he bought a used Voigtländer Brillant camera and began to take pictures. He started out with fashion photography and, beginning in 1942, also worked for the Farm Security Administration. Between 1949 and 1970 he worked as a photojournalist for *Life* magazine. He portrayed the lives of people in the Southern United States and in Brazilian slums, as well as those of fashionably dressed rich people in New York and Washington. He portrayed artists and produced a touching report about black leader Malcolm X. His pictorial reports from the slums of Harlem, to which he had access being black himself, opened the eyes of white Americans to their own divided country. He became most popular because of his motion

Parks, Gordon

1912 Fort Scott,
Kansas
2006 New York

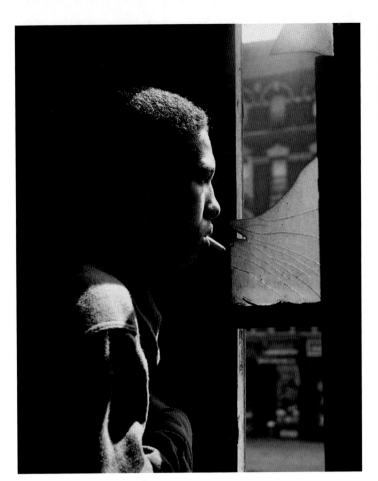

◀ **Gordon Parks**
Red Jackson in "The
Harlem Gang Story",
1948

Gelatin silver print
24.2 x 19.1 cm
ML/F 1977/575

Gruber Collection

pictures, in particular "The Learning Tree" of 1969, and because of his
mystery stories, which for the first time had a black as hero. Through his
exemplary career, Parks, who could not be hired by Alexey Brodovitch
because of the color of his skin, has contributed greatly to the recogni-
tion of blacks in American life. *RM*

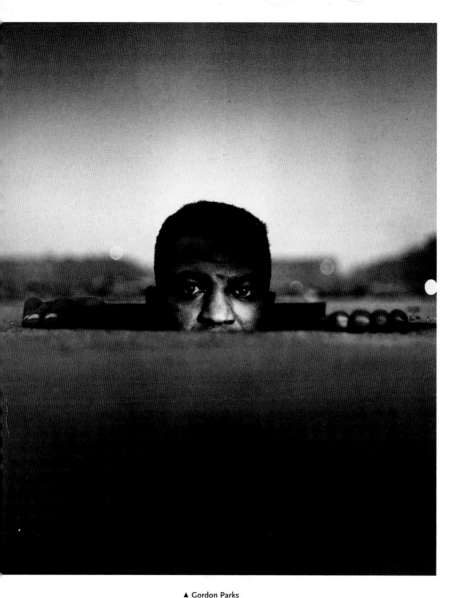

▲ **Gordon Parks**
Portrait of the
Harlem Story, 1948

Gelatin silver print
32.2 x 26.5 cm
ML/F 1977/566

Gruber Collection

Penn, Irving

1917 Plainfield,
New Jersey
Lives in New York

▼ Irving Penn
Jean Cocteau,
Paris, 1948

Gelatin silver print
27.7 x 25.5 cm
ML/F 1977/599

Gruber Collection

After studying design under Alexey Brodovitch, Irving Penn worked as a graphic artist at the Philadelphia Museum School of Industrial Art. In 1938 he moved to New York and began freelancing. In 1943 he produced his first cover picture for *Vogue*, a still life. Since then his photographs have appeared regularly in *Vogue* and other magazines. Since 1951 he has been taking pictures for individual clients all over the world. Like Richard Avedon, Penn is mainly known for his work as a fashion photographer. Unlike his counterparts, Penn is not interested in photography outside the studio, let alone shots in streets and cafés. All his life he has remained faithful to photography in the studio, under very specific lighting conditions, allowing cognoscenti of his work to distinguish between his pictures taken in Paris and those taken in New York. Despite these fundamental differences in approach, Penn also sees the interest in the human being as central to his work. In his fashion photographs, the personality of the model is always given considerable play, so that his pictures at times appear close to being portraits. His series, such as his 1949 assignment for *Vogue* to photograph fashion that is characteristic of the first half of the 20th century in five shots, appear to have been customized for the model – the scene depicting the fifties with the relaxed pose and dress almost allowing us to forget that this is a fashion shot, were it not for the repeated subtle background color.

The significance of this background only becomes clear when one remembers that even his portraits, his series on British and French small business people and skilled workers, his shots of people in Morocco, Benin, or New Guinea feature that background. The background is Penn's stage, on which he allows his models to act. Be it fashion or portraits, he detaches people from their own social context, isolating them to draw greater attention to their idiosyncrasies. Indeed, by con-

▲ Irving Penn
Pablo Picasso, 1957

Gelatin silver print
34.1 x 34.1 cm
ML/F 1977/591

Gruber Collection

sistently using the same background, he both highlights the individual, pulling him or her out of anonymity, and draws to the clothing. For Penn, every piece of clothing, as soon as it is presented on a specific stage, becomes fashion. From the viewpoint of cultural history, this idea can certainly be justified, even if the style of clothing of earlier centuries changed at a somewhat slower pace. In his series of pictures taken of carpenters, lesser employees, and workers in England and France, Penn removed their different uniforms and work-clothes from their practical purpose and presented them as a fashion phenomenon. Likewise, these

◄ **Irving Penn**
Marlene Dietrich,
1950

Gelatin silver print
48.7 x 38 cm
ML/F 1977/581

Gruber Collection

▲ **Irving Penn**
Max Ernst and
Dorothea Tanning,
New York, 1947

Gelatin silver print
24.2 x 19.1 cm
ML/F 1988/27

Gruber Donation

Penn | 485

intentions were expressed in his portraits of native inhabitants of New Guinea, whose tribal dress was defined in terms of fashion. Even the scars on the skin of the girls from Benin are suggested to the viewer in this sense. At the same time, these pictures enhanced the idea of the portrait, with people being perceived as individuals.

Penn published a number of highly acclaimed books. In particular his *Moments Preserved* and *Worlds in a Small Room* caused a sensation in the European world of photography. This was made particularly obvi-

▲ **Irving Penn**
Cecil Beaton, 1950
Gelatin silver print
33.9 x 32.9 cm
ML/F 1977/587
Gruber Collection

◄ **Irving Penn**
The Bonapartist
Armand Fevre, 1950
Gelatin silver print
32.5 x 23 cm
ML/F 1993/374
Gruber Donation

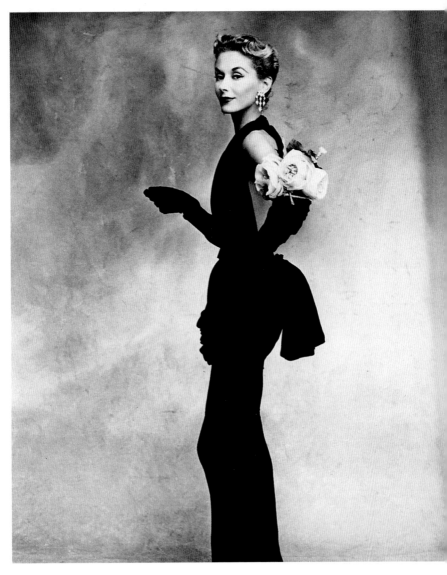

▲ Irving Penn
Lisa with Roses, 1950

Gelatin silver print
41.5 x 34.5 cm
ML/F 1993/378

Gruber Donation

► Irving Penn
Fashion, 1950

Gelatin silver print
47.9 x 35.8 cm
ML/F 1983/130

Gruber Donation

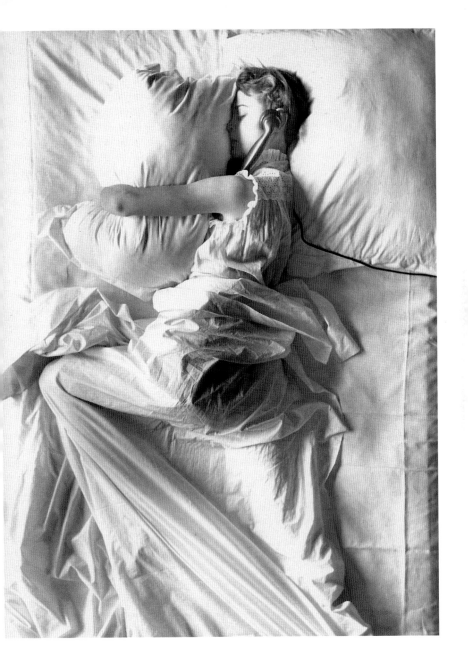

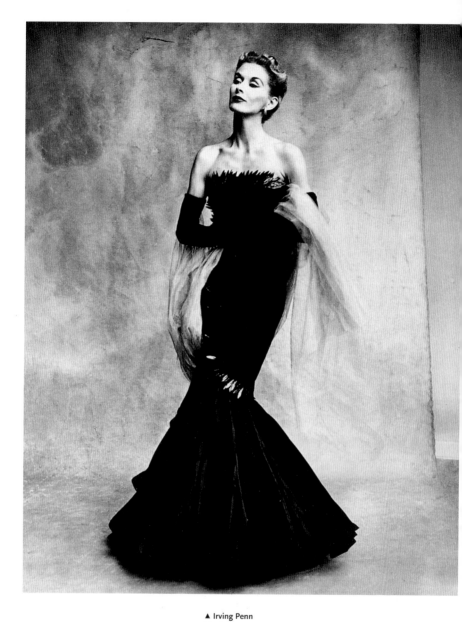

▲ Irving Penn
Lisa Fonssagrives,
1950

Gelatin silver print
39.4 x 31.6 cm
ML/F 1977/579
Gruber Collection

ous by the publication of the retrospective, containing topics in a ran-
dom sequence, which he put together with John Szarkowski in 1984. For
Penn, as for other great photographers of our time, his own photo-
graphic interest and photography performed under contract become
one in the course of the years. He uses these as an expression of a view
of the world, an interest in the medium of photography which offers
the opportunity to approach his fellowman and his environment for dis-
tinctive interpretation. *RM*

▲ **Irving Penn**
The 1910s, 1949

Gelatin silver print
39 x 39 cm
ML/F 1977/590

Gruber Collection

▲ **Irving Penn**
The 1920s, 1949

Gelatin silver print
43.1 x 39.5 cm
ML/F 1977/608

Gruber Collection

▶ **Irving Penn**
The 1930s, 1949

Gelatin silver print
40.9 x 31.8 cm
ML/F 1977/578

Gruber Collection

◄ **Irving Penn**
The 1940s, Dorian
Leigh, 1949

Gelatin silver print
41.9 x 32.8 cm
ML/F 1977/582

Gruber Collection

▲ **Irving Penn**
The 1950s, Dorian
Leigh and Evelyn
Tripp, 1949

Gelatin silver print
38.7 x 38.8 cm
ML/F 1977/584

Gruber Collection

**Petrussow,
Georgii**

1903 Rostow,
Ukraine
1971 Moscow

▼ **Georgii Petrussow**
Caricature of Rod-
chenko, 1933-1934

Gelatin silver print
29 x 40 cm
ML/F 1992/161

Ludwig Collection

Between 1920 and 1924 Georgii Petrussow worked as a bookkeeper in a bank, devoting his spare time to his hobby of photography. In 1924 he moved to Moscow, where he made his hobby his profession by working as a photojournalist for the trade union papers *Metallist* and *Rabochi-chmik*. Between 1926 and 1928 he worked for *Pravda*. Petrussow special-ized in industrial topics. Between 1928 and 1930 he took the post of de-partmental head of information at the Magnitogorsk mine in the Ural mountains, where he produced a documentary about the building of this plant. During subsequent years Petrussow worked as an associate for the newspaper *USSR under Construction*, creating many photo-graphic essays on the subject of heavy industry. In 1931 he joined the group "October" and worked closely with photographers of the avant-garde, to whom he owed significant encouragement. Photographers like Alexander Rodchenko or Boris Ignatovitch affected his style and encour-aged him to use bold perspectives and to experiment with photography – as he did, for example, by using a double exposure for *Caricature of Rodchenko* (1933–1934).

▶ **Georgii Petrussow**
Soldiers with
Helmets, 1935

Gelatin silver print
20 x 25 cm
ML/F 1992/159

Ludwig Collection

During World War II he worked with Petrussow as a war reporter
for the Soviet Office of Information and the newspaper *Izvestiya*. In
April 1945 he reached Berlin with the first troops and used his camera
to document the Soviet occupation of the city. Between 1957 and 1971
he worked in the USA for the newspaper *Soviet Life*, published by the
"Nowosti" press agency. In 1967 he was honored with a solo exhibi-
tion in Berlin. *MBT*

◄ **Georgii Petrussow**
Dam, 1934

Gelatin silver print
54.4 x 41 cm
ML/F 1992/162

Ludwig Collection

► **Georgii Petrussow**
Monument to
Workers and Peasant
Women, around
1936-1937

Gelatin silver print
49 x 36.6 cm
ML/F 1992/163

Ludwig Collection

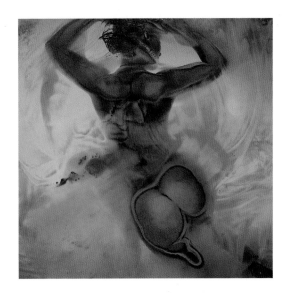

◄ **Wolfgang Pietrzok**
Squashing 127/10 I,
1992

Color print
50 x 50 cm
ML/F 1993/398

Gruber Donation

**Pietrzok,
Wolfgang**

1949 Eilum,
Germany
Lives in Etzling, near
Saarbrücken

Between 1970 and 1971 Wolfgang Pietrzok studied art pedagogy at the
Arts and Crafts School of Hanover, and between 1971 and 1975 he
studied fine arts and art history at the Arts Academy of Kassel. Since
then he has been working as an art teacher, organizer of exhibitions,
and photographer in Saarbrücken and Etzling. In his work Pietrzok has
combined artistic activism and his experience at the Arts Academy of
Kassel with the concept of photo-performance art. Here, the square of
the glass plate proves to be his special universe, in which the body is
reduced to a black imprint or where it appears to have been frozen in
battle, where body parts are reassembled puzzle-like to form a new
physical entity. On a large pane of glass covered with blue ink he has
male and female models take poses that are partly derived from move-
ment, but which nonetheless are the result of the exact planning of his
multi-piece work. To be sure, Pietrzok's work has been affected by the
anthropomorphic images of Yves Klein, but in his case the imprint of
the body is but one element of his photography. Decisive is the photo-
graphic momentum of tension resulting from focus, the absence of fo-
cus, of imprint and transparency. By blurring the color, the image be-
comes a dialog of expressive color tracks, imprints of body parts, which
are often deformed and alienated themselves, and of vague looks at
rounded parts of the body through spots where the glass is blank and

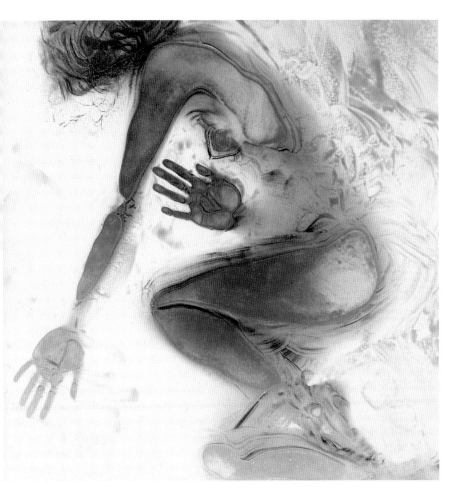

transparent. At times, in particular in his most recent work, the freezing of phases of motion could be called a memory of color that has accurately captured positions and attitudes that have changed in the meantime. Pietrzok's "Ecrasements" are marked by a dance-like ease, whereas deformities and outlines of ribs in his earlier black-and-white work were reminiscent of injuries. In those instances the happy ballet on the square shape inadvertently becomes a dance of death. *TM*

▲ **Wolfgang Pietrzok**
Squashing 20/16, 1989

Gelatin silver print
30.8 x 50.2 cm
ML/F 1993/400

Gruber Donation

Pitz, Fritz

1923 Bocholt,
Germany
2006 Bocholt

▼ Fritz Pitz
Karel Appel, 1964

Gelatin silver print
97.8 x 78 cm
ML/F 1992/11

Donation of the
City of Bocholt

After completing his apprenticeship in his parents' business, Fritz Pitz studied photography at the School of Creative Crafts in Weimar. Following a master program he participated in numerous international exhibitions in the fifties. In 1963 he began his long-term association with the Galerie de France with portraits of artists represented there. These included Henry Moore, Hans Hartung, Emil Schumacher, Salvador Dalí, Paul Delvaux, Lynn Chadwick, Ossip Zadkine, George Mathieu, André Masson and Joseph Beuys. In 1970 he was one of the first photographers to have an opportunity for a show at the Louvre.

Pitz was one of those portrait artists who follow a traditional pattern. His portrait studies dispensed entirely with backgrounds that would allow conclusions regarding those depicted.

Portraits of artists especially often include such hints in the form of a painting or a sculpture. Pitz, however, focused on the face and frequently even cropped the head in order to intensify his approach to physiognomy. He approached faces like a sculptor, modeling heads and facial lines out of the dark with the help of light. The most significant aspect of Pitz' skill was his ability to stand back and to size up the person before him, to challenge and at the same time to put that person at ease in order to elicit the essence of a person. He also employed unconventional darkroom techniques that yielded prints of extraordinary precision and depth. In addition to his portraiture, it was always important to Pitz to create abstract works, to be active as a painter in the realm of surreal expressionism in the circle of the "Cobra" group. *RM*

▲ **Fritz Pitz**
Ossip Zadkine, 1960

Gelatin silver print
97.8 x 87 cm
ML/F 1992/14

Donation of the
City of Bocholt

▲ **Fritz Pitz**
Paul Delvaux, 1965

Gelatin silver print
64.7 x 87.5 cm
ML/F 1992/37
Donation of the
City of Bocholt

▲ **Fritz Pitz**
Henry Moore, 1969

Gelatin silver print
64.7 x 87.5 cm
ML/F 1992/26
Donation of the
City of Bocholt

Pocock, Philip

1954 Ottawa, Canada
Lives in Cologne

▲ **Philip Pocock**
East Berlin, 1984

Cibachrome print
49.5 x 33.9 cm
ML/F 1994/230
Gruber Donation

▲ ▶ **Philip Pocock**
Kreuzberg, 1984

Cibachrome print
49.2 x 33.2 cm
ML/F 1994/213
Gruber Donation

▶ **Philip Pocock**
Mawlianmee, 1989

Cibachrome print
101.6 x 76 cm
ML/F 1994/8
Uwe Scheid Donation

Philip Pocock, a Canadian of Irish descent, completed his formal education at the New York University Film School under Haig Manoogian in 1979. Since then he has been active as an artist in the field of new media. After living in Toronto, Marseilles and New York, he moved to Cologne in 1991, where he has been working ever since. In his early years of artistic development he produced color photographs on Cibachrome, and his first book entitled *The Obvious Illusion: Cibachromes from the Lower East Side* was published in 1982. In 1982 he departed from this type of photographic image reproduction and began to experiment. He developed a completely new type of photochemical painting on Cibachrome, at times painting illusionary versions of baroque paintings with themes such as *Venus* or *Daphne*, but he also experimented with a type of dot painting that was strongly reminiscent of Australian Aboriginal painting. He constantly sought to fuse opposites in his work, as he did in *Mawlianmee*, where he combined pornography and abstraction. *RM*

◄ William Boyd Post

Winter Weather,
from: Camera
Work 6, 1904

Photogravure
15.1 x 16.5 cm
ML/F 1995/36

Gruber Donation

Post, William Boyd

1857 New York
1925 Fryeburg, Maine

William B. Post, a New York financier by profession, was a prominent amateur photographer in the 1890s. His picturesque shots of young ladies in idyllic scenes appeared regularly in the photographic magazines of his time. Shortly after the founding of the "Photo Secession" by Alfred Stieglitz in 1902, he joined this group, whose goal was "to promote photography as a means of artistic expression". One year earlier, in 1901, Post had moved to Fryeburg, Maine, where he focused mostly on two topics: lily-covered lakes and snowy landscapes. Snow was a particular challenge to him, to bring out the subtle nuances of the interplay of light and shadows on the white surfaces. *Winter Weather*, one of this photographer's most famous shots, proves Post's talent for composition. Post boldly positioned the large white area of the snowy field, divided only by a diagonal path, below the lone farm house at the upper edge of the picture. *MBT*

Barry Pringle
Nude, 1977

Gelatin silver print
17.7 x 12.7 cm
ML/F 1984/88

Gruber Donation

Barry Pringle studied at the Guilford School of Arts and later at the Royal College of Arts in London. After completing his studies he began his photographic career and worked with numerous publishing houses. Pringle has devoted himself mainly to two themes: the erotic child picture and the still-life. They are particularly distinguished by the simplicity of their composition. Pringle is interested in the beauty of one single object or a smaller number of similar objects, be they corn cobs or stalks of leeks, and directs his eye at the differences in similar things. The use of lighting is particularly significant in all his photographs, still-life pictures as well as nudes, and it is his specific way of emphasizing his way of seeing things. *RM*

Pringle, Barry

1943 South Africa
Lives in Copenhagen

◄ Jaroslav Rajzík
Apocalyptic Vision ◖
Light, 1988-1989

Gelatin silver print
58.3 x 40.9 cm
ML/F 1990/74

Rajzík, Jaroslav

1940 Hradec
Lives in Prague

Jaroslav Rajzík attended a technical school and then studied photography at the Motion Picture and Television Faculty in Prague. In 1966 he began to teach there. In 1981 he became assistant professor and was head of the Motion Picture and Television Faculty in Prague between 1987 and 1990. In his work Rajzík has pursued the tradition of experimental photography of the twenties. His work concentrates on geometric abstraction, but not so much in the area of camera-less photography, but rather in the arrangement of pure light phenomena and light refraction, a photographic trend originated by Alvin Langdon Coburn, the father of the vortograph. At the same time, his work has roots in the visualism of the seventies and in the geometric light experiments of the Czech pioneer of experimental photography, František Drtikol. Rajzík's adherence to the experimental tradition has been of great importance to Czech photography and it has been particularly fruitful in teaching the younger generation of Czech photographers. *RM*

John Wilsey Rawlings, the fashion, theater and portrait photographer, had a number of different jobs before being hired as an amateur photographer by Condé-Nast. He was sent to England to establish and head the *Vogue* studio there. In 1945 Rawlings moved to New York to open his own studio. In addition to his work for the American edition of *Vogue*, he also wrote photographic books, such as *100 Studies of the Figure*. In 1966 Rawlings published *The Model*, based on more than three years of work with the same model. Rawlings considered it most important for the model to arrive at a pose naturally, so that he would mostly record situations. Rawlings also propagated the art of omission, for example by masking the background. His body studies clearly show that movements can be as characteristic as a look. *LH*

**Rawlings,
John Wilsey**

1912 Ohio
Died in 1970

Ray, Man

(Emmanuel
Rudnitzky)

1890 Philadelphia,
Pennsylvania
1976 Paris

Man Ray first studied art by taking night courses at various schools, including the National School of Design in New York. Between 1908 and 1912 he studied drawing at the Francisco Ferrer Social Center in New York. In 1911 he began to work as a painter and sculptor. He was one of the first abstract painters of the USA and had close contact with the avant-garde of European art. In 1915 he began to turn to photography, working as a freelance photographer, movie-maker, and painter. In 1917 he was co-founder of the New York Dada group. In 1921 he went to Paris, where he worked closely with the surrealists for a number of years. In addition to his artistic activities he accepted commercial projects, especially in the areas of portrait and fashion photography. When the Germans invaded Paris in 1940, he returned to the USA, where he lived in Hollywood until 1950 and where he taught painting and photography. In 1951 he returned to Paris, remaining there until his death.

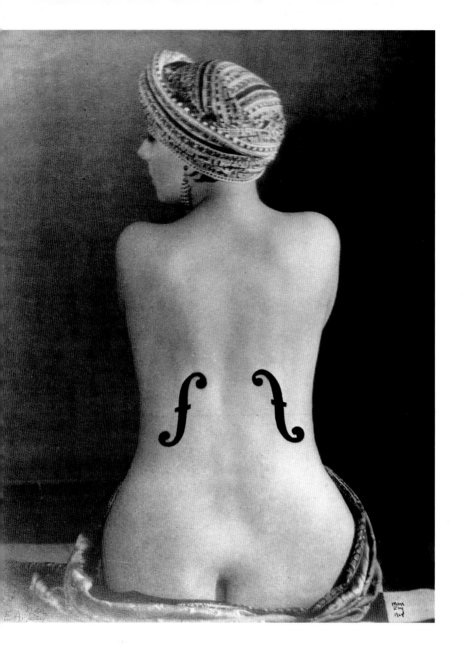

▲ **Man Ray**
Jean Cocteau, 1922

Gelatin silver print
36.5 x 30 cm
ML/F 1977/617

Gruber Collection

▲ **Man Ray**
Pablo Picasso,
1932–1933

Gelatin silver print
29.9 x 23.9 cm
ML/F 1977/632

Gruber Collection

◀ **Man Ray**
Lee Miller, 1929

Gelatin silver print
28.9 x 22.2 cm
ML/F 1977/643

Gruber Collection

▶ **Man Ray**
Lips on Lips, 1930

Gelatin silver print
22.9 x 17.5 cm
ML/F 1977/620

Gruber Collection

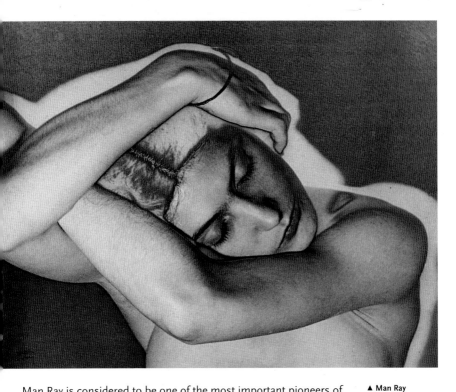

Man Ray is considered to be one of the most important pioneers of contemporary photography. His photographs broke new ground, especially in the experimental sector. Together with Lee Miller he developed the solarization process, which he used mostly in portraits but also in nude photography. With his "rayographs" he provided an important impetus to camera-less photography. His friendship with avant-garde artists of his time paved the way for the recognition of photography in the artistic context. Man Ray is one of the first artists whose photographic works have been valued more in the world of the arts than his paintings or sculptures. *RM*

▲ **Man Ray**
Solarization, 1929

Gelatin silver print
24.6 x 32.4 cm
ML/F 1977/646

Gruber Collection

◄ **Man Ray**
Dora Maar,
around 1936

Gelatin silver print
27.1 x 21 cm
ML/F 1988/39

Gruber Donation

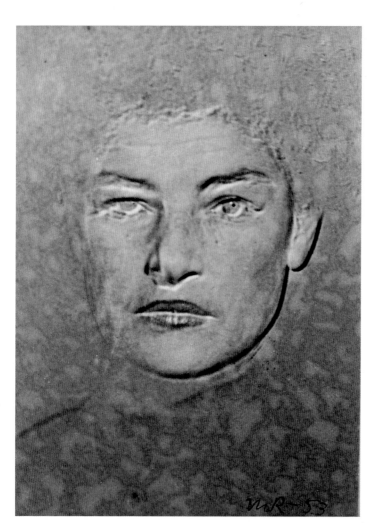

◄ **Man Ray**
Juliet, 1953

Gelatin silver print
17.5 x 12 cm
ML/F 1988/38

Gruber Donation

► **Man Ray**
The Veil, around
1930

Gelatin silver print
27.9 x 21.5 cm
ML/F 1988/37

Gruber Donation

Ill. p. 524:
Man Ray
Max Ernst, 1935

Gelatin silver print
24.9 x 19.8 cm
ML/F 1977/634

Gruber Collection

Ill. p. 525:
Man Ray
Coco Chanel,
1935/1936

Gelatin silver print
22.1 x 15.7 cm
ML/F 1977/621

Gruber Collection

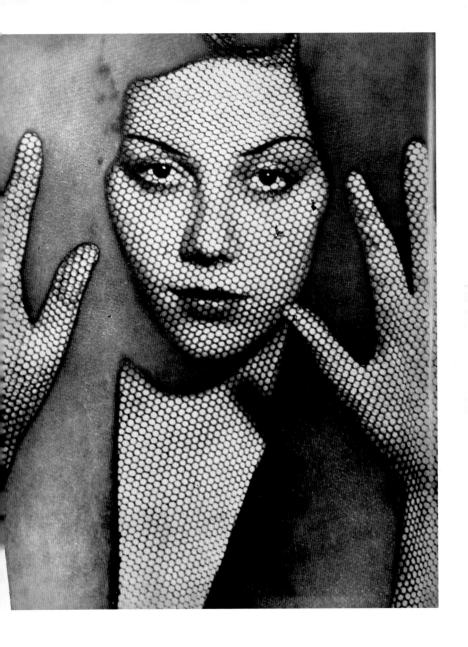

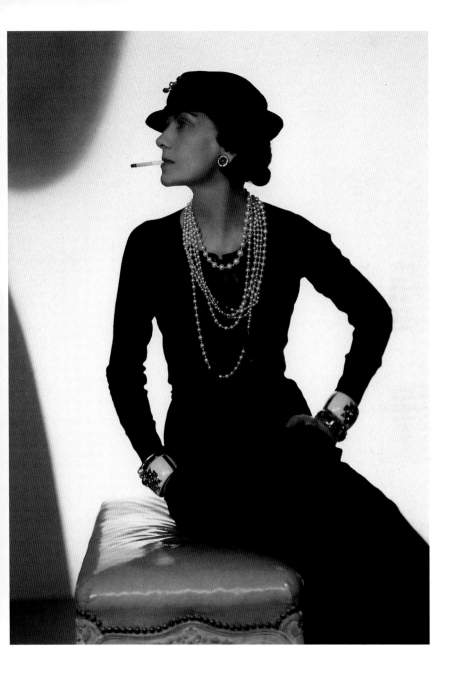

◄ **Man Ray**
Untitled (rear view
of nude), 1920/1934

Gelatin silver print
23 x 17.6 cm
ML/F 1993/408

Gruber Donation

▲ **Man Ray**
Untitled (solarized rear
view of nude), 1920/1934

Gelatin silver print
25 x 20 cm
ML/F 1993/409

Gruber Donation

Relang, Regina

1906 Stuttgart
1989 Munich

Regina Relang's exposure to the arts began at her parents' home. After graduating from high school, she studied painting, first in Stuttgart, later in Berlin and Paris, where she was greatly impressed by Amédée Ozenfant. Following her exams, however, she changed her mind about the teaching career she had planned originally and started to teach herself photography.

In 1933 she began to travel as a photojournalist through Southern Europe. After stays in France, Spain, Turkey, and Corsica, she achieved her first success with a report on "Fishermen in Need" in Portugal. In 1936 she met the stateless Russian Arkadii Kuzmin, who later was to become her husband. After trips to Southern France and Yugoslavia she began to turn to fashion photography in 1938.

She landed a contract with *Vogue* in Paris, London, and New York, and during these years had her first successes with *Shoes Walk Around a Tree* and *The Glove Ballet*. World War II broke out while she was on a photographic assignment in Spain and she returned to Germany, where she worked for Deutscher Verlag, a publishing house in Berlin and Vienna. Between 1940 and 1942 she took pictures for *Die Dame* in Berlin. In 1944 the house where she was born in Stuttgart was completely destroyed. After the war she moved to Munich and opened her new studio.

▼ Regina Relang
Shoes Walk Around
a Tree, 1936

Gelatin silver print
25.6 x 23.8 cm
ML/F 1989/129

During this time she worked with every leading fashion journal and enjoyed particularly good contacts with the magazine *Madame*. In 1951 she began to report twice a year on fashion shows in Paris, Florence, Rome, and Berlin.

After the death of her husband in 1971 she also turned to independent artistic work and, in this regard, was mainly interested in the merging of art and photography. These early examples of staged photography with fashionably dressed models placed in familiar contemporary settings are distinct, in particular because of the rich use of colors. Regina

Relang continued working as a photographer until she passed away. During her later years she donated her collection to the photographic museum at the City Museum of Munich. *RM*

▲ **Regina Relang**
The Glove Ballet,
1936

Gelatin silver print
25.3 x 23.4 cm
ML/F 1989/127

Renger-Patzsch, Albert

1897 Würzburg
1966 Wamel, near
Soest

▲ Albert Renger-
Patzsch
Ring-spinning
Machine, Head-
stock, 1961

Gelatin silver print
22.4 x 16.6 cm
ML/F 1986/240

▲► Albert Renger-
Patzsch
Pipe Air-Release
Valve, 1961

Gelatin silver print
22.3 x 15.6 cm
ML/F 1990/898

Albert Renger-Patzsch, like August Sander, Karl Blossfeldt, or László Moholy-Nagy, was one of the photographers whose name became synonymous with the photography of the twenties. Being a firm opponent of so-called artistic photography, Renger-Patzsch developed a precise photographic style that strove for an exact reproduction of form, which made him a leading German exponent of the factual rendition of industrial and technical subjects. He became symbolic of the contemporary enthusiasm for technical progress and its abundance of new shapes. In publications such as *The World is Beautiful* (1928), *Pioneering Technology* (1928), and *Lübeck* (1928), he couched his industrial photographs in a programmatic context. These pictures are documents and aesthetic guides of a technological age.

As a proponent of factual, realistic photography that should always be subject to its imaging technique, Renger-Patzsch clearly distanced himself from the artistic trends affected by Moholy-Nagy. In the eyes of Renger-Patzsch, who understood photography to be more of a skill, the experiments and new viewpoints of the photographic avant-garde appeared more and more like an artistic fad, and he literally mocked them

▲ **Albert Renger-Patzsch**
Advertising Picture for the
Jena Works, around 1935
Gelatin silver print, 38 x 28.2 cm
ML/F 1977/655, Gruber Collection

► **Albert Renger-Patzsch**
Katharina Mine, 1954

Gelatin silver print
22.4 x 14.3 cm
ML/F 1993/112

◄ **Albert Renger-Patzsch**
Blast Air Heater in
the Herrenwyk
Furnace, 1927

Gelatin silver print
37.8 x 27.9 cm
ML/F 1977/660

Gruber Collection

Ill. p. 534, top left:
Albert Renger-Patzsch
Weeping Willow
Tree, Aasee, Mün-
ster, around 1962

Gelatin silver print
22.5 x 16.4 cm
ML/F 1991/213

Ill. p. 534, top right:
Albert Renger-Patzsch
Reinhard Forest,
Oak Tree, around
1962

Gelatin silver print
22.5 x 16.4 cm
ML/F 1991/216

Ill. p. 534, bottom left:
Albert Renger-Patzsch
Spruce Trees,
around 1962

Gelatin silver print
22.5 x 16.6 cm
ML/F 1991/222

Ill. p. 534, bottom right:
Albert Renger-Patzsch
Fern Beech Tree,
around 1962

Gelatin silver print
22.2 x 16.7 cm
ML/F 1991/219

in his critique of the exhibition "Film and Photo" of 1929: "Their recipe for success: type from the top or from the bottom, maximize or minimize enormously, the trash-can is the most grateful subject."

In 1944 Renger-Patzsch, who lived in Essen at that time, lost his studio during an air raid. After the war he and his family moved to the small village of Wamel near Soest. In the fifties and sixties Renger-Patzsch became well known mostly as a photographer of landscapes and architecture. The fact that he continued to take industrial photographs was not recognized for a long time. Only in 1993 was he honored for this aspect of his later works by the Museum Ludwig in Cologne on the occasion of the exhibition "Albert Renger-Patzsch: Late Industrial Photography". *MBT*

▲ Albert Renger-Patzsch
Bulk Turneny, Card Cylinder, 1950s

Gelatin silver print
16.6 x 22.4 cm
ML/F 1986/250

Rheims, Bettina

1952 Neuilly-sur-
Seine
Lives in Paris

Before becoming a photographer, Bettina Rheims worked as a fashion model, actress, art dealer, and journalist. In 1978 she began making portrait photographs and while doing so, she devoted special attention to black-and-white prints. A series of nudes of fairground strippers and acrobats was published in *Egoïste* in 1980. During the following year she had her first two solo exhibitions, in the Centre Georges Pompidou and nude portraits in the Texbraun Gallery, Paris.

In 1982 she began a series of animal portraits which were exhibited in 1983 in Paris in the Texbraun Gallery and in 1984 in the Daniel Wolf Gallery in New York. She worked for magazines, took her first fashion shots and photographs for record covers and movie posters. From 1984 on, in cooperation with the "Sygma" agency, she created photographic essays and portraits of celebrities. In 1986 she produced a number of advertising films, several video clips, and the leader for a feature film. She worked equally on portraits, fashion, and advertising photographs. At the same time she prepared a retrospective covering ten years of her photographic work for the "Photographic Space in Paris". Accompanying this presentation, which took place in 1987/1988, "Paris Audiovisuel" published a book. Her work was well received by the press and reviews appeared in *Le Monde, Le Figaro,* and *Le Matin.* Various photographic magazines *(Photo, Photographic Magazine, Annual Photography, Collector Photography)* and journals *(Paris Match, Stern)* published portfolios of her work.

In 1989 the Musée de l'Elysée in Lausanne exhibited Bettina Rheims pictures. In the same year her book *Female Trouble* was published in Germany, France, and Japan. Simultaneously, the City Museum of Munich and the Parco Gallery, Tokyo, and Sapporo sponsored exhibitions. In 1990 she completed a series of portraits entitled *Modern Lovers,* which was first exhibited at the Palais des Beaux-Arts in Charleroi, Belgium. The Maison Européenne de la Photographie in Paris opened with this exhibition, and a book with the same title appeared in France, Germany, and Japan. In 1992 *Spies* and *Behind Closed Doors* were published, the latter with a text by Serge Bramly. From 1992 to 1993 *Behind Closed Doors* was shown at exhibitions in the Galerie Maeght in Paris, the Hamiltons Gallery in London, and the Galerie Bodo Niemann in Berlin. In 1994 *Animal* was published and Bettina Rheims received Le Grand Prix de la Photographie de la Ville de Paris. Her work is represented in numerous public and private collections in Europe, the USA, and Japan. *RM*

► **Bettina Rheims**
Claudya with Gloves,
Paris, 1987 From:
Female Trouble,
1989

Gelatin silver print
57.3 x 42.8 cm
ML/F 1995/245

Uwe Scheid
Donation

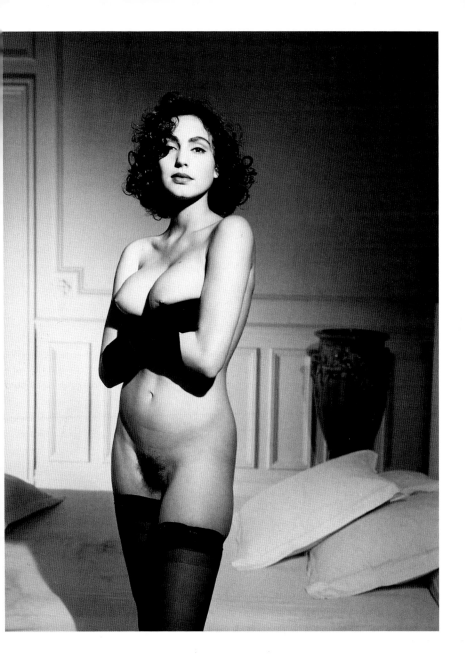

Riboud, Marc

1923 Lyon
Lives in Paris

▲ **Marc Riboud**
Applause for
Churchill, 1954

Gelatin silver print
33.1 x 49.4 cm
ML/F 1977/666

Gruber Collection

▶ **Marc Riboud**
Hunger in the
Congo, 1961

Gelatin silver print
29.5 x 19.7 cm
ML/F 1993/416

Gruber Donation

Marc Riboud's interest in photography began at the age of 14, when his father gave him a Kodak Pocket camera. After having fought in the French Resistance during World War II, he studied mechanical engineering at the Ecole Centrale in Lyon from 1945 to 1948. In 1951 he became a freelance photographer and, in 1952, joined the "Magnum" agency in Paris. In 1959 he became European vice president of this world-famous photographic cooperative and served as its president between 1975 and 1976. Riboud's work stands for sensitive photojournalism reporting on misery from travels all over the world, for example, Africa, China, and Vietnam, not with exposures of great dramatic gestures but with moving insight reaching into small details. Riboud performs his journalistic work not only in classic black-and-white but also in color, where exquisite composition and finesse of color are expertly applied. A selection of his publications includes *Women of Japan* (1951), *Ghana* (1964), *Face of North Vietnam* (1970), *Visions of China* (1981), *Gares et Trains* (1983). *AS*

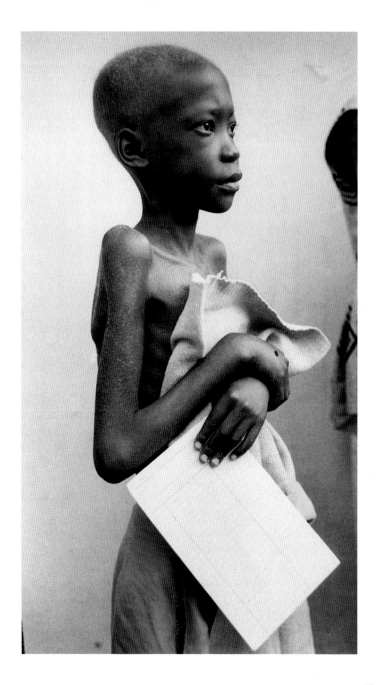

Richter, Evelyn

1930 Bautzen
Lives in Leipzig

▲ **Evelyn Richter**
Receptionist at
Leipzig Town Hall,
around 1975

Gelatin silver print
19.3 x 29.7 cm
ML/F 1988/67

Gruber Donation

From 1948 to 1952 Evelyn Richter studied photography under Pan Walther and Franz Fiedler in Dresden. Between 1953 and 1956 she studied at the College of Graphic Design and Book Art in Leipzig. She was a member of the Association of Creative Artists and worked on a freelance basis between 1956 and 1980. Between 1958 and 1962 she was a member of the group "Operation Photography" in Leipzig. Since 1980 she has been teaching at the College of Graphic Design and Book Art in Leipzig, first as head of the school of photography, then as lecturer, and since 1992 as full professor. Evelyn Richter never could accept conditions in the GDR (the former East Germany) and was constantly subjected to more or less open criticism. In spite of the fact that she was regarded as one of the country's leading contemporary photographers, she was refused a professorship at her college before the dissolution of the GDR. Even though she was permitted to travel to the West, where she had been celebrated since the eighties, she was denied recognition at home. Her photographic journalism, along with her ingrained critical stance, exerts a great influence on the younger generation. *RM*

Alexander Rodchenko was one of the most versatile artists in the Russia of the twenties and thirties. Between 1910 and 1914 he studied under Nikolai Feshin and Georgii Medvedev at the Arts College of Kasan, where he met his future wife Varvara Stepanova. In 1914 he moved to Moscow and attended the Stroganov School of the Arts. There Rodchenko met Kasimir Malevich and Vladimir Tatlin, and during the years that followed he evolved into one of the leading artists of the Russian avant-garde. He worked as a sculptor, painter, and graphic artist, designed posters for movie theaters, businesses and factories, and designed book covers and furniture. In 1921 his triptych *Pure Colors: Red, Yellow, Blue* was a masterpiece of absolute painting.

Between 1922 and 1924 Rodchenko turned increasingly to photomontages as related to poster art and book design. Especially famous were his illustrations of Vladimir Mayakovski's poetry *Pro éto* (About This), in which that poet proclaims his love for Lilia Brik. In his montages Rodchenko tried to create a visual image of Mayakovski's verses, thereby creating a unique connection between photomontage and constructivistic form. As he did in his other, earlier montages, Rodchenko

**Rodchenko,
Alexander**

1891 St. Petersburg
1956 Moscow

► Alexander
Rodchenko
Stairs, 1930

Gelatin silver print
27 x 40 cm
ML/F 1978/1048

Ludwig Collection

► Alexander
Rodchenko
Girl with Leica, 1934

Gelatin silver print
40 x 29 cm
ML/F 1978/1072

Ludwig Collection

◄ Alexander
Rodchenko
Photomontage
for Mayakovski's
Pro éto, 1923

Gelatin silver print,
mixed media
22.5 x 14 cm
ML/F 1978/1018

Ludwig Collection

used existing photographic originals in *Pro éto*, i.e. not photographs he produced himself. Only in 1924, when he was less and less able to find suitable picture material for his montages, did Rodchenko reach for the camera, at last recognizing photography as the artistic medium of his era. Because pictures can be taken with a camera from every position, photography, in Rodchenko's opinion, corresponded to the active eye of man. Therefore, photography was predestined to render, in a representative manner, the confusing impressions to which modern big city dwellers are exposed. By using bold and unusual perspectives, he wanted to liberate photography from conventions and from the standard belly-button perspective and thus he evolved into a distinct pioneer of photographic Constructivism. In 1928 he wrote in his manifesto-like text *Ways of Contemporary Photography*: "In order to educate man to a new longing, everyday familiar objects must be shown to him with totally unexpected perspectives and in unexpected situations. New objects should be depicted from different sides in order to provide a complete impression of the object." In 1928 Rodchenko, who had given up painting in favor of photography in 1927, bought himself a Leica which, because of its handy format and quick operation, became his preferred

◄ Alexander
Rodchenko
Vladimir Mayakovs
with Cigarette, 1924

Gelatin silver print
40.2 x 27.4 cm
ML/F 1978/1080

Ludwig Collection

► Alexander
Rodchenko
Portrait of Mother,
1924

Gelatin silver print
29 x 29 cm
ML/F 1978/1083

Ludwig Collection

tool for his work. This camera enabled him to realize to excess his ideas of unusual camera positions, severe foreshortenings of perspective, and views of surprising details. Increasingly Rodchenko's photography was dominated by the artistic element of the line. He liked to integrate elements such as grids, stairs, or overhead wires in his photographic compositions, converting them into abstract constructivistic line structures. *Stairs* of 1930 and *Girl with Leica* of 1934 are undoubtedly among the most famous photographs of this kind.

In 1930 Rodchenko became a founding member of the "October" group, the most important organization for photographic and cinematographic art of that time. Between 1933 and 1941 he also worked for the journal *SSSR na stroike (USSR under Construction)* which he had founded together with Varvara Stepanova. *MBT*

▲ **Alexander Rodchenko**
Gears, 1930

Gelatin silver print
6.5 x 10 cm
ML/F 1978/1106

Ludwig Collection

◄ **Alexander Rodchenko**
Pine Tree, 1925

Gelatin silver print
39.9 x 25.8 cm
ML/F 1978/1103

Ludwig Collection

◄ Alexander
Rodchenko
Hot Air Balloon,
1927

Gelatin silver print
40 x 29 cm
ML/F 1978/1053

Ludwig Collection

► Franz Roh
Untitled, 1930

Gelatin silver print
22.2 x 15.2 cm
ML/F 1995/127

Uwe Scheid
Donation

Beginning in 1908, Franz Roh studied philosophy, literature, history, and art history in various cities of Germany. From 1916 to 1919 he was assistant to Heinrich Wölfflin in Munich, were he obtained his doctorate.

In 1919 Roh began to work as an independent writer and art critic for various newspapers. Between 1922 and 1923, encouraged by his work in contemporary art, he began to produce collages and experimental photographs. In his photographic work, which was created mostly between 1923 and 1933, he favored abstractions, such as negative prints, photograms, or the superimposed printing of several negatives. Employing these techniques, he created a fantasy world of images where, among other things, female nudes are superimposed on architectural and nature photographs.

In 1929 Roh and Jan Tschichold published the epoch-making book *Photographic Eye*, which was the first documentation of experimental photography besides László Moholy-Nagy's Bauhaus book. The time of National Socialism became a time of internal emigration for Roh, during which he worked on his collages and wrote his book *The Unrecognized Artist*, which appeared in 1948. It was only toward the end of his life that Roh went public with his own artistic work and exhibited his collages in galleries. *TvT*

Roh, Franz

1890 Apolda,
Germany
1965 Munich

Rohde, Werner

1906 Bremen
1990 Worpswede

▼ Werner Rohde
Self-portrait – The
Photographer, 1935

Gelatin silver print
33.9 x 23.9 cm
ML/F 1978/1010

Originally Werner Rohde wanted to become a painter like his father. In 1925 he attended the Arts and Crafts School at Burg Giebichenstein in Halle, studying painting under Erwin Hahs. It was at this time that Rohde took up photography. Initially, he considered this medium a by-product of his artistic development, but increasingly came to recognize it as a separate means of expression. It was because of Hahs that Rohde also discovered his love for motion pictures, in particular Charlie Chaplin. In many of his self-portraits he makes reference to his idol by taking pictures of himself wearing a white mask or white make-up and a black bowler hat.

After Rohde had left Burg Giebichenstein in 1927, and before finishing his studies, in order to learn the trade of glass-painting from his father, he concentrated more on his photographic work. He aligned himself with the avant-garde trends of the New Vision and experimented with bold perspectives, double exposures, photomontages, or exciting light effects. In 1929 he achieved his first success. He showed a few photographs at the photographic avant-garde's famous exhibition "Film and Photo" in Stuttgart. In 1935 his companion and future wife Renata Bracksieck introduced Rohde to Berlin gallery owner Karl Nierendorf, who asked him to take pictures of his friends and artists at the gallery.

After the war Rohde settled with his wife in Worpswede. There he devoted himself again to glass painting and verre églomisé, utilizing the medium of photography only for reproducing his glass paintings. *MBT*

▶ Ulrike Rosenbach
and Hildegard
Weber
It Became a Matter
of Life and Death,
Museum Ludwig,
Cologne, 1985

Gelatin silver print
59.7 x 50.4 cm
ML/F 1985/155

Between 1964 and 1969 Ulrike Rosenbach studied sculpture under Prof. Joseph Beuys at the Art Academy of Düsseldorf, where she became a master student. Since 1972 her work has concentrated on video productions, in particular video installations and performance art. Her artistic work is based on her own experiences of life, questioning the historical position of women in society and exposing structures of oppression. Traditional notions and images of women become the mirror in which she reflects the fundamental problems of women in society. Her video work deals with subjects such as Venus, the Amazon, or Hercules as a counterpoint and also introduces occasional connections with Far Eastern philosophies and trains of thought. *It Became a Matter of Life and Death* was created in 1985 on the occasion of a performance at the Museum Ludwig in Cologne. Hildegard Weber studied at the Technical College, Cologne. She has documented the work of a number of artists in addition to her own. *RM*

**Rosenbach,
Ulrike**

1943 Bad Salzdetfurth,
Germany
Lives in Homburg

**Weber,
Hildegard**

1939 Kleve, Germany
Lives in Cologne

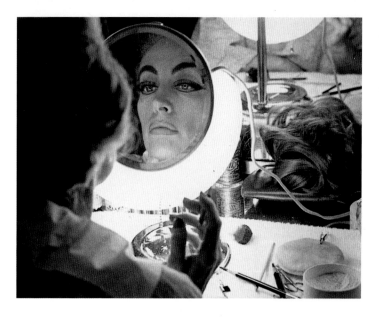

◄ **Sanford H. Roth**
Joan Crawford, 1958

Gelatin silver print
27 x 34.5 cm
ML/F 1977/670

Gruber Collection

**Roth,
Sanford H.**

1906 Dresden
1962 New York

Sanford H. Roth was a self-taught photographer. From the very begin-
ning he worked as a freelance photographer. In 1946 he moved to Paris
and began working for numerous international magazines, including
Life, Harper's Bazaar, Paris Match, Collier's, Oggi, and *Elle.* The main
focus of his work was portraits. He included just enough ambiance in
his images to characterize the personality's essential traits. For exam-
ple, he positioned Alfred Hitchcock exactly as the great director himself
liked to portray himself for a few moments in his films – half hidden,
peeking from around the corner of a house. He portrayed Joan Crawford
as a mirror image sitting at a make-up table. Roth dealt with artists in a
special manner and took portraits of almost all the famous ones. From
1954 on, he lived and worked mostly in Rome. *RM*

Harry C. Rubicam
At the Circus,
around 1907

Heliogravure
15.6 x 19.3 cm
ML/F 1995/37

Gruber Donation

Harry C. Rubicam moved to Denver in 1897, where he was an agent for "Fidelity and Casualty Co." insurance company. In 1903 he became a member of the New York based group "Photo Secession". His picture *At the Circus*, using the complex technique of heliogravure, appeared next to those of Gertrude Käsebier, Edward J. Steichen, Alfred Stieglitz, and others in issue No.17 of 1907 of *Camera Work*. This book showed that art photography was splitting into two directions, which could be defined as "pictorial against straight photography". While photographs based on symbolist art were still prevalent, new picture ideas were beginning to emerge that were to blossom a short time later in Paul Strand's work and especially in the photographs of the twenties. In Rubicam's photograph taken under the canvas of the circus tent, daylight filters down on spectators' heads, an artist standing on a white horse with her arms gracefully extended rides around in a ring that is cropped on the right side. The composition is well thought out, without being artistically stilted, and it relies on the photographic elements of image composition and the effectiveness of an everyday subject. *AS*

**Rubicam,
Harry C.**

1871 Philadelphia
1940 Denver

Rubinstein, Eva

1933 Buenos Aires,
Argentina
Lives in New York

▲ Eva Rubinstein
Bed in Mirror, 1972

Gelatin silver print
14.7 x 21.4 cm
ML/F 1984/93

Gruber Donation

► Eva Rubinstein
Standing Nude, 1972

Gelatin silver print
20.7 x 14.1 cm
ML/F 1984/92

Gruber Donation

Eva Rubinstein, daughter of Arthur Rubinstein, grew up in Paris and studied ballet under Mathilde Kszesinska in Paris. In 1939 her family emigrated to the USA, where Eva Rubinstein attended the French High School in New York. Beginning in 1941, she attended ballet school in California, where she studied under Bolm, Bekefi, and finally under Oboukhoff and Nemtchinova in New York. Between 1951 and 1952 she studied acting in Los Angeles, where she took part in productions and studied modern dance under Bella Lewitzky. In 1953 she settled in New York and danced at the Balanchine School and at the Martha Graham School. Until the sixties, Eva Rubinstein devoted herself exclusively to dance, but after her divorce she turned to photography, taking courses at the New York Institute.

She participated in workshops given by Lisette Model and Diane Arbus and began to travel. In addition, she devoted herself to portrait and nude photography. In 1973 she photographed the Yom Kippur War on the Golan Heights and at the Suez Canal. In 1974 she began to teach photography at various colleges throughout Europe and the USA. *RM*

▲ **Erich Salomon**
Aristide Briand at the League
of Nations, 1928

Gelatin silver print, 37.2 x 29.5 cm
ML/F 1984/98

Gruber Donation

Between 1906 and 1909 Erich Salomon studied zoology and engineering in Berlin, followed by law in Munich and Berlin. Between 1914 and 1918 he was on war duty in the German Reichswehr. He was taken prisoner of war and became an interpreter and spokesman for the prisoners at a French camp. After World War I he worked at the stock exchange, then in a piano factory, eventually founding a rental business for automobiles and motorcycles with sidecars. In 1926 he joined the Ullstein publishing house, where he was responsible for public relations work. There he was exposed to photography, which motivated him to acquire his first camera, an Ermanox. In 1928 he attracted attention with a series of pictures he had taken with a hidden camera in a courtroom. These pictures were published in the *Berliner Illustrirte*, which compensated him with two months' wages. He then left the Ullstein publishing house and began working as a freelance photographer for such publications as the *Berliner Illustrirte Zeitung, Müncher Illustrierte Presse, Fortune, Life, Daily Telegraph*, and also for the Ullstein publishing house.

Salomon, Erich

1886 Berlin
1944 Auschwitz

▲ **Erich Salomon**
Summit Conference,
Chamberlain,
Stresemann and
Briand, 1928

Gelatin silver print
26.1 x 35.1 cm
ML/F 1977/690

Gruber Collection

▲ **Erich Salomon**
Round-table Talks,
1930

Gelatin silver print
27.8 x 36 cm
ML/F 1977/685

Gruber Collection

◄ **Erich Salomon**
Dr. Gustav Strese-
mann with Journal-
ists in the Foyer of
the Reichstag, 1928

Gelatin silver print
27.8 x 36 cm
ML/F 1977/676

Gruber Collection

◄ **Erich Salomon**
Interview with
Fridtjof Nansen in
Geneva, 1928

Gelatin silver print
29.8 x 39.6 cm
ML/F 1977/691

Gruber Collection

► **Erich Salomon**
Hugo Eckener in
conversation with
Oskar von Miller at
the Hotel Esplanade,
Berlin, around 1930

Gelatin silver print
29.9 x 39.9 cm
ML/F 1977/695

Gruber Collection

Salomon's way of photographing political and social events made him the founder of modern political photojournalism. He had an inimitable gift for being everywhere without being noticed and thus his photographs reflect accurate observation. He took advantage of his Ermanox camera and its large aperture lens, as well as high-speed glass plates, which made intrusive flash unnecessary. His pictures gave the viewer the feeling of actually being present at the events he portrayed. It was Aristide Briand who, during a political debate from which journalists had been excluded, finally discovered Salomon and exclaimed: "There he is, the king of the indiscreet!"

Following his emigration to the Netherlands, Salomon was discovered by the National Socialists in Scheveningen and, being a Jew, he was sent to Theresienstadt and later to Auschwitz, where he, his wife and son Dirk were murdered. *RM*

▲ **Erich Salomon**
American newspaper magnate William Randolph Hearst in his castle La Cuesta Encantada, California, 1930

Gelatin silver print
28.3 x 36 cm
ML/F 1977/694

Gruber Collection

▲ **Erich Salomon**
King Fuad of Egypt
with Hindenburg,
1930

Gelatin silver print
17.7 x 23.7 cm
ML/F 1988/80

Gruber Donation

▶ **Erich Salomon**
Max Liebermann,
around 1905

Gelatin silver print
28.4 x 36 cm
ML/F 1977/692

Gruber Collection

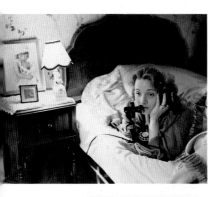
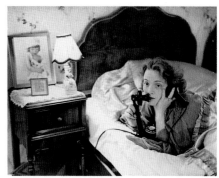
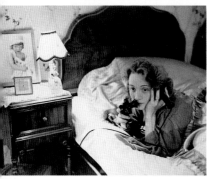
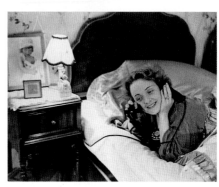
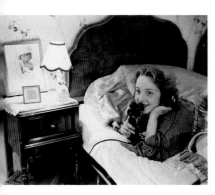
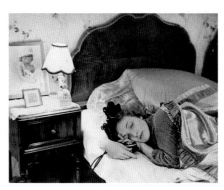

▲ **Erich Salomon**
Marlene Dietrich, 1930

Gelatin silver print
each 28.3 x 36 cm
ML/F 1977/697-702

Gruber Collection

Sander, August

1876 Herdorf,
Germany
1964 Cologne

After working in the mines for seven years and serving in the military, August Sander studied painting in Dresden between 1901 and 1902. His intention was to enhance his artistic skills, in order to apply them to his interest in photography, which he had developed on numerous trips and while working at many photographic businesses in Berlin, Magdeburg, Leipzig, Halle, and Dresden in 1898 and 1899. Finally, in 1902, he moved to Linz, where he first worked at Studio Greif and then, in 1904, founded the August Sander Studio for artistic photography and painting. In 1909 he returned to Cologne, where he founded his studio in Lindenthal in 1910. There he began his life's work, *People of the 20th Century*, which occupied him into the fifties. In the thirties he got into trouble with the National Socialists on account of his son's political activities, causing him in those years to devote himself almost exclusively to taking pictures of landscapes in the Rhine River area and in old Cologne. Prior to that, by publishing the *Mirror of Germany* and *Face of the Times*, he was

◄ **August Sander**
Publisher, 1923/1924

Gelatin silver print
22.5 x 16.7 cm
ML/F 1977/708
Gruber Collection

► **August Sander**
Heinrich Hoerle,
around 1928

Gelatin silver print
22.8 x 16.7 cm
ML/F 1977/711
Gruber Collection

►► **August Sander**
Prof. Dr. Wilhelm
Schaefer, around 192

Gelatin silver print
22 x 15.9 cm
ML/F 1977/736
Gruber Collection

► **August Sander**
The Architect Prof.
Dr. Hans Poelzig,
Berlin, 1928

Gelatin silver print
28.4 x 19.4 cm
ML/F 1977/748
Gruber Collection

►► **August Sander**
The Scholar Max
Scheler, 1925

Gelatin silver print
26.9 x 19.4 cm
ML/F 1977/745
Gruber Collection

Ill. p. 572:
August Sander
Albert Fischbach as a
Hunter with Dog,
arround 1910

Gelatin silver print
14.6 x 10.1 cm
ML/F 1989/27
Lotte Lohe Donation

Ill. p. 573:
August Sander
Pharmacist Linz,
around 1907

Gelatin silver print
47 x 32.4 cm
ML/F 1977/747
Gruber Collection

▲ August Sander
Porter, 1929

Gelatin silver print
28.3 x 22.5 cm
ML/F 1993/433

Gruber Donation

► August Sander
Unemployed, 1928

Gelatin silver print
22.5 x 14.2 cm
ML/F 1977/735

Gruber Collection

◀◀ **August Sander**
Innkeeper and his
Wife, 1915

Gelatin silver print
12.8 x 15.9 cm
ML/F 1977/740

Gruber Collection

◀ **August Sander**
Cobbler, around
1930

Gelatin silver print
22.8 x 17.5 cm
ML/F 1977/742

Gruber Collection

◀◀ **August Sander**
Two Daughters of
Albert Fischbach,
around 1910

Gelatin silver print
15.6 x 10 cm
ML/F 1989/29

Lotte Lohe Donation

◀ **August Sander**
Käthe Lamers with
Hannelore and
Helmy, 1922

Gelatin silver print
14.2 x 10.2 cm
ML/F 1993/437

Gruber Donation

▲ **August Sander**
Anton Räderscheidt,
1927

Gelatin silver print
28.5 x 21 cm
ML/F 1993/434

Gruber Donation

Sander | 575

able to accomplish at least the initial stage of his idea of an encyclo-
pedic and systematic picture of the German people. Finally, in 1980, his
son Gunther, collaborating with Ulrich Keller, published the combined
work under the original title *People of the 20th Century*. After the destruc-
tion of his studio and archive in 1944, Sander moved to Kuchhausen in
the Westerwald region, where he continued working under the most
primitive conditions. His name was almost forgotten in Cologne until

◄ **August Sander**
Photograph for a
Sanka Advertise-
ment, 1925

Gelatin silver print
20.8 x 15.1 cm
ML/F 1977/723
Gruber Collection

August Sander
Glass Panes, 1924

Gelatin silver print
8.6 x 17.5 cm
ML/F 1988/118

Gruber Donation

L. Fritz Gruber showed his work at photokina in 1951 and arranged for his pictures of old Cologne to be taken over by the Museum of the City of Cologne.

Sander's portrait work constitutes an important contribution to the recognition of photography as an art. Today, his systematic approach is viewed as an early example of conceptual art, which was also not without influence on the development of the creative arts. He is now considered to be Germany's internationally best-known photographer of this century. *RM*

Saudek, Jan

1935 Prague
Lives in Prague

▲ Jan Saudek
Lips with Drop, 1974

Gelatin silver print
15.8 x 22.8 cm
ML/F 1993/443

Gruber Donation

▶ Jan Saudek
Super Striptease,
1982

Gelatin silver print,
colorized
each 16.2 x 12.2 cm
ML/F 1984/107

Gruber Donation

To a great extent Jan Saudek's work is marked by two circumstances: by his childhood, when he and his twin brother Karl were interned in a concentration camp, where only by sheer luck they escaped the experiments of Josef Mengele, and by visiting the exhibition "The Family of Man", which he considered an expression of the deep need for familial harmony and which made him aware of photography as a means of expression.

Between 1950 and 1952 Saudek studied at the School of Industrial Photography in Prague, before taking various jobs in farming and in numerous factories. He has been interested in photography since the early fifties and he stages his own pictorial reality. Saudek was one of the first Czech photographers whose work became known in the West and this earned him the suspicion of the Czech government until the eighties.

His photographs, initially black and white, later in color, revolve around sexuality and the relationship between men and women, old age and youth, clothing and nudity. Generally, he takes an antagonistic approach to attain powerful pictorial effects. To accomplish this, Saudek sometimes uses strong imaging language, reminiscent of the coarse ribaldry of medieval sexual life, an impression which is enhanced by the always unchanged, drab ambiance of his pictures. Frequently, he stages scenes in which couples appear alternately dressed and naked, young

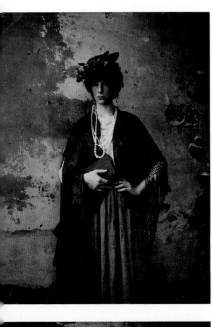
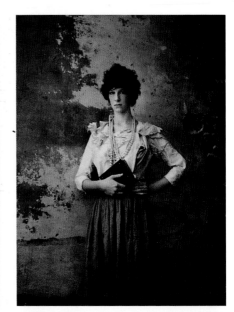
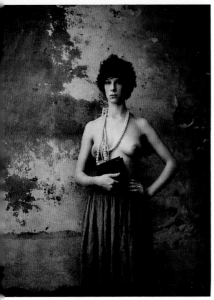

◄ **Jan Saudek**
Untitled (Sugar),
1975

Gelatin silver print
14.6 x 11.9 cm
ML/F 1994/258

Gruber Donation

► **Jan Saudek**
Untitled (Rear View
of Nude), around
1985

Color print
22 x 16.8 cm
ML/F 1993/442

Gruber Donation

Ill. p. 582:
Jan Saudek
Marie Nr. 1, around
1986

Gelatin silver print
17.1 x 11.5 cm
ML/F 1994/254

Gruber Donation

Ill. p. 583:
Jan Saudek
What an Unlucky
Girl, 1983

Gelatin silver print
13.9 x 9 cm
ML/F 1994/256

Gruber Donation

girls reappear pregnant, and children grow older. Without artifice
Saudek's photography reaches into life at its fullest. His direct language
very quickly met with lively acclaim in the art world. *RM*

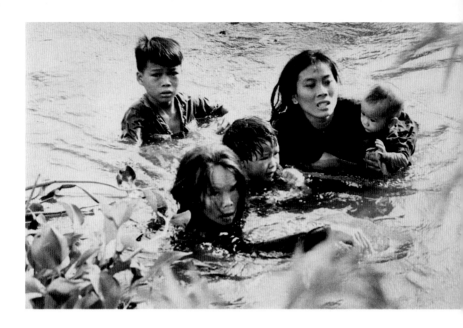

Sawada, Kyoichi

1936 Aomori, Japan
1970 Cambodia

Kyoichi Sawada became known as a press photographer who worked for "United Press International" during the Vietnam War. Sawada's interest in photography began early in life. At the age of 20 he became a newspaper editor in Tokyo. In 1965 he had himself transferred to Vietnam in order to experience the reality of war with his own eyes. He received several international awards, such as the first prize of "World Press Photo" in 1965 and the Pulitzer Prize for his picture *Flight to Freedom* in 1966. The human drama of grief and terror, expressed by the distorted faces of four children and their mother who were able to flee an attack on their village by swimming for their lives, tells of the reality of the Vietnam War.

Sawada's pictures document the suffering of civilians under the rule of soldiers, as well as wounding and pain on both sides. *Time* magazine called this photojournalist "the best, certainly the most daring photographer working for UPI in Indochina". Sawada risked his life numerous times on his many assignments to isolated territories of war. On October 28, 1970, Sawada was killed while on a photographic assignment in Cambodia. *LH*

▲ Kyoichi Sawada
Flight to Freedom,
1960

Gelatin silver print
25.2 x 39.3 cm
ML/F 1977/751

Gruber Collection

Hajime Sawatari studied photography with Kishin Shinoyama at the Faculty of Fine Arts of Nihon University in Tokyo. Between 1963 and 1966 he belonged to a circle of permanent employees at the Nihon Design Center in Tokyo. Since then, however, he has been active as a freelance photographer, working both in motion picture and fashion photography, and also as a photojournalist for *Asahi Camera*. In 1966 he worked as a cameraman for the movie "The Tomato Ketchup Emperor". Here he already showed his inclination for fantasy themes. In 1968 he married Hiroko Arahari, with whom he had a daughter. Between 1969 and 1980 Sawatari kept a studio in Roppongi. In 1973 he was awarded the annual prize of the Japanese Photographic Association. In that year he published his series *Alice*, which earned him the nicknames "Brother Alice" and "Gilles de Rais of the Camera" for years to come, influencing his image as a photographer of young girls and women. In 1979 he was named Photographer of the Year in Tokyo. Since 1980 he has had a studio in Minami Aoyama in Tokyo. *RM*

**Sawatari,
Hajime**

1940 Tokyo
Lives in Tokyo

▲ **Hajime Sawatari**
Untitled (Girl on
Stairs) from the
series: Alice, 1973

Color print
10 x 13.2 cm
ML/F 1984/110

Gruber Donation

Schad, Christian

1894 Miesbach,
Germany
1982 Stuttgart

▲ Christian Schad
Shadograph 15, 1960

Gelatin silver print
10.5 x 14.1 cm
ML/F 1977/752

Gruber Collection

► Christian Schad
Shadograph 20,
1960

Gelatin silver print
23.5 x 17.7 cm
ML/F 1977/753

Gruber Collection

From 1913 to 1914 Christian Schad studied painting for two semesters at the Academy of Creative Arts in Munich. In 1915 he avoided war duty and until 1920 lived as a painter and graphic artist in Zurich and Geneva.

Through Walter Serner, with whom he worked at his newspaper *Sirius* in Zurich, he remained in touch with Zurich dadaists Hans Arp, Hugo Ball and Tristan Tzara while he was in Geneva. During his time in Geneva he discovered camera-less photography while experimenting with "found objects" and photographic papers. These photographs, of which he produced approximately 30 in 1919, are the first artistic photograms – actually preceding the work of Man Ray and László Moholy-Nagy. Since 1936 they have been called "Shadographs", a name first coined by Tristan Tzara. Not until 1960 did Schad use this technique again, creating a comprehensive late work.

His was a restless spirit. Between 1920 and 1925 he lived in Naples and in Rome, then in Vienna and, from 1928 on, in Berlin. Beginning in 1935, when he was unable to support himself with painting alone, he

◄ **Christian Schad**
Shadograph 24b,
1960

Gelatin silver print
15.6 x 11.5 cm
ML/F 1993/512

Gruber Donation

worked temporarily in various other professions. Following the destruction of his studio during an air raid in 1943 he moved to Aschaffenburg, and finally, in 1962, settled in Keilberg in the Spessart region. *RM*

A. T. Schaefer started out studying painting and design at the Arts and Crafts School of Hanover, taking an interest in sculptures and painting. In the late seventies he began to work more and more with the medium of photography and since 1981 has been devoting himself exclusively to this technology. In photography he discovered possibilities of exploring the phenomenon of color and its perception in a more authentic manner than it was possible to do with painting. Photography creates color as a function of light, and vision is subject to the same conditions. Schaefer investigates the vividness of photographic color against the backdrop of Goethe's Theory of Colors, seeing it as an opportunity for transforming its teachings in a novel, visual manner. Whereas his early work investigated mainly the possibilities offered by pure color spectra, in particular the color red, his cosmic images of the series *Skieron* offered subtle colors, in particular in tones of deep black and blue, as well as variations of white. What appears to be the result of experimental photography, reminiscent of the macrocosm and microcosm, is in fact the result of pure "straight photography". *RM*

Schaefer, A. T.

1944 Enningerloh, Germany
Lives in Stuttgart

▲ A. T. Schaefer
MB 29, 1990

Cibachrome print, acrylic paint
234 x 120 cm
ML/F 1991/149

Schagin, Ivan

1904 Jaroslaw
1982 Moscow

Ivan Schagin left home when he was quite young in order to earn his living as a sailor. In 1924 he moved to Moscow, where he pursued differ-ent activities. During this time he began to take an interest in photo-graphy. In 1930 he made his hobby his profession and began working as a press photographer for the newspapers *Nascha shizn*, *Kooperativnaya* and *Selchosgis*, the national publisher for agricultural matters. In the thirties Schagin specialized in the contemporary subject of technical progress and took a number of pictures of the Red Army. Between 1933 and 1950 Schagin worked as a photojournalist for the central youth newspaper, *Komsomolskaya Pravda*, as well as for *SSSR na stroike (USSR under Construction)*. During World War II Schagin worked as a reporter at various fronts. Beginning in 1950, he produced photographic volumes and reports for "Isogis", a government-operated publishing house, and for *Sowjetskij khudozhnik*, *Progress*, *Pravda*, and "Nowosti", the press agency. *MBT*

▶ Arkadii S. Shaikhet
Strengthening the
Body, 1927

Gelatin silver print
31.5 x 41 cm
ML/F 1992/142

Ludwig Collection

After arriving in Moscow, Arkadii Samoilovich Shaikhet began working as a retoucher for a portrait photographer. In 1924 he turned to photojournalism and worked for *Rabochaya gazeta* and *Ogonek*. He became a member of the Union of Russian Proletarian Photoreporters (ROPF), on whose avant-garde style he had an influence. At that time his work dealt mainly with the new life under Socialism, in particular the heroic struggle of the individual. Together with Max Alpert and Solomon Tules, he prepared a pictorial report covering 24 hours in the life of steelworker Fillipov, which presented an image of the high standard of living of Soviet industrial workers and which was strongly tinged by propaganda. Also, Shaikhet worked for newspapers such as *SSSR na stroike (USSR under Construction)* and the *Workers Illustrated Newspaper*. During World War II he was at the front, working as a war reporter. *RM*

**Shaikhet,
Arkadii
Samoilovich**

1898 Nikolajew
1959 Moscow

◄ **Arkadii S. Shaikhet**
Steel Furnace, 1935

Gelatin silver print
37.7 x 24.7 cm
ML/F 1992/146

Ludwig Collection

◄ **Arkadii S. Shaikhet**
Moving Locomotive,
1935–1939

Gelatin silver print
38.9 x 58.5 cm
ML/F 1992/143

Ludwig Collection

Arkadii S. Shaikhet
Tower at Red Square,
1936–1940

Gelatin silver print
43 x 28.5 cm
ML/F 1992/140

Ludwig Collection

Scheffer, Michael

1953 Schmalkalden, Germany
Lives in Leipzig

▲ Michael Scheffer
From: City, 1987

Gelatin silver print
42.2 x 63.8 cm
ML/F 1991/194

After graduating from high school, Michael Scheffer began an apprenticeship as a surveyor. Between 1974 and 1977 he was a forest worker in the area of the Eastern Harz. Until 1982 he worked as skilled surveyor. Between 1982 and 1987 he studied photography under Prof. Arno Fischer at the College of Graphic Design and Book Art in Leipzig. Since then he has been working as a freelance photographer and has been a member of the "EIDOS" group in Berlin. Scheffer's photography depicts the mundane, banal, and yet it has a disquieting effect on the viewer because of its lack of sharpness, its tight cropping and the direct access permitted by photography. In his pictures Scheffer duplicates the view of the citizen of the former East Germany. Concentrating on the immediate environment to simulate an apparently accidental look into private life, it is in fact the absence of social contexts that conveys the feeling of impending threat. *RM*

Regina Schmeken started out studying art history and German art and literature at the University of Essen, and it was only in 1976 that she became a self-taught photographer. As early as 1978 she received the Prix de la Critique in Arles and, in 1984, was awarded a grant for photography by the City of Munich. Since 1986 she has been working in Munich for the *Süddeutsche Zeitung*. In addition to her professional activities, Regina Schmeken has been continuing her artistic work. Following picture series resulting from trips to New York, Paris, and Montreal, her series of photographs of slaughterhouses caused a sensation. She did not produce a photographic report, but concentrated on a few shots illustrating the burden and sorrow of the slaughterers and the slaughtered. The focal point was the relationship between humans and the bodies of animals, being intertwined in a symbiotic, fateful relationship. Her most recent publication *Closed Society* demonstrates that she has maintained her artistic force in her professional work. *RM*

Schmeken, Regina

1955 Gladbeck, Germany
Lives in Munich

▲ **Regina Schmeken**
New York, 1981

Gelatin silver print
25 x 37.2 cm
ML/F 1988/86

Gruber Donation

Schmölz, Hugo

1879 Sonthofen,
Germany
1938 Cologne

▲ **Hugo Schmölz**
Glass Roof over the
Staircase of the Po-
lice Headquarters in
Düsseldorf, 1934

Gelatin silver print
16.5 x 22.4 cm
ML/F 1986/24

▶ **Hugo Schmölz**
Handrail, 1932

Gelatin silver print
47.8 x 35.1 cm
ML/F 1986/25

Hugo Schmölz studied photography under Richard Eder and attended a
trade school in Kempten. In 1896 he began to work as an assistant in a
studio. In November 1911 he and portrait photographer Eugen Bayer
founded a studio in Cologne-Nippes. Schmölz concentrated on architec-
tural photography. The architect Wilhelm Riphahn was one of his most
important clients. During this time Schmölz also took pictures for Do-
minikus Böhm, Theodor Merrill, Adolf Abel, Bruno Paul and others, and
he worked as a press photographer. His sober, factual style made its
mark on the architectural photography of his time. He had an excep-
tionally congenial relationship with Dominikus Böhm. In 1924 he and
Eugen Bayer parted ways and Schmölz opened his own photographic
business. After Schmölz's death, his son Karl Hugo operated the busi-
ness under the name "Fotowerkstätte Hugo Schmölz" well into the
fifties. *RM*

Because his father Hugo Schmölz was an architectural photographer, Karl Hugo Schmölz was exposed to photography early on. In the thirties he began accompanying his father on photographic assignments. He took pictures for architects, including Adolf Abel, Bruno Paul, Dominikus Böhm, Gottfried Böhm, Wilhelm Riphahn, and Rudolf Schwarz. When his father died in 1938, the close cooperation he had had with his father enabled Karl Hugo to continue contract work for their business "Fotowerkstätte Hugo Schmölz" without interruption. Karl Hugo Schmölz returned to his home town after serving in World War II and documented the wartime destruction with a large-format camera. This was one of the few photographic topics that he covered without an assignment, as did his father, who had photographed the city of Cologne during the twenties and thirties. His factual approach creates a completely different tone from the emotional view taken by Hermann Claasen. The continuation of his work for the great architects of the Rhineland resulted in an impressive documentation of the reconstruction of the city of Cologne. In conjunction with this, he also took a comprehensive series of pictures of Augustusburg Castle in Brühl.

At the same time Schmölz accepted more and more advertising

**Schmölz,
Karl Hugo**

1917 Weissenhorn,
Germany
1986 Lahnstein

600 | Schmölz, K. H.

◄ **Karl Hugo Schmölz**
Hohenzollern Bridge,
1946

Gelatin silver print
60 x 44 cm
ML/F 1989/192

▲ **Karl Hugo Schmölz**
View from Cologne Cathedral
onto Wallraf Square, 1946

Gelatin silver print
61 x 48 cm
ML/F 1989/195

Schmölz, K. H. | 601

602 | Schmölz, K. H.

◄ **Karl Hugo Schmölz**
St. Alban, 1959

Gelatin silver print
60.9 x 43.7 cm
ML/F 1989/193

▲ **Karl Hugo Schmölz**
The East Choir of Cologne Cathedral, 1938

Gelatin silver print
53.9 x 45 cm
ML/F 1989/191

Ill. p. 604:
Karl Hugo Schmölz
Staircase, WRM/ML, Detail, 1986

Gelatin silver print
23.2 x 16.5 cm
ML/F 1986/153

Ill. p. 605:
Karl Hugo Schmölz
Main Floor, WRM, 1986

Gelatin silver print
22.8 x 16.2 cm
ML/F 1986/164

604 | Schmölz, K. H.

▲ **Karl Hugo
Schmölz**
WK (Society for
Interior Design),
Two white plastic
Chairs, 1967

Color print
49.4 x 59.3 cm
ML/F 1986/29

▶ **Karl Hugo
Schmölz**
Draenert, Two white
Tables with Ball and
Two Columns, 1979

Color print
59.2 x 49.8 cm
ML/F 1986/36

assignments, took pictures for Westag and concentrated especially on furniture photography. Today, his archive holds Germany's most comprehensive documentation of 30 years of living in Germany, from Interlübke to Eugen Schmidt, from Thomé to Draenert. He was masterful in portraying suggested home décor through the effective arrangement of even the simplest furniture. Following his marriage to Walde Huth, a photographer in Stuttgart, they set up a joint studio under the name "schmölz + huth", thus adding fashion and portrait photography to their range of services. The last assignment he accepted was to take pictures of the new Museum Ludwig in Cologne, but he was unable to complete it. Nevertheless, his "test pictures" had already established the most important focal points of this building, setting the standards for the task. *RM*

**Schneider,
Dietmar**

1939 Breslau
Lives in Cologne

Dietmar Schneider has been living in Cologne since 1945. In the sixties
he gave up his profession to devote himself to art management. He be-
came the driving force of the Cologne art scene and was famous for
bringing art to a broader spectrum of the public. His project "Current
Art on High Street" involved the display of art in shop windows. Be-
cause of his connections with businesses, he was successful in arousing
their interest in art at a time when they were only accustomed to spon-
sorships of sports. He promoted artists and committed himself to an
art award given by the "4711" perfume company.

As a sideline, he has always documented art events and taken por-
traits of artists. In this way he has compiled an almost encyclopedic col-
lection of portraits of artists and art events in Cologne over the past 30
years. Also, many artists have used his photographs as a starting point
for manipulation. *RM*

Between 1936 and 1939 Toni Schneiders took an apprenticeship as a photographer. He used his first Leica, which he bought in 1938, until the fifties. During World War II he spent some of his time as a war reporter in Italy and France. After being released from captivity, he again set up his own studio in Meersburg on Lake Constance in 1948. In 1949 he co-founded "fotoform". In 1950 he took over the direction of Werner Mannsfeld's studio, a position which was to influence his later work. In 1951 he settled in Lindau. In 1953 he traveled to Ethiopia, Sardinia, Crete, Yugoslavia, Scandinavia, and Japan. During the years that followed he built a comprehensive archive of photographs of buildings and land-scapes that were published in numerous calendars and picture books. RM

Schneiders, Toni

1920 Urbar
2006 Lindau

Eberhard Schrammen studied at the Art Academy of Düsseldorf and at the Archducal Saxonian College of Creative Arts in Weimar. Under Henr van de Velde he cultivated additional contacts with the Arts and Crafts Academy and expanded his studies with numerous trips. In 1914 he par ticipated in the "Burga" exhibition of the German Association of Artists in Leipzig and, as a result, shared the Villa Romana Award in Florence. He was drafted during World War I, after which he participated in the merging of the former Arts and Crafts College and the Academy of Art into the State Bauhaus of Weimar. He was a student of Oskar Schlem- mer, publisher of the first Bauhaus journal, *Der Austausch*, master teacher of the carpentry workshop, and he built furniture. In 1925 he joined the Gildenhall Cooperative of Commercial Artists and also be- came a member of the German Crafts Association.

▼ Eberhard
Schrammen
Untitled (Self-
portrait), 1930

*Gelatin silver print,
stencil photogram*
23.8 x 17.9 cm
ML/F 1993/523

Gruber Donation

Schrammen remained active as an artist, painter, graphic artist, and writer. There is little evidence of his written work. Even his art was for- gotten for many years until it was rediscovered by L. Fritz Gruber, who donated a number of Schram- men's works to the photographic collection of the Museum Ludwig Schrammen worked especially in the field of pattern photograms, a technique he developed that is particularly suitable for illustra- tions in books and newspapers. Schrammen considered himself a craftsman and universal artist who integrated applied work in his understanding of art. *RM*

▶ Gundula Schulze
l Dowy
amerlan, Berlin,
984

ielatin silver print
9.7 x 55.6 cm
1L/F 1995/128

lwe Scheid
)onation

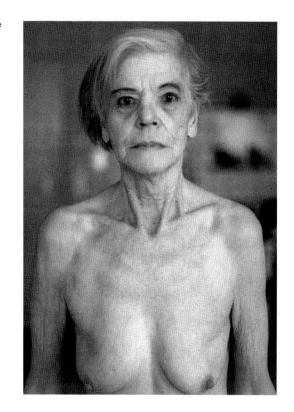

Gundula Schulze el Dowy trained as an industrial trader and attended a college of advertising and design in Berlin before studying photography under Horst Thorau at the College of Graphic Design and Book Art in Leipzig between 1979 and 1984. Initially, her photographic work dealt with black-and-white cycles of social criticism. Near her apartment at the Prenzlauer Berg she took pictures of people in the backyards of East Berlin. The unbeautified, yet also sensitive photographs in this series show people in the Scheunenviertel area, the Pfarrstraße, at work or in the slaughterhouse. In 1983 she changed to color photography. Her international breakthrough came when she participated in the exhibition "Private Photography" in the USA in 1987 and in the Rencontres Internationales de la Photographie in Arles in 1988. *TvT*

**Schulze
el Dowy,
Gundula**

1954 Erfurt
Lives in Berlin

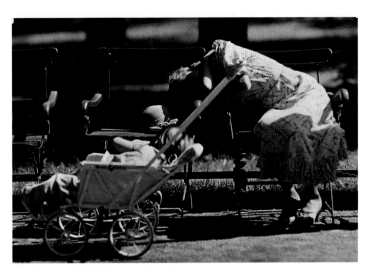

Seidenstücker, Friedrich

1882 Unna
1966 Berlin

Friedrich Seidenstücker became interested in photography at an early age. When he was only 17, he built his own camera from a cigar box, using the lens from a laterna magica. From 1902 to 1903 he studied mechanical engineering, first in Hagen, later in Berlin. There he developed close connections with artists of his time and began to take pictures of them. His first major series was created in the Berlin Zoo, and it showed the specific sense of humor which was evident in much of his work. His powers of observation and his feeling for the comical in everyday situations made him an extraordinary chronicler of Berlin's daily life. Between 1914 and 1918 he worked in the Zeppelin building in Potsdam. From 1919 to 1922 he studied sculpture at the Arts College in Berlin, after which he decided to make a profession out of his artistic inclinations. Between 1922 and 1930 he made frequent trips to Munich, Paris, Berlin, and Rome and he participated in numerous exhibitions, but he was unable to make a living with his art. Therefore, he decided to be-

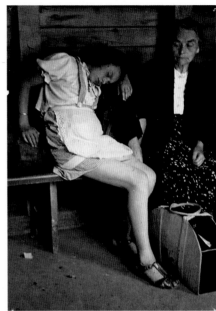

come a photographer and entered into a contract with the Ullstein pub-
lishing house. He became a chronicler of Berlin life, took pictures in
Pomerania and Prussia and produced photo-reports for *Berliner Illu-
strirte*. He became famous, in particular, for his pictures of daily life in
Berlin and for his *Puddle Jumpers*, young women and girls in summer
dresses who with legs spread, at times umbrella in hand, jumped over
puddles onto the sidewalk. *RM*

◄ **Michel Seuphor**
Mondrian Studio,
1929

Gelatin silver print
20.4 x 27.8 cm
ML/F 1980/355 VI

Seuphor,
Michel

(Michel Berckelaers)

1901 Antwerp
1989 Paris

It was in school that Michel Berckelaers used his pseudonym "Seuphor"
for the first time, having derived that name as an anagram of the word
"Orpheus". At the end of World War I he joined the Flemish movement
and published a number of battle pamphlets. In 1921 he founded the
newspaper *Het Overzicht*, which dealt with abstract art and which was
joined by such artists as Robert Delaunay, László Moholy-Nagy, Fernand
Léger, Kurt Schwitters, and others. Following several trips between 1922
and 1924, he ceased publishing his newspaper in 1925.

In 1925 Seuphor began to turn to photography. He developed into
a chronicler of the Paris art scene and took portraits of many of his
artist colleagues. Together with Joaquín Torres García, he founded the
group "Cercle et Carré" in Paris. Between 1937 and 1948 he withdrew to
Anduze in Southern France and worked for the magazine *L'Aube*, pub-
lishing autobiographical novels, essays, and poetry. From 1943 to 1944
Seuphor was active in the Resistance. In 1951 he returned to Paris and
worked as the French correspondent for the American *Art Digest*. He
published books on contemporary art, devoted himself intensely to
drawing, and worked as an art critic. *RM*

Peter Sevriens was a sailor for many years before he began trading in antiques in Germany. This business eventually led him to be interested in making art objects. The unusual aspect of all his objects is the inclusion of photography. In this context he does not restrict himself to making collages of photographs, but includes in his works like a leitmotif a camera, parts of a camera, or reconstructed camera-like objects. On one hand, he understands the camera as an object that may be used and defamiliarized in many ways, and on the other he recognizes its facilitating function between reality and perception. In some of his early works this is still evident in a quiet and reserved manner. Lined up and tied up are a fragment and a photograph of the fragment, a shell and a photograph of the shell, a stone and a photograph of the stone, etc. on a clean background reminiscent of an archeological collection or a museum display. In the center is the camera, the evidence. In his more recent works Sevriens increasingly cultivates his ironic, provocative discourse with the camera. It is worked into the art, from the old folding camera to the expensive Leica. It has to be incorporated in things which it was originally meant to record from a distance – the camera itself becomes the subject. *RM*

Sevriens, Peter

1942 Venlo, Netherlands
Lives in Meinerzhagen, Germany

◄ **Peter Sevriens**
Untitled, 1991

Metal, photography, mixed media
149 x 50 cm
ML/F 1991/286

Seymour, David

1911 Warsaw, Poland
1956 Suez, Egypt

▲ David Seymour
School Vaccination,
around 1948

Gelatin silver print
15.9 x 24 cm
ML/F 1994/273

Gruber Donation

David Seymour grew up in Warsaw and in Russia. After finishing high school, he began to study art and photography at the Leipzig Academy of Graphic Arts. After completing his studies in 1931 he moved to Paris, where he continued his training at the Sorbonne until 1933. There, he also assumed the pseudonym "Chim", by which he was known to most of his friends and colleagues. He became an independent photographer and, beginning in 1934, was able to publish his work regularly in the magazine *Regards*. In Paris, Seymour became friends with Henri Cartier-Bresson and Robert Capa.

In 1936 Seymour, a passionate liberal and anti-fascist, went to Spain. With his camera he captured the terror of civil war, documenting soldiers fighting at the front and the daily life of the civilian population in the back country. His pictures of air raids on Barcelona earned him worldwide recognition as a photojournalist.

In 1939 Seymour returned to Paris, went from there to Mexico, and in the same year settled in New York. Between 1942 and 1945 he was in the US Army in photo-reconnaissance and as an interpreter. After World War II he traveled for UNESCO to Czechoslovakia, Poland, Hungary, Germany, Greece, and Italy to record the effects of war on children. In

▲ David Seymour
Greece, Evacuation of
Children, around 1940

Gelatin silver print
23.7 x 19.3 cm
ML/F 1993/502

Gruber Donation

1949 UNESCO published the result of this work in the book *Children of Europe*. Beyond this assignment, children remained his favorite and most impressive photographic theme.

In 1947 Seymour, together with his friends Henri Cartier-Bresson, Robert Capa and George Rodger founded the international picture agency "Magnum". When Robert Capa died, Seymour took over the presidency of the agency. Nine years later, in 1956, Seymour traveled to Greece to study antique monuments when the Suez Crisis escalated into war. The photographer went to Suez via Cyprus. He was killed in Suez on November 10 of that year by Egyptian machine-gun fire while he was reporting on an exchange of prisoners. *MBT*

Shinoyama, Kishin

1930 Tokyo
Lives in Tokyo

▲ Kishin Shinoyama
Two Rear Views of
Nudes, 1968

Gelatin silver print
19.8 x 30.6 cm
ML/F 1977/764

Gruber Collection

Kishin Shinoyama, the son of a Buddhist monk, was supposed to fol-
low in his father's footsteps and become a monk at his temple. Instead,
he let his brother take his place and opted in favor of photography. Be-
tween 1961 and 1963 he studied photography at Nihon University in
Tokyo. Between 1961 and 1968 he worked for the Light-House advert-
ising agency in Tokyo. In 1966 he was awarded the Prize for Young Pho-
tographers by the Japanese Association of Critics, and his first pictures
were published in *Camera Mainichi*. Since 1968 Shinoyama has been
working as a freelance photographer in the areas of fashion, sports, ad-
vertising, and the press. In 1970 he was honored by the Japanese Asso-
ciation of Photographers as Photographer of the Year. He became
known as a photographer of nudes, and his pictures were exhibited
at photokina. His nudes attracted attention because he did not adhere
to conventions, but rendered highly formalized views of the body. Shi-
noyama saw nude photography as a modeling problem encountered
by a sculptor, leading him at times to create abstract forms. In 1974
he caused an international sensation with his series on the Tattooing
House in Yokohama. He was the first photographer to provide images
of the world of traditional tattooing art by Japanese artist Kuniyoshi.

Shinoyama followed this up with a quiet, almost meditative study of tradi-
tional Japanese houses and gardens, offering the European world an in-
timate glance at the Japanese way of life. Nevertheless, he continued to
pursue nude photography with great intensity. In 1985 he published *Shi-
norama*, a series for which he photographed nude dancers with nine
cameras triggered at the same time, so that the final picture was com-
posed of as many parts. In 1990 he also employed the large format with
his photographic series *Tokyo Nude*, for which he arranged panorama-like

▲ **Kishin Shinoyama**
Brown Lily, 1968

Gelatin silver print
18.8 x 18.7 cm
ML/F 1977/766

Gruber Collection

▲ **Kishin Shinoyama**
The Birth, 1968

Gelatin silver print
18.4 x 18.2 cm
ML/F 1977/765

Gruber Collection

overviews of nudes to create a surreal world which is illuminated artificially and populated by doll-like beings. Today, Shinoyama is considered to be one of the leading Japanese photographers, representing the generation that brought recognition to Japanese photography all over the world. *RM*

▲ **Kishin Shinoyama**
Nude Over Fence, 1969

Color print, 23.1 x 18.2 cm
ML/F 1977/767

Gruber Collection

Sieff, Jeanloup

1933 Paris
2000 Paris

▼ Jeanloup Sieff
Homage to Seurat,
1964

Gelatin silver print
30 x 20 cm
ML/F 1984/114

Gruber Donation

In 1953 Jeanloup Sieff studied literature, journalism and photography at the Vaugirard School of Photography in Paris. A year later he studied photography in Vevey in Switzerland. He began his career as a freelance journalist in Paris, working for *Elle* as a photojournalist and fashion photographer between 1955 and 1958. Following a brief membership in "Magnum" in 1959, during which he reported from Greece, Turkey and Poland, he worked as a freelance photographer until 1961, winning the "Prix Niepce" in the same year. Since then, he has photographed fashion for all the important magazines, including *Harper's Bazaar, Glamour, Esquire, Look, Vogue*, and *twen*, in both the USA and Europe.

Sieff was also a celebrated photographer of nudes. One of his stylistic tools is the wide angle, which gives his nudes a feeling of dreaminess, suggesting a kind of distance of the naked models, even though they are often looking directly at the camera. Sieff is less known for his excellent landscape photographs. *Black House* of 1964 is an early example of this genre – a picture that indicates the dramatizing effect of a 28 mm lens and the virtuosity with which Sieff captures in his black-and-white photographs on the one hand the textures of wood and red grass and on the other silhouettes, shadows and sky formations. AS

▶ Jeanloup Sieff
Black House, 1964

Gelatin silver print
30 x 20 cm
ML/F 1984/113

Gruber Donation

Simonds, Charles

1945 New York
Lives in New York

In his miniaturized cities, such as *Park Model/Fantasy* (1974–1976) in the collection of the Museum Ludwig in Cologne, Simonds demonstrates the evolutionary process of an imaginary people, the "Little People", in various stages: from a "linear" via a "circular" to a "spiral" culture. Simonds' "Little People" are nomadic. Their settlements, landscapes and ritual spaces can usually be found in easily overlooked corners and niches of modern, largely devastated big cities. For Simonds the life of these invisible people is based on faith, on a special attitude to nature, and on close ties to the earth. The theme of his *Park Model* and related works is always excavation, in the historical as well as psychological sense.

Simonds' interest in cultural and psychological relationships between man and his environment, the earth, is expressed in different ways – from a plane of personal imagination up to a social metaphor. "I have an interest in the earth and in myself, or in my body and the earth, in what happens when they are intertwined with each other or with all the related things, symbolically and metaphorically, such as my body as the body of all humans, or the earth as the place where we all live."

In his private rituals, which he documents in films or photographs, Simonds goes in search of the tracks of human evolution. In his photographic series *Birth* of the year 1970, a human figure appears – the artist himself – from a reddish rock. This, too, concerns an evolutionary process of man, as well as his being in harmony with nature, in harmony with his environment. Like many of his photographic works, *Birth* is a series of still images derived from filming a performance. In other works, for example *Body/Landscape* (1974), the artist's body forms a

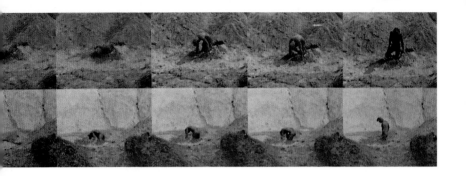

mountain landscape, in which he writhes in the nude in a field of mud. His body is born to the earth and at the same time of the earth.

Simonds' work is closely linked with the land and body art of the seventies. Dennis Oppenheim, for example, made an 8 mm film in 1970 entitled "Petrified Hand", in which he gradually covered his right hand with stones, thus making it invisible. In his large-scale project "Earthworks", the land-art artist Michael Heizer "made drawings" with and on the earth. "My personal association with earth is quite real. I like lying in earth. [...] my work with earth satisfies an extremely fundamental desire", says Michael Heizer. In all cases man finds his way back to nature, and the injured relationship between man and his environment is healed. *GG*

▲ **Charles Simonds**
Birth, 1970

Color prints
20 photographs,
each 18.6 x 23.6 (alto-
gether 49 x 145) cm
ML/F 1979/1166 I–XX

Slavin, Neil

1941 New York
Lives in New York

Between 1959 and 1963 Neil Slavin studied painting, graphic design and photography at Cooper Union School. In 1961 he received a scholarship to study at Oxford. In the same year he worked as a photographic assistant at the Guggenheim Museum in New York. Since then he has been working as a freelance graphic designer and photographer for *Fortune*, *Newsweek* and *Stern*, among others. Since 1975 Slavin has been working in his own studio as well as workshops at colleges including the famous School of Visual Arts in New York. Slavin has become especially known for two publications which could be called sociological photographic project studies: *When Two or More are Gathered Together* (1976) and *Britons* (1986). Since 1973 he has addressed the phenomenon of groups, clubs, and organizations, which he carefully composes in group pictures with the concerned interest of an anthropological researcher. The technically brilliant color photographs used for *Britons* were created with a 20 x 24 inch Polaroid Instant Camera. *AS*

▲ Neal Slavin
Miss USA Pageant and Miss Universe, 1973

Gelatin silver print
24.2 x 33.5 cm
ML/F 1984/115

Gruber Donation

"Humanity is worth more than a picture of humanity, which ultimately can serve only for exploitation." This is the credo of W. Eugene Smith, who has rendered outstanding services to photojournalism with his extraordinary political and social commitment.

In 1933 Smith took his first photographs and, a short time later, managed to sell them to various newspapers. In 1936 he received a scholarship for photography at Notre Dame University in Indiana. Thereafter he moved to New York, where he studied under Helene Sanders at the New York Institute of Photography. In 1937 and 1938 Smith worked as a photojournalist for *Newsweek* before moving to the "Black Star" agency as a freelance photographer. Between 1939 and 1942 he had a contract with *Life* magazine. During World War II

**Smith,
W. Eugene**

1918 Wichita, Kansas
1978 Tucson,
Arizona

▲ **W. Eugene Smith**
Charlie Chaplin
with Top Hat During
the Filming of
"Limelight", 1952

Gelatin silver print
23.1 x 34 cm
ML/F 1977/779

Gruber Collection

▶ **W. Eugene Smith**
Charlie Chaplin Dur-
ing the Filming of
"Limelight", 1952

Gelatin silver print
34.2 x 25.9 cm
ML/F 1977/778

Gruber Collection

Smith worked as a war photographer in the South Pacific, where he took some of his most impressive pictures, for which he paid with serious injuries caused by grenades. After the war and after his recovery – his wounds required 32 operations altogether – Smith returned to *Life* magazine.

During subsequent years he had an impact on the photography of this magazine, because he wanted to do away with the conventional approach of using pictures as mere illustrations to accompany the text, wanting instead to give greater emphasis to the pictures themselves. As a result of this, Smith was instrumental in the development of the independent form of the photo-essay. One of his most famous pieces of journalism in this regard was the photographic series on a Spanish village, published in *Life* in 1951. Because the editor had room for only 17 pictures, a supplement with an additional eight pictures was added. Here, the photographs – completely according to Smith's concept – were presented entirely on their own strength, without any text.

In 1955 Smith left *Life* magazine to work with the "Magnum" agency, a relationship that he kept up until 1959. During subsequent years the

◀ **W. Eugene Smith**
Self-portrait in the
Rear View Mirror,
around 1963

Gelatin silver print
26.6 x 34.5 cm
ML/F 1977/768

Gruber Collection

▶ **W. Eugene Smith**
Albert Schweitzer,
1949

Gelatin silver print
26.7 x 34.2 cm
ML/F 1977/773

Gruber Collection

► W. Eugene Smith
Tennessee Williams,
1948

Gelatin silver print
34 x 26.1 cm
ML/F 1977/771
Gruber Collection

photographer discovered the book as a suitable medium for publishing
his photographs. By using this medium, he could exercise complete
control over the presentation of his photographs.

In memory of Smith's immense human commitment, the Interna-
tional Center of Photography in New York has been awarding the W.
Eugene Smith Memorial Fund Scholarship since 1980. *MBT*

Snow, Michael

1929 Toronto,
Canada
Lives in Toronto

▼ Michael Snow
Imposition, 1976

Color print
160 x 96 cm
ML/F 1985/39

In the early fifties, Canadian Michael Snow attended the Ontario College of Art, marrying artist and film-maker Joyce Wieland in 1959. The multifaceted talents of Snow manifested themselves in his activities as a photographer, musician, artist, and film-maker. He sees his photography influenced by painting and sculpting rather than by photographic technology. In 1961 Snow began with his *Walking Women* series and created new forms and environments with various arrangements of many small pictures of details of persons. In 1962 he introduced *Four to Five*, a montage of twelve rectangular photographs with sections of a walking woman in various contexts, thereby establishing new spatial and optical relationships. The vertical arrangement of the two central pictures alone assures the curiosity of the viewer, triggering the necessary search for a new pictorial reality. In this context Snow considers important the process and the new arrangement of the individual parts, which indirectly illustrate the progress of the woman. Snow's work with motion pictures and his photography exhibit many similar elements. The environment *Field/Champ* (1973–1974) includes 99 rectangular photographs with details of plants. Since 1955 Snow has been a professor at the University of Toronto, receiving several awards and a Guggenheim grant. In 1977 he was represented in the Canadian pavilion at the Biennale in Venice and at "documenta VI" in Kassel. *LH*

Frederick Sommer showed an interest in photography early on, but first he studied landscape architecture at Cornell University in Ithaca, New York. Between 1931 and 1935 Sommer lived as a painter and occasional photographer in Arizona. His acquaintance with Alfred Stieglitz convinced him to devote himself entirely to photography. In 1936 he met Edward Weston, whose tone value scale impressed him especially. Shortly thereafter, the young photographer began to work with an 18 x 24 cm camera.

Sommer's preferred subjects were rock fissures and the expansive landscape of Arizona. In 1939 he created a series of grotesque still-life photographs depicting the heads and entrails of chickens with impressive precision. This series also reflects his interest in the art of Surrealism, which stemmed from his friendship with the painter Max Ernst, whom he froze "in stone" in a famous portrait taken in 1946. *MBT*

**Sommer,
Frederick**

1905 Angri, Italy
1999 Los Angeles

▲ **Frederick Sommer**
Max Ernst, 1946

Gelatin silver print
19.2 x 24.1 cm
ML/F 1977/785

Gruber Collection

◀ **Erich Spahn**
Mixco Viejo,
Guatemala, 1992

Gelatin silver print
160 x 160 cm
ML/F 1995/131

Locher Donation

Spahn, Erich

1957 Weiden,
Germany
Lives in Amberg

Following an apprenticeship in photography in Regensburg, Erich
Spahn studied painting and photography at the Academy of Arts in
Kassel and he became the fifth-generation photographer to follow in
the footsteps of his ancestors. From 1980 to 1981 he attended a master
class at the Bavarian State Institute of Photography in Munich. His
photographic work relates to the tradition of the abstract-concrete, to
structures, stone patterns or light and shadow effects, and he uses crop-
ping techniques in order to carry out minimal changes with horizontal,
vertical, or diagonal shifts, axial rotations, counter-movements, or color
changes from one picture to the next. The image is conceived in his
mind and composed in the camera. *RM*

▶ Erwin Olaf
Springveld
From the series:
Chessmen, 1988

Gelatin silver print
37.4 x 37.4 cm
ML/F 1990/54

Deutsche Leasing
Donation

Between 1977 and 1980 Erwin Olaf (Erwin Olaf Springveld) attended a school for journalism in Utrecht. Since 1981 he has been working as a freelance photographer for the homosexual scene in the Netherlands and for various international papers such as *Gai-Pied*, *The Advocate*, *Rosa Flieder*, and *Gay-krant*.

In 1968 he secured a contract to produce all the covers for *Vinyl*, a magazine for young people. During subsequent years his magazine covers, posters and record covers were highly successful. In 1988 he achieved his breakthrough with the first publication of his series *Chessmen*, earning him international recognition. It was published in *Focus* and awarded first prize for Young European Photographers by Deutsche Leasing. Since then he has been working predominantly for newspapers. In 1990 he published his next picture series entitled *Blacks*. Since then he has also been working as a movie director. In 1991 he made the 30-minute-long film "Tadzio". *RM*

Springveld, Erwin Olaf

1959 Hilversum, Netherlands
Lives in Amsterdam

Springs, Alice

(June Brown)

1923 Melbourne
Lives in Monaco

▼ Alice Springs
Helmut Newton as a
Nun, 1975

Gelatin silver print
7.3 x 11.7 cm
ML/F 1985/80

Gruber Donation

Alice Springs was an actress when she met Helmut Newton, to whom she had been recommended as a model. She is a self-taught photographer. She ended up as a photographer because she substituted at short notice for Newton, who was ill with a cold. Her pictures published under his name were successful and encouraged her to try her hand in this field. She concentrated on portraits and currently works for a number of magazines such as *Vanity Fair*. Alice Springs does not interfere with her pictures. She allows subjects to be free and she waits for moments that seem important to her. Because she usually takes portraits of people in an environment familiar to them, relaxed situations may develop, which are of decisive importance to her method. Since 1990 Alice Springs has been photographing her models with a video camera, which enables her to review the recorded material at leisure and to print out those moments that appear important to her. In so doing, she is not attempting to cloud her method, but to utilize the structure of the video image as a tool characteristic of her work. *RM*

▶ Alice Springs
Untitled (Rear View)
around 1970

Gelatin silver print
29.5 x 20 cm
ML/F 1993/505

Gruber Donation

Stankowski, Anton

1906 Gelsenkirchen
1998 Esslingen

▼ Anton Stankowski
Self-portrait, 1938

Gelatin silver print
23.9 x 26.2 cm
ML/F 1991/109

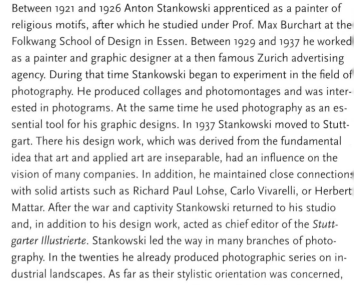

Between 1921 and 1926 Anton Stankowski apprenticed as a painter of religious motifs, after which he studied under Prof. Max Burchart at the Folkwang School of Design in Essen. Between 1929 and 1937 he worked as a painter and graphic designer at a then famous Zurich advertising agency. During that time Stankowski began to experiment in the field of photography. He produced collages and photomontages and was interested in photograms. At the same time he used photography as an essential tool for his graphic designs. In 1937 Stankowski moved to Stuttgart. There his design work, which was derived from the fundamental idea that art and applied art are inseparable, had an influence on the vision of many companies. In addition, he maintained close connections with solid artists such as Richard Paul Lohse, Carlo Vivarelli, or Herbert Mattar. After the war and captivity Stankowski returned to his studio and, in addition to his design work, acted as chief editor of the *Stuttgarter Illustrierte*. Stankowski led the way in many branches of photography. In the twenties he already produced photographic series on industrial landscapes. As far as their stylistic orientation was concerned,

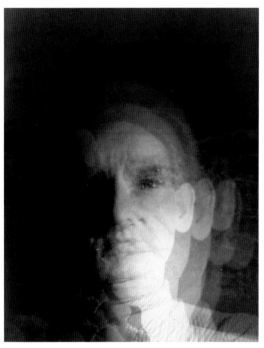

these early photographs were based on photographic Constructivism, yet they already contain the concept of photography of inanimate objects. In the forties he experimented with heated gelatin silver layers as did his contemporary, Chargesheimer, who developed gelatin silver painting at that time. In the fifties he created the first examples of Op Art, producing them in black and white and integrating optical effects which only became effective when the viewer moved. In 1953 he created his first nudograms. Because they were created in the context of his professional work, they especially satisfied his claim that artistic work and applied work should not be

▲ **Anton Stankowski**
Nudogram, 1954

Gelatin silver print
59.7 x 48.3 cm
ML/F 1991/102

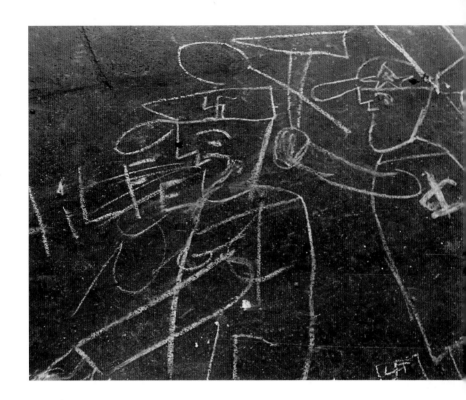

▲ **Anton Stankowski**
Children's Pavement
Drawing, 1929

Gelatin silver print
23.8 x 30.4 cm
ML/F 1991/107

► **Anton Stankowski**
Notre Dame, 1930

Gelatin silver print
11.2 x 8.1 cm
ML/F 1991/103

perceived as contradictory but as equivalent. He always combined innovative artistic work with the requirements of advertising and design. On the one hand he utilized photography in a supportive function for his design work, but on the other used it as an independent medium of equal importance. Taking this approach, Stankowski proved to be an artist who has consistently carried the spirit and tradition of the Bauhaus and the constructivists forward into the present. *RM*

Stano, Tono

1960 Zlaté Moravce
Lives in Prague

▲ Tono Stano
Current Relation-
ship, 1988

Gelatin silver print
43.3 x 52.3 cm
ML/F 1990/1324

Locher Donation

Tono Stano studied at the College of Arts and Crafts in Bratislava and then pursued photography at the Prague Film Faculty. At this school, a group of young photographers formed who developed a new type of staged photography. It included Miro Svolik, Peter Zupnik, Rudo Prekop, Vasil Stanko, and Martin Strba. Fantastic scenes using models in a studio are characteristic of their creative work. They exhibit humor, irony, and hidden metaphors, and frequently refer to mythological traditions. Many times these works deal with the problem of human re-lationships and sexuality.

In this group, Stano is the one who minimizes his imagery the most. He dispenses with narrative moments and concentrates on a restrained pictorial language and simple symbols. *RM*

► **Christian Staub**
Warming Up, 1953

Gelatin silver print
26.5 x 26.5 cm
ML/F 1993/103

Christian Staub conducted his first photographic experiments with a pinhole camera. However, while in Paris between 1938 and 1940, he devoted himself to surrealistic painting. After meeting André Lhote he embraced Cubism for a while. Upon his return to Switzerland in 1940, he realized that he could not make a living with his paintings and decided to study photography under Hans Finsler at the Arts and Crafts School of Zurich. Between 1943 and 1946 he worked as a freelance photographer for magazines such as *Du* and *Annabelle*. After meeting Willi Maywald, he was encouraged to try fashion photography and society portraits. In 1956 he went to New York for the first time. Between 1958 and 1963 he taught at the College of Design in Ulm. Then, between 1963 and 1966, he lectured in photography at the National Design Institute Ahmadabad in India. In 1966 he taught at the University of California in Berkeley and in 1967 he started teaching at the University of Washington in Seattle. Staub, who had always been interested in photo-

Staub, Christian

1918 Menzingen,
near Zug,
Switzerland
2004 Seattle,
Washington

▲ **Christian Staub**
Regensburg, 1962

Gelatin silver print
24.4 x 26.6 cm
ML/F 1993/106

graphic experimentation, created distortions of architecture and nudes, worked on sequences and, in his photograph of St. Severin, alluded to Robert Delaunay and his cubist fragmentation of a space. In his last years he used a panoramic camera with a movable lens to take pictures of spaces, making the viewer feel transported into the scene. *RM*

▶ **Christian Staub**
St. Severin, Paris,
Homage to Delau-
nay, 1975

Gelatin silver print
34.2 x 14.4 cm
ML/F 1993/107

◄ **Edward Steichen**
George Frederick
Watts, from: Camera
Work 14, 1906

Photogravure
21.2 x 16.5 cm
ML/F 1995/47

Gruber Donation

► **Edward Steichen**
Rodin, from: Camera
Work 2, 1903

Photogravure
21.2 x 16.2 cm
ML/F 1995/38

Gruber Donation

**Steichen,
Edward**

1879 Luxembourg
1973 West Redding,
Connecticut

Edward Steichen, who was born in Luxembourg, grew up in the USA after his family emigrated in 1881. Between 1894 and 1898 he studied under Richard Lorenz and Robert Schade at the Milwaukee Art Students' League and was an apprentice in a lithographic business in Milwaukee.

Steichen painted, was interested in photography and, in 1895 began working in the style of artistic photography. During subsequent years he successfully participated in photographic exhibitions in America and in Europe. Despite his early commitment to photography, Steichen continued to pursue his career as a painter.

In an early self-portrait taken in 1901, Steichen drew attention to his double role. Although acting as a photographer, he deliberately took the pose of a painter. In his eyes, apparently the rich tradition of the medium of painting was a more suitable medium for depicting artistic genius than was the medium of photography. Nevertheless, he ultimately decided in favor of photography. In 1923 he broke entirely with

his vocation as a painter by single-handedly burning those of his paint-
ings that were in his possession.

In 1902 Steichen became one of the founding members of "Photo
Secession", which was initiated by Alfred Stieglitz in New York. By
spending several years in Paris and by taking extended trips through-
out Europe, Steichen became familiar with local avant-garde art and
arranged exhibitions for artists in the USA, particularly in Stieglitz' fam-
ous Gallery 291 in New York.

▲ Edward Steichen
The Brass Bowl, from:
Camera Work 14, 1906

Halftone print
19.3 x 16.3 cm
ML/F 1995/54

Gruber Donation

▶ Edward Steichen
Eleonora Duse, 1903

Photogravure
17.7 x 13.5 cm
ML/F 1994/290

Gruber Donation

◄ **Edward Steichen**
George Bernard
Shaw, 1907

Photogravure
20.3 x 16.3 cm
ML/F 1977/802

Gruber Collection

► **Edward Steichen**
John Pierpont
Morgan, 1903

Silver bromide print
25 x 19.6 cm
ML/F 1977/789

Gruber Collection

During World War I, Steichen served as a photographer in the Air
Force and in the Marines, an assignment that was to change his photo-
graphic style fundamentally. The precision required by aerial photo-
graphs honed his eye and taught him to appreciate the beauty of non-
manipulated photography.

In 1923 Steichen became the chief photographer at Condé-Nast,
where he was responsible especially for the fashion magazines *Vanity
Fair* and *Vogue* until 1938. During these years he advanced to become
one of the best-paid fashion and portrait photographers of his time.

After World War II, the now 67-year-old photographer embarked

▲ **Edward Steichen**
William M. Chase, from: Camera Work 14, 1906

Photogravure, 20.7 x 16.1 cm
ML/F 1995/48

Gruber Donation

▲ Edward Steichen
The Flatiron Evening, from: Camera Work 14, 1906

Three-color halftone print, 21 x 15.9 cm
ML/F 1995/55

Gruber Donation

◄ Edward Steichen
Laughing Boxes,
New York, 1921

Silver bromide print
24.4 x 19.4 cm
ML/F 1977/80

Gruber Collection

► Edward Steichen
George Washington
Bridge, 1931

Gelatin silver print
24.1 x 19.4 cm
ML/F 1988/72

Gruber Donation

on a second career. He became director of the photographic department
of the Museum of Modern Art in New York, organizing numerous ex-
hibitions. His "Family of Man", representing not only a photographic
concept but also a moral ideal, became world famous. This exhibition
was meant to be a "mirror of the essential unity of man worldwide".
MBT

▲ **Edward Steichen**
Self-portrait, 1929

Gelatin silver print
25.1 x 20 cm
ML/F 1977/786

Gruber Collection

▲ **Edward Steichen**
Charlie Chaplin, 1931

Silver bromide print
25 x 19.8 cm
ML/F 1977/790

Gruber Collection

▲ **Edward Steichen**
Marlene Dietrich, 1935

Silver bromide print
24.2 x 19.3 cm
ML/F 1977/791

Gruber Collection

▲ **Edward Steichen**
Gloria Swanson, 1926

Silver bromide print
24.2 x 19.3 cm
ML/F 1977/810

Gruber Collection

Otto Steinert, who made history as an outstanding personality of German post-war photography, started out wanting to become a physician. In 1934 he began to study medicine, graduating in 1939. After World War II he worked as a doctor in residence in Kiel from 1945 to 1947. Simultaneously, however, he taught himself photography, eventually giving up his profession as a physician to pursue his passion for photography. In 1948 he became the director of the photographic class at the State College of Arts and Trades in Saarbrücken. There he, Peter Keetman, Ludwig Windstoßer, and others, founded the group "fotoform" in 1949, which was dedicated to rekindling people's awareness of the photographic design possibilities and modes of expression of the pre-war avant-garde, which had been suppressed by the dictatorial cultural policy of the National Socialists. In 1951 Steinert organized the first of three exhibitions whose title "subjective photography" was to become synonymous with a whole new direction in style. In the second catalog of this small series of exhibitions Steinert explained: "We feel all the more

► Otto Steinert
Dancer's Mask, 1952

Gelatin silver print
34.5 x 26.5 cm
ML/F 1977/817

Gruber Collection

obligated [...] to encourage all efforts to work actively and creatively on the synthesis of the creative, contemporary photographic image and to generate a genuine relationship with photographic image quality." High-contrast prints, radical cropping, abstract structures, surreal-looking situations, negative prints, and solarizations became the favorite forms of expression espoused by Steinert and his students. Their idols were photographers such as Man Ray and especially László Moholy-Nagy.

In 1959 Steinert accepted an invitation to teach at the Folkwang School of Design in Essen, where he directed the photography work group until he passed away. During these years Steinert not only acted as a photographer and teacher, but also assembled an excellent photographic collection. *MBT*

▲ **Otto Steinert**
Pedestrian's Foot,
1950

Gelatin silver print
28.7 x 40 cm
ML/F 1977/818

Gruber Collection

Ill. p.668:
Otto Steinert
Appeal, 1950

Gelatin silver print
39.4 x 28.7 cm
ML/F 1977/819

Gruber Collection

Curt Stenvert studied painting, sculpting, theater and motion picture
sciences in Vienna. Following an initial involvement with German Ex-
pressionism and Futurism, he became co-founder of the Vienna School
of Fantastic Realism. His motion studies, however, concentrated on the
development of a synthesis of Futurism, Constructivism, and Cubism.
After a few years of making films ("The Raven", "Venice"), he turned to
object art in 1962, writing his manifesto on "Functional Art of the 21st
Century". Stenvert was active as an object artist, producing his series
Human Situations as well as photocollages, verse-collages, screened
prints, and watercolor paintings. In the seventies he began to paint
again and developed pictures that implemented his idea of a process
perspective with motion studies and a gold background. *RM*

Stenvert, Curt

(Curt Steinwendner)

1920 Vienna
1992 Cologne

Stern, Bert

1929 New York
Lives in New York

Bert Stern is a self-taught photographer. In 1951 he was a cameraman for the US Army in Japan. Since 1953 he has been working as a fashion and advertising photographer. He was one of the first to design newspaper advertisements in color that were difficult to distinguish from editorial picture pages. His style can be circumscribed with words such as glamour, romanticism, and delicacy: "If you want to be seduced by the camera, by a man who can fall in love with any object, go see Bert Stern", is how a publisher characterized him. His outstanding abilities in portrait photography were especially noticeable in *Louis Armstrong*, a picture taken around 1959 on the occasion of an advertising campaign for an early Polaroid film. The sharpness of detail and gradation of the black-and-white tones was perfect to a point that the client considered it "too good", but still had it printed. But without doubt the most famous of Stern's photographs are those he took of Marilyn Monroe. They were shot during her last photographic session for *Vogue* magazine at a Los Angeles hotel in June of 1962, six weeks before she died. In the course of three days Stern shot almost 2700 pictures, including portraits, fashion photographs and nudes, which were published in the 1992 picture book *The Complete Last Sittings* and which attest to the unique intimacy and understanding between model and photographer during that ses-

▼ **Bert Stern**
Eartha Kitt, around 1956

Gelatin silver print
28.1 x 27.4 cm
ML/F 1977/824

Gruber Collection

sion. At that time *Vogue* published a total of eight of the black-and-white shots. Bert Stern became increasingly successful during the sixties, but his photographs of Marilyn Monroe remained very special: "In the course of the years I noticed that the pictures we had taken together now belonged to everyone. What we created had grown beyond me. Somehow they slipped away from me and into the dreams of everyone." *AS*

▲ Bert Stern
Louis Armstrong,
around 1959

Gelatin silver print
41.9 x 34.5 cm
ML/F 1977/821

Gruber Collection

Alfred Stieglitz was the son of a well-to-do German-Jewish family. He studied engineering and photographic chemistry in Berlin, where he trained under Hermann Wilhelm Vogel, the inventor of orthochromatic film.

Initially, he was particularly interested in the functional, scientific aspect of his studies of photography. His first works, oriented to conventional photography, were created in 1883 in Berlin. In 1890, at the age of 26, he returned to New York. Because he had quickly reached the technical limits of photography, Stieglitz began to look for new methods of exposure and processing. Together with Joseph T. Keiley, he invented "pure photography", using the gelatin process.

In the 1890s Stieglitz worked in gravure printing and also wrote articles for photographic journals. Photographs of this time, including *A Street in Sterzing, South Tyrol,* and *Sun Rays, Paula* show his intense interest in lighting conditions and their effects, such as light stripes created by Venetian blinds as shown in the latter of the aforementioned photographs. There is also a certain influence of German genre painters evident in Stieglitz' understanding of imagery.

In 1893 he created his first successful photograph of snow, and three years later he made his first night-time photograph. Also in 1893 Stieglitz became the publisher of *American Amateur Photographer* and in 1897 of *Camera Notes.*

In 1902 Stieglitz, Edward Steichen, and Alvin Langdon Coburn founded "Photo Secession" and the journal *Camera Work*. The title "Photo Secession" was selected in honor of Symbolism and of the Vienna Secession. The photographers of "Photo Secession", including Gertrude Käsebier, Clarence H. White, and Frank Eugene, did not so much see mimetic qualities in photography, but the spiritual expression of the artist himself. In the aesthetics of his pictures Stieglitz emphasized his own perception, totally independent of any viewing tradition. Despite the group's goal of artistic aesthetics, Stieglitz' photography remained quite untouched by these ideas. Symbolic titles like *The Hand of Man* can still be found here and there, but his main subjects in those years were the city of New York and the formal, architectural aspects of its buildings.

In 1905 he opened Gallery 291, which derived its name from its location on 291 Fifth Avenue in New York City, where Stieglitz introduced the European avant-garde to Americans. His newspapers and the presenta-

▲ **Alfred Stieglitz**
The Steerage, 1907

Heliogravure
19.7 x 15.8 cm
ML/F 1982/1

▲ **Alfred Stieglitz**
The Mauretania, from:
Camera Work 36, 1911

Photogravure
20.9 x 16.3 cm
ML/F 1995/59

Gruber Donation

▲ **Alfred Stieglitz**
In the New York Central
Yards, from: Camera
Work 36, 1911

Photogravure
19.4 x 15.9 cm
ML/F 1995/69

Gruber Donation

◄ **Alfred Stieglitz**
Spring Rain, from:
Camera Work 36,
1911

Photogravure
23 x 9.2 cm
ML/F 1995/71

Gruber Donation

► **Alfred Stieglitz**
Old and New New
York, from: Camera
Work 36, 1911

Photogravure
20.3 x 15.8 cm
ML/F 1995/61

Gruber Donation

▲ Alfred Stieglitz
A Dirigible, from:
Camera Work 36,
1911

Photogravure
17.8 x 18 cm
ML/F 1995/63

Gruber Donation

tion of modern European artists in the USA place Stieglitz in the center of photography and art of the early twenties.

In 1917, the last year *Camera Work* was published, he met Georgia O'Keeffe, a photographer and later his life companion, whose pictures he exhibited in 1926 in his second gallery, the Intimate Gallery. As a result of numerous photographs he took of Georgia O'Keeffe Stieglitz' portrait photography set new standards, exhibiting unadulterated directness and the search for objective truth through "pure photography". As is obvious from a voluminous exchange of letters, Stieglitz' friendship with newspaper illustrator Arthur G. Dove was of great importance. In

1929 Stieglitz' second gallery was closed. Soon he opened another one, "An American Place", which he operated until he died. Regardless of the fact that he managed his gallery more on idealistic than commercial lines, Stieglitz saw himself mainly as a photographer who wanted to convey what he saw – his "idea photography". In 1922 he photographed a series of clouds at Lake George, which were of an abstract nature. *LH*

▲ **Alfred Stieglitz**
Aeroplane, from:
Camera Work 36,
1911

Photogravure
14.4 x 17.6 cm
ML/F 1995/62

Gruber Donation

◄ **Alfred Stieglitz**
At the Pool, from:
Camera Work 36,
1911

Photogravure
12.6 x 15.9 cm
ML/F 1995/67

Gruber Donation

► **Alfred Stieglitz**
The Swimming
Lesson, from:
Camera Work 36,
1911

Photogravure
14.9 x 23.1 cm
ML/F 1995/66

Gruber Donation

Stock, Dennis

1928 New York
Lives in the
Provence, France

▼ Dennis Stock
New Orleans, 1961

Gelatin silver print
19.4 x 24 cm
ML/F 1994/298

Gruber Donation

Following a photographic apprenticeship with Gjon Mili (1947–1951), Dennis Stock worked as a freelance photographer for *Life, Paris Match, Look, Geo,* and *Queen,* among others. He has been a full member of the "Magnum" photo-agency since 1954. In 1951 *Life* magazine already awarded him the first prize for young photographers for his picture series on refugees from East Germany. From the late fifties into the seventies he worked as a chronicler and portrait photographer of the jazz scene (picture book, *Jazz World,* 1959), where he accompanied musicians on all sorts of locations, on the stage, during rehearsal, on the way home in the early morning after a gig in a club. In addition to his publications and reports on Italy, Japan, California, and Alaska, he became known for his plant impressions. His encounter with James Dean in 1955 made Stock famous. In 1956 his *Portrait of a Young Man, James Dean,* was published. He photographed him in Hollywood, New York, and in his home in Indiana. By taking the picture *James Dean in Times Square, New York City* in 1955, showing the actor with shoulders raised, hands deep in his coat pockets, cigarette dangling from the corner of his mouth on a street wet from rain, Stock created an icon that symbolized the cult around the movie star who died young and who was the idol of an entire generation. That picture has been reprinted on thousands of posters and postcards, and it remains in everyone's mind to this day. *AS*

Wolf Strache obtained his doctorate in political science in Cologne and Munich. After working for just one year for the Ullstein publishing house in Berlin, he began his career as a freelance photojournalist. His first picture books were published in 1936. His work as a photographer and writer was interrupted by World War II, when he had to serve in the Foreign Office. Later on he was drafted to become a photographic reporter for the German air force. His photographic style is strongly based on the New Vision and its extreme perspectives. Some of his photographs of the destruction in Germany, such as *Berlin, Kurfürstendamm After a Major Air Raid*, became world famous because of their powerful symbolism. In 1945 Strache moved to Stuttgart. He published a broad spectrum of photographic picture books with topics relating to culture, art history, natural science, and geography. He used different publishers, but he also published his own series of books *The Beautiful Books*. In 1955 he began publishing the annual *The German Photograph*, which

Strache, Wolf

1910 Greifswald,
Germany
2001 Stuttgart

has been presenting outstanding work by German photographers for 25 years. Today, it is considered one of the most important documents of recent German photographic history. Between 1971 and 1985 he was the secretary-treasurer of the Association of Freelance Photo-Designers.
RM

Strand, Paul

1890 New York
1976 Orgeval, France

In 1909 Paul Strand completed his studies under Lewis Hine at the Ethical Cultural School in New York. Hine introduced him to Alfred Stieglitz, the founder of "Photo Secession" and the publisher of *Camera Work*. Strand began producing abstract photographs in 1915. In 1917, the last double-edition of *Camera Work* was dedicated exclusively to Strand's photographs. He imparted this medium with a new direction in style, called "straight photography" ever since. The traditional orientation to painting was replaced by a self-assured exploration of the genuinely photographic, where the charm is frequently found in the mundane, in a structure, or in the shadow of the world of things, in excerpts and rhythms. *Abstraction, Shadows of a Veranda, Connecticut* (1916) is representative of this style. Strand's works cover almost all subjects, including portraits and documentary pictures, landscapes and plant photography, architectural themes and photographs of machines and industrial sites. *AS*

Strauß, Helfried

1943 Plauen
Lives in Leipzig

▶ **Helfried Strauß**
From: Sanssouci, 1982

Gelatin silver print
45 x 30 cm
ML/F 1991/182

▼ **Helfried Strauß**
From: Sanssouci, 1982

Gelatin silver print
448 x 30 cm
ML/F 1991/181

Between 1963 and 1965 Helfried Strauß studied singing and voice at the Conservatory in Halle, after which he sang for two years at the theater of the City of Cottbus. Between 1967 and 1972 he studied photography at the College of Graphic Design and Book Art in Leipzig. From 1973 to 1976 he was a photojournalist for *Freie Welt* in Berlin. Between 1976 and 1979 he completed additional studies at the aforementioned college, becoming an assistant and, in 1980, its director of the photography program. He has been a professor there since 1993. Strauß is a photographer who has always been meticulous in preparing and carrying out his projects. He is not only interested in successful individual pictures, but also in completed self-contained projects. He adopted this method of working when in the former East Germany it was anything but politically expedient to do so. He documented religious folk customs of the

Sorbs dating back hundreds of years, daily life in Moscow, and the life and work of ferrywoman Brigitte Höfgen in Grimma, which he was only able to publish in book form after German reunification. One of his most extensive projects is the documentation of parks designed by landscape architect Peter Joseph Lenné, where he devotes equal interest to preserved, as well as modified or destroyed parks. In his view, the history of the park is as important as its original design. Another series deals with the sculptures in Sanssouci. Here he examined the relationship of sculptures and space, and in another series he approached parts of the sculptures so closely that their surfaces began to look deceptively like living skin. *RM*

◄ **Liselotte Strelow**
Winifried Wagner in
Front of Her House,
1959

Gelatin silver print
25.5 x 22.3 cm
ML/F 1977/829

Gruber Collection

► **Liselotte Strelow**
Prof. Oskar Fritz
Schuh, around 1958

Gelatin silver print
39.5 x 29.7 cm
ML/F 1977/827

Gruber Collection

Strelow,
Liselotte

1908 Redel,
Pomerania
1981 Hamburg

After attending a private school in Neustettin, Liselotte Strelow began to
study agronomy and then, from 1930 to 1932, photography at the Lette-
Verein in Berlin. In 1933 she was an assistant to Sys Byk in Berlin, where
between 1933 and 1938 she was subsequently employed by Kodak AG.
In 1936 she completed her training with a diploma. In 1938 she set up
a studio at Kurfürstendamm in Berlin, later working as a freelancer for
various papers such as the *Frankfurter Allgemeine, Die Welt, Der Spiegel*,
and *Theater der Zeit*. Her camera of choice was a Rolleiflex, which influ-
enced her style. In 1943 she moved to Neustettin where she devoted
herself mainly to landscape photography. Between 1945 and 1950 she set
up a studio in Detmold and began to work on theater photography with
Gustaf Gründgens at the Düsseldorf Theater. In 1949 she had her first
solo exhibition. One year later Liselotte Strelow moved to Düsseldorf,
from where she traveled extensively. Her work was very successful and
the name "Strelow" became synonymous with fine portrait photography.
She also cultivated the portrait in her theater photography. She made
portraits of socially and culturally prominent people of her time, she
was official photographer at the Wagner Festivals from 1952 to 1962,

◄ Liselotte Strelow
Alice Bettina
Constance Gruber,
1960

Gelatin silver print
28.2 x 23 cm
ML/F 1993/532

Gruber Donation

and she received numerous awards, including the Cultural Award of the German Society for Photography (DGPh) and the David Octavius Hill Medal of the Society of German Photographers (GDL). Between 1959 and 1962 she was the chief photographer at the theaters of the City of Cologne, and in 1966 received the Adolf Grimme Prize. She lived in Munich between 1969 and 1976, and in Hamburg from 1977 until she died after seven cancer operations. *RM*

► **Carl Strüwe**
Plant Thorns, 1933

Gelatin silver print
23.8 x 18.4 cm
ML/F 1991/87

Carl Strüwe apprenticed in lithography and studied at the Arts and Crafts School of Bielefeld. His interest in photography emerged during that time. At the beginning of the twenties he was employed as a commercial artist at a large graphic arts company in Bielefeld. In the course of his activities, which included the design of logos, packages, and posters, he discovered photography as a new medium. Between 1924 and 1952 Strüwe traveled to Italy, the Alps, and Africa. His publication *Hohenstaufen in Italy – Pictures and Words* of 1986 goes back to that time. In 1926 he produced his first micro-photographs, a subject that continued to fascinate him. After his book *Shapes of the Microcosm – Form and Design of a World of Images* first appeared in 1955, his name was inseparably linked with micro-photography. *RM*

Strüwe, Carl

1898 Bielefeld
1988 Bielefeld

▲ Carl Strüwe
Notched Butterfly Pro-
boscis. Roll-up Mecha-
nism, from the series:
Forms of Structure and
Motion, 1928
Gelatin silver print
22.7 x 18.5 cm
ML/F 1991/83

► Carl Strüwe
Archetype of Adaptation.
Ocean Rhythms in the Str
ture of A Sea Algae, from
the series: Original Image
Symbolic Images, 1930
Gelatin silver print
24.5 x 19 cm
ML/F 1991/84

Sudek, Josef

1896 Kolín, Bohemia
1976 Prague

▲ Josef Sudek
Untitled
(panorama), around
1950

Gelatin silver print
14 x 37.8 cm
ML/F 1993/506

Gruber Donation

Following an apprenticeship as a bookbinder, Josef Sudek served as a soldier in World War I. In 1916 he was seriously injured in Italy, losing his right arm. After spending three years in hospitals he decided to become a photographer. In 1920 he became a member of the Prague Club for Amateur Photographers, going on to study photography for two years under Karel Novak at the National School of Graphic Art in Prague. Together with Jaromir Funke and other photographers he founded the Czech Photographic Association in 1924. In the twenties he shot a series of photographs of the reconstruction of St. Vitus Cathedral (Portfolio *Svazy Vit*, 1928) which earned him the title of official photographer of the City of Prague. Until 1936 Sudek was co-publisher and illustrator of the magazines *Panorama* and *Zijeme*, at the same time carrying out advertising and portrait work in his own studio. Sudek used an 1894 Kodak panoramic camera (negative format 10 x 30 cm) to produce an extensive series of views of Prague, which was only published in 1959. Beginning in 1940, he used mostly large-format cameras because he was fascinated by the possibilities of contact prints. Sudek is considered a master of the still life and of nature shots. The objects in his still-life pictures are illuminated with lyrical sensitivity. Diffused daylight, direct sunlight, or a cloudy sky provide an extremely melancholy, romantic, and at times sinister atmosphere despite the realistic rendition. Following a large exhibition in 1974 at the George Eastman House in Rochester, New York, he was honored two years later on the occasion of his 80th birthday with retrospectives in Prague and Brno in his home country. *AS*

► **Josef Sudek**
Untitled (cherry blossom), around 1940

Gelatin silver print
29.3 x 22.3 cm
ML/F 1993/507

Gruber Donation

► **Josef Sudek**
Park and Bridge, 1964

Gelatin silver print
11 x 17.2 cm
ML/F 1984/117

Gruber Donation

Székessy, Karin

1939 Essen
Lives in Hamburg

▼ Karin Székessy
Nude with Mask and
Fish, 1973

Gelatin silver print
27.9 x 22.2 cm
ML/F 1993/508

Gruber Donation

Karin Székessy grew up in Hertfordshire, England, where she decided to become a photographer. In 1954 she began to take pictures with her first Leica. Following high school in Düsseldorf, she studied photography under Prof. Hans Schreiner in Munich from 1958 to 1960. In 1959 she gave birth to her son Oliver. Since 1960 she has been living in Hamburg, where she works as a freelance photographer and takes portraits of famous people. Between 1960 and 1963 she collected dolls, which she photographed, publishing the pictures in different newspapers such as *Die Zeit, Die Welt,* und *Süddeutsche Zeitung.* Between 1962 and 1967 she produced a series of photographs of *Contemporaries.* From 1963 until 1967 she worked for *Kristall* magazine, which published her pictures of politicians and children in the big city. Between 1967 and 1970 she worked for *Brigitte, Zeitmagazin, Konkret,* and *Photo* and began to photograph nudes. She developed her very own style with long-legged models posing in unconventional ways, frequently alluding to historical prototypes

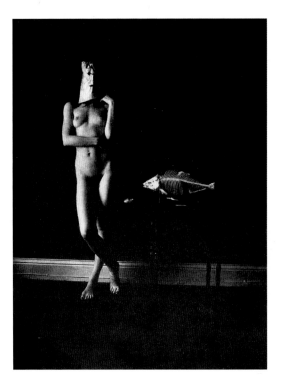

in paintings. In conjunction with this type of work, a congenial collaboration developed with painter and sculptor Paul Wunderlich, with whom she published the book *Correspondences* in 1976, which expressed the harmony of their perceptions. Karin Székessy took photographs of Paul Wunderlich's paintings and it is difficult to say who had the greater influence on whom. In 1971 she married Paul Wunderlich. From 1970 to 1971 she worked with *Orion Press* in Japan and with *twen, Brigitte, Knoll International,* and *Zeitmagazin.* In 1972 her daughter Laura was born. During subsequent years she also photographed advertising campaigns, among others for Draenert-Möbel, a furniture company, and for Ergee-Strümpfe, a stocking com-

▶ **Karin Székessy**
Mask in Easy Chair,
1980

Gelatin silver print
23.9 x 29 cm
ML/F 1994/280

Gruber Donation

◀ **Karin Székessy**
Girls and Plants,
1989

Gelatin silver print
24.7 x 37.2 cm
ML/F 1994/281

Gruber Donation

◄ **Karin Székessy**
Torso (at Studio VII),
1974

Print-out, colorized
27.1 x 19.9 cm
ML/F 1993/511

Gruber Donation

► **Karin Székessy**
Dance with Cactus,
1990

Gelatin silver print
30.8 x 22.3 cm
ML/F 1994/284

Gruber Donation

pany. Her photographs and publications have won many prizes. In the
eighties she took an interest in another topic, over and above her pho-
tography of young women; she took advantage of her travels to Italy,
France, Japan, and the USA to photograph a series of melancholy south-
ern landscapes. *RM*

**Tillmann,
Ulrich**

1951 Linnich
Lives in Cologne

Ulrich Tillmann was born in Linnich in 1951. He studied photography at
the Technical College of Cologne and art history, theater, motion-picture,
and television sciences at the University of Cologne. From 1978 to 1985
he operated the "Gallery without a Gallerist", an exhibition space for ex-
perimental photography, video art, and film. From 1977 to 1987 he lec-
tured at universities in Cologne, Wuppertal, and Düsseldorf. Since 1986
he has been employed at the Agfa Foto-Historama in Cologne.

**Vollmer,
Wolfgang**

1952 Marburg
Lives in Cologne

Between 1978 and 1984 Wolfgang Vollmer studied liberal arts and art-
istic photography under Arno Jansen at the Technical College of Col-
ogne. Between 1982 and 1985 he operated the "Gallery without a Gal-
lerist" together with Ulrich Tillmann. In 1985 Vollmer began lecturing
at various German universities. Since 1994 he has been teaching in
the department of design of the Technical College of Würzburg.

Tillman and Vollmer worked very closely together in the mid-eighties. In 1984 they created the cycle *Masterpieces of Photographic Art*, which proved that some of the most famous pictures in the history of photography, such as Irving Penn's portraits of Pablo Picasso, can be attributed to unknown, only recently discovered predecessors. *RM*

▲ N.N. Pablo Gruber, from: Masterpieces of Photographic Art, Tillmann and Vollmer Collection, 1984

Gelatin silver print
30 x 30 cm
ML/F 1993/539

Gruber Donation

▲ Mariana Swanson, 1987, from:
Masterpieces of Photographic Art,
Tillmann and Vollmer Collection

Gelatin silver print, 32.6 x 27.3 cm
ML/F 1994/308

Gruber Donation

► Paul Outerbridge (attributed to), Woman
with Kitchen Gloves and Trap-the-Cap Caps,
from: Masterpieces of Photographic Art,
Tillmann and Vollmer Collection, 1987

Color print, 40.1 x 29.9 cm
ML/F 1994/302

Gruber Donation

**Tourdjman,
Georges**

1935 Casablanca,
Morocco
Lives in Boulogne

▼ Georges
Tourdjman
Alexey Brodovitch,
1964

Gelatin silver print
37.5 x 24.7 cm
ML/F 1988/68

Gruber Donation

Beginning in 1956, Georges Tourdjman was an assistant producer. In 1963 he moved to New York to study photography. His teachers Ike Weegler and especially Alexey Brodovitch had a decisive influence of Tourdjman's subsequent career. In 1964 this Moroccan photographer went to Paris to freelance, and during the following years obtained advertising contracts with Chanel, Dior, L'Oréal, Air France Maroc and several French automobile companies. Tourdjman designed many cover pages for international magazines such as *Marie-France, Queen, Kodak International Photography*, and *Stern*, and he was responsible for over 50 advertising movie spots. His portrait photographs of the eighties depicting major artists and photographers such as Man Ray, Robert Doisneau and his teacher Brodovitch share a remarkable intensity of expression, obtained on the one hand by a frontal, direct look at the viewer and on the other hand by a certain intimate ambiance. For example, by contrasting the painted portrait and the persons, he has imparted the double portrait of the Prévert brothers with a certain clownish aura. This creates a teasing picture-within-a-picture confusion, because the painting almost emphasizes the characters more than the realistic photograph does. In other black-and-white work the photographer emphasizes cropping, diagonals, and effects like reflections on a table or in the lenses of spectacles. Tourdjman has conducted several workshops in Arles, on portraits in 1976 and on nudes and portraits in 1984. These were followed by several solo exhibitions in Paris, Arles, and Bordeaux. Tourdjman lives and works in France. *LH*

Judith Turner graduated with a Bachelor of Fine Arts from Boston University. She has been interested in photography since 1972, concentrating largely on architectural photography. She has worked for numerous newspapers and magazines in Europe and in America. Her first publication was entitled *Five Architects*, and it brought her instant international fame. Other exhibitions followed at the Tel Aviv Museum, the International Center of Photography in New York, and at Princeton University in New Jersey. Judith Turner works in black and white as well as in color, valuing pure, clear colors. She is considered to be one of the best architectural photographers in the USA. *RM*

Turner, Judith

Born in Atlantic City
Lives in New York

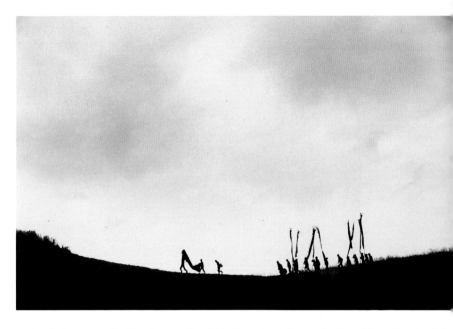

Ueda, Shoji

1913 Sakaiminato,
Japan
2000 Sakaiminato

▲ **Shoji Ueda**
Silhouette Pro-
cession, 1978

Color print, satiny
23.8 x 36.2 cm
ML/F 1984/121

Gruber Donation

Shoji Ueda completed his formal training under Toyo Kikuchi at the Ori-
ental School of Photography. Ueda opened his first studio in his home
town in 1933. Ueda points out that, because in Japan photography is not
held in the same high esteem as painting, he fostered the new age with
a cosmopolitan way of thinking. He is frequently called a "poet of im-
ages". Ueda's main subjects are people set in landscapes, such as the
sand dunes of the Samin region. The staged character of his pictures is
conspicuous in his publication *Dunes* of 1978, and also in *Children the
Year Round*. A person, be it in the form of a rear view of a nude, a man
with a bowler hat, or a child, is the extraneous object in the dunes with
an infinite expanse of sky. Frequently the horizon provides the only
boundary, and spatial concepts are often suspended. Ueda plays with
artificial perspective tricks in nature. Clothes hangers, carpets, and
bowler hat, are often used to confuse perspective viewing.

From 1975, Ueda was a professor at the Kyushyn Sangyo University
in Sakaiminato-shi. *LH*

► **Umbo**

Sinister Street, 1928

Gelatin silver print
29.8 x 22.8 cm
ML/F 1981/574

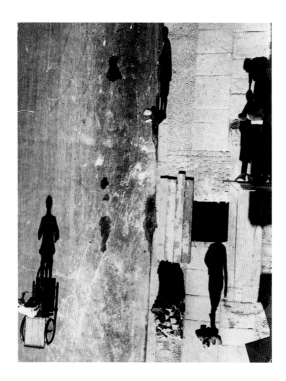

From 1921 to 1923 Umbo studied at the Bauhaus in Weimar. In 1926 he produced photomontages for Walter Ruttmann's film "Berlin". He made the acquaintance of Paul Citroen, the painter, who introduced him to photography. The actress Ruth Landshoff became his preferred model for his innovative portraits, a combination of the broad view of the motion picture and the classical portrait. He adopted the pseudonym Umbo, and his pictures of large cities, portraits and photograms earned him international acclaim as one of the leading German avant-garde artists of the twenties. His style influenced the photojournalism of "Dephot" (German Picture Agency). During the time of the National Socialist regime he joined the resistance movement, and his agency was closed. During World War II Umbo lost his entire archive, and his significance went unrecognized until he was finally rediscovered in 1978 as a pioneer of modern art. *RM*

Umbo

(Otto Maximilian
Umbehr)

1902 Düsseldorf
1980 Hanover

Vogt, Christian

1946 Basel
Lives in Basel

▼ Christian Vogt
Stone, Presentation
– Series, 1974

*Gelatin silver print,
toned blue, with mat
18.3 x 12 cm*
ML/F 1977/834

Gruber Collection

After completing his training as a photographer at the Crafts School in Basel, Christian Vogt traveled and worked as an assistant in Will McBride's studio in Munich. Since 1970 Vogt has been working successfully out of his own studio in Basel, serving advertising clients and magazines such as *Du, Camera, Photo, Playboy, Time-Life,* etc. He has received numerous prizes and awards, including the photokina Prize in Cologne in 1972, the Grand Prix of the Phototriennale Fribourg in Switzerland 1975, and the Prize of the Art Directors' Club of Germany in 1978.

Parallel to his work in commercial photography, Vogt also pursues his personal artistic interests in photography. In 1972 he had his first solo exhibition in Basel, and in 1980 he published the photographic volume *Christian Vogt, Photographs,* which was followed in 1982 by *In Camera, Eighty-Two Photographs with Fifty-Two Women.* He prefers the implementation of a pictorial concept in large cycles. In the seventies, for example, he created the series *Images of Clouds,* with distinctly surrealist overtones reminiscent of René Magritte, and a *Red Series, Blue Series,* and *Yellow Series.* Of particular importance among his works has been the *Frame* series, in which he used a photographed frame to define and change the cropping of the picture. With these pictures he connected with the conceptual art of those years, but also related to Land Art and its methodology of surveying and archiving certain

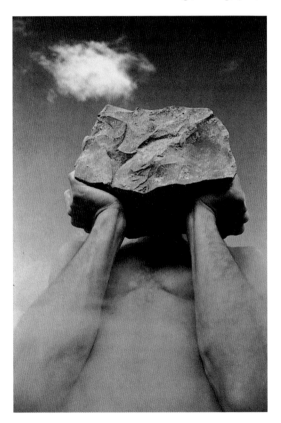

► Christian Vogt
Nina, 1985

*Gelatin silver print
33.5 x 26.4 cm*
ML/F 1988/77

Gruber Donation

▲ ▶ **Christian Vogt**
Portraits, Duane
Michals I–III, 1976

*Gelatin silver print
each 14 x 21 cm*
ML/F 1985/111–113

Gruber Donation

positions in a landscape. The *Frame* series was meant to illustrate the fact that an event is the result of certain conditions, which themselves make these circumstances transparent in the picture. In addition, this series demonstrated the extent to which a change in these parameters caused a change in the image.

In his nude photography, which was temporarily pre-eminent during the eighties, he preferred a subtle approach to the subject, which was sometimes created in dialog with the women. For the project *In Camera* he asked over 50 women to come to his studio, inviting them to select their own poses in front of a curved, colored background. The only condition was that an open wooden crate had to appear in the picture. This resulted in very aesthetic, intimate, humorous, and narrative photographs. *AS*

Vormwald, Gerhard

1948 Heidelberg
Lives in Paris

▼ Gerhard
Vormwald
Maren – Nude, 1989

Gelatin silver print
32.2 x 45.5 cm
ML/F 1995/80

Gruber Donation

Between 1966 and 1971 Gerhard Vormwald studied commercial art and liberal arts at the Applied Arts School in Mannheim. In 1970 he began working as a stage photographer for the National Theater of Mannheim. In addition, he accepted advertising assignments and created photographic illustrations for magazines. In 1975 he created his first photographic productions. In 1983 he moved to Paris, where he established himself as photographer for advertising, magazines and cover pages. Vormwald earned the reputation of a pioneer of staged advertising photography inspired by surreal ideas. The particular attraction of his photographic interpretation was that the physically impossible appeared real in the picture. Vormwald's photographic worlds of photographic images could be considered precursors of computer-generated virtual worlds of images. His flying African, who made every viewer wonder how something like this was possible, became the symbol of this development and was published as such all over the world. But Gerhard Vormwald also increasingly showed his humorous side, as demon-

strated by his photograph of several gentlemen lined up to be measured with a surveyor's staff. In the nineties he distanced himself from producing virtual worlds and turned to a rather obvious form of artifice. Countering the trend that he himself had launched and that was now booming by way of the computer, he began to be interested in pictorial arrangements more reminiscent of a world of Arcimboldo. He used everyday objects, kitchen utensils, rubbish, flowers and food to cobble assemblages, fantasy arrangements that quite obviously are not what they pretend to be, but which assert themselves as ironic statements about that comical world. These photographs too, attest to humor and to obvious fun with surprising and amusing picture ideas, and they are evidence of a fantasy world in which utilitarian thinking is eccentric. He produced these new Cibachrome prints at his own initiative. In 1989 Vormwald opened a studio in the country, devoting himself more and more to his own ideas. *RM*

◀▲ **Gerhard Vormwald**
St. Oskar the Gourmet, 1992

Color print
53.7 x 41.8 cm
ML/F 1995/82

Gruber Donation

▲ **Gerhard Vormwald**
Mykons, Paris, 1992

Color print
53.6 x 43 cm
ML/F 1995/83

Gruber Donation

Walther, Pan

1921 Dresden
1987 Bangkok

▼ Pan Walther
The German Michel,
from the series:
Think About It, 1983

Color print
29.8 x 30 cm
ML/F 1991/110

Pan Walther became aware of photography through his father. After attending the Waldorf School he studied photography in The Hague and in Dresden, where he founded a studio in 1945. After obtaining his diploma as a master photographer in 1946, he worked as a freelance photographer concentrating on portraits, first in Dresden and then, beginning in 1950, in Münster. In addition, he taught for more than 30 years at various colleges, both in Cologne and, since 1963, in Dortmund. There, with single-minded determination, he succeeded in consolidating his own photography classes into an autonomous department with the name "Subject Group Photo-Film-Design", and he soon gave it its own individual profile. His portraits, heads precisely modeled in light, have been regarded as classics for many years. Walther loved dramatic light that brings his faces out of the dark. In addition to people prominent in politics, literature, the arts, and theater, he devoted equal enthusiasm to unknown people he encountered and whose faces he found fascinating. During his many journeys he often had an opportunity encounter peasants, workmen and gypsies whose faces had been etched by the rigors of life and labor.

In addition to this classic theme, Walther developed several sequences of staged photography in the latter works of his life which dealt with the problems of present-day life. These picture series were produced in color and in the manner of photographic performance art. For example, an ode to human stupidity he presented like a fight against a windmill in the form of a Japanese swordfighter holding a club and wrapped in toilet paper and entitled *Think About It*, or the ecological wave which he satirizes in the form of a green catalyst in the thicket of his overgrown garden. Finally, he also addressed the nuclear threat, posing in a rubber suit and gas mask. These later works again demonstrate Walther's fundamentally rebellious attitude and his conviction

of the unity of art and life. Being a pugnacious contemporary, he was always able to earn his colleagues' respect at all times, and he succeeded in producing convincing work and in creating surprises. *RM*

▲ **Pan Walther**
Fighter in the Japan-Look, from the series: Think About It, 1983

Color print
28 x 30.2 cm
ML/F 1991/111

Warhol, Andy

1928 Pittsburgh
1987 New York

Andy Warhol, the son of Czech immigrants, studied at the Carnegie Institute of Technology in Pittsburgh from 1945 to 1949 and started out as a graphic artist in advertising. In 1960 he decided to become an artist and began by painting comic strip figures. His love of money and fame motivated him to search for themes that were as banal as they were provocative: money bills, soup cans, catastrophes, criminals, and stars such as Marilyn Monroe, Elvis Presley, and Robert Rauschenberg. His connections, such as his friendship with Henry Geldzahler, who at that time was a curator at the Metropolitan Museum of Art, helped Warhol to achieve his dream of world fame. In his studio, called "The Factory", he produced screen prints almost in assembly-line fashion. He promoted the ideal of being a machine and of producing art that is equivalent to money – ideally one would convert money into art. In his art, Warhol concentrated completely on the world of consumers and thus became the star and protagonist of American Pop Art. While he was active in the field of painting, screen-printing, and sculpture, Warhol also constantly took photographs. His book *Andy Warhol's Exposures*, published in 1980, containing his casual portraits of the New York art scene, caused a scandal. Warhol provided an insight into the private life of high society in a provokingly artless manner, popping flash pictures of the goings-on with a cheap camera. Shortly thereafter, his patched-together architectural shots appeared, and they were no less of a surprise. The triple portrait of Peter Ludwig is one of the photographic variants of Warhol's large-format work in the possession of that collector. *RM*

▲ Andy Warhol
Three Portraits of
Peter Ludwig, 1980

Color print
each 12.9 x 12.9 cm
ML/F1980/1375

Ludwig Collection

After completing high school, Jürgen Wassmuth began an apprentice-ship in industrial administration, after which he studied economics in Mannheim. In 1981 he decided to change to photography and began to study under professor Ulrich Mack at the Technical College of Dort-mund. In 1982 he married Annette Hitzegrath, and his daughter Anna was born in 1984. Since 1985 Wassmuth has been a graduate photo-graphic designer and freelance photographer for architectural and in-dustrial photography. He has had a studio in Dortmund since 1987. He is a lecturer at the Parsons School of Design in New York and in Paris. In the eighties he undertook numerous study tours of France, Denmark, Poland and Greece, and he also organized the international FOCUS workshop in New York and in Dortmund. In 1988, while on a two-month study tour in New York, Wassmuth produced a comprehensive series of pictures on the architecture of this city. He repeatedly succeeded in pre-senting entirely new perspectives of buildings that were otherwise famil-iar from countless conventional pictures. He has been lecturing at the Technical College of Dortmund since 1989. *RM*

Wassmuth, Jürgen

1955 Balve, Germany
Lives in Dortmund

▲ Jürgen Wassmuth
Flatiron Building,
New York, 1988

Gelatin silver print
30.7 x 40.3 cm
ML/F 1993/553

Gruber Donation

Webster, Christine

1958 Pukekohe,
New Zealand
Lives in Dunedin
and Paris

▼ Christine Webster
Post Crucifixion,
1988

Cibachrome print
156.3 x 95 cm and
25.1 x 25 cm
ML/F 1989/180 I–II

Between 1976 and 1979 Christine Webster studied at Massey and Victoria Universities, as well as at Wellington Polytechnic. In 1982, 1984, and 1988 she was the recipient of the Queen Elizabeth II Arts Council Grant and in 1989 received a scholarship through Agfa Hong Kong. Christine Webster's large-format works deal with myths and traditions that have defined the image of women and the relationship of the sexes through history. By setting picture and word ambiguously opposite each other, she alludes to handed-down meanings while at the same time questioning them in order to suggest new meanings. In so doing, she consciously establishes references to the traditional Tableau Vivant in Victorian salons. She herself arrived at these scenes at Victoria University while studying theater and began to take pictures of her fellow students on the stage. In her current work she deliberately plays with the idea of a voyeuristic look and erotic imagery in order to arouse interest and simultaneously to pose a critical challenge. Christine Webster considers herself an artist who formulates the feminine viewpoint of sexuality and relationship between the sexes. Despite the complexity of its content, Christine Webster's work concentrates on formal execution and perception, limiting itself to what is essential. Text and picture are separate, and people, glowing reddish yellow, emerge from the darkness of the black background. Initially she served as her own model, but today she works more and more with partners. While it may appear unusual for an artist from New Zealand to address European myths and traditions, the discussion of the role of women in society is a topic discussed in all cultures. Christine Webster's art, which has also been successful in Western Europe, has quickly brought her into contract with the international art world. *RM*

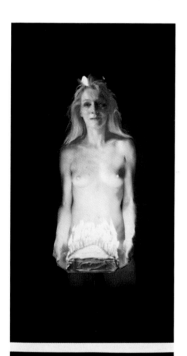

POST CRUCIFIXION

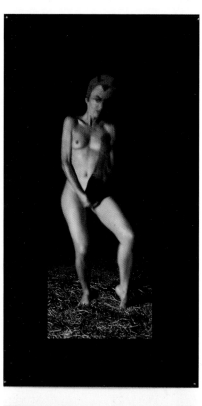
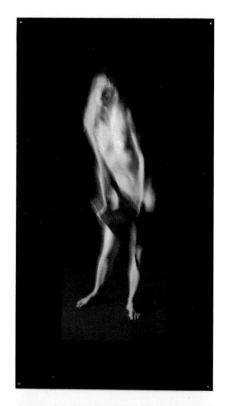

▲ **Christine Webster**
Game Bird, 1987

Cibachrome print
each 154 x 85.7 cm
and 25 x 85.7 cm
ML/F 1987/155 I–IV

Weegee

(Arthur H. Fellig)

1899 Zloczwe
1968 New York

▼ Weegee
Nikita Khrushchev,
1959

Gelatin silver print
22.7 x 19 cm
ML/F 1977/845

Gruber Collection

"WEEGEE... I have never met a better name or a better photographer." This is how famous American sensationalist photographer Arthur H. Fellig, called Weegee, saw himself. In 1910 he and his family emigrated from Austria to New York, where he grew up in poor conditions on the Lower East Side. In 1914 he quit school prematurely in order to help support his family. He held jobs as a candy salesman and street photographer, finally becoming an assistant to a photographic dealer. After he left his family at the age of 18, he took occasional jobs at train stations and shelters for the homeless until he found a job taking passport pictures. At 24 he went to "Acme Newspictures", a photo-agency for newspapers. There, he worked predominantly as a laboratory technician in the darkroom and occasionally helped to take pictures of fires at night and of other catastrophes.

In 1935 Weegee started working as a freelance photojournalist. With absolute obsession he chased sensational events such as traffic accidents, violent crimes, and catastrophic fires. He sent these pictures to the tabloid press. "Photos by Weegee, the famous", read the self-assured stamp on the reverse side of his press photographs. Because of friendly contacts he had with policemen of the Manhattan Police Headquarters, Weegee was informed of all crimes and accidents as quickly as the policemen themselves. In 1938 he even received official permission to install a police radio in his car. This unusual privilege frequently enabled him to be first at the scene and, no less important for the tabloid press, he could be the first to submit photographs to his editor. This collaboration with the Manhattan Police Headquarters lasted for about ten years. During that time he produced over 5000 photographic reports – according to Weegee's own estimates – making him the most famous picture

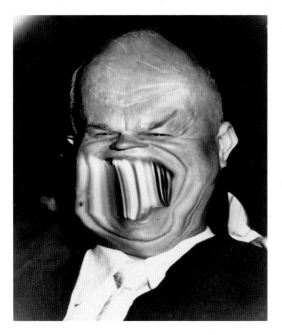

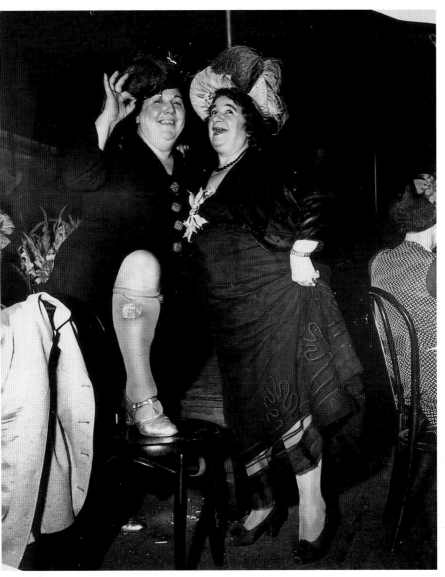

▲ **Weegee**
Sammy's in the Bowery, 1944

Gelatin silver print, 24.1 x 19.8 cm
ML/F 1977/849

Gruber Collection

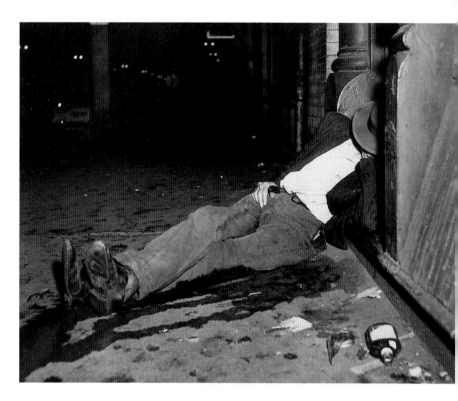

chronicler of New York at that time. In his photographs he captured traces of the Great Depression with anguishing directness. To this day, his work constitutes an impressive documentation of life in modern large cities marked by violence, brutality, and mercilessness. As a balance to this miserable side of life, Weegee began taking pictures of High Society in 1938. These photographs reflect a sarcastic opinion of the rich, decadent stratum of society.

The intensity radiated by Weegee's photographs is also based on a crassly realistic style, paired with a tendency toward expressionistic staging. He liked to use strong flashlight, producing dramatic effects of light and shadow and harsh black-and-white contrasts. Whether these effects are the result of the requirements of the tabloid press or whether he exercised his artistic creativity is not important. The fact is that today his work is justifiably valued for its stylistic uniqueness, making this photographer's work a milestone of photojournalism.

▲ Weegee
Policeman with Dog,
1950

Gelatin silver print
23 x 18.9 cm
ML/F 1977/846

Gruber Collection

▲ **Weegee**
Onlookers, 1936

Gelatin silver print
30 x 27.3 cm
ML/F 1977/836

Gruber Collection

In 1947 Weegee moved to Hollywood, where his first book, *Naked City* (1945), was made into a motion picture. He remained in this center of the motion-picture industry, working as technician and actor in small parts. During that time he collected material for his new book *Naked Hollywood*. In 1952 he returned to New York and produced mainly caricatures of personalities in politics and society. To accomplish this, Weegee developed a kaleidoscope for his camera, calling it a "Weegeescope". In

1961 he published his autobiography, *Weegee by Weegee*, in which he summarized: "I had taken famous pictures of an infamous decade [...] I had photographed the soul of the city that I knew inside out and that I loved." *MBT*

▲ **Weegee**
Coney Island Crowd,
1940

Gelatin silver print
19.1 x 23.5 cm
ML/F 1977/839

Gruber Collection

▲ Weegee
Simply Add Boiling
Water, around 1950

Gelatin silver print
21.4 x 17.5 cm
ML/F 1977/834

Gruber Collection

▲ **Weegee**
The Human Cannon-
ball, 1952

Gelatin silver print
23.9 x 19.7 cm
ML/F 1977/844

Gruber Collection

**Weston,
Edward**

1886 Highland Park,
Illinois
1958 Wildcat Hill

▲ Edward Weston
Nude, 1936

Gelatin silver print
19.1 x 24.1 cm
ML/F 1977/855

Gruber Collection

The photographer Edward Weston is considered to be a pioneer and one of the most consistent representatives of American "straight photography".

His career in photography began in 1902, when he received a camera as a gift from his father and began to take a passionate and committed interest in the possibilities of this medium. At first he taught himself and started traveling as a portrait photographer. In 1908 he attended the Illinois College of Photography and then went to Los Angeles, where he worked as a retoucher and a laboratory assistant in a photographic studio.

In 1911 he opened his own studio in Tropoico (now Glendale), California. Here, as earlier, Weston worked mainly with the soft-focus lens in the style of painterly Pictoralism. During subsequent years he earned the reputation of a successful, respected photographer who was honored with numerous prizes and exhibitions. Between 1921 and 1922 a

▲ **Edward Weston**
Nude, 1936

Gelatin silver print
24.5 x 19.3 cm
ML/F 1977/850

Gruber Collection

change began to take place in Weston's photographic work. He began to enjoy experimenting, seeking abstract motives, unusual viewing angles and lighting conditions. He photographed fragments of faces and nudes, and began to use soft-focus techniques instead of sharply focusing lenses. In 1922, during a visit to his sister May in Middletown, Ohio, he took his first industrial photographs of the Armco Steelworks. These photographs mark the actual turning point of his career.

From now on Weston produced only precise, detailed, and extremely sharp photographs. His change of style was enhanced by his acquaintance with photographers Alfred Stieglitz, Charles Sheeler, and Paul Strand, whom he met during that same year in New York.

In 1923 Weston left his family and moved to New Mexico with his son Chandler and Tina Modotti, a young Italian woman who was his model, his pupil, and later his lover. Together, the three kept a studio until 1926. Weston established contacts with Mexican intellectuals and artists, including Diego Rivera, Frida Kahlo, and others. Weston specialized not only in portraits but also in nudes and still-life pictures, and from 1924 to 1925 he also devoted himself intensely to close-ups. These particular photographs demonstrate this photographer's extraordinary sense for the texture of surfaces, which he depicted with an exquisite

WILLIE

▲ Edward Weston
In Hornitos,
California, 1940

Gelatin silver print
19.4 x 24.3 cm
ML/F 1977/858

Gruber Collection

richness of nuances in black-and-white tones on his photographic pa-
per, giving them an almost tactile quality.

"Presentation instead of interpretation" was one of Weston's much-
quoted mottoes. To him, presentation meant the attempt to illustrate
"things per se", to show their essence. About his photograph of a head
of cabbage he wrote in 1933: "In the cabbage I sense the entire secret of
life's force; I am baffled, emotionally excited, and, because of my way of
presenting, I can communicate to others why the shape of the cabbage
is this way and no other, and what its relationship is to all other forms."
Even though Weston explained realism, presentation, and not inter-
pretation, as being of artistic concern to him, it is his rigorously de-
signed compositions of nature and of natural objects that frequently im-
press viewers, because they evoke absolutely ambivalent interpretations
and associations of forms.

In 1932 Weston, Ansel Adams, Imogen Cunningham, and others

founded the group "f-64", which was to evolve into an important forum of "straight photography". In 1937 Weston received a grant from the John Simon Guggenheim Memorial Foundation, becoming the very first photographer to receive this honor. This grant allowed him to travel through California and its neighboring states for two years.

In the mid-forties he became ill with Parkinson's disease, which forced him to give up photography in 1948. *MBT*

▲ **Edward Weston**
Solano Country,
California, 1937

Gelatin silver print
19.1 x 24.4 cm
ML/F 1977/853

Gruber Collection

◀ **Edward Weston**
Pelican, 1942

Gelatin silver print
19.2 x 24.1 cm
ML/F 1977/854

Gruber Collection

▶ **Edward Weston**
Cabbage Leaf, 1931

Gelatin silver print
19.3 x 24.8 cm
ML/F 1977/856

Gruber Collection

► **Edward Weston**
Armco Steel, Ohio,
1922

Gelatin silver print
23.5 x 17.1 cm
ML/F 1977/857

Gruber Collection

▲ Edward Weston
Rock, Point Lobos, 1930

Gelatin silver print, glossy
24 x 19.2 cm
ML/F 1977/862
Gruber Collection

▲ **Edward Weston**
Pepper, 1930

Gelatin silver print
24 x 19.2 cm
ML/F 1977/864
Gruber Collection

Wilp, Charles

1934 Berlin
2005 Düsseldorf

▼ Charles Wilp
Untitled (Rear View
of Nude), 1972

Gelatin silver print
29.5 x 39 cm
ML/F 1993/557

Gruber Donation

In 1950 Charles Wilp began to study psychology, journalism, and music, training also as a photographer and movie maker. In 1953 he worked on the Brasilia project with the architect Oscar Niemeyer in Rio de Janeiro. One year later his first "Photos of Emptiness" were created during his collaboration with Yves Klein and Jean Tinguely. In 1958 Wilp joined the group of artists "New Realism" as a movie maker. In 1959 his "Photos of Emptiness" were exhibited together with works by Klein, Tinguely, Arman, Jesus Raphael Soto, and Franco Fontana. While collaborating with this group of artists, Arman created the *Portrait of Charles Wilp* in 1961. Between 1962 and 1964 Wilp made several movies about projects by Christo, Tinguely, Arman, and Fontana. In 1965 he began making advertising photographs, in which he incorporated the aesthetics of Pop Art. Wilp received several international awards for his Volkswagen advertisements. His advertising campaign for Afri-Cola was particularly successful. The novel aesthetics of advertising that he developed consisted mainly of the merging of erotic and psychedelic image effects. In 1970 he received the assignment to create a pop portrait of Chancellor Willy Brandt's cabinet. In 1972 he had a one-man exhibition at "documenta V" entitled "Consumer Realism". He designed the stage props and wrote the music for the "Consumer's Opera" during the XX Olympic Games in Munich in 1972. During subsequent years he also concentrated on political portraits. In the mid-eighties Wilp worked as "Artronaut" on projects in which he expressed space travel and high technology in the artistic mode. *TvT*

In Dorothee von Windheim's work, photography often plays the part of notes made with pictures instead of writing, similar to protocols or entries in a journal, telling of the processes in which her works of art are formed, developed, and changed. Dorothee von Windheim studied under Dietrich Helms and Gotthard Graubner (1965–1971) at the College of Creative Arts in Hamburg. With a grant she received from the German Academic Foreign Service, she went to Florence and apprenticed with a restorer. She has been professor at Kassel Polytechnic since 1989. Towards the end of the sixties she began working with life-size images of figures on pieces of cloth. These ghostly silhouettes of bodies were created with techniques such as etching, burning, rubbing, or burying, and they are suggestive of mythological, psychological, and religious themes (like the famous "Turin Shroud"). Other projects are *Strappo*, pieces of cloth with stucco removed from a wall; *Tree Cloths*, in which the trunk of a tree is wrapped in cloth and the pattern of the bark is then transferred to the cloth by the rubbing technique; and *Wine Cloths*, sheets that are stretched in vineyards to protect the vines from birds. Dorothee von Windheim has participated in numerous important exhibitions, including "documenta VI" in Kassel in 1977, Women Artists of the 20th Century in Wiesbaden in 1990, and the Biennale in Venice in 1995. A major solo exhibition was organized by the Wiesbaden Museum in 1989. *AS*

Windheim, Dorothee von

1945 Volmersdingen, near Minden, Germany
Lives in Cologne

▲ **Dorothee von Windheim**
One of the Eleven Thousand Pairs of Eyes from among the Followers of St. Ursula, 1984

Photographic emulsion on gauze between two plates of glass
9 x 21 cm
ML/F 1986/217

Winquist, Rolf

1910 Gothenburg,
Sweden
1968 Stockholm

▲ Rolf Winquist
Dancer in Medea,
around 1957

Gelatin silver print
29.4 x 23.3 cm
ML/F 1977/874

Gruber Donation

▲▶ Rolf Winquist
Dancer Gertrud Frith
in Medea, around
1957

Gelatin silver print
28.7 x 22.6 cm
ML/F 1977/873

Gruber Donation

Rolf Winquist studied photography under David Sorbon in his hometown of Gothenburg. In 1939 he was hired as an assistant by the Ake-Lange Studio in Stockholm. In the same year he became the chief photographer of the Ateljé Uggla in Stockholm. Under his direction that studio became one of the best known addresses in Sweden. Winquist was a portrait, advertising, and fashion photographer. His early portraits showed the influence of English and German photographers, whereas his later work featured sensual studies of women reminiscent of American fashion journals and Hollywood glamour shots. Distanced on the one hand, and sensitive on the other, his photography appears to place more emphasis on a physical impression than on an intellectual background. This is apparent in his portraits of women and children. Winquist photographed famous Swedish people and, during his spare time acted as an amateur, photographing people in the street. He published articles in various newspapers under the titles "Bildmässig fotografi" in 1947 and "Engelska Bilder" in 1959. He managed the Ateljé Uggla until he passed away in 1968. *LH*

▶ Joel Peter Witkin
Courbet in Rejlan-
der's Pool, 1985

Gelatin silver print
38.2 x 37.9 cm
ML/F 1995/129

Uwe Scheid
Donation

At first, Joel Peter Witkin worked as a technician in a studio producing dye transfer prints and then as an assistant in two photographic studios. After that he worked as a military photographer. In 1967 he began to freelance, becoming the official photographer for City Walls Inc. in New York. Later on he studied at the Cooper Union School of Fine Arts in New York, where he obtained his Bachelor of Arts degree in 1974. After receiving a scholarship for poetry at Columbia University in New York, he completed his studies at the University of New Mexico at Albuquerque with a Master of Fine Arts degree, and he currently teaches photography at that school. In the eighties, Witkin shocked the public with photographs of misshapen people, of parts of corpses, and by staging events of church history, frequently citing known masterpieces in a morbid way. Many of his works are reminiscent of Hieronymus Bosch. Even though he is a maverick, he has gained acceptance in the established art scene. *RM*

**Witkin,
Joel Peter**

1939 New York
Lives in Albuquerque,
New Mexico

Wolf, Reinhart

1930 Berlin
1988 Hamburg

Until 1954 Reinhart Wolf studied psychology, literature and art history in the USA, Paris, and in Hamburg. He was already interested in photography in his youth, and this interest matured into his decision to make his hobby his profession. He began his study of photography at the Bavarian State Institute of Photography in Munich, completing it in 1956. Wolf settled in Hamburg and set up a studio. In 1969 he started moving into the "studio-house" which he designed, adding a studio for advertising films to this studio for advertising photography. In addition to his professional work, he pursued topics of personal interest, with which he caused a sensation even among the broader public. His first success was a publication of his picture series of American buildings. Conceived quite differently from conventional New York-style photography, he used an 18 x 24 cm camera to take pictures of façades of buildings, mostly by taking elevators to the top floors of skyscrapers. In 1977 he traveled to Georgia and in 1979 to New York in order to create his series *Faces of Buildings*. This large-format book, for which he received many awards, set the standard for a different type of architectural photography. Shortly afterwards *Stern* magazine asked him to take pictures of castles in Spain. During his two trips in 1981 and 1982 he created his picture

◄ **Reinhart Wolf**
Vienna, Hofburg,
1983

Color print
19.5 x 24.5 cm
ML/F 84/126

Gruber Donation

series *Castles of Spain*. Wolf's independent projects became more and more central to his work and philosophy. Most important in this context is the fact that his professional photography became increasingly affected by his freelance work, so much so that the boundaries became blurred. This was evident especially in his food photography, which culminated in 1987 in the publication *Japan – Culture of Eating* and which exhibited a quality of high artistic standards. By taking pictures of Japanese cuisine, mostly on his small hotel night table, he broke all the rules of commercial food photography and created images that embodied Japanese sensibilities to a very high degree while expressing them in the medium of photography. *RM*

▲ **Reinhart Wolf**
Washing and Changing Hall for Miners, Stadthagen, 1978

Color print
17.2 x 23.2 cm
ML/F 1984/129

Gruber Donation

Wolff, Paul

1887 Mulhouse,
upper Alsace
1951 Frankfurt on
Main

▼ Paul Wolff
New York, Fifth
Avenue West, 1932

Gelatin silver print
23.2 x 17 cm
ML/F 1984/131

Gruber Donation

Paul Wolff started out by studying medicine, planning to become a doctor. In 1920, while exercising his profession, he came into contact with photography, and in 1926 was fortunate enough to win a Leica at a photographic exhibition in Frankfurt. Wolff became a pacesetter for 35 mm photography in the realms of professional photography and photojournalism. He illustrated numerous books and wrote theoretical discourses on the use of the 35 mm format. In doing so, he helped to make this format popular for serious applications. In 1930 photography became his second profession. He taught many students how best to use a Leica, gave instructions on new perspectives and viewing angles, and in 1934 published his experiences in a book entitled *My Experiences with the Leica*, which he dedicated to Oskar Barnack, the inventor of the Leica. In 1948 he published another book on taking pictures with a Leica, and this time his topic was color photography. Wolff, who never specialized in a topic or concept, but who took pictures of everything he found interesting and suitable, was mainly a theoretician, technician, and image designer of photohistorical importance. In this regard he greatly affected amateur photography in the fifties and thus certainly contributed to the exceptionally high level of photographic technology in Germany. *RM*

▶ Paul Wolff
Steel Cable
Manufacture,
around 1936

Gelatin silver print
23.7 x 17.8 cm
ML/F 1984/130

Gruber Donation

◀ Wols
Cassis, 1940–1941

Gelatin silver print
15.4 x 15.4 cm
ML/F 1979/148

Gruber Donation

Wols

(Alfred Otto
Wolfgang Schulze)

1913 Berlin
1951 Paris

Alfred Otto Wolfgang Schulze, alias Wols, worked as a photographer for 16 years. During the last ten years of his life he devoted himself mainly to drawing and painting. After his death his work as a painter became known, famous and celebrated, but no one was interested in his photographs. Only with the generally growing interest in the medium of photography did Wols' photography begin to attract attention.

This unexpected success came in 1937 with a request for the fashion pavilion at the World Fair. This is when the young photographer received his pseudonym Wols. This name, as his wife Gréty recalls, was "the product of an accident". The then director of the House of Lanvin sent a telegram to Wolfgang Schulze asking him to come to his office. During the transmission the name was mutilated into "Wols", but Schulze considered it a good solution. The photographs shown at the "Pavilion of Elegance" were promptly published under the name "Wols".

By far the greatest part of Wols' photographs consists of portraits.

He always took a series of pictures, photographing people in many different poses. Occasionally he would make up to two dozen exposures of the same person; of Nicole Bauban he even took more than 40 pictures.

As a photographer, Wols did not develop any new techniques or theories. Neither was he interested in daring perspectives, special camera settings, or details. He was no virtuoso with the camera, and did not want to create a new vision. It was always his way of seeing and his world that he portrayed, a world that was lonely and cold. When he photographed Paris, his pictures showed empty streets, sleeping tramps, steep stairs, and always grids. Many of the people whose portraits he took had their eyes closed. Sometimes Wols took pictures of only part of a person – an arm, a hand, a foot. His strange affection for fragmentation and for the inorganic becomes ever more obvious upon

► **Wols**
Gutter, Paris,
around 1937

Gelatin silver print
15.9 x 15.4 cm
ML/F 1979/1147

Gruber Donation

closer study of his photographs. Most amazing are his still-life pictures, his pictures of objects: strange, bizarre compositions peaked to psychic obsession with images of a broken doll in the gutter or of dead, skinned birds. The elements of an apparent reality become psychograms of a soul. He never misused, adulterated, or manipulated the medium of photography.

Ewald Rathke wrote as follows about Wols' photographs: "Wols increasingly arranged objects that did not match and that did not belong together, placing them in a contradictory environment. The realities of his compilations lost their individuality and they simultaneously combined into a new entity. The sense of the familiar was eliminated and recognition impeded. The substance of the external form was removed, the spatial relationship rearranged, the field of view narrowed. But, paradoxically, that is precisely what enhances the physical presence of the object in the picture." In one of his many aphorisms, Wols himself confirmed the fact that chance always played an important role for him:

◀ Wols
Section of Road,
around 1937

Gelatin silver print
19.9 x 15.4 cm
ML/F 1977/1153

Gruber Donation

▶ **Wols**
Picture of a Man
with a Bowler Hat,
around 1936

Gelatin silver print
16.5 x 15.4 cm
ML/F 1979/1150

Gruber Donation

"Chance is a great master because it is actually not an accident. Chance
exists only in our eyes. It is an assistant to the Master's 'Universe'." *GG*

Zelma, Georgii

1906 Tashkent,
Uzbekistan
1984 Moscow

▲ Georgii Zelma
Military Exercise.
Tanks and Airplanes,
around 1920–1924

Gelatin silver print
28 x 42 cm
ML/F 1992/106

Ludwig Collection

▶ Georgii Zelma
Covered Street in
Asia with Man and
Small Child, 1926

Gelatin silver print
10.7 x 8.1 cm
ML/F 1992/109

Ludwig Collection

In 1921 Georgii Zelma joined the camera club of his school. At that time he took pictures with a Kodak 9 x 12 cm box camera. During subsequent years he worked at the "Proletkino" motion-picture studio and with the "Russfoto" agency, which forwarded his documentary photographs to the foreign press. In 1924 Zelma returned to Tashkent as the "Russfoto" correspondent for Uzbekistan and Central Asia.

He published many of his pictures in *Prawda Wostoka (Truth of the East)*. In the thirties he was on the staff of *SSSR na stroike (USSR under Construction)* magazine, producing major reports such as *The USSR Viewed From the Sky* and *Ten Years of Soviet Republic in Jakutia*. During World War II Zelma was a combat reporter for *Izvestiya* in Odessa and Stalingrad among other places. After the war he worked for the magazine *Ogonjok* and for the "Nowosti" press agency.

Many of Zelma's works show the influence of the Russian photographic avant-garde. Thematically, his work covers a spectrum ranging from military exercises, demonstrations, factory and farm workers, all the way to ethnological subjects. *MBT*

Zeun, Renate

1946 Radebeul
Lives in Berlin

▲ **Renate Zeun**
Hand on Body, from:
Afflicted, Images of
My Cancer, 1983

Gelatin silver print
17.8 x 23.8 cm
ML/F 1991/147

After finishing high school, Renate Zeun trained to become a beautician, going on to study photography from 1978 to 1979 by taking a correspondence course at the renowned College of Graphic Design and Book Art in Leipzig. In 1988 she became a member of the Association of Creative Artists. In 1986 she published the book *Afflicted, Images of My Cancer*, in which she addresses the subject of breast cancer. These photographs are as effective in the form of a sequence as they are as individual pictures. They offer the viewer an opportunity for reflection and empathy in the often taboo area of disease, suffering, fear, and death. In 1987 she created the sequence *Mrs. Anneliese St. – Clinic for Oncology, Berlin,* about which she said: "I hope that these photographs encourage reflection and discussion, and that it might be a step on the way for those who are healthy to be able to meet those who are sick in an understanding and uninhibited manner." *AS*

► Willi Otto Zielke
Stack of Glass
Plates I, 1929

Gelatin silver print
23.5 x 17.6 cm
ML/F 1988/21 I

In 1921, following his studies of railroad technology in Tashkent, Willy Otto Zielke and his family moved to Munich. There he attended the Bavarian State Educational Institute of Photography. Beginning in 1928 he was a teacher who influenced the evolution of numerous photographers, including Hubs Flöter, Kurt Julius, and Erwin von Dessauer. In those years he also began to create motion pictures, achieving such a great success with his first film "Unemployed" that he was motivated to make another motion picture called "The Steel Animal" on the occasion of the 100th anniversary of the Nuremberg-Fürth railway. In addition to his motion-picture work, Zielke also became known for his photography of objects, his brilliant technique, and his unconventional perspectives. He was experimenting with color photography as early as 1933. In the fifties he was Chargesheimer's predecessor at the BIKLA School in Düsseldorf. *RM*

Zielke,
Willy Otto

1902 Lodz, Poland
1989 Bad Pyrmont

◄ Georgii Zimin
Still Life with Comb
and Scissors,
1928–1930

Gelatin silver print
23.7 x 29.5 cm
ML/F 1992/104

Ludwig Collection

Zimin, Georgii

1900 Moscow
1985 Moscow

► Georgii Zimin
Still Life with Light
Bulb, 1928–1930

Gelatin silver print
24 x 18 cm
ML/F 1992/102

Ludwig Collection

Between 1914 and 1917 Georgii Zimin attended the Stroganov School
of Arts for Industry in Moscow. Between 1918 and 1920 he studied at
SWOMAS and from 1921 at WCHUTEMAS, the center of suprematist
and constructivist art in revolutionary Russia. El Lissitzky, who was also
teaching there at that time, was creating his first photograms. During
this time Zimin designed decorations for agitprop events celebrating
May Day in Moscow, and he cultivated contacts with the group "Art of
Motion" at the Academy of Sciences in Moscow. In the late twenties he
tried his hand at experimental photography by creating his own pho-
tograms. His work is characterized by great simplicity and clarity while
using few pictorial elements. His still-life pictures abstain from any nar-
rative content and, with their simple arrangement, they not only re-
semble the photograms of El Lissitzky but also the first experiments of
Henry Fox Talbot. *RM*

**Židlický,
Vladimír**

1945 Hodonin
Lives in Brno

Vladimír Židlický studied photography under Prof. Jan Smok and Prof. Jaroslav Rajzík at the Prague Faculty of Film. Between 1977 and 1988 he worked at Hodonin's art gallery, where he organized numerous photographic exhibitions and initiated a collection of photography. Between 1977 and 1982 he was the head of the Photography Department at the School of Applied Arts in Brno and in 1982 became the director of that school. Židlický's work represents a new beginning for Czech photography. It is closer to painting and drawing than to photography. He began manipulating the technical process of producing a print, devising a technique of light-drawing that he blended with the photographic image. Thus his photographic work stands between photographic imaging and experimental, abstract photography. With his light-drawings, Židlický creates cosmic spaces into which he places human bodies. Some of his compositions move so weightlessly in the image plane that they are reminiscent of baroque figures in church cupolas. His nudes appear to float in an abstract space, integrated in a network of lines and areas with which he composes the structures of his pictures. Frequently,

▼ **Vladimír Židlický**
Dramatic Figure,
1985

Gelatin silver print
45.5 x 40.5 cm
ML/F 1990/1283

these lines and structures are the result of light effects, while many others suggest rather destruction, leading one to suppose some violent treatment of the negative, which also affects the integrity of the nude figures. In many of his photographs the latter only play a subordinate role, incorporating themselves in the abstract drawings and becoming dark silhouettes. Židlický has developed an expressive blend of light-drawing and nude photography. He is considered to be one of the leading Czech artists of the middle generation. *RM*

▶ **Piet Zwart**
Cable Machines,
1933

Gelatin silver print
25.2 x 18.5 cm
ML/F 1979/1663/VII

Piet Zwart initially became known as a typographer and designer of interior spaces and craft objects. In 1924, encouraged by the constructivist El Lissitzky, Zwart for the first time integrated a photogram into advertising that he was designing for the "Dutch Cable Factory" in Delft. A few years later, when he received a request from the same company to handle the typographic design for a catalog of cable products, he recognized that photography, because of its capability for exact reproduction of materials and structures, was predestined for this task. The catalog, which was published in 1928, was an enormous success, meeting with acclaim beyond the borders of the Netherlands. His precise pictures, as well as his utopian ideas of the possibilities of technology, set the standards for the Dutch photographic avant-garde during the years that followed. *MBT*

Zwart, Piet

1885 Zaandijk, near
Amsterdam
1977 Leidschendam,
near The Hague